the freelance photographer's market handbook 2015

the freelance photographer's market handbook 2015

Edited by John Tracy & Stewart Gibson

BFP BOOKS London

© Bureau of Freelance Photographers 2014

All rights reserved. No part of this publication may be reproduced, stored in a retrieval system or transmitted in any form or by any means, without the written permission of the copyright holder. All information was believed correct at the time of going to press. However, market information is subject to change, and readers are advised to check with the publication concerned before preparing a contribution. Members of the Bureau of Freelance Photographers are kept in touch with changes in the marketplace through *Market Newsletter*, published monthly. Every care has been taken in the compilation of this book, but the publisher can assume no responsibility for any errors or omissions, or any effects arising therefrom.

A catalogue record for this book is available from the British Library

ISBN3: 978-0-907297-68-0

31st Edition

Published for the Bureau of Freelance Photographers by BFP Books, Vision House, PO Box 474, Hatfield AL10 1FY Cover design and photography by picktondesign, www.picktondesign.co.uk Printed in Great Britain by Berforts Information Press

CONTENTS

PREFACE		7
ABOUT THE BFP		
HOW TO USE THIS BOOK		
APPROACHING THE MARKET		
MAGAZINES: Introduction		
New Listings, Changes and Deletions		
Subject Index		
MAGAZINE MARKETS	: Angling	27
	Animals & Wildlife	.28
	Architecture & Building	31
	Arts & Entertainment	.34
	Aviation	
	Boating & Watersport	
	Business	43
	Camping & Caravanning	44
	County & Country	
	Cycling & Motorcycling	
	Equestrian	
	Farming	
	Food & Drink	
	Gardening	
	General Interest	62
	Health & Medical	64
	Hobbies & Crafts	66
	Home Interest	
	Industry	74
	Local Government & Services	77
	Male Interest	79
	Motoring	82
	Music	88
	Parenting	91
	Photography & Video	92

	Politics & Current Affairs	
	Railways	
	Religion	104
	Science & Technology	105
	Sport	106
	Trade	
	Transport	
	Travel	122
	Women's Interest	
NEWSPAPERS		
BOOKS: Introduction		
Subject Index		
Listings		
CARDS, CALENDARS, POSTERS & PRINTS		
AGENCIES: Introduction		
Subject Index		167
Listings		
SERVICES: Courses & Training		
Equipment Hire		
Equipment Repair		193
Insurance		
Postcard Printers		
Processing & Finishing		
	Equipment & Materials	
	Presentation	
	& Services	
Web Servic	es & Software	
USEFUL ADDRESSES		
INDEX		
BFP MEMBERSHIP APPLICATION FORM		

PREFACE

The past 12 months has been remarkably quiet and uneventful in the magazine world. Unsurprisingly, few publishers have been prepared to risk new launches while most of their potential readers remain in the grip of austerity.

Yet at the same time there have been remarkably few magazine closures, with perhaps fewer noted in this edition of the *Market Handbook* than in any previous one.

Although overall magazine sales have declined in the past year, it has been a gentle decline and sales of established titles have held up. And again all the evidence suggests that sales of digital editions – which stubbornly refuse to translate into meaningful revenue – are complementing rather than cannibalising print sales.

Print is still a long way from dead. Indeed, there are even signs of a boom in demand for glossy magazines, especially in categories like fashion, lifestyle, interiors and cookery.

The titles that are succeeding best are those that provide an escape from the speed and intensity of everyday life, an opportunity to relax away from the demands of the computer or smartphone screen.

What seems to be sustaining the print market is that despite the "instant" appeal of digital, a chosen magazine is not merely ephemeral but something the reader wants to have and to hold, something that has value and quality in itself.

Where stock photography is concerned some older picture libraries have quit the market as giants like Alamy and Getty continue to suck in images from across the globe – more images, selling at lower prices.

Veteran stock photographers may complain about those falling fees but it was only the inevitable result of smartphones, new distribution channels and market forces combining to revolutionise the marketplace.

And who could have guessed that image sharing via social media would

almost overnight present a massive new bank of images freely available to astute commercial picture buyers?

But supply is coinciding with demand as the worldwide need for images continues its exponential growth. Now, from selling a small number of images to a select group of customers, Alamy and Getty sell millions of images to millions of customers.

There are now vastly more photographers earning a useful income from their images. How many of these people consider themselves "freelance photographers" is a moot point, but this is where we are today.

Once again we find ourselves unable to resist that recent comment by Getty chief Jonathan Klein: "The world's most-spoken language isn't Mandarin – it's pictures."

ABOUT THE BFP

Founded in 1965, the Bureau of Freelance Photographers is today the major body for the freelance photographer. It has a worldwide membership, comprising not only full-time freelances, but also serious amateur and semi-professional photographers. Being primarily a service organisation, membership of the Bureau is open to anyone with an interest in freelance photography.

The most important service offered to members is the *Market Newsletter*, a confidential monthly report on the state of the freelance market. A well-researched and highly authoritative publication, the *Newsletter* keeps freelances in touch with the market for freelance work, mainly by giving information on the type of photography currently being sought by a wide range of publications and other outlets. It gives full details of new magazines and their editorial requirements, and generally reports on what is happening in the publishing world and how this is likely to affect the freelance photographer.

The *Newsletter* also includes in-depth interviews with editors, profiles of successful freelances, examples of successful pictures, and other general features to help freelances in understanding and approaching the marketplace.

The *Newsletter* is considered essential reading for the freelance and aspiring freelance photographer, and because it pinpoints launches and changes in the marketplace as they occur, it also acts as a useful supplement to the *Handbook*. The *Handbook* itself is an integral part of BFP membership services; members paying the full annual fee automatically receive a copy every year as it is published.

Other services provided to members for the modest annual subscription include:

• Advisory Service. Individual advice on all aspects of freelancing is available to members.

• Mediation Service. The Bureau tries to protect its members' interests in every way it can. In particular, it is often able to assist individual members in recovering unpaid fees and in settling copyright or other disputes.

• Exclusive items and special offers. The Bureau regularly offers books and other useful items to members, usually at discount prices.

• In the Services section of this *Handbook* can be found a number of companies providing special discounts to BFP members on production of a current membership card. Amongst various services members can obtain comprehensive photographic insurance cover at competitive rates.

For further details and an application form, write to Bureau of Freelance Photographers, Vision House, PO Box 474, Hatfield AL10 1FY, telephone 01707 651450, e-mail mail@thebfp.com, or visit the BFP website at www.thebfp.com.

Or if you wish to join right away, you'll find an application form at the back of this book, after the main index.

HOW TO USE THIS BOOK

Anyone with the ability to use a camera correctly has the potential to make money from their pictures. Taking saleable photographs isn't difficult; the difficulty lies in finding the market. It isn't enough for you, the photographer in search of a sale, to find what you think *might* be a suitable market; rather you must find *exactly* the right magazine, publisher, agency or whatever for your particular type of work. Many a sale is lost when work which is, in itself, technically perfect fails to fulfil the total requirements of the buyer.

The Freelance Photographer's Market Handbook has been designed to help resolve these difficulties. It puts you in touch with major markets for your work, telling you exactly what each is looking for, together with hints and tips on how to sell to them and, wherever possible, an idea of the rates they pay.

The *Handbook* covers five big markets for your pictures: magazines (by far the largest), newspapers, book publishers, picture agencies, and companies producing cards, calendars, posters and other print products. There are three ways of using the book, depending on the way you need or wish to work:

1. If you are out to sell to magazines and you can offer coverage on a theme particularly applicable to a certain type of publication (eg gardening, angling, sport) turn to the magazine section and look for the subject. The magazines are listed under 34 categories, each of which has a broad heading covering specific magazines. The categories are in alphabetical order, as are the magazines within those categories. You need only read through them to discover which is best for your type of work.

2. If you have a set of pictures that fall into a specific photographic category (landscapes, children, celebrities etc), turn to the subject index on page 21.

Look up your chosen subject and there you will find a list of all the magazines with a strong interest in that particular type of picture. You then have only to look up each one mentioned in the appropriate section for precise details of their requirements. (If in doubt as to where to find a particular magazine consult the general index at the back of the book.) There are separate subject indexes for book publishers and agencies in those sections of the *Handbook*.

3. If you are looking for the requirements of a specific magazine, book publisher, agency, card or calendar publisher, whose name is already known to you, simply refer to the general index at the back of the book.

Some points to remember

With this wealth of information open to you, and with those three options for finding the right market, there is no reason why you shouldn't immediately start earning good cash from your camera. But before you rush off to submit your images, here are some points worth bearing in mind and which will help you to more successful sales:

1. The golden rule of freelancing: don't send people pictures they don't want. Read the requirements listed in the various parts of this directory and obey them. When, for instance, a Scottish magazine says they want pictures of all things Scottish with the exception of kilts and haggis, you can be sure they are over-stocked with these subjects. They are not going to make an exception just for you, however good you think your pictures might be.

2. Digital image files are the norm nowadays, but always check preferred image file format and size with your chosen market in advance. Small selections of low-resolution files may be sent as initial samples via e-mail, but email is rarely an acceptable method of submission for larger files or batches of material intended for publication.

3. When submitting pictures, make sure they are accompanied by detailed captions. And don't forget to attach your own name and address on each photograph/disc.

4. If you have an idea for a picture or feature for a particular publication, don't be afraid to telephone or e-mail first to discuss what you have in mind. Nearly every editor or picture buyer approached when the *Handbook* was being com-

piled said they would much prefer to hear from potential freelances in advance, rather than have inappropriate pictures or words landing on their desks.

5. If seeking commissions, always begin by making an appointment with the appropriate person in order to show your portfolio and/or cuttings. Do not turn up at a busy editor's office unannounced and expect to be met with open arms.

6. Enclose a stamped addressed envelope if you want a posted submission returned if unsuccessful.

APPROACHING THE MARKET

You've chosen your market, taken the pictures and written the captions. Full of hope and expectation, you put your work in the post. A week later, it comes back with a formal rejection slip. Why? Where did you go wrong?

You have only to look through the pages of this book to see that there are a lot of markets open to the freelance photographer, yet the sad fact remains that a great many of those who try their hand at editorial freelancing fail the first few times, and many never succeed at all. That isn't meant to be as discouraging as it might sound. On the contrary, because so many freelances fail, *you*, with the inside knowledge gleaned from these pages, stand a better chance of success than most. What's more you can gain from the experience of others.

So let's take a look at some of the areas where the inexperienced freelance goes wrong. Knowing the common mistakes, you can avoid them and consequently stand the best chance of success with your own work.

The first big mistake made by the novice is in the actual form of the pictures they supply.

Images taken with digital cameras are acceptable to all markets, but really need to be produced on a well-specified digital SLR in order to provide the quality parameters necessary for high-quality reproduction. For submission to picture markets they must also be of a suitable high resolution (usually 300dpi) and large file size.

Most publications are all-colour, but a number of smaller magazines still use some black and white, while many up-market titles like to use a proportion of high-quality monochrome imagery.

The quality of your work must be first class. Images should be pinsharp and perfectly exposed to give strong, saturated colours. Slight underexposure of around one-third to half a stop may be acceptable, but overexposure never. *Never* send over-exposed, washed-out pictures.

While all markets accept images in digital form, each will have specific

technical requirements or preferences that should be ascertained before submission. File format and image size preferences do vary, so always check with your chosen market for their precise requirements in each case.

Unless otherwise stated in an individual entry, it can be assumed that all the markets listed here prefer digital submissions, not film.

So much for picture format, but what of the actual subject of your pictures? Here again, a lot of fundamental mistakes are made. The oldest rule in the freelancing book is this: don't take pictures, then look for markets; find a market first and then shoot your pictures specifically with that market in mind.

Every would-be freelance knows that rule; yet the many who ignore it is frankly staggering. Remember that rule and act accordingly. First find your market, analyse it to see the sort of pictures it uses, then go all out to take *exactly* the right type of picture.

Editors see a lot of pictures every day, and the vast majority are totally unsuited to their market. Of those that are suited, many are still rejected because, despite being the right *type* of pictures, the subjects are still uninspiring. They are subjects the editor has seen over and over again; and the type that the magazine will already have on file. So once again, the work gets rejected.

Remember this and learn from it. Most of the pictures that fall on an editor's desk are pretty ordinary. If you want to make yours sell, you have to show them something different. It might be a fairly straightforward view of an unusual subject, or it might be a more common subject, seen and photographed from a new angle. Either way, it will be different.

So when you set out to take your pictures, really look at your subject and, even before you press the shutter, ask yourself, why am I taking this picture? Why will an editor want to buy it? What's so different or unusual about it? How can I make a few changes here and now to give it a better chance of success?

Good, traditional picture composition also plays a part in a picture's chances. Many would-be freelances submit pictures of people in which the principal subject is far too small and surrounded by a wealth of unwanted, distracting detail. So make a point, whenever you shoot, of moving in close and really filling the viewfinder with your subject.

Many potentially saleable landscapes are ruined by a flat perspective. So watch out for, and try to include, foreground interest in such pictures.

People at work on a craft or a hobby can be good sellers, but a good many pictures depicting such subjects are shot candidly without the necessary thought needed to really show the subject to its best. Always pose pictures like these before you take them. Finally, a word about presentation. If submitting by post, make sure your material is well packed and presented so that an editor can quickly see what you are offering. For example, an editor will always appreciate a print-out of thumbnail images for quick reference.

If you are sending words – either captions to pictures or a full-blown article – always submit a "hard copy" print-out as well as including your text and/or caption files on the disc.

Send your submission with a brief covering letter, not with pages of explanations about the work. The sale will stand or fall by your pictures and/or words, never by the excuses you offer as to why certain pictures might not be too good. If they're not good enough, they won't sell.

Give your editors what they want. Give them originality and sparkle, and present the whole package in the best way you can. Learn the rules and you'll be on your way to a good many picture sales.

But don't think that anyone is going to break those rules just for you. If your pictures don't measure up to what is required, there will always be another submission right behind full of pictures that do. And there are no prizes for guessing which submission is going to make the sale.

MAGAZINES

The British magazine market is vast. Anyone who doubts that has only to look at the racks of periodicals in any major newsagent. And this is only the tip of the iceberg, the largest section of the consumer press. Beneath the surface there is the trade press, controlled circulation magazines and many smaller publications that are never seen on general sale. At the last count more than 8,000 magazines were being published on a regular basis in Britain.

In this section you will find detailed listings of magazines which are looking for freelances. Some pay a lot, others are less generous, but all have one thing in common – they are here because they need freelance contributions on a regular basis and they are willing to pay for them.

When you come to start looking at these listings in detail, you might be surprised by the number of magazines of which you have never heard. Don't let that put you off. What the newcomer to freelancing often fails to realise is that there are as many, if not more, trade magazines or small specialist titles as there are major consumer publications, and very few of these are ever seen on general sale.

Trade magazines, as the term implies, are aimed at people whose business is making money from the particular subject concerned. As such, their requirements are usually totally different to their consumer counterparts.

As an example, consider boating. A consumer magazine on that subject will be aimed at the boat owner or enthusiast and could contain features on boats and the way they are handled. A trade magazine on the same subject is likely to be more interested in articles about the profits being made by the boating industry and pictures of shop displays of boating accessories.

Trade magazines do not necessarily have a separate section to themselves. If the subject is a common one, such as the example above in which there are both trade and consumer publications, they have been listed for your convenience under a common heading. Despite that, however, there *is* a section specifically for trade. This contains trade magazines that have no consumer counterparts, as well as magazines whose subject is actually trade itself and trading in general.

As you go through these listings, therefore, it is important for you to realise that there is a very real difference between the two sides of the subject, but it is a difference which is explained under each publication's requirements. So don't ignore trade magazines of whose existence you were not previously aware. Very often such a magazine will have just as big a market for your pictures and the fees will be just as good, if not better, than those offered by the consumer press.

It is often a good idea for the freelance to aim at some of the more obscure publications listed here, be they trade magazines or the smaller hobbyist magazines. Simply because they are a little obscure they may not have been noticed by other freelances and, as such, your sales potential may well be higher even if fees paid by some of these publications are relatively low.

When you are looking through the entries, don't stop at the section on illustrations. Read what the magazine needs in the way of text too. A publication that might appear to have a very small market for individual pictures often has a larger potential for illustrated articles, and all you need to do to make a sale is add a few words.

You will also find that many publications talk about needing mainly commissioned work. Don't be misled by this. The commissions are given to freelances and, although this means they won't consider your work on spec, they could well be interested in giving you a commission if you can prove you are worth it. That's where previous experience comes in. When trying for commissions, you should always have examples of previously published work to show an editor.

Many of the larger magazines employ a specific editor to deal with picture submissions and with photographers. They may go under various titles – picture editor, art editor, art director – but this is the person directly responsible for picture selection and for commissioning photographers for specific jobs. This, therefore, is the person you should approach when sending pictures or seeking photographic assignments. When sending written material though – illustrated or not – your approach is best made direct to the editor.

The magazine market is one of the largest available to the freelance. You might not receive as large a fee per picture as you would from, say, the calendar market, or for certain sales that might be made on your behalf by an agency, but what this field does offer is a *steady* income, especially once you have made a breakthrough with one or more titles. There are so many magazines, covering so many different subjects, that freelances who have their wits about them would be hard put *not* to find one to which their own style and interests can be adapted. Make yourself known to a few chosen magazine editors, let them see that you can turn out good quality work on the right subject, at the right time, and there is no reason why this market shouldn't make you a good, regular income, either part time or full time.

New Listings, Changes & Deletions

The following is designed to alert readers to possible new markets as well as to important changes that have taken place since the last edition of the *Handbook*.

'New Listings' includes magazines that have been launched since the last edition appeared as well as established titles that appear in the *Handbook* for the first time. 'Title Changes' lists publications that have changed their names (previous titles in brackets). 'Deletions' lists publications that appeared in the previous edition but are omitted from this one. Publications under this heading have not necessarily ceased publication – they may have been deleted because they no longer offer a worthwhile market for the contributor.

To find the page number for any particular magazine, refer to the main index at the back of the book.

New Listings

Equi-Ads Fibre Forever Sports Hello! Fashion Monthly Smallish The Rugby Paper World of Animals

Title Changes

C+D (Chemist and Druggist) CSMA Club Magazine (Motoring & Leisure) Craft Butcher (Food Trader for Butchers) PCS People (PCS View)

Deletions

Climber Containerisation International Front Mizz Motor Boats Monthly Nuts Planning Real People Spin That's Amazing!

Subject Index

Only magazines are included in this index, but it should be noted that many of these subjects are also required by agencies, book publishers and card and calendar publishers.

Separate subject indexes for book publishers and picture agencies appear in those sections of the book..

To find the page number for any magazine, refer to the main index at the back of the book.

Agriculture

Country Smallholding Countryfile The Countryman Crops Dairy Farmer Eurofruit Magazine Farmers Guardian Farmers Weekly Home Farmer Poultry World

Aircraft

Aeroplane Air International Airforces Monthly Airliner World Aviation News Defence Helicopter Flight International How It Works Jane's Defence Weekly Pilot Rotorhub

Birds

BBC Wildlife Bird Watching Birdwatch The Falconers & Raptor Conservation Magazine Parrots Pet Product Marketing The Racing Pigeon/ Racing Pigeon Pictorial

World of Animals Your Chickens

Boats/Nautical

Boat International Canal Boat **Classic Boat** Coast International Boat Industry Marine Engineers Review Motor Boat and Yachting **RYA** Magazine **Rowing & Regatta** Sailing Today Towpath Talk Water Craft Waterways World Yachting Monthly Yachting World Yachts and Yachting

Buildings

Architecture Today Build It Builders Merchants Journal (BMJ) Country Homes and Interiors The English Home FX House Beautiful Housebuilder Icon The MJ Period Living RIBA Journal SelfBuild & Design Panstadia & Arena Management World of Interiors

The Freelance Photographer's Market Handbook 2015

Business

Director Financial Management MEED North East Times People Management

Celebrities

Bella Best Closer Glamour Grazia Heat Hello! Look Now OK! Radio Times Red Reveal Saga The Stage TV Times Woman Woman&Home

Children

Gurgle Mother & Baby Nursery World Prima Baby & Pregnancy Right Start Scholastic Magazines Smallish

Crafts

Best of British The Countryman Evergreen Furniture & Cabinetmaking Good Woodworking The Lady LandLove LandScape The Simple Things This England Woodcarving Woodturning The Woodworker

Domestic/Farm Animals

Country Smallholding Dairy Farmer Dogs Today Equi-Ads Farmers Guardian Farmers Weekly Home Farmer Horse & Rider Kennel and Cattery Management The Lady Pet Product Marketing Your Cat Your Dog

Fashion

Attitude Bella Best Company Condé Nast Customer Publishing Drapers Elle Esquire Essentials FHM Fibre GQ Glamour Good Housekeeping Grazia Harper's Bazaar Hello! Fashion Monthly The Lady Loaded Look Marie Claire Prima Red Woman Woman&Home Woman's Own Woman's Weekly

Flowers/Plants

Country Homes & Interiors The English Garden The Garden Garden Answers Garden News Garden Trade News Gardeners' World Gardens Illustrated Good Homes Good Housekeeping Homes & Gardens Horticulture Week House Beautiful The Lady LandLove LandScape The Simple Things Woman&Home

Food/Drink

Bella Best **British Baker** Caterer & Hotelkeeper Decanter Essentials Eurofruit Magazine Food and Travel France FrenchEntrée Magazine Good Housekeeping Home Farmer Homes & Gardens House Beautiful Italia! LandLove LandScape Olive Prima The Publicans' Morning Advertiser Red Restaurant Scottish Licensed Trade News The Simple Things Waitrose Kitchen Woman&Home

Glamour/Erotic

Club International Escort FHM Loaded Mayfair Men Only Zoo

Homes/Interiors

Best. Build It Coast Country Homes & Interiors Elle Decoration The English Home Essentials Glamour Good Homes Good Housekeeping Homes & Gardens House Beautiful Ideal Home Marie Claire Period Living Prima Real Homes Red SelfBuild & Design The Simple Things **25 Beautiful Homes** Woman&Home Woman's Own Woman's Weekly World of Interiors Your Home

Industry

Director Education in Chemistry The Engineer Engineering People Management Post Magazine Professional Engineering Urethanes Technology International Utility Week Works Management

Landscapes

Amateur Photographer Best of British Bird Watching

The Freelance Photographer's Market Handbook 2015

Camping Cheshire Life Coast Cotswold Life **Country** Life **Country Walking** The Countryman Cumbria Dalesman Dorset Dorset Life Evergreen The Great Outdoors The Lady Lancashire Life Lincolnshire Life **Outdoor Photography** Photography Monthly Practical Photography The Scots Magazine Somerset Life Sussex Life The Great Outdoors This England Trail Walk Waterways World **Yorkshire** Life

Military

Air International Airforces Monthly Defence Helicopter Jane's Defence Weekly

Motor Vehicles

American Car Magazine Auto Express Autocar The Automobile Automotive Management CSMA Club Magazine Classic American Classic Cars Classic Land Rover Classic Land Rover Classic Evorts Car Classic Plant & Machinery Classics Monthly Coach and Bus Week Commercial Motor Evo 4x4 Fleet News GP International Land Rover Monthly Land Rover Owner International Motor Sport 911 & Porsche World Octane Performance Ford Top Gear Magazine Total911 Tractor Tractor & Machinery Truck and Driver

Motorcycles

Back Street Heroes Bike Classic Bike The Classic Motor Cycle Dirt Bike Rider Motor Cycle News Practical Sportsbikes Ride Scootering Superbike Visordown

Pop/Rock

Heat Front Kerrang! Keyboard Player Loaded Metal Hammer MixMag Mizz Mojo NME Pro Sound News Europe Q Rhythm Total Guitar

Railways

Engineering in Miniature Heritage Railway International Railway Journal Rail Rail Express Railnews The Railway Magazine Steam Railway Today's Railways UK Traction

Sport

All Out Cricket Athletics Weekly Badminton **Boat International** Boxing Monthly The Cricket Paper The Cricketer Cycle Sport **Cycling Plus** Cycling Weekly Cvclist Darts World Dirt Bike Rider Esquire F1 Racing Fieldsports Forever Sports Forty-20 FourFourTwo GQ **GP** International Golf Monthly Golf World Horse & Hound Loaded Martial Arts Illustrated Match Men's Health Motor Cycle News Motor Sport Mountain Biking UK Nuts **Outdoor Fitness Rowing & Regatta** The Rugby Paper **Rugby World Running Fitness** Shooting Gazette Shooting Times & Country Magazine Ski & Board The Skier & Snowboarder Magazine Snooker Scene Sports Shooter

Swimming Times Today's Golfer Visordown Windsurf Yachts and Yachting Zoo

Travel

A Place in the Sun Australia & New Zealand **Business Life Business Traveller CSMA** Club Magazine Coach and Bus Week Condé Nast Customer Publishing Condé Nast Traveller Food and Travel .fr France Travel Magazine France France Today FrenchEntrée Magazine Geographical Good Housekeeping Italia! The Lady Living France Motorhome Monthly National Geographic Traveller Olive Saga Magazine Sunday Times Travel Magazine TLM The Traveller Wanderlust Woman&Home

Wildlife

Amateur Photographer BBC Wildlife Bird Watching Birdwatch Coast Country Life Country Walking Countryfile The Countryman Cumbria Dalesman

The Freelance Photographer's Market Handbook 2015

The Falconers & Raptor Conservation Magazine The Field Geographical The Lady LandLove Landscape Outdoor Photography Photography Monthly PhotoPlus Practical Photography The Scottish Sporting Gazette The Shooting Gazette Shooting Times and Country Magazine Sporting Shooter World of Animals

Angling

ANGLER'S MAIL

Time Inc (UK) Ltd, Blue Fin Building, 110 Southwark Street, London SE1 0SU. Tel: 020 3148 4150. E-mail: tim.knight@timeinc.com Editor: Tim Knight.

Weekly publication with news and features for followers of coarse and carp fishing in the UK. **Illustrations:** Topical news pictures of successful anglers with their catches. Captions should give full details concerning weight and circumstances of capture. Covers: pictures of anglers with exceptional specimen fish or catches.

Text: Features on coarse and carp fishing topics only. Up to 800 words.

Overall freelance potential: Minimal for non-angling freelances.

Editor's tips: Contributors really need knowledge and experience of the subject; pictures and text seen from non-anglers are rarely acceptable.

Fees: By agreement.

ANGLING TIMES

Bauer Media, Media House, Peterborough Business Park, Lynch Wood, Peterborough, PE2 6EA. Tel: 01733 395097. E-mail: steve.fitzpatrick@bauermedia.co.uk

Editor: Steve Fitzpatrick.

Weekly newspaper format publication covering mainly coarse angling. Includes news, features and general instruction.

Illustrations: General angling images, especially newsworthy catches, action and scenics.

Covers:"stunning" action shots featuring anglers in the environment.

Text: Illustrated features on all aspects of the hobby. Up to 800 words.

Overall freelance potential: A good percentage used each week. **Fees:** By agreement.

FLY FISHING & FLY TYING

Rolling River Publications Ltd, The Locus Centre, The Square, Aberfeldy, Perthshire PH15 2DD. Tel: 01887 829868. E-mail: markb.ffft@btinternet.com

Editor: Mark Bowler.

Monthly for the fly fisherman and fly-tyer.

Illustrations: Shots of fly fishermen in action, scenics of locations, flies and fly-tying, and appropriate insect pictures.

Text: Illustrated articles on all aspects of fly fishing.

Overall freelance potential: Fairly good.

Editor's tips: Make an effort to avoid bland backgrounds, especially at watersides. **Fees:** Colour from $\pounds 24-\pounds 58$; covers $\pounds 50$. Text $\pounds 50$ per 1,000 words.

IMPROVE YOUR COARSE FISHING

Bauer Media, Media House, Lynchwood, Peterborough PE2 6EA.

Tel: 01733 468000. E-mail: stephen.stones@bauermedia.co.uk

Associate Editor: Stephen Stones.

Monthly, inspirational,"hints and tips" style magazine for coarse fishing enthusiasts.

Illustrations: Photographs depicting all aspects of coarse fishing.

Text: Ideas for illustrated features from experienced angling writers always considered. 2,500 words; submit a synopsis first.

Are you working from the latest edition of The Freelance Photographer's Market Handbook? It's published on 1 October each year. Markets are constantly changing, so it pays to have the latest edition **Overall freelance potential:** Limited; much of the editorial content is produced in-house. **Editor's tips:** Always query the editor before submitting.

Fees: £50 per picture unless supplied with article; articles £100- £200 inclusive of pictures.

SEA ANGLER

Bauer Media, Media House, Lynchwood, Peterborough PE2 6EA.

Tel: 01733 468000. E-mail: mel.russ@bauermedia.co.uk

Editor: Mel Russ.

Monthly magazine dealing with the sport of sea angling from both boat and beach.

Illustrations: Good sea fishing and shore fishing pictures, scenic coastline pictures from around the country, and proud anglers with good catches. Covers: Head shots of individual sea fish and anglers displaying an exceptional catch (must be a fresh catch).

Text: Instructional features, fishing expeditions, match articles, etc. 1,000 words.

Overall freelance potential: 50 per cent of published material comes from freelance sources. **Fees:** By negotiation; good rates for the right kind of material.

TROUT & SALMON

Bauer Media, Media House, Lynchwood, Peterborough PE2 6EA.

Tel: 01733 468000. E-mail: andrew.flitcroft@bauermedia.co.uk

Editor: Andrew Flitcroft.

Monthly magazine for game fishermen.

Illustrations: Photographs of trout or salmon waters, preferably with an angler included in the picture. Close-up and action shots to illustrate particular techniques. Captioned news pictures showing anglers with outstanding catches. Covers: attractive pictures of game fishing waters, always with an angler present.

Text: Instructional illustrated articles on all aspects of game fishing.

Overall freelance potential: Excellent for those who can produce the right sort of material. **Fees:** Pictures inside according to use. Cover shots, £80. Text according to length.

TROUT FISHERMAN

Bauer Media, Media House, Lynchwood, Peterborough PE2 6EA.

Tel: 01733 395131. E-mail: russell.hill@bauermedia.co.uk

Editor: Russell Hill.

Monthly magazine for the trout fishing enthusiast.

Illustrations: Photographs depicting any aspect of angling for trout–outstanding catches, angling locations, techniques, flies and equipment.

Text: Illustrated articles on all aspects of trout fishing, around 1,500 words.

Overall freelance potential: Excellent scope for top quality material.

Editor's tips: Too much angling photography is dull and uninteresting; an original and lively approach would be welcome.

Fees: On a rising scale according to size of reproduction or length of text.

Animals & Wildlife

BBC WILDLIFE

Immediate Media Company Bristol, Tower House, Fairfax Street, Bristol BS1 3BN. Tel: 0117 927 9009. E-mail: wanda.sowrv@immediate.co.uk

Editor: Matt Swaine. Picture Editor: Wanda Sowry.

Heavily-illustrated magazine for readers with a serious interest in wildlife and environmental matters. 13 issues per year.

Illustrations: Top-quality wildlife and environmental photography of all kinds, mostly to illustrate specific features. See www.discoverwildlife.com for submission guidelines.

Text: Feature and photo story suggestions considered from contributors who have a genuine knowledge of their subject.

Overall freelance potential: Limited as the magazine works with a large number of photographic agencies, as well as professional wildlife photographers worldwide.

Editor's tips: Ensure that you have first familiarised yourself with the magazine and the quality and type of photography used.

Fees: Pictures according to use.

BIRD WATCHING

Bauer Active Ltd, Media House, Lynchwood, Peterborough PE2 6EA.

Tel: 01733 468419. E-mail: matthew.merritt@bauermedia.co.uk

Editor: Matthew Merritt.

Monthly magazine devoted to bird watching and ornithology.

Illustrations: Top quality photographs of birds in the wild, both in the UK and overseas. Prefer to use pictures that illustrate specific aspects of bird behaviour. Also, landscape shots of British birdwatching sites and of people watching birds. Always query editor before submitting.

Text: Illustrated features on all aspects of birds and bird watching.

Overall freelance potential: Excellent scope for wildlife specialists but much is obtained from regular contributors.

Fees: By negotiation.

BIRDWATCH

The Chocolate Factory, 5 Clarendon Road, London N22 6XJ.

Tel: 020 8881 0550. E-mail: editorial@birdwatch.co.uk

Managing Editor: Dominic Mitchell.

Monthly for all birdwatchers. Includes a strong emphasis on the photographic side of the hobby.

Illustrations: Good photographs of British and European birds in their natural habitat. Those with collections of such material should send lists of subjects available.

Text: Well-illustrated features on birdwatching topics, including practical articles on bird photography. 1,000 - 1,200 words, but send a synopsis first.

Overall freelance potential: Average.

Fees: According to use.

COUNTRY SMALLHOLDING

Archant South West, Fair Oak Close, Exeter Airport Business Park, Clyst Honiton,

Near Exeter EX5 2UL.

Tel: 01392 888481. E-mail: editorial.csh@archant.co.uk

Editor: Simon McEwan.

Magazine for smallholders, poultry keepers, organic gardeners and small livestock farmers.

Illustrations: Especially looking for high-quality cover shots that encapsulate what the magazine is about. Frequently features chickens or waterfowl in the foreground, with a property or some other livestock in the background. "Dead space" is required at the top of all cover photos to accommodate the masthead. Submit low-res sample images via e-mail in the first instance.

Text: Ideas for illustrated features always considered; e-mail with outline or suggestions first. Much of the magazine is written by outside contributors, though many of them regulars.

Overall freelance potential: Very good for genuinely suitable material.

Fees: Covers £50, others material by negotiation.

DOGS TODAY

Pet Subjects Ltd, The Old Print House, 62 High Street, Chobham GU24 8AA.

Tel: 01276 858880. E-mail: enquiries@dogstodaymagazine.co.uk

Editor: Beverley Cuddy.

Monthly magazine for the pet dog lover.

Illustrations: News pictures or shots showing dogs in action, in specific situations (training,

The Freelance Photographer's Market Handbook 2015

walking, play, vets etc) and interacting with people (especially children). Will also consider exciting or amusing photo sequences and pictures of celebrities with their dogs. No requirement for dog portraits or breed pictures.

Text: General illustrated features about dogs. Should be positive and have a"human interest" feel. **Overall freelance potential:** Limited; the magazine has a large library of studio photography to draw on.

Fees: According to use.

THE FALCONERS & RAPTOR CONSERVATION MAGAZINE

PW Publishing Ltd, Tayfield House, 38 Poole Road, Westbourne, Bournemouth BH4 9DW. Tel: 0845 803 1979. E-mail: peter@pwpublishing.ltd.uk

Editor: Peter Eldrett. Art Editor: Stephen Hunt.

Quarterly magazine devoted to falconry and birds of prey.

Illustrations: Images usually only required to illustrate specific articles as below. Covers: Striking images of birds of prey.

Text: Articles on falconry and related topics. 1,000-5,000 words.

Overall freelance potential: Little scope for individual photographs, but complete illustrated articles always welcome.

Editor's tips: Free author's guide available on request.

Fees: By negotiation.

KENNEL AND CATTERY MANAGEMENT

Albatross Publications, PO Box 523, Horsham, West Sussex RH12 4WL.

Tel: 01293 871201. E-mail: kennelandcattery@aol.com

Editor: Carol Andrews.

Bi-monthly magazine for boarding kennel/cattery proprietors, dog/cat breeders, rescue homes, etc. **Illustrations:** Pictures depicting relevant subjects, but only required as part of a complete illustrated feature.

Text: Illustrated articles on any topic relating to the above, including cat/dog care.

Overall freelance potential: Limited.

Fees: By negotiation.

WORLD OF ANIMALS

Imagine Publishing Ltd, Richmond House, 33 Richmond Hill, Bournemouth BH2 6EZ.

Tel: 01202 586220. E-mail: helen.harris@imagine-publishing.co.uk

Editor: Charis Webster. Art Editor: Helen Harris.

Wildlife magazine featuring premium wildlife photography and accessible articles for a general readership.

Illustrations: Top-quality international wildlife photography,"unique and powerful" images considered on spec for use in their own right in photo gallery section. Other material also of interest for use elsewhere; send details of subjects and coverage available in the first instance. **Text:** Limited scope.

Overall freelance potential: Very good for outstanding and unque images, though much is supplied by photo agencies and professional wildlife photographers. **Fees:** Variable according to use.

YOUR CAT

BPG Media, 1-6 Buckminster Yard, Main Street, Buckminster, Grantham NG33 5SB. Tel: 01476 859820. E-mail: chloe@yourcat.co.uk

Editor: Chloe Hukin.

Monthly magazine for all cat lovers. Covers every type of cat including the household moggie and pedigree cats.

Illustrations: Mostly by commission to accompany features as below. Limited scope for interesting, unusual or humorous single pictures.

Magazines: Architecture & Building

Text: Illustrated news items and features on the widest variety of topics relating to cats: famous cats, cats in the news, readers' cats, rare cats, cats that earn a living, etc. Also authoritative articles on practical matters: behaviour, grooming, training, etc.

Overall freelance potential: Limited.

Fees: By negotiation.

YOUR CHICKENS

Archant South West, Fair Oak Close, Exeter Airport Business Park, Clyst Honiton, Near Exeter EX5 2UL.

Tel: 01392 888481. E-mail: editorial.csh@archant.co.uk

Editor: Simon McEwan.

Magazine for people who keep chickens on a small scale, not smallholders but the urban or suburban family that has just a few birds.

Illustrations: Especially looking for high-quality cover shots that encapsulate what the magazine is about– attractive images of chickens in urban or suburban back gardens or yards, family oriented, preferably with children involved."Dead space" is required at the top of all cover photos to accommodate the masthead. No general stock pictures of chickens, farm birds or anything else unrelated to the specific theme of the magazine. Submit low-res sample images via e-mail in the first instance.

Text: Ideas for illustrated features always considered; e-mail with outline or suggestions first. **Overall freelance potential:** Very good for genuinely suitable material.

Editor's Tips: Remember the theme of the magazine; straight images of chickens or farm birds are not required.

Fees: Covers £50, other material by negotiation.

YOUR DOG

BPG Media, 1-6 Buckminster Yard, Main Street, Buckminster, Grantham, Lincs NG33 5SB. Tel: 01476 859830. E-mail: editorial@yourdog.co.uk

Editor: Sarah Wright.

Monthly magazine for "the everyday dog owner", with the emphasis on care and training.

Illustrations: Top quality pictures showing dogs and their owners in a practical context, i.e.

walking, training, grooming; dogs in the news; amusing pictures.

Text: Illustrated news stories, practical features, and articles on any interesting canine subject, i.e. working dogs, dog charities, celebrities and their dogs, etc. Always contact editor before submitting. **Overall freelance potential:** Fair.

Editor's tips: Make sure that pictures have the "wow" factor and are of the highest quality. **Fees:** According to size of reproduction and by negotiation.

Architecture & Building

ARCHITECTURE TODAY

Architecture Today plc, 161 Rosebery Avenue, London EC1R 4QX.

Tel: 020 7837 0143. E-mail: chris.f@architecturetoday.co.uk

Editor: Chris Foges.

Independent monthly for the architectural profession. Covers the most important projects in the UK and Europe, from art galleries to social housing and from interiors to urban design.

Illustrations: Most photography is commissioned, but interesting pictures of current architectural projects are always of interest on spec.

Text: Illustrated articles of genuine interest to a professional readership; submit ideas only first. 800 - 2,000 words.

Overall freelance potential: Some scope for specialists.

Editor's tips: Potential contributors must contact the editors before submitting anything. **Fees:** £100 per 1,000 words; photography by arrangement.

BUILD IT

Castle Media, Suite 434, Earls Court Centre, Warwick Road, London SW5 9TA.

Tel: 020 3627 3240. E-mail: buildit@castlemedia.co.uk

Editor: Anna-Marie De Souza.

Monthly devoted to the self-build and home improvement market– ranging from those building a one-off home or converting old buildings to major extension and renovation projects.

Illustrations: Commissions available to experienced photographers to cover architecture, building work and interiors. Some interest in relevant stock photographs of housing and interior decoration subjects.

Text: Authoritative features on building, landscaping and interior design, plus specialised articles on finance, legal issues, weatherproofing, etc.

Overall freelance potential: Excellent for the experienced contributor in the architecture and interiors field.

Fees: Good rates for photographers; text negotiable.

BUILDERS MERCHANTS JOURNAL (BMJ)

Datateam Business Media, 15A London Road, Maidstone, Kent ME16 8LY.

Tel: 01622 699189. E-mail: mrowland@datateam.co.uk

Editor: Mark Rowland.

Monthly business to business magazine for the builders merchants industry– wholesale distributors of building products, including heating, bathroom and kitchen fixtures.

Illustrations: Always interested in unusual photography of merchants' yards, computers, showrooms and vehicles. Ongoing requirement for shots of house building/refurbishment work. Possible scope for creative still life shots of items such as bricks, blocks, timber, etc. Commissions also available, depending on geographic location- write in with details of experience and rates. **Text:** Limited scope for freelance articles on suitable subjects- send business card and samples of published work in the first instance.

Overall freelance potential: Limited.

Editor's tips: Most commissions here tend to be rather mundane, usually involving quite general shots of a merchant's yard. Need photographers who can provide a more creative approach. **Fees:** Photographs by negotiation. Text around £125 per 1,000 words.

FX

Wilmington Business Information Ltd, The Colonnades, 34 Portchester Road, London W2 6ES. Tel: 020 7936 6400. E-mail: tdowling@fxmagazine.co.uk

Editor: Theresa Dowling. Art Editor: Wesley Mitchell.

Monthly interior design business magazine for the retail, hotel and commercial sectors. Aimed at architects, designers and their clients.

Illustrations: By commission only; experienced architectural and interiors photographers with fresh ideas always welcome.

Text: Articles on commercial design matters and related business issues, only from those with real expertise in these areas.

Overall freelance potential: Good for the experienced worker.

Editor's tips: The magazine is very receptive to original ideas. Articles should be hard-hitting and possibly contentious.

Fees: Photography around £200-£250 per day. £160 per 1,000 words.

HOUSEBUILDER

Housebuilder Publications Ltd, Byron House, 7-9 St James's Street, London SW1A 1DW. Tel: 020 7960 1630. E-mail: ben.roskrow@house-builder.co.uk

Editor: Ben Roskrow.

Monthly journal of the House Builders Federation. Aimed at key decision makers, managers, technical staff, marketing executives, architects and local authorities.

Illustrations: Some scope for housebuilding coverage, but only by prior consultation

with the editor.

Text: Features on marketing, land and planning, government liaison, finance, materials, supplies, etc. Always to be discussed before submission.

Overall freelance potential: Around 50 per cent comes from freelances.

Editor's tips: Authoritative articles and news stories only. No PR"puffs".

Fees: £150 per 1,000 words; pictures by agreement.

ICON

Media Ten Ltd, Crown House. 151, High Road, Loughton, IG10 4LF

Tel: 020 3225 5200. E-mail: justin@icon-magazine.co.uk

Editor: Chris Turner. Art Editor: Shazai Chaudry.

Monthly magazine covering architecture and design, aimed at both professionals and interested consumers.

Illustrations: Top quality architectural and design photography, mostly by commission. Submit ideas and samples in the first instance. Also runs a regular monthly showcase,"Icon Hang", for individual photographer's portfolios.

Text: Suggestions considered, but contributors must really know their subject.

Overall freelance potential: Fair.

Editor's tips: Potential contributors should really study the magazine first in order to"tune in" to what it is trying to do.

Fees: By negotiation.

LANDSCAPE

Darkhorse Design Ltd, 42 Hamilton Square, Birkenhead, Wirral, Merseyside CH41 5BP. Tel: 020 8265 3319. E-mail: landscape@darkhorsedesign.co.uk

Editor: Ruth Slavid.

Official magazine of The Landscape Institute. Aimed at professionals either producing or commissioning landscape architecture and designed to showcase the best work in the field. **Illustrations:** Mostly by commission only; always happy to hear from photographers who can offer

high-level skills in architectural work.

Text: Ideas for features will be considered.

Overall freelance potential: Good scope for experienced workers.

Editor's tips: Requirements are very specific, so in the first instance submit only a couple of samples as an indication of style.

Fees: By negotiation.

PANSTADIA & ARENA MANAGEMENT

Alad Ltd, 6 Wealden Place, Bradbourne Vale Road, Sevenoaks, Kent TN13 3QQ. Tel: 01732 459683. E-mail: katie@aladltd.co.uk

Editor: Katie McIntyre.

Quarterly international magazine covering all aspects of stadium and arena design, construction, operation, management and technology.

Illustrations: Photographs of new stadia or arenas internationally, both at the construction stage and on opening. Also newsworthy images involving stadia, arenas, sporting events and venues. **Text:** No requirement.

Overall freelance potential: Fair.

Editor's tips: Always make contact before undertaking a shoot; it may be possible to link the pictures to a feature story.

Fees: By negotiation.

RIBA JOURNAL

RIBA Enterprises, Broad Street House, 55 Old Broad Street, London EC2M 1RX. Tel: 020 7496 8306. E-mail: hugh.pearman@ribajournal.com Editor: Hugh Pearman. Art Editor: Patrick Myles. Monthly magazine of the Royal Institute of British Architects. Covers general aspects of architectural practice as well as criticisms of particular buildings, profiles and interviews. **Illustrations:** Fully-captioned pictures of newly-completed building projects, either brand new or refurbished. Best to send list of subjects initially.

Text: Illustrated features on architectural subjects and criticisms of particular buildings.

Overall freelance potential: Fair.

Fees: By arrangement.

SELFBUILD & DESIGN

WW Magazines Ltd, 151 Station Street, Burton-on-Trent DE14 1BG.

Tel/fax: 01584 841417. E-mail: ross.stokes@sbdonline.co.uk

Editor: Ross Stokes.

Monthly practical consumer magazine covering self-build housing, including conversions and major extensions.

Illustrations: Striking photographs of recently completed self-builds (interiors and exteriors), particularly those of an innovative design or in unusual or visually appealing locations. Coverage of new builds by celebrities also welcomed.

Text: Authoritative and well illustrated articles covering all aspects of building and renovation, including brief items of a quirky, amusing or informative nature. Telephone to discuss ideas before submission.

Overall freelance potential: Good. **Fees:** By negotiation.

Arts & Entertainment

HEAT

Bauer Media, Endeavour House, 189 Shaftesbury Avenue, London WC2H 8JG.

Tel: 020 7295 5000. E-mail: steph.seelan@heatmag.com

Editor: Jeremy Mark. Picture Editor: Steph Seelan.

Popular entertainment weekly with news, reviews and heavy celebrity content.

Illustrations: Interested in hearing from photographers covering live events throughout the UK. Assignments available to shoot performances and behind-the-scenes coverage. Some scope for paparazzi-type material.

Text: No scope.

Overall freelance potential: Good.

Fees: By negotiation.

RADIO TIMES

Immediate Media Company Ltd, Vineyard House, 44 Brook Green, London W6 7BT. Tel: 020 7150 5000. E-mail: roger.dixon@radiotimes.com

Editor: Ben Preston. Picture Editor: Roger Dixon.

Weekly TV and radio listings magazine, containing news and features on programmes and personalities from all broadcast media.

Illustrations: Coverage of broadcasting events, productions and TV personalities, usually by commission.

As a member of the Bureau of Freelance Photographers, you'll be kept up-to-date with markets through the BFP Market Newsletter, published monthly. For details of membership, turn to page 9 Text: Commissioned features on TV personalities or programmes of current interest. Overall freelance potential: Fair for commissioned work. Fees: Various.

THE STAGE

The Stage Media Company Limited, 47 Bermondsey Street, London SE1 3XT. Tel: 020 7403 1818. E-mail: editor@thestage.co.uk Editor: Alistair Smith. Weekly newspaper for professionals working in the performing arts and the entertainment industry. Illustrations: News pictures concerning people and events in the theatre and television worlds. Text: Features on the theatre and light entertainment. **Overall freelance potential:** Limited. Fees: Pictures by agreement, text £100 per 1,000 words.

TV TIMES

Time Inc (UK) Ltd, Blue Fin Building, 110 Southwark Street, London SE1 0SU. Tel: 020 3148 5571. E-mail: elaine.mccluskey@timeinc.com

Editor: Ian Abbott. Art Director: Steve Fawcett. Picture Editor: Elaine McCluskey.

Weekly television programme listings magazine, plus features on major programmes.

Illustrations: Usually commissioned or requested from specialist sources. Mainly quality colour portraits or groups specific to current programme content.

Text: Articles on personalities and programmes.

Overall freelance potential: Between 50 and 75 per cent each week is freelance, but mostly from recognised contributors.

Fees: Negotiable.

Aviation

AEROPLANE

Kelsey Publishing Group, Cudham Tithe Barn, Berry's Hill, Cudham, Kent TN16 3AG. Tel: 01959 541444. E-mail: aero.ed@kelsev.co.uk

Editor: Jarrod Cotter.

Monthly aviation history magazine, specialising in military aircraft from the period 1930-1960 as well as historic civil aviation.

Illustrations: Colour and B&W archive material. Photographs for use in their own right or for stock. Main interest is in veteran or vintage aircraft, including those in museums; preserved airworthy aircraft; occasional unusual pictures of modern aircraft. Action shots preferred in the case of recent material - air-to-air, ground-to-air, or air-to-ground. Covers: high quality air-to-air shots of vintage or veteran aircraft.

Text: Short news stories concerning preserved aircraft, new additions to museums and collections, etc. Not more than 300 words.

Overall freelance potential: Most contributions are from freelance sources, but specialised knowledge and skills are often necessary.

Editor's tips: The magazine is always in the market for sharp, good quality colour images of preserved aircraft in the air.

Fees: Photographs according to size of reproduction, up to full page £80; spreads £100; covers £180.

AIR INTERNATIONAL

Key Publishing Ltd, PO Box 100, Stamford, Lincolnshire PE9 1XQ. Tel: 01780 755131. E-mail: mark.ayton@keypublishing.com Editor: Mark Avton.

Monthly general aviation magazine covering modern military and civil aviation. Aimed at both

The Freelance Photographer's Market Handbook 2015

enthusiasts and industry professionals.

Illustrations: Topical single pictures or picture stories on aviation subjects worldwide. Overseas material welcomed. Air show coverage rarely required.

Text: Illustrated features on topics as above, from writers with in-depth knowledge of the subject. Length variable.

Overall freelance potential: Very good for suitable material.

Editor's tips: Remember the magazine is read by professionals and is not just for enthusiasts. **Fees:** Usually based on page rate of £75. Covers, up to £120 for full-bleed sole reproduction.

AIRFORCES MONTHLY

Key Publishing Ltd, PO Box 100, Stamford, Lincolnshire PE9 1XQ.

Tel: 01780 755131. E-mail: gary.parsons@keypublishing.com

Editor: Gary Parsons.

Monthly magazine concerned with modern military aircraft.

Illustrations: Interesting, up-to-date pictures of military aircraft from any country. Must be current; archive material rarely used.

Text: Knowledgeable articles concerning current military aviation. No historical matter.

Overall freelance potential: Good for contributors with the necessary knowledge and access. **Fees:** Pictures inside from £20; covers £120. Text by negotiation.

AIRLINER WORLD

Key Publishing Ltd, PO Box 100, Stamford, Lincs PE9 1XQ.

Tel: 01780 755131. E-mail: mark.nicholls@keypublishing.com

Editor: Mark Nicholls.

Heavily-illustrated monthly for civil aviation enthusiasts.

Illustrations: Always interested in topical photos covering the commercial airline scene, including business jets- new aircraft being rolled out, new liveries, new airlines, airport developments, etc. International coverage. Some archive material used; send stock lists.

Text: Will consider ideas for articles on any civil aviation theme, around 2,000 words. Contributors must have in-depth knowledge of their subject.

Overall freelance potential: Excellent.

Fees: Pictures from £20; text £50 per 1,000 words.

AIRPORT WORLD

Aviation Business Media, Sovereign House, 26-30 London Road, Twickenham TW1 3RW.

Tel: 020 8831 7507. E-mail: joe@airport-world.com

Editor: Joe Bates.

Bi-monthly trade journal published for the Airports Council International, circulated to airport operators worldwide.

Illustrations: Recent photographs taken in airports and airport terminals in any part of the worldmust be high quality pictures with a creative approach. Before submitting photographers should first send details of airports they have on file.

Text: No scope.

Overall freelance potential: Fair. **Fees:** By negotiation.

rees: by negotiation.

AIRPORTS INTERNATIONAL

Key Publishing Ltd, PO Box 100, Stamford, Lincs PE9 1XQ. Tel: 01780 755131. E-mail: tom.allett@keypublishing.com

Editor: Tom Allett.

Published nine times a year, dealing with all aspects of airport construction, management, operations, services and equipment worldwide.

Illustrations: Photographs related to airport operational affairs. Particularly interested in high quality images for cover use, and coverage of exotic overseas locations. Always contact the editor

before submitting.

Text: Possible scope for overseas material, depending on region; Middle East, Asia-Pacific, South America and Africa of particular interest.

Overall freelance potential: Fair.

Fees: By negotiation.

AVIATION NEWS

Key Publishing, PO Box 100, Stamford, PE9 1XQ.

Tel: 01780 755131. E-mail: dino.carrara@keypublishing.com

Editor: Dino Carrara.

Monthly magazine covering aviation in general, both past and present. Aimed at both the industry and the enthusiast.

Illustrations: Colour; B&W archive material. Photographs of all types of aircraft, civil and military, old or new. Captioned news pictures of particular interest, but no space exploration or aircraft engineering.

Text: News items about current aviation matters. Historical contributions concerning older aircraft. Overall freelance potential: About 45 per cent is contributed by freelances.

Fees: On a rising scale according to size of reproduction or length of text.

DEFENCE HELICOPTER/ROTORHUB

The Shephard Press Ltd, 268 Bath Road, Slough, Berkshire SL1 4DX.

Tel: 01753 727020. E-mail:tony.s@shephard.co.uk

Editor: Tony Skinner.

Defence Helicopter is concerned with military and parapublic helicopter use. Rotorhub magazine covers the civil, public service and corporate rotorcraft market.

Illustrations: Pictures of military, public service (police, coastguard, etc), civil and corporate helicopters anywhere in the world. Must be accurately captioned. Covers: high quality pictures of appropriate helicopters. Should preferably be exclusive and in upright format. No"sterile" pictures; must be action shots.

 ${\bf Text:}$ News stories and features on helicopters in service use and helicopter technology. Up to 1,500 words.

Overall freelance potential: Moderate.

Fees: By negotiation.

FLIGHT INTERNATIONAL

Reed Business Information Ltd, Quadrant House, The Quadrant, Sutton, Surrey SM2 5AS. Tel: 020 8652 3842. E-mail: murdo.morrison@flightglobal.com

Editor: Murdo Morrison. News Editor: Dominic Perry.

Weekly aviation magazine with worldwide circulation, aimed at aerospace professionals in all sectors of the industry.

Illustrations: Weekly requirement for news pictures of aviation-related events. Feature illustrations on all aspects of aerospace, from airliners to satellites. Covers: clean, uncluttered pictures of aircraft– civil and military, light and business.

Text: News items always welcomed. Features by prior arrangement only; submit ideas in the first instance.

Overall freelance potential: Limited for those without contacts in the industry.

Editor's tips: News material can be submitted on spec. Pictures should always be as new as possible or have a news relevance.

Fees: Pictures and news items according to size of reproduction and/or length of text. Commissioned features by negotiation.

FLYPAST

Key Publishing Ltd, PO Box 100, Stamford, Lincs PE9 1XQ. Tel: 01780 755131. E-mail: flypast@keypublishing.com Editor: Nigel Price.

Monthly magazine devoted to aviation history and heritage.

Illustrations: Photographs of interesting old aircraft or aircraft collections from anywhere in the world, but always contact the editor before submitting.

Text: Articles on collections, museums, aircraft operators and personal accounts of past flying experiences. In-depth features profiling aircraft, manufacturers, air forces and countries.

Overall freelance potential: Good for those with access to suitable material.

Fees: By agreement with editor.

PILOT

Archant Specialist, 3 The Courtyard, Denmark Street, Wokingham, Berkshire RG40 2AZ.

Tel: 0118 989 7246. E-mail: philip.whiteman@archant.co.uk

Editor: Philip Whiteman.

Monthly publication for the general aviation (business and private flying) pilot.

Illustrations: Pictures on topics associated with this field of flying, usually to accompany features. **Text:** Illustrated features on general aviation, preferably subjects of widespread, rather than purely personal, interest. Also aviation-related travel articles with pictures that "tell the story".

Overall freelance potential: Excellent. Virtually all of the editorial matter in the magazine is contributed by freelances, though many are regulars.

Editor's tips: Read a copy of the magazine before submitting and study style, content, subject and coverage.

Fees: Pictures inside £30; covers £250. Text with pictures from £50–£300 for shorter items/features; longer or more specialist articles by negotiation.

Boating & Watersport

BOARDS

Factory Media Ltd, 1 West Smithfield, London, EC1A 9JU Tel: 020 7332 9700. E-mail: amy@boards.co.uk

Editor: Amy Carter.

Online magazine devoted to boardsailing and windsurfing, supplemented by free ëBasics' magazine and print annuals published each summer and winter.

Illustrations: Good clear action shots of boardsailing or windsurfing; pictures of attractive girls in a boardsailing context; any other visually striking material relating to the sport.

Text: Articles and features on all aspects of the sport.

Overall freelance potential: Very good for high quality material.

Editor's tips: Action shots must be clean, clear and crisp.

Fees: By negotiation.

BOAT INTERNATIONAL

Boat International Media, First Floor, 41-47 Hartfield Road, Wimbledon, London SW19 3RQ, Tel: 020 8545 9330. E-mail: stewart.campbell@boatinternationalmedia.com

Editor: Stewart Campbell. Art Editor: Nina Hundt.

Monthly glossy magazine focusing on the top, luxury level of sailing and power vessels.

Illustrations: Will consider images of world class yacht racing and luxury cruising.

Text: Mostly staff produced or commissioned from top writers in the field.

Overall freelance potential: Excellent for the best in boating photography and marine subjects. **Editor's tips:** Only the very best quality is of interest.

Fees: By negotiation.

BOATING BUSINESS

Mercator Media Ltd, The Old Mill, Lower Quay, Fareham, Hants PO16 0RA.

Tel: 01329 825335. E-mail: pnash@boatingbusiness.com

Editor: Peter Nash. News Editor: Anne-Marie Causer.

Monthly magazine for the leisure marine trade.

Illustrations: News pictures relating to the marine trade, especially company and overseas news. Some scope for commissioned work.

Text: Features on marine trade topics; always consult the editor first.

Overall freelance potential: Limited.

Fees: Photographs from £20; text £100 per 1,000 words.

CANAL BOAT

Archant Specialist, 3 The Courtyard, Denmark Street, Wokingham, Berkshire RG40 2AZ. Tel: 0118 989 7215. E-mail: nick.wall@archant.co.uk

Editor: Nick Wall.

Monthly specialist title covering inland boating especially on canals, looking at boats, boat ownership and cruising.

Illustrations: Photographs depicting colourful boats, attractive waterways, scenery and seasonal elements, but mainly published as part of an illustrated article and often contributed by readers. **Text:** Some opportunities for illustrated features on canal boats and boating personalities.

Overall freelance potential: Limited.

Fees: According to use of material.

CLASSIC BOAT

The Chelsea Magazine Company, Jubilee House, 2 Jubilee Place, London SW3 3TQ.

Tel: 020 7349 3700. E-mail: dan.houston@chelseamagazines.com

Editor: Dan Houston. Art Editor: Peter Smith.

Monthly magazine for the enthusiast interested in traditional or traditional-style boats from any part of the world. Emphasis on sailing boats, but also covers traditional power boats, steam vessels and modern reproductions of classic styles.

Illustrations: Digital files and transparencies accepted. Pictures to accompany features and articles. Single general interest pictures with 100 word captions giving full subject details. Particular interest in individual boat photo essays. Covers: spectacular sailing images, but

exceptional boat building shots may be used. Upright format with space for logo and coverlines. **Text:** Well-illustrated articles covering particular types of boat and individual craft, combining wellresearched historical background with hard practical advice about restoration and maintenance. Some scope for humorous pieces and cruising articles involving classic boats. Always send a detailed synopsis in the first instance.

Overall freelance potential: Good for those with specialist knowledge or access.

Editor's tips: Well-documented and photographed practical articles do best. Contributors' notes available on request, or see website www.classicboat.com.

Fees: £90-£100 per page pro rata; covers £200.

INTERNATIONAL BOAT INDUSTRY

Time Inc (UK) Ltd, Blue Fin Building, 110 Southwark Street, London SE1 0SU. Tel: 020 3148 4938. E-mail: ed.slack@timeinc.com **Editor:** Ed Slack.

Ealtor: Ed Slack.

Business publication dealing with the marine leisure industry worldwide. Eight issues a year. **Illustrations:** Pictures of boat building and moulding, chandlery shops, showrooms, new boats and equipment. Also marinas.

Text: News items about the boat industry are always of interest.

Overall freelance potential: Good for those in touch with the boat trade.

Editor's tips: This is strictly a trade magazine; general pictures of cruising or racing are not required.

Fees: Linear scale- £100 per page down.

MOTOR BOAT & YACHTING

Time Inc (UK) Ltd, Blue Fin Building, 110 Southwark Street, London SE1 0SU. Tel: 020 3148 4651. E-mail: mby@timeinc.com

Editor: Hugo Andreae. Deputy Editor: Stewart Campbell. Art Editor: Neil Singleton. Monthly magazine for owners and users of motor cruisers.

Illustrations: Mostly required as part of feature packages as below. May consider pictures of motor cruisers at sea, harbour scenes, people enjoying life on motor boats, but check with editor before submitting.

Text: Features on interesting, unusual or historic motor boats; first-person motor boat cruising accounts; technical motor boating topics. 1,500–2,500 words.

Overall freelance potential: Around 40 per cent of features and 20 per cent of pictures are freelance contributed.

Fees: Good; on a rising scale according to size of reproduction or length of article.

PRACTICAL BOAT OWNER

IPC Media Ltd, Westover House, West Quay Road, Poole, Dorset BH15 1JG.

Tel: 01202 440820. E-mail: pbo@ipcmedia.com

Editor: David Pugh. Art Editor: Kevin Slater.

Monthly magazine for yachtsmen, sail and power.

Illustrations: Up to date pictures of boats, harbours and anchorages. Covers: Action shots of cruising boats up to about 35ft (preferably sail). Must have strong colours.

Text: Features and associated illustrations of real use to the people who own boats. Subjects can cover any aspect of boating, from buying a boat through to navigation, seamanship, care and maintenance.

Overall freelance potential: About 25 per cent bought from contributors.

Fees: On a rising scale according to size of reproduction or length of feature.

RYA MAGAZINE

Royal Yachting Association, RYA House, Ensign Way, Hamble, Southampton SO31 4YA. Tel: 023 8060 4100. E-mail: deborah.cornick@rya.org.uk

Editor: Deborah Cornick.

Quarterly publication for personal members of the Royal Yachting Association, affiliated clubs and class associations.

Illustrations: Pictures of boats, yachting events and personalities, used either in their own right or as illustrations for reports and articles. Covers: seasonal/topical shots of yachting subjects. **Text:** Reports and articles on yachting.

Text: Reports and articles on yachting.

Overall freelance potential: Moderate.

Fees: By arrangement.

ROWING & REGATTA

British Rowing Ltd, 6 Lower Mall, London W6 9DJ. Tel: 020 8237 6700. E-mail: wendy.kewley@britishrowing.org **Editor:** Wendy Kewley.

Are you working from the latest edition of The Freelance Photographer's Market Handbook? It's published on 1 October each year. Markets are constantly changing, so it pays to have the latest edition Covers rowing and sculling– competitive, recreational and technical. Nine editions annually. **Illustrations:** Any coverage of the subject considered, especially action pictures of rowing and rowing in scenic settings.

Text: Short, illustrated articles and longer features on all aspects of rowing. Technical topics such as coaching, training and boat-building.

Overall freelance potential: Good.

Fees: By arrangement with editor.

SAILING TODAY

The Chelsea Magazine Company Ltd, Swanwick Marina, Lower Swanwick, Southampton SO31 1ZL. Tel: 01489 585214. E-mail: guy.foan@chelseamagazines.com

Managing Editor: Sam Fortescue. Art Editor: Guy Foan.

Practical monthly for active sail cruising enthusiasts.

Illustrations: Dynamic action shots of cruising yachts from 30-55ft, from home waters to blue waters. Sunny Mediterranean shots, sailing or at anchor, always required for library. Contact sheets/thumbnails accepted for library.

Text: Well-illustrated features on boat improvements and cruising.

Overall freelance potential: Good.

Fees: By negotiation.

WATER CRAFT

Pete Greenfield Publishing, Bridge Shop, Gweek, Helston, Cornwall TR12 6UD.

Tel: 01326 221424. E-mail: ed@watercraft-magazine.com

Editor: Pete Greenfield.

Bi-monthly magazine devoted to traditional small boats and boat building.

Illustrations: Photographs mainly required as part of complete feature packages, but interesting or unusual singles and sequences considered if accompanied by detailed caption information.

Text: Well-illustrated features on suitable subjects

Overall freelance potential: Limited at present; much is produced by regular contributors. **Fees:** Around £60 per published page inclusive of pictures.

WATERWAYS WORLD

Waterways World Ltd, 151 Station Street, Burton-on-Trent DE14 1BG.

Tel: 01283 742950. E-mail: editorial@waterwaysworld.com

Editor: Bobby Cowling.

Monthly magazine that covers all aspects of canal and river navigations (not lakes) in Britain and abroad. Aimed at inland waterway enthusiasts and holiday boaters.

Illustrations: No scope for stand-alone pictures except for cover use. Covers: colourful canal or river scenes with boating activity prominently in the foreground.

Text: Well-illustrated features on inland waterways, 500–2,000 words. Send see website for contributors' guide.

Overall freelance potential: Around 20 per cent freelance contributed. **Fees:** Covers £75.

WINDSURF

Arcwind Ltd, Suite 2, 25 Bankside, Kidlington, Oxon OX5 1JE.

Tel: 01865 378000. E-mail: editor@windsurf.co.uk

Editor: Graeme Fuller.

Ten issues a year, aimed at the enthusiast and covering all aspects of windsurfing.

Illustrations: Sequences and singles of windsurfing action, must be top quality shots.

Text: Illustrated articles on any aspect of windsurfing.

Overall freelance potential: Excellent.

Fees: According to use.

YACHTING MONTHLY

Time Inc (UK) Ltd, Blue Fin Building, 110 Southwark Street, London SE1 0SU. Tel: 020 3148 4872. E-mail: yachting.monthly@timeinc.com

Editor: Kieran Flatt. News Editor: Dick Durham. Art Editor: Simon Fevyer. Monthly magazine for cruising yachtsmen.

Illustrations: News pictures considered for immediate use; location pictures for stock; pictures illustrating seamanship, navigation and technical subjects to illustrate features. Top quality images also considered for covers (sailing boats, 25–45ft, under sail, at anchor or in harbour). No motorboats or dinghies.

Text: Articles relevant to cruising yachtsmen, and short accounts of cruising experiences. Submit synopsis to the editor in the first instance.

Overall freelance potential: Around 40 per cent comes from outside contributors, but most are experienced specialists.

Fees: Dependent upon size of reproduction or length of feature. Normally around $\pounds 50-\pounds 110$ for colour; $\pounds 200$ for covers. Text from $\pounds 75$ per 1,000 words.

YACHTING WORLD

Time Inc (UK) Ltd, Blue Fin Building, 110 Southwark Street, London SE1 0SU.

Tel: 020 3148 4845. E-mail: vanda.woolsey@timeinc.com

Editor: Elaine Bunting. Picture Editor: Vanda Woolsey.

Monthly magazine for informed yachtsmen.

Illustrations: Pictures of general yachting techniques or types of boat; pictures of events and occasions; location shots and mood pictures. Major feature photography commissioned from known specialists. Covers: top quality pictures of yachts in 35ft+ range- action pictures on board, at sea. **Text:** Informative or narrative yachting articles; technical yachting features; short humorous articles; and news. 1,000–1,500 words and 2,000–2,500 words. Send for writers' guidelines. **Overall freelance potential:** Around 30 per cent comes from freelances.

Editor's tips: Contributors must know the subject and know the market. The most successful photographers we use are the ones who work the hardest.

Fees: Inside pictures according to size, from £16. Text up to £160 per 1,000 words.

YACHTS & YACHTING

The Chelsea Magazine Company, Jubilee House, 2 Jubilee Place, London SW3 3TQ. Tel: 020-7349 3700. E-mail: georgie.corlett@chelseamagazines.com

Editor: Georgie Corlett. Picture Editor: Tom Gruitt.

Fortnightly publication covering all aspects of racing, including dinghies and offshore racers.

Illustrations: Pictures of racing dinghies, yachts and general sailing scenes. Covers: Action shots of relevant subjects.

Text: Will consider features on all aspects of the race sailing scene.

Overall freelance potential: Quite good.

Fees: Negotiable.

Business

DIRECTOR

Director Publications Ltd, 116 Pall Mall, London SW1Y 5ED.

Tel: 020 7766 8950. E-mail: director-ed@iod.co.uk

Group Editor: Lysanne Currie. **Creative Director:** Chris Rowe. **Picture Editor:** Claire Woodall. Monthly journal for members of the Institute of Directors.

Illustrations: Top quality portraits of company chairmen or major business personalities. Covers: portraits as above or top quality business/industry subjects. More creative, avant-garde illustrations also used.

Text: Interviews; management advice; company profiles; business controversies; EU affairs. **Overall freelance potential:** Good. **Fees:** By negotiation.

FINANCIAL MANAGEMENT

CIMA, 26 Chapter Street, London SW1P 4NP.

Tel: 020 8849 2251. E-mail: editor@fm-magazine.com

Editor: Lawrie Holmes.

Monthly publication for financial managers. Published for the Chartered Institute of Management Accountants (CIMA).

Illustrations: Regular profile photography to accompany business-related articles.

Text: Occasional freelance market for articles on management/accountancy subjects.

Overall freelance potential: Fair.

Fees: By agreement.

MEED

MEED Media FZ LLC, Telephone House, 69-77 Paul Street, London EC2A 4NQ.

Tel: +971 4390 0045. E-mail: colin.foreman@meed-dubai.com

Editorial Director: Richard Thompson. News Editor: Colin Foreman.

Weekly business journal covering the affairs of Middle Eastern countries. Now edited from Dubai. **Illustrations:** Pictures of current major construction projects in the Middle East, contemporary Middle East subjects preferably with an obvious business flavour, and stock shots of important personalities (politicians, leading businessmen) in the region. Recent general views of particular locations occasionally used.

Text: Specialist articles on relevant business matters.

Overall freelance potential: Limited.

Fees: On a rising scale according to size of reproduction or length of text.

NORTH EAST TIMES

North East Times Ltd, 5-11 Causey Street, Gosforth, Newcastle-upon-Tyne NE3 4DJ. Tel: 0191 284 9994. E-mail: alison.cowie@accentmagazines.co.uk

Editor: Alison Cowie.

Monthly up-market business magazine.

Illustrations: Any general interest pictures connected with the North East of England. Text: Features on business, fashion, property, motoring, wining and dining, sport, etc, all with

North East connections. Around 750 words with two pictures.

Overall freelance potential: Fully committed to freelances.

Fees: By agreement.

PEOPLE MANAGEMENT

Haymarket Business Information, 174 Hammersmith Road, London W6 7JP.

Tel: 020 8267 4446. E-mail: pmeditorial@haymarket.com

Editor: Robert Jeffery. Picture Editor: Dominique Campbell.

Monthly magazine of the Chartered Institute of Personnel and Development. Covers all aspects of staff management and training.

Illustrations: Photographs of people at work in business and industry, particularly any depicting staff education and training. Detailed lists of subjects available welcomed. Some commissions may be available to experienced workers.

Text: Ideas for articles always welcome; submit a short written proposal first.

Overall freelance potential: Quite good- a lot of stock pictures are used.

Fees: By negotiation.

POST MAGAZINE

Incisive Media, Haymarket House, 28-29 Haymarket, London SW1Y 4RX. Tel: 020 7316 9134. E-mail: stephanie.denton@incisivemedia.com **Editor:** Stephanie Denton.

Weekly publication covering insurance at home and abroad.

Illustrations: Pictures of traffic, houses, offices, building sites, damage (including fire and motoring accidents), shipwrecks or aviation losses, etc. Also political and industry personalities. **Text:** News and features on insurance, including general insurance, reinsurance, financial services, investment, marketing, technology, offices and personnel areas.

Overall freelance potential: Most news and features are contributed by freelances. **Fees:** By negotiation.

Camping & Caravanning

CAMPING

Warners Group Publications plc, The Maltings, West Street, Bourne, Lincs PE10 9PH. Tel: 01778 392442. E-mail: iaind@warnersgroup.co.uk

Editor: Iain Duff.

Monthly magazine covering all aspects of tent camping. Emphasises the range of activities that camping makes available.

Illustrations: Single pictures considered for cover use, strong images of campers obviously enjoying themselves on a family or lightweight camping holiday. Other pictures only used as an integral part of features as below.

Text: Picture-led features that show camping as"a means to an end" and illustrate the range of people and lifestyles that camping embraces. Always check with the editor before submitting. **Overall freelance potential:** Excellent for covers.

Editor's tips: Although the majority of images are landscapes remember to take shots of people around tents, for possible front covers.

Fees: £70 per published page, £100 for covers.

CAMPING & CARAVANNING

The Camping and Caravanning Club, Greenfields House, Westwood Way, Coventry CV4 8JH. Tel: 02476 475274. E-mail: magazine@thefriendlyclub.co.uk

Editor: Simon McGrath.

Monthly magazine concerning all aspects of tent camping, caravanning and motorhoming, exclusive to C&CC members.

Illustrations: Limited scope for good shots of camping and caravanning scenes, but usually only required in conjunction with feature articles.

Text: Illustrated features on camping and caravanning in Britain and occaionally overseas, around 1,200 words. Contact the editor with ideas only in the first instance.

Overall freelance potential: Fair.

Fees: By agreement.

CARAVAN

Warners Group Publications, The Maltings, West Street, Bourne PE10 9PH.

Tel: 01778 392450. E-mail: johns@warnersgroup.co.uk

Editor: John Sootheran.

Monthly magazine for all caravanners.

Illustrations: Occasional need for generic caravanning images of touring and caravan-related subjects to illustrate features. High quality photography from all UK regions, landscapes, attractions, festivals, fairs, etc. Send list of subjects and low-res samples in the first instance. **Text:** Well-illustrated accounts of touring in specific areas, or more general caravanning-related

items with a human interest angle. Call or write with ideas first. **Overall freelance potential:** Fair. **Fees:** By negotiation.

CARAVAN INDUSTRY & PARK OPERATOR

A E Morgan Publications Ltd. Editorial: PO Box 618, Norwich NR7 0QT. Tel: 01603 708930. E-mail: chris@themag.fsnet.co.uk **Editor:** Chris Cattrall. Monthly publication for manufacturers, traders, suppliers and park operators in the caravan industry.

Illustrations: News pictures of interest to the industry- new caravan park developments, new models, new dealer depots, etc.

Text: Company profiles on park owners and their businesses, traders and manufacturers. 900–1,200 words.

Overall freelance potential: Up to 30 per cent of the content comes from freelance contributors. **Fees:** By agreement.

MOTORHOME AND CAMPERVAN

Stone Leisure Ltd, Andrew House, 2a Granville Road, Sidcup, Kent DA14 4BN. Tel: 020 8302 6150/6069. E-mail: mhm2007@stoneleisure.com

Editor: Bob Griffiths.

Monthly magazine about motorhomes and their use. Covers travel, lifestyle, etc.

Illustrations: Good photographs related to above subjects will always be considered.

Text: Illustrated features on travel and motorhoming. 500–1,000 words. Also reports on shows or other relevant events.

Overall freelance potential: Good.

Editor's tips: Preference for copy that requires a minimum of subbing or rewriting, sent as emails. **Fees:** Around £50 for illustrated articles.

PARK HOME & HOLIDAY CARAVAN

Kelsey Publishing Group, Cudham Tithe Barn, Berry's Hill, Cudham, Kent TN16 3AG.

Tel: 01959 541444. E-mail: phhc.ed@kelsey.co.uk

Editor: Alex Melvin.

Monthly covering residential park homes and caravan holiday homes.

Illustrations: Always interested in good photographs of park homes, static holiday caravans (not touring caravans), residential and holiday parks.

Text: Illustrated features on the above.

Overall freelance potential: Fair.

Fees: According to use.

PRACTICAL CARAVAN

Haymarket Consumer Media, Teddington Studios, Broom Road, Teddington, Middlesex TW11 9BE. Tel: 020 8267 5629. E-mail: practical.caravan@haymarket.com

Editor: Alastair Clements. Art Editor: Simon Mortimer.

Monthly for caravanning holidaymakers.

Illustrations: Mostly commissioned to accompany specific features, but interesting or unusual caravanning images may be considered on spec.

Text: Feature ideas and first-person stories always considered.

Overall freelance potential: Only for those with experience.

Fees: Commissions start at £250 rising according to suitability and quality.

PRACTICAL MOTORHOME

Haymarket Publishing Ltd, Teddington Studios, Broom Road, Teddington, Middlesex TW11 9BE. Tel: 020 8267 5629. E-mail: practical.motorhome@haymarket.com

Editor: Alastair Clements. Art Editor: Elizabeth Paterson.

Monthly for all motorhome holidaymakers and enthusiasts.

Illustrations: Mostly commissioned to accompany specific features, but interesting motorhome images may be considered on spec.

Text: Feature ideas and first-person stories always considered.

Overall freelance potential: Only for those with experience.

Fees: Commissions £200-£300 per day; other material negotiable.

County & Country

CHESHIRE LIFE

Cinnamon House, Cinnamon Park, Crab Lane, Fearnhead, Warrington WA2 0XP.

Tel: 01925 661904. E-mail: louise.taylor@cheshirelife.co.uk

Editor: Louise Taylor. Picture Editor: John Cocks.

Monthly up-market county magazine specialising in regional features from Cheshire and the North West.

Illustrations: Photographs required mainly to accompany features on topics such as property, antiques, wildlife, society, arts and crafts, sport. Attractive local scenes also of interest– landscapes, towns, villages, heritage, etc.

Text: Articles and features on regional topics. Always consult the editor in the first instance. **Overall freelance potential:** Good.

Fees: By negotiation.

COTSWOLD LIFE

Archant Life, Archant House, Oriel Road, Cheltenham GL50 1BB.

Tel: 01242 216050. E-mail: mike.lowe@archant.co.uk

Editor: Mike Lowe.

Monthly showcasing"the best of the Cotswolds".

Illustrations: Pictures of local scenes and events, preferably with some life in them. Covers: At least A4 at 300dpi depicting lively local scenes, with clear space at top for title logo and space for coverlines elsewhere.

Text: Illustrated articles of varying lengths, on local people, places, events, etc.

Overall freelance potential: Most material comes from regular freelance contributors but new contributors always considered.

Fees: Cover shots £100. Articles and other illustrations negotiable.

COUNTRY LIFE

Time Inc (UK) Ltd, Blue Fin Building, 110 Southwark Street, London SE1 0SU.

Tel: 020 3148 4421. E-mail: vicky.wilkes@timeinc.com

Editor: Mark Hedges. Picture Editor: Vicky Wilkes.

Weekly magazine for an upmarket readership.

Illustrations: Professional-quality pictures of British countryside, UK native wildlife, architecture, interiors, country pursuits and rural life. Covers: Finest quality rural landscapes, country villages, gardens and large detached houses. Outstanding photographs of UK wildlife and dfogs also of interest.

Text: No scope.

Overall freelance potential: Limited; around 80 per cent of the magazine comes from regular suppliers.

Fees: Good; on a rising scale according to size of reproduction. Covers, £300.

COUNTRY WALKING

Bauer Active Ltd, Media House, Lynchwood, Peterborough PE2 6EA.

Tel: 01733 468208. E-mail: mark.sutcliffe@bauermedia.co.uk

Editor: Mark Sutcliffe.

Monthly magazine for all walkers who enjoy great days out in the countryside.

Illustrations: Pictures depicting walkers in attractive locations, who must be wearing proper outdoor gear. Also top quality landscapes of suitable parts of the country, historic locations, landscapes with elements of walking interest (eg. stile, path), nature and wildlife. Covers: seasonal pictures of very attractive landscape settings.

Text: Well-illustrated articles and features on any walking or countryside topics. Strong emphasis on inspiration and entertainment and capturing the essence of why people walk.

Overall freelance potential: Limited, as much is produced by regulars or obtained from picture libraries.

Editor's tips: The emphasis is always on getting enjoyment from walking and the countryside. Fees: By negotiation.

COUNTRYFILE

Immediate Media Company Ltd, 9th Floor, Tower House, Fairfax Street, Bristol BS1 3BN. Tel: 0117 314 8849 (editor); 0117 314 8372 (pictures). E-mail: editor@bbccountryfile.com; hilary.clothier@immediate.co.uk

Monthly magazine celebrating the British countryside. Linked to the popular BBC TV programme. Editor: Fergus Collins. Art Editor: Tim Bates. Picture Editor: Hilary Clothier.

Illustrations: Photographers based in rural areas often required for specific assignments. Also occasional need for photographers specialising in outdoor activities. Submit a few sample images in the first instance. No scope to submit general countryside or landscape pictures on spec. Text: Mostly produced by regular specialists, but ideas always considered.

Overall freelance potential: Good possibilities for those with suitable skills. Fees: By negotiation.

THE COUNTRYMAN

Country Publications Ltd, The Water Mill, Broughton Hall, Skipton, North Yorkshire BD23 3AG. Tel: 01756 701381. E-mail: editorial@thecountryman.co.uk

Editor: Mark Whitley.

Monthly covering all matters of countryside interest other than blood sports.

Illustrations: Sequences of pictures about particular places, crafts, customs, farming practices, kinds of wildlife, etc. Must be accompanied by ample caption material. Only limited scope for single stock pictures, but always seeking high-quality wildlife/countryside images for covers.

Text: Well-illustrated articles of 800-1,200 words, on such subjects as mentioned above. Must be accurate, and usually based on the writer's own experience.

Overall freelance potential: Excellent; almost all photographs, and most articles, are from freelance contributors.

Fees: £15-£80 for photographs inside; £150 for cover. Text up to £75 per 1000 words used.

CUMBRIA

Country Publications Ltd, The Water Mill, Broughton Hall, Skipton, North Yorkshire BD23 3AG. Tel: 01756 701381. E-mail: editorial@cumbriamagazine.co.uk

Editor: John Manning.

Monthly countryside magazine for Cumbria and the surrounding area.

Illustrations: Attractive shots of local landscapes, rural characters, wildlife, country pursuits and heritage.

Text: Illustrated articles on any aspect of Lakeland country life. 800-1,200 words.

Overall freelance potential: Excellent.

Fees: Half-page £20; full-page £30; covers £100.

DALESMAN

Country Publications Ltd, The Water Mill, Broughton Hall, Skipton, North Yorkshire BD23 3AG. Tel: 01756 701381. E-mail: editorial@dalesman.co.uk

Editor: Adrian Braddy. Picture Editor: Eleanor Morton.

Monthly countryside magazine for Yorkshire.

Illustrations: Attractive shots of local landscapes, local characters, wildlife and heritage.

Text: Illustrated articles on any aspect of Yorkshire life. 800-1,200 words.

Overall freelance potential: Excellent.

Fees: Quarter-page £10, half-page £20, full-page £40, double-page £70, covers £100.

DORSET

Archant Life, Archant House, Babbage Road, Totnes, Devon TQ9 5JA.

Tel: 01803 860920. E-mail: helen.stiles@archant.co.uk

Editor: Helen Stiles.

Monthly for people who like to explore the Dorset region.

Illustrations: Good stock photographs of the region suitable for cover use: places, landscapes, natural history, culture and heritage.

Text: Local news and illustrated articles on Dorset subjects as above, around 1,000 words. **Overall freelance potential:** Fair.

Fees: Covers £80-£100, but no budget for pictures used inside; text £75 per 1,000 words.

DORSET LIFE

Dorset County Magazines Ltd, 7 The Leanne, Sandford Lane, Wareham, Dorset BH20 4DY. Tel: 01929 551264. E-mail:editor@dorsetlife.co.uk

Editor: Joel Lacey.

Monthly magazine for the Dorset area.

Illustrations: Interesting but realistic photographs of the region, most required as part of an article, not in isolation. Attractive local seasonal scenes also required for covers and centre-spreads, must be original but should avoid over-manipulation. Good sets of local wildlife images also of interest.

Text: Well-illustrated articles on any topic relating to Dorset, around 1,000 words.

Overall freelance potential: Most contributions come from regular freelance contributors but new contributors always considered.

Fees: From £15 quarter-page to £80 covers, £120 centre-spreads, £200 photo essays.

THE FIELD

Time Inc (UK) Ltd, Blue Fin Building, 110 Southwark Street, London SE1 0SU.

Tel: 020 3148 4777. E-mail: rebecca.hawtrey@timeinc.com

Editor: Jonathan Young. Art Editor: Rebecca Hawtrey.

Monthly publication concerned with all rural and country sports interests.

Illustrations: Good pictures illustrating relevant topics as below. Most used for article illustration but good single pictures always considered for cover use. Commissions available to specialists.

Text: Illustrated features on country and country sporting subjects, especially shooting, fly-fishing, working dogs (gundogs, terriers). Length according to article, in the range 1,000–2,000 words.

Overall freelance potential: Around 80 per cent comes from outside contributors, many of whom are specialists, but opportunities are good for the right material.

Fees: According to merit.

LANCASHIRE LIFE

3, The Serpentine, Lytham, Lancashire FY8 5NL.

Tel: 01253 379558. E-mail: roger.borrell@lancashirelife.co.uk

Editor: Roger Borrell.

Monthly up-market county magazine specialising in regional features, covering Lancashire and the Lake District.

Illustrations: Pictures of the Lancashire and the South Lakes region, mainly to accompany features. Pictures of nationally known personalities with a Lancashire connection. Covers: top quality regional scenes.

Text: Articles and features on regional topics. Always consult the editor in the first instance. Overall freelance potential: Around 20 per cent is from freelance sources.

Editor's tips: Unlikely to be interested unless there is a definite Lancashire or Lake District angle. Fees: By negotiation.

LINCOLNSHIRE LIFE

County Life Ltd, County House, 9 Checkpoint Court, Sadler Road, Lincoln LN6 3PW. Tel: 01522 527127. E-mail: editorial@lincolnshirelife.co.uk

Editor: Caroline Bingham.

Monthly magazine, dealing with county life past and present from the Humber to the Wash. **Illustrations:** Pictures of people and places within the county of Lincolnshire Covers: portrait format colour pictures of local landscapes, architecture, people, street scenes, etc. Submissions for annual calendar also accepted.

Text: Features on people and places within the appropriate area. No more than 1,600 words. Contact editor first to discuss.

Overall freelance potential: Fifty per cent of the magazine comes from freelance sources. Fees: £50 for covers, other material by agreement.

THE SCOTS MAGAZINE

D. C. Thomson and Co Ltd. 80 Kingsway East, Dundee DD4 8SL.

Tel: 01382 575178. E-mail: mail@scotsmagazine.com

Editor: Robert Wight.

Monthly magazine for Scots at home and abroad, concerned with Scottish subjects.

Illustrations: Scottish scenes, but avoid the obvious. Non-Highland subjects particularly welcome. Scenics with one or more figures preferred to"empty pictures".

Text: Features on all aspects of Scottish life past and present. 500-1,500 words. E-mail outlining idea in the first instance.

Overall freelance potential: Around 70 per cent of the magazine comes from freelances. Fees: Variable.

SCOTTISH FIELD

Craigcrook Castle, Craigcrook Road, Edinburgh EH4 3PE.

Tel: 0131 312 4550, E-mail: editor@scottishfield.co.uk

Editor: Richard Bath.

Monthly magazine reflecting the quality of life in Scotland today for Scots at home and abroad. **Illustrations:** Varied subjects of Scottish interest: must be accompanied by appropriate text. Text: Illustrated features with a Scottish dimension. 850-1,200 words. Submit only ideas initially, rather than completed articles.

Overall freelance potential: There are only limited openings for new contributors. Editor's tips: Market study is essential.

Fees: Negotiable.

SOMERSET LIFE

Archant Life, Archant House, Babbage Road, Totnes, Devon TQ9 5JA.

Tel: 01803 860914, E-mail: charlotte.richardson@archant.co.uk

Editor: Charlotte Richardson.

Monthly magazine for Somerset and Bristol area.

Illustrations: Interesting and original photographs of the area, usually only required as part of a words and pictures package. Covers: always on the lookout for portrait-format shots that will carry the title and coverlines, preferably seasonal pictures of recognisable Somerset scenes.

Text: Well-illustrated articles on any topic relating to Somerset, around 1,000 words.

Overall freelance potential: Keen to find new contributors with photographic skills who can also write well.

Fees: By arrangement.

SUSSEX LIFE

Sussex Life Ltd, 28 Teville Road, Worthing, West Sussex BN11 1UG.
Tel: 01903 703735. E-mail: jenny.mark-bell@archant.co.uk
Editor: Jenny Mark-Bell.
Monthly county magazine.
Illustrations: Stock photographs always welcomed, but complete illustrated articles are preferred.
Covers: Sussex scenes, usually depicting landscapes, but houses, activities, interiors and personalities from Sussex considered.
Text: Well illustrated features on any topic relevant to the county.1,000–2,000 words.

Overall freelance potential: Quite good.

Fees: 1,000-word article plus pics, £150.

THE GREAT OUTDOORS

Newsquest Magazines, 200 Renfield Street, Glasgow G2 3QB.

Tel: 0141 302 7736. E-mail: emily.rodway@tgomagazine.co.uk

Editor: Emily Rodway.

Monthly magazine for walkers in the UK. Covers hill and mountain walking, and related topics. **Illustrations:** Material required for stock- mostly landscapes featuring walker; also pictures to illustrate features. Covers: Pictures in upright format considered independently of internal content. Photographs of walkers, backpackers and fell walkers in landscape settings. Must be contemporary, well-equipped people in photos; action shots preferred.

Text: Features on the subjects mentioned above. 2,000 words.

Overall freelance potential: Most of the magazine comes from freelance sources.

Editor's tips: Too many freelances send material which is outside the scope of the magazine- not interested in low level rambling. Send e-mail for guidelines.

Fees: Stock pictures according to use, covers around £200.

THIS ENGLAND/EVERGREEN

This England Publishing Ltd, The Lypiatts, Lansdown Road, Cheltenham GL50 2JA.

Tel: 01242 225780. E-mail: editor@thisengland.co.uk

Editor: Stephen Garnett. Deputy Editor: Angeline Wilcox.

Quarterly magazines about England and the United Kingdom respectively, mainly its people, places, customs and traditions and with strong emphasis on nostalgia.

Illustrations: Town, country and village scenes, curiosities, craftsmen at work, nostalgia,

patriotism. Prefer people in the picture, but dislike modernity etc. Pictures for stock or use in their own right.

Text: Illustrated articles on all things traditionally British. 1,000–1,500 words.

Overall freelance potential: Around 50 per cent comes from freelance sources.

Editor's tips: Send SAE or e-mail for contributor guidelines.

Fees: By negotiation.

TRAIL

Bauer Active Ltd, Media House, Lynchwood, Peterborough PE2 6EA.

Tel: 01733 468363. E-mail: trail@bauermedia.co.uk

Editor: Simon Ingram.

Monthly magazine aimed at more adventurous walkers, especially hillwalkers.

Illustrations: Well-composed pictures of walkers, backpackers, climbers and mountain bikers in attractive and dramatic British landscapes, high viewpoints preferred. Walkers seen close up should be wearing proper outdoor gear. Covers:"stunning" colour shots as above.

Text: Illustrated articles on any aspect of hill walking, backpacking and trekking, including diet, fitness, etc. Only accepted from contributors who clearly understand what the magazine is about and what the readers need. Always discuss ideas with the editor in the first instance. **Overall freelance potential:** Very good for high quality material.

Editor's tips: It is essential that people in pictures be wearing proper walking/climbing clothes and shoes- no ieans and trainers.

Fees: From £25-£150 (DPS). Text from £140 per 1,000 words.

WALK

The Ramblers, 2nd Floor, Camelford House, 87-90 Albert Embankment, London SE1 7TW.

Tel: 020 7339 8500. E-mail: denise.noble@ramblers.org.uk

Editor: Dominic Bates. Assistant Editor: Denise Noble.

Quarterly journal for members of the Ramblers.

Illustrations: Scenic views of the British countryside, preferably with walkers in shot. Also pictures of difficulties encountered when walking in the countryside, eg damaged bridges, locked gates,

obstructed footpaths, etc. Walking images from abroad also required.

Text: Little scope for text as most articles are commissioned from regulars.

Overall freelance potential: Limited other than by commission.

Editor's Tips: Pictures usually only used in the service of commissioned articles and features; contact editor with portfolio and details of geographical coverage and specialisations. **Fees:** By agreement.

YORKSHIRE LIFE

Archant Life, PO Box 163, Ripon, HG4 9AG.

Tel: 01765 692586. E-mail: esther.leach@yorkshirelife.co.uk

Editor: Esther Leach.

Monthly up-market county magazine for Yorkshire.

Illustrations: Pictures of the Yorkshire region, mainly to accompany features. Pictures of nationally known personalities with a Yorkshire connection, and local society events, but most by commission. Covers: top quality regional scenes.

Text: Articles and features on regional topics, from those with a truly professional approach. Always consult the editor in the first instance.

Overall freelance potential: Fair.

Fees: By negotiation for certain material only; check with editor.

Cycling & Motorcycling

BACK STREET HEROES

Ocean Media Group, One Canada Square, Canary Wharf, London E14 5AP. Tel: 07884 052003. E-mail: nik@backstreetheroes.com

Editor: Nik Sansom.

Monthly magazine for custom bike enthusiasts.

Illustrations: Pictures of individual customised or one-off machines, and coverage of custom bike meetings and events. The style of photography must be tailored to fit the style of the magazine. **Text:** Limited freelance market.

Overall freelance potential: Good for those who can capture the flavour and style of the custom bike scene.

Editor's tips: This is something of a lifestyle magazine, and it is essential that the stylistic approach be absolutely right.

Fees: By negotiation.

BIKE

Bauer Automotive Ltd, Media House, Lynchwood, Peterborough PE2 6EA.

Tel: 01733 468000. E-mail: hugo@bikemagazine.co.uk

Editor: Hugo Wilson.

Monthly motorcycling magazine aimed at all enthusiasts.

Illustrations: Interesting or unusual topical pictures always required for news section. Sporting pictures for file. Top quality action pictures,"moody" statics and shots that are strong on creative effects. Reportage/documentary shots of events/people.

Text: Interesting or unusual news items. Scope for features on touring, personalities, icons etc; 1,000–3,000 words.

Overall freelance potential: Good for those with experience.

Editor's tips: Always looking for new photographers and styles. Fees: By agreement.

CLASSIC BIKE

Bauer Automotive Ltd, Media House, Lynchwood, Peterborough PE2 6EA. Tel: 01733 468081. E-mail: hugo.wilson@bauerautomotive.co.uk Editor: Hugo Wilson. Monthly magazine dealing with thoroughbred and classic motorcycles from 1896 to 1990. Illustrations: Pictures of rallies, races, restored motorcycles. Text: Technical features, histories of particular motorcycles, restoration stories, profiles of famous riders, designers etc. 500–2,000 words. Overall freelance potential: Most photography is freelance.

Editor's tips: Contact the editor before submitting.

Fees: By agreement and on merit.

THE CLASSIC MOTORCYCLE

Mortons Media Group Ltd, PO†Box 99, Horncastle, Lincs LN9 6LZ.

Tel: 01507 529405. E-mail: jrobinson@mortons.co.uk

Editor: James Robinson.

Monthly magazine covering veteran, vintage and post-war motor cycles and motorcycling. **Illustrations:** Pictures that cover interesting restoration projects, unusual machines, personalities with a background story, etc. Covers: colour pictures, usually a well-restored and technically interesting motor cycle, always related to editorial.

Text: Features on subjects detailed above. 1,500-2,500 words.

Overall freelance potential: Around 50 per cent of the magazine comes from freelances, but much of it is commissioned.

Editor's tips: Potential contributors must have a good technical knowledge of the subject. **Fees:** Good; on a rising scale according to size of reproduction or length of article.

CYCLE SPORT

Time Inc (UK) Ltd, Leon House, 233 High Street, Croydon CR9 1HZ.

Tel: 020 8726 8453. E-mail: robert.garbutt@timeinc.com

Editor: Robert Garbutt.

Monthly devoted to professional cycle sport, offering a British perspective on this essentially Continental sport.

Illustrations: High quality, topical photographs relating to professional cycle racing.

Text: Illustrated features on the professional scene, but always query the editor before submitting. 1,500–4,000 words.

Overall freelance potential: Good for those with access to the professional scene, but most coverage comes from specialists based on the Continent.

Editor's tips: Most interested in"the news behind the news".

Fees: Pictures according to nature and use. Text £100-£200 per 1,000 words.

CYCLING PLUS

Future Publishing Ltd, Beauford Court, 30 Monmouth Street, Bath BA1 2BW. Tel: 01225 442244. E-mail: chris.borgman@futurenet.co.uk

Editor: Rob Spedding. Art Editor: Chris Borgman.

Monthly magazine aimed at recreational cyclists, concentrating on touring and leisure/fitness riding. Some racing coverage.

Illustrations: Photographs that capture the excitement and dynamics of cycle sport. Speculative submissions welcomed; commissions also available.

Text: Little freelance scope; most is produced by a team of regular writers.

Overall freelance potential: Good for photographers.

Fees: By negotiation.

CYCLING WEEKLY

Time Inc (UK) Ltd, Leon House, 233 High Street, Croydon CR9 1HZ. Tel: 020 8726 8453. E-mail: cycling@timeinc.com

Editor: Robert Garbutt.

News-based weekly magazine covering all aspects of cycling; aimed at the informed cyclist.

Illustrations: Good photographs of cycle racing, plus any topical photographs of interest to cyclists. Covers: striking colour photographs of cycle racing; must be current.

Text: Well-illustrated articles on racing and technical matters. Around 1,500 words.

Overall freelance potential: Fairly good.

Fees: According to use.

CYCLIST

Dennis Publishing Ltd, 30 Cleveland Street, London W1T 4JD.

Tel: 020 7907 6000. E-mail: peter_muir@dennis.co.uk; rob_milton@dennis.co.uk

Editor: Pete Muir. Art Editor: Rob Milton.

monthly title for the contemporary road cycling enthusiast, in print and app format.

Illustrations: Mostly commissioned, ranging from inspirational shots, such as touring in the Alps, to more gritty reportage material where appropriate. Approaches from photographers skilled in action, portraiture or reportage are welcomed.

DIRT BIKE RIDER

L&M Newspapers, 41 Northgate, Whitelund Industrial Estate, Morecambe LA3 3PA.

Tel: 01524 385971. E-mail: anthony.sutton@dirtbikerider.co.uk

Editor: Anthony Sutton.

Monthly covering all forms of off-road motorcycle sport, aimed at competitors and those who aspire to compete.

Illustrations: Current pictures of off-road events, bikes and riders.

Text: Illustrated features on all aspects of off-road motorcycling and racing. Contact editor with suggestions in the first instance.

Overall freelance potential: Good.

Fees: Negotiable.

MOTO MAGAZINE

Factory Media Ltd, 1 West Smithfield, London EC1A 9JU.

Tel: 020 7332 9700. E-mail: ben.johnson@factorymedia.com

Editor: Ben Johnson.

Bi-monthly magazine covering motocross from an international perspective.

Illustrations: Will consider any topical and relevant images on spec. Has two regular photographers covering main events but commissions may be available.

Text: Possible scope for features on leading riders - contact editor with suggestions.

Overall freelance potential: Quite good for specialists.

Fees: By negotiation.

MOTOR CYCLE NEWS

Bauer Automotive Ltd, Media House, Lynchwood, Peterborough PE2 6EA.

Tel: 01733 468006. E-mail: andy.calton@motorcyclenews.com

Editor: Andy Calton.

Weekly tabloid for all road-riding and recreational motorcyclists. Also covers motorcycle sport. **Illustrations:** Rarely use on-spec material, but frequently require freelances for assignments. Seek competent photographers with keen news sense, able to work closely to a given brief yet able to incorporate their own visual ideas. Successful applicants are added to a nationwide contact list and may be approached to cover stories at any time.

Text: Illustrated news stories on all aspects of motorcycling always considered. Lively tabloid style required.

Overall freelance potential: Good.

Editor's tips: Assignments are often at short notice and to tight deadlines – photographers who can work quickly and flexibly stand the best chance of success. Commission fees include copyright assignment to MCN, though permission for re-use by the photographer is rarely denied. **Fees:** Single pictures from £50; day rate £200 plus expenses.

MOUNTAIN BIKING UK

Future Publishing Ltd, Beauford Court, 30 Monmouth Street, Bath BA1 2BW.

Tel: 01225 442244. E-mail: danny.walter@futurenet.co.uk

Editor: Danny Walter.

Monthly magazine devoted to the sport of mountain biking.

Illustrations: Spectacular or unusual shots of mountain biking, action pictures that convey a sense of both movement and height. General coverage of events and individual riders may be of interest. **Text:** Well-illustrated articles that show good knowledge of the sport.

Overall freelance potential: Good scope for individual and original photography. **Fees:** By negotiation.

PRACTICAL SPORTSBIKES

Bauer Automotive Ltd, Media House, Lynchwood, Peterborough PE2 6EA.

Tel: 01733 468043. E-mail: jim.moore@bauermedia.co.uk

Editor: Jim Moore.

Monthly magazine focused on sports motorcycles from the mid-70s to mid-90s era.

Illustrations: Will consider single images if highly relevant to the magazine, but mostly required as part of illustrated article packages as below.

Text: Well-illustrated feature stories about individual bikes and restoration projects, but

contributors must have detailed knowledge of machines from the relevant era.

Overall freelance potential: Mainly for the specialist.

Editor's Tips: Ideas or suggestions should be submitted to the editor along with examples of work that show the contributor genuinely knows the subject.

Fees: By negotiation.

RIDE

Bauer Automotive, Media House, Lynchwood, Peterborough PE2 6EA.

Tel: 01733 468081. E-mail: colin.overland@bauermedia.co.uk

Editor: Colin Overland.

Monthly magazine for the motorcycling enthusiast.

Illustrations: Always interested in expanding network of photographers, for reader shots, news pictures etc. Commissions available to produce coverage for road tests and general features, but only for those with prior experience of motor sport or similar action photography.

Text: Little scope.

Overall freelance potential: Limited.

Fees: Around £250 per day.

SCOOTERING

Mortons Media Group Ltd, PO Box 99, Horncastle, Lincs LN9 6LZ. Tel: 01507 524004. E-mail: editorial@scootering.com Editor: Andy Gillard.

Monthly magazine for motor scooter enthusiasts.

Illustrations: Pictures of motor scooters of the Lambretta/Vespa type- shows, meetings,"runs", racing, special paint jobs,"chopped" scooters, etc. Covers: usually staff-produced, but a good freelance shot might be used.

Text: Original ideas considered, but contributors must have detailed knowledge of the particular lifestyle and terminology attached to the scooter scene.

Overall freelance potential: Potential scope for those who know the current scooter scene and its followers, but most is produced by staff or regular contributors.

Editor's tips: Be aware that the readers have a very good knowledge of this specialised subject. **Fees:** By negotiation.

SUPERBIKE

Blaze Publishing, Lawrence House, Morrell Street, Leamington Spa CV37 5SZ.

Tel: 01926 339808. E-mail: huw@blazepublishing.co.uk

Editor: John Hogan. Art Editor: Huw Williams.

Monthly for sports motorcycle enthusiasts. Specialising in new model tests and old model reviews, motorcycle Grand Prix, World Superbike and UK racing scene.

Illustrations: Pictures of unusual motorcycles, road-racing, drag-racing and other sports pictures of unusual interest or impact; crash sequences; motorcycle people.

Text: Features of general or specific motorcycle interest. Editorial style is humorous, irreverent. 1,500–3,000 words.

Overall freelance potential: Around 30 per cent of the magazine is contributed from outside sources.

Fees: Dependent on size and position in magazine.

VISORDOWN

Immediate Media Company Ltd, 15-18 White Lion Street, London N1 9PG.

Tel: 020 7843 8800. E-mail: ben.cope@immediate.co.uk

Editor: Ben Cope.

Wide-ranging monthly for all motorcycling enthusiasts. Covers road bikes, racing, touring and scooters.

Illustrations: Any strong and interesting images connected with any aspect of motorcycling and the biking lifestyle– unusual bikes or biking situations, good race action, celebrities with bikes, etc. Most major feature photography is handled by a regular team but commissions may be available to those with experience.

Text: Limited scope, but original ideas considered.

Overall freelance potential: Good for the specialist.

Editor's tips: Images from the sidelines of the motorcycling scene may be of more interest than action or straight shots of bikes.

Fees: Negotiable, depending on what is offered.

WOMEN'S CYCLING

Wild Bunch Media Ltd, 1st Floor, Gable House, 18-24 Turnham Green Terrace, London W4 1QP. Tel: 020 8996 5135. E-mail: lara.dunn@womenscyclinguk.co.uk

Editor: Lara Dunn.

Monthly magazine "written by women, for women", aimed primarily at hobby or commuter cyclists, both those who already cycle or those who want to get started.

Illustrations: Mostly only required as part of complete illustrated features as listed below. **Text:** Well-illustrated features on any relevant topic including real-life stories, travel, interviews, fashion, nutrition, health, workouts and basic bike maintenance. **Overall freelance potential:** Good for the right material. Editor's Tips: The magazine aims for"an accessible, motivational tone". **Fees:** By negotiation.

Equestrian

EQUESTRIAN TRADE NEWS

Equestrian Management Consultants Ltd, Stockeld Park, Wetherby, West Yorkshire LS22 4AW. Tel: 01937 582111. E-mail: editor@equestriantradenews.com

Editor: Liz Benwell.

Monthly publication for business people and trade in the equestrian world.

Illustrations: Pictures covering saddlery, feedstuffs, new riding schools and business in the industry. Also news pictures of people connected with the industry– people retiring, getting married,

etc.

Text: Features on specialist subjects and general articles on retailing, marketing and business. 1.000 words.

Overall freelance potential: Around 50 per cent comes from freelances.

Editor's tips: Only stories with a business angle will be considered. No scope for general horsey or racing material.

Fees: Text, £25 per 1,000 words; pictures by arrangement.

EQUI-ADS

Stone Leisure Ltd, Andrew House, 2a Granville Road, Sidcup, Kent DA14 4BN.

Tel: 020 8302 6069. E-mail: bob@equiads.net

Editor: Bob Griffiths.

Widely distributed free equestrian title with separate editions for the UK and for Scotland. Caters for all disciplines at all levels.

Illustrations: Seeks interesting illustrated stories about horses and ponies, as well as reports from shows around the country. Text should run to around 250– 500 words with one or two photographs. **Text:** Stories as above. Also articles on horse welfare written for both amateur and professional owners, breeders and competitors.

Overall freelance potential:

Fees: Usually £50 per contribution.

HORSE

MyTimeMedia Ltd, Enterprise House, Enterprise Way, Edenbridge, Kent TN8 6HF.

Tel: 01689 869848. E-mail: joanna.browne@mytimemedia.com

Editor: Jo Browne. Picture Editor: Lucy Merrell.

Monthly aimed at the serious leisure rider.

Illustrations: All photography by commission only to illustrate specific features. Experienced workers should send an introductory letter with examples of previously published work. **Text:** No scope.

Overall freelance potential: Limited and only for the experienced equestrian specialist. **Fees:** By negotiation.

HORSE & HOUND

Time Inc (UK) Ltd, Blue Fin Building, 110 Southwark Street, London SE1 0SU.

Tel: 020 3148 4554. E-mail: hhpictures@timeinc.com

Editor: Lucy Higginson. Picture Editor: Jayne Toyne.

Weekly news magazine covering all equestrian sports.

Illustrations: News and feature pictures considered on spec for immediate use or for stock, covering racing, point-to-pointing, showjumping, eventing, polo, hunting, driving and showing. Commissions

available to experienced equestrian/countryside photographers; make appointment with the picture editor to show portfolio.

Text: Possible opportunities for those with knowledge and experience of the above disciplines. **Overall freelance potential:** Good for those who can show skill in this field; enquiries from photographers are encouraged.

Fees: Single pictures according to size of reproduction. Commission rates £200 per day (all rights); £135 per day (first use).

HORSE & RIDER

D. J. Murphy (Publishers) Ltd, Headley House, Headley Road, Grayshott, Surrey GU26 6TU. Tel: 01428 601020. E-mail: editor@djmurphy.co.uk

Editor: Louise Kittle.

Monthly magazine aimed at adult horse riders.

Illustrations: Off-beat personality shots and pictures for photo stories illustrating equestrian subjects, eg plaiting up, clipping, etc. May also consider general yard pictures, riding pictures, people and horses, but only by prior arrangement.

Text: Illustrated instructional features on stable management, grooming, etc, from contributors with real knowledge of the subject. Submit ideas only in the first instance.

Overall freelance potential: Only for freelances who have a real understanding of the market. **Editor's tips:** Material must be technically accurate-riders must be shown wearing the correct clothes, especially hats; horses must be fit and correctly tacked.

Fees: Pictures £25-£60. Text £65 per 1,000 words.

Farming

CROPS

Reed Farmers Publishing Group, Quadrant House, The Quadrant, Sutton, Surrey SM2 5AS. Tel: 020 8652 4081. E-mail: richard.allinson@rbi.co.uk

Editor: Richard Allinson.

Monthly magazine catering exclusively for the arable farmer.

Illustrations: News pictures depicting anything of topical, unusual or technical interest concerning crop farming and production. Captions must be precise and detailed.

Text: Limited scope for short topical articles written by specialists.

Overall freelance potential: Good for farming specialists.

Fees: By negotiation.

DAIRY FARMER

Briefing Media Limited, 2 Puddle Dock, Blackfriars, London.. Tel: 020 7332 2919. E-mail: peter.hollinshead@briefingmedia.com **Editor:** Peter Hollinshead.

Monthly journal for dairy farmers.

Illustrations: Captioned pictures, technical or possibly historical. Also humourous or unusual pictures concerning the dairy industry. Some assignments to visit farms available.

Text: In-depth, technical features to help dairy farmers run their businesses more profitably. **Overall freelance potential:** Limited, but open to suggestions.

Fees: By arrangement.

FARMERS GUARDIAN

Briefing Media Limited, Unit 4, Fulwood Park, Caxton Road, Fulwood, Preston PR2 9NZ. Tel: 01772 799445. E-mail: theresa.eveson@farmersguardian.com **Editor:** Emma Penny. **Picture Editor:** Theresa Eveson. Weekly news publication for all farmers, with the emphasis on commerce. **Illustrations:** Current farming, rural and equestrian news pictures accompanied by story or extended captions.

Text: News items always of interest. Possible scope for articles on current agricultural and rural issues.

Overall freelance potential: Fair.

Fees: According to use.

FARMERS WEEKLY

Reed Business Information, Quadrant House, The Quadrant, Sutton, Surrey SM2 5AS. Tel: 020 8652 4080. E-mail: farmers.weekly@rbi.co.uk

Editor: Jane King. Group Picture Editor: Caroline Morley.

Weekly publication covering all matters of interest to farmers.

Illustrations: News pictures relating to the world of farming and picture stories on technical aspects of agriculture. Also opportunities for assignments.

Text: Tight, well-written copy on farming matters and anything that will help farmers run their business more efficiently.

Overall freelance potential: Good.

Fees: News material by negotiation. Photo assignment work around £200 per job.

Editor's tips: News pages are started on Monday and close for press on Wednesday afternoon, so news material should be submitted during that period. Copy and pics can be received by e-mail.

HOME FARMER

The Good Life Press Ltd, PO Box 536, Preston PR2 9ZY.

Tel: 01772 633444. E-mail: ruth@thegoodlifepress.co.uk/paul@thegoodlifepress.co.uk

Editors: Ruth Tott, Paul Melnyczuk.

Monthly magazine aimed at anyone interested in small-scale farming and home-based food production, as well as environmental issues.

Illustrations: Will consider interesting images in their own right, but prefer to see them as part of a complete illustrated feature as below.

Text: Always interested in articles that can help readers realise their lifestyle dreams on subjects such as self-sufficiency, recycling, vegetable growing, urban poultry or pig keeping, beekeeping, caring for animals on a small acreage, etc. Initial contact by e-mail is preferred.

Overall freelance potential: Excellent for the right type of material.

Editor's Tips: Prefer to publish material on accessible and practical options that don't assume that people have a lot of land at their disposal.

Fees: By negotiation, depending upon what is on offer.

POULTRY WORLD

Reed Business Information, Quadrant House, The Quadrant, Sutton, Surrey SM2 5AS.

Tel: 020 8652 3500. E-mail: poultry.world@rbi.co.uk

Editor: Philip Clarke.

Monthly publication aimed at the UK, EU and worldwide commercial poultry industries. Covers egg production as well as chickens, turkeys, ducks and geese. Includes Pure Breeds section.

Illustrations: News pictures and good general stock relating to the poultry industry, both in UK and overseas.

Text: News stories and ideas for features always considered; breeding, processing, packing, marketing, etc.

Overall freelance potential: Limited.

Fees: By negotiation.

As a member of the Bureau of Freelance Photographers, you'll be kept up-to-date with markets through the BFP Market Newsletter, published monthly. For details of membership, turn to page 9

Food & Drink

DECANTER

Time Inc (UK) Ltd, Blue Fin Building, 110 Southwark Street, London SE1 0SU.

Tel: 020 3148 5000. E-mail: decanterpictures@decanter.com

Managing Editor: Amy Wislocki. Art Editor: Patrick Grabham.

Monthly magazine for the serious wine enthusiast, featuring producer and regional profiles, tastings, and wine-related food and travel features.

Illustrations: Stock images of wine-producing regions occasionally needed to illustrate features, including attractive travel images of the region, specifically wine-related. Send details of coverage available in the first instance.

Text: Illustrated articles on topics as above; submit synopsis first.

Overall freelance potential: Limited.

Fees: By negotiation.

OLIVE

Immediate Media Company Ltd, Vineyard House, 44 Brook Green, London W6 7BT.

Tel: 020 7150 5274. E-mail: christine.hayes@immediate.co.uk

Editor: Christine Hayes. Deputy Editor: Lulu Grimes.

Monthly food and travel magazine for a young, upmarket readership.

Illustrations: Almost all photography by commission to illustrate major features. Experienced workers should make an an appointment to show portfolio to the creative director.

 ${\bf Text:}$ Will consider ideas from experienced contributors, especially for travel-related material, but no on spec submissions.

Overall freelance potential: Opportunities for specialists only. **Fees:** By negotation.

THE PUBLICAN'S MORNING ADVERTISER

William Reed Business Media Ltd, Broadfield Park, Crawley RH11 9RT.

Tel: 01293 610344. E-mail: rob.willock@wrbm.com

Editor: Rob Willock. News Editor: James Wallin.

Weekly independent newspaper for publicans and pub companies throughout the UK.

Illustrations: Topical pictures concerning pubs and publicans, brewery and pub company management, and the drinks trade generally. Must be newsworthy or have some point of unusual interest, and preferably include people. Call before submitting.

Text: News items and picture stories about publicans- humorous, unusual, or controversial. Stories that have implications for the whole pub trade, or that illustrate a problem; original ways of increasing trade.

Overall freelance potential: Good for original material, especially from outside London and the South East.

Editor's tips: Forget pub openings and pictures of people pulling or holding pints-hundreds of these are received already.

Fees: On a rising scale according to size of reproduction or length of text.

RESTAURANT

William Reed Business Media Ltd, Broadfield Park, Crawley, West Sussex RH11 9RT.

Tel: 01293 610214. E-mail: william.drew@wrbm.com

Editor: Will Drew. Art Director: Gary Simons.

Monthly magazine for the restaurant trade, with coverage ranging from top London restaurants to high street operations. Also designed to appeal to serious food lovers and restaurant-goers.

Illustrations: Mostly by commission to shoot food, interiors, portraiture, reportage, still life and travel. Some scope for those with in-depth stock collections on suitable subjects. On-spec

opportunities for coverage of restaurant openings, events and informal shots of trade personalities.

The Freelance Photographer's Market Handbook 2015

Text: Will consider ideas on any relevant subject. **Overall freelance potential:** Good for experienced freelances. **Fees:** By negotiation.

SCOTTISH LICENSED TRADE NEWS

Peebles Media Group,11-12 Claremont Terrace, Glasgow G3 7XR. Tel: 0141 567 6000. E-mail: gillian.mckenzie@peeblesmedia.com Editor: Gillian McKenzie. Fortnightly publication for Scottish publicans, off-licensees, hoteliers, caterers, restaurateurs, drinks executives, drinks companies. Illustrations: News pictures connected with the above subjects. Text: News and features of specific interest to the Scottish trade. Overall freelance potential: Limited.

Fees: By agreement.

WAITROSE KITCHEN

John Brown Publishing, 136-142 Bramley Road, London W10 6SR. Tel: 020 7565 3000. E-mail: food@johnbrowngroup.co.uk

Editor: William Sitwell. Photography & Style Director: Sarah Birks.

Picture-led monthly concentrating on the "culture of food" as well as recipes and cookery.

Illustrations: Very high quality food photography, plus coverage of food producers, gourmet travel, restaurants and chefs. Much commissioned from established specialists; those with suitable skills should initially submit some examples of previous work. Limited use of top quality specialist stock; send lists to art editor.

Text: Scope for well-experienced food and drink writers.

Overall freelance potential: Excellent, but only for the experienced worker in the field. **Fees:** By negotiation.

Gardening

THE ENGLISH GARDEN

Archant Specialist, Archant House, Oriel Road, Cheltenham GL50 1BB. Tel: 01242 211073. E-mail: theenglishgarden@archant.co.uk

Editor: Stephanie Mahon.

Picture-led monthly featuring the most attractive gardens in Britain, from cottage gardens to stately homes.

Illustrations: Pictures mainly required as part of complete feature packages as below and usually commissioned. Possible scope for library shots illustrating specific types of garden, plant or tree-send lists of subjects available in the first instance.

Text: High-quality, exclusive features on individual gardens accompanied by a good selection of pictures (15-20 published within each feature). Discuss with the editor first.

Overall freelance potential: A lot of photography is used but much is produced by regular contributors.

Editor's tips: Most interested in beautiful, idyllic gardens that readers can either visit or just fantasise about.

Fees: By negotiation and according to use.

THE GARDEN

RHS, 4th Floor, Churchgate, New Road, Peterborough PE1 1TT. Tel: 0845 260 0909. E-mail: thegarden@rhs.org.uk **Editor:** Chris Young. Monthly Journal of the Royal Horticultural Society. Publishes articles on plants and specialist aspects and techniques of horticulture.

Illustrations: Top quality photographs of identified plants, general horticultural subjects and specific gardens.

Text: Some freelance market; submit suggestions first.

Overall freelance potential: Some potential opportunities.

Fees: £40-£165 according to size of reproduction.

GARDEN ANSWERS

Bauer Media, Media House, Lynchwood, Peterborough PE2 6EA.

Tel: 01733 468000. E-mail: clare.derry@bauermedia.co.uk

Editor: Geoff Stebbings. Art Director: Clare Derry.

Monthly magazine for the enthusiastic gardener.

Illustrations: Little scope for speculative submissions, but always interested in receiving lists of subjects available from photographers. Do not submit images unless requested.

Text: Experienced gardening writers may be able to obtain commissions.

Overall freelance potential: Limited to the experienced gardening contributor.

Editor's tips: Practical gardening pictures are required, rather than simple shots of plants. Must be accompanied by detailed and accurate captions.

Fees: By arrangement.

GARDEN NEWS

Bauer Media, Media House, Lynchwood, Peterborough PE2 6EA.

Tel: 01733 468000. E-mail: clare.foggett@bauermedia.co.uk

Editor: Clare Foggett.

Weekly magazine for all gardeners.

Illustrations: Top quality colour portraits of trees, shrubs, flowers and vegetables (usually specific cultivars or varieties), as well as coverage of quality small/medium sized gardens.

Text: Short practical features of interest to keen, experienced gardeners. 600-800 words.

Overall freelance potential: Fair.

Fees: By agreement.

GARDEN TRADE NEWS

The Garden Communication and Media Company, The Old School, 4 Crowland Road, Eye, Peterborough PE6 7TN.

Tel: 01733 775700. E-mail: editorial@gardentradenews.co.uk

Editor: Mike Wyatt.

Monthly business publication containing news, features and advice for retailers, wholesalers, manufacturers and distributors of horticultural products.

Illustrations: Pictures to illustrate news items or features.

Text: Illustrated news stories or articles concerning garden centres, nurseries and garden shops. Maximum 600 words.

Overall freelance potential: Limited.

Fees: £12.50 per 100 words; pictures from £17.50-£50 according to size of reproduction.

GARDENERS' WORLD

Immediate Media Company Ltd, Vineyard House, 44 Brook Green, London W6 7BT.

Tel: 020 7150 5700. E-mail: guy.bennington@immediate.co.uk

Editor: Lucy Hall. Art Director: Guy Bennington.

Monthly magazine for gardeners at all levels of expertise, allied to the BBC TV programme of the same name.

Illustrations: No speculative submissions. Photographers with specialist gardening collections should send lists of material available with all plants properly named. Commissions may be available to photograph individual gardens; the editor will always be pleased to hear from photographers who can bring potential subjects to her attention. Also photographers prepared to set

up small studios with lights on location: good studio, portrait and reportage photography also commissioned.

Text: All text is commissioned.

Overall freelance potential: Mainly for specialists.

Editor's tips: Always looking for interesting"real" gardens for possible coverage. Small gardens, patios and container gardening of particular interest.

Fees: By negotiation.

GARDENS ILLUSTRATED

Immediate Media Company Bristol, 14th Floor, Tower House, Fairfax Street, Bristol BS1 3BN. Tel: 0117 314 7440. E-mail: gardens@gardensillustrated.com

Editor: Juliet Roberts. Art Director: David Grenham.

Heavily-illustrated monthly style guide to gardens and plants.

Illustrations: Usually commissioned. Photography should have a narrative and journalistic slant rather than just pretty pictures of gardens. The gardens should be depicted in relation to the landscape, houses and the people who own or work them and plants should be recommended by the owner/designer. Coverage from outside UK welcome.

Text: Scope for experienced gardening writers– submit samples of previously published work first. **Overall freelance potential:** Good for the right material.

Editor's tips: Quality is key. Material previously published in the UK is not of interest. **Fees:** By negotiation.

HORTICULTURE WEEK

Haymarket Media Ltd, 174 Hammersmith Road, London W6 4JP.

Tel: 020 8267 4977. E-mail: hortweek@haymarket.com

Editor: Kate Lowe. Art Editor: Sarah Baldwin.

Weekly news magazine for commercial growers of plants and those employed in landscape work, garden centres, public parks and gardens.

Illustrations: Captioned news and feature pictures relating to commercial horticulture, landscaping, public parks, garden centres. Stock botanical images occasionally needed. Some commissions available.

Text: No scope.

Overall freelance potential: Limited.

Fees: By arrangement.

General Interest

BEST OF BRITISH

Church Lane Publishing Ltd, Unit 101, The Perfume Factory, 140 Wales Farm Road, London W3 6UG.

Tel: 020 8752 8181. E-mail: chris.peachment@bestofbritishmag.co.uk Editor: Chris Peachment.

Monthly magazine covering all aspects of British heritage and nostalgia, but with a strong emphasis on 1940s/1950s/1960s.

Illustrations: Mainly colour plus B&W for archive pictures from earlier eras. Top quality coverage of all British heritage subjects, from landscapes and museums to craftspeople and collectors; send details of material available in the first instance.

Text: Illustrated articles offering a positive view of aspects of Britain, past and present. Also profiles of people with unusual passions, humorous pieces about the British people and interviews with celebrities about aspects of Britain they love. Submit ideas or an outline first.

Overall freelance potential: Excellent.

Editor's tips: Pictures with good captions are always more interesting than those without. Material

should always reflect a positive view of Britain. Nostalgic pictures always welcome, with a particular interest in the 1940s. See website at www.bestofbritishmag.co.uk. **Fees:** By negotiation with editor.

BIZARRE

Dennis Publishing Ltd. Editorial: Blackthorn Communications, PO Box 59844, London SW14 9BH. Tel: 020 8251 0079. E-mail: bizarre@blackthorncommunications.com

Editor: David McComb.

Monthly magazine specialising in alternative (fetish and subversive) lifestyles. Heavily illustrated, including special 14-page photo section.

Illustrations: Will consider pictures depicting anything that broadly falls within the above parameters, with a heavy emphasis on shocking reportage photography."Weird, disturbing and downright bizarre photos from around the world, the more unique the better." Prefer material that has not been previously published.

Text: Little freelance scope unless the contributor is a genuine expert in a specific subject. **Overall freelance potential:** Very good.

Editor's tips: Always call first with details of what you have to offer. Please no"ghost" photos. Fees: By negotiation and dependent on what is being offered.

COAST

Kelsey Publishing Group, Cudham Tithe Barn, Berry's Hill, Cudham, Kent TN16 3AG. Tel: 01959 541444. E-mail: firstname.secondname@kelsey.co.uk

Editor: Alex Fisher. Art Editor: Hallam Foster.

Monthly glossy that celebrates the best of British coastal and seaside living.

Illustrations: High-quality seaside imagery, including coastal landscapes, seascapes, marine wildlife, etc, either for use in their own right with captions or to illustrate features. Mainly interested in hearing from photographers who can offer good coverage of specific coastal locations or subjects. Initial approach should be by e-mail with a small selection of low-res images. Also some opportunities for commissions, mainly for homes and interiors work.

Text: Illustrated articles and features on suitable subjects always considered.

Overall freelance potential: Excellent for quality material.

Editor's tips: Keep in mind that requirements vary from month to month according to what features and locations are being included in each issue.

Fees: By negotiation.

CONDE NAST CUSTOMER PUBLISHING

6-8 Bond Street, London W1 0AD.

Tel: 020 7152 3954. E-mail: michael.harrison@condenast.co.uk

Creative Director: Michael Harrison. Group Picture Editor: Victoria Lukens.

Contract publishing division of Conde Nast. Produces upmarket titles for corporate clients such as major store and hotel groups.

Illustrations: Opportunities for experienced photographers to obtain commissions in the fields of fashion, portraiture, travel, lifestyle and still life. Contact creative director by e-mail with details of previous experience and examples of work.

Text: N/A.

Overall freelance potential: Scope for photographers producing the highest quality work. **Fees:** By negotiation.

FIBRE

86-90 Paul Street, Shoreditch, London EC2A 4NE.

Tel: 07745 937680. E-mail: laura@fibremagazine.com; dave.alexander@fibremagazine.com
 Web: www.fibremagazine.com

Editor-in-Chief: Laura Bartlett. Director of Photography: Dave Alexander.

Luxury fashion and lifestyle title with both digital and print editions. Covers fashion, beauty and

The Freelance Photographer's Market Handbook 2015

grooming, food and drink, fitness, travel, music and technology.

Illustrations: Always interested in fresh contributors, established or newcomers. For initial contact e-mail with links to website and/or portfolio. Prefer to discuss shoots in advance but will consider existing material if it fits the look and feel of the magazine.

Text: Suitable ideas always considered.

Overall freelance potential: Good opportunities for new talent.

Fees: By negotiation.

READER'S DIGEST

Vivat Direct Ltd (T/A Reader's Digest), 9th Floor, 1 Eversholt Street, London NW1 2DN. Tel: 020 7045 0713. E-mail: theeditor@readersdigest.co.uk

Editor-in-Chief: Catherine Haughney. Deputy Editor: Martin Colyer. Picture Editor: Roberta Mitchell.

British edition of the monthly magazine for a general interest readership.

Illustrations: Pictures to illustrate specific general interest features. Some commission possibilities for experienced photographers and illustrators.

Text: High quality features on all topics.

Overall freelance potential: Limited opportunities for new freelance contributors. **Fees:** By agreement.

SAGA MAGAZINE

Saga Publishing Ltd, The Saga Pavilion, Enbrook Park, Sandgate, Folkestone CT20 3SE.

Tel: 01303 771523. E-mail; paul.hayes-watkins@saga.co.uk

Editor: Katy Bravery. Art Director: Paul Hayes-Watkins.

Monthly, subscription-only, general interest magazine aimed at readers over 50.

Illustrations: Photography is mainly by commission only, but some top quality photo features occasionally accepted.

Text: Will consider wide range of articles– human interest,"real life" stories, intriguing overseas interest (not travel), celebrity interviews, some natural history– all relevant to 50+ readership.

Overall freelance potential: Limited, but some possiblities for carefully-targeted ideas exclusive to UK.

Fees: Good, but by negotiation.

TLM

TLM Media Ltd, Langdale House, 11 Marshalsea Road, London SE1 1EN.

Tel: 020 3176 2570. E-mail: info@tlm-magazine.co.uk

Editor: Iain Robertson.

Family-oriented travel and leisure quarterly targeting readers in London and the South East, covering travel plus motoring, health, interiors, gardens, food and drink.

Illustrations: Always interested in seeing potential front cover shots. These are always seasonal in nature and most frequently feature happy families in a seasonal setting.

Text: Some scope for illustrated articles, mainly on the travel side and for the magazine's regular sections— intending contributors should ask for a copy of the magazine so that they can see the usual format of the sections. Rarely take speculative pieces but often ask freelances to write on specific locations or topics.

Overall freelance potential: Limited.

Fees: By negotiation.

As a member of the Bureau of Freelance Photographers, you'll be kept up-to-date with markets through the BFP Market Newsletter, published monthly. For details of membership, turn to page 9

Health & Medical

ALPHAFIT

Target Eye Publishing Limited, 9 East Parade, Leeds LS1 2AJ.

Tel: 0113 245 1168. E-mail: peter@alphafitmagazine.co.uk

Editor: Peter Baber.

Monthly magazine for men aged 24-45 who wish to improve their fitness. Distributed via health clubs around the country.

Illustrations: Will consider samples of suitable subjects, initially via e-mail. Some commission potential.

Text: Will consider short items of around 200 words to be placed on website. More substantial opportunites may follow.

Overall freelance potential: Fair.

Fees: By agreement.

GP

Haymarket Medical Ltd, 174 Hammersmith Road, London W6 7JP.

Tel: 020 8267 4857. E-mail: emma.bower@haymarket.com

Editor: Emma Bower. News Editor: Nick Bostock.

Fortnightly newspaper for family doctors.

Illustrations: Pictures of general practitioners involved in news stories, and clinical/scientific pictures for features. Commissions frequently available to shoot portraits of GPs or practice nurses. **Text:** News stories, up to 400 words, preferably by prior arrangement. Features considered, by prior arrangement with the features editor.

Overall freelance potential: The paper uses a lot of pictures from freelances.

Fees: By negotiation, but around $\pounds 200 - \pounds 300$ per 1,000 words, and £100 for half-day photographic session.

H&E NATURIST

Hawk Editorial Ltd, PO Box 545, Hull HU9 9JF. Tel: 01482 342000. E-mail: editor@henaturist.net

Editor: Sam Hawcroft.

Monthly naturist/nudist magazine.

Illustrations: High-quality photos of naturists in landscapes, on beaches, in countryside, but not indoors. Couples and singles, male and female, any age from 18 upwards, preferably doing things other than simply sunbathing or posing for the camera. Must look as natural as possible and avoid coy or deliberately covered-up poses. No glamour photography. Also photos of beaches and naturist venues from around the world.

Text: Illustrated articles 800–1,250 words about naturist lives and resorts, and off the beaten track naturism, plus related articles about nakedness/nudity and lifestyle/health features.

Overall freelance potential: Excellent.

Editor's tips: Full contributors' guidelines are available on the website at www.henaturist.net. Fees: Cover £120; £10-£30 inside.

HEALTH & FITNESS

Iris Publishing, 10th Floor, Marble Arch Tower, 55 Bryanston Street, London W1H 7AJ. Tel: 020 7907 6000. E-mail: lucy_pinto@dennis.co.uk

Editor: Mary Comber. Art Editor: Lucy Pinto.

Glossy monthly covering all aspects of fitness, health and nutrition, aimed at women.

Illustrations: Photographs for use in illustrating articles and features on topics as above. Covers:

outstanding and striking shots featuring an obviously fit and healthy young female model. **Text:** Articles and features on suitable topics, with an appeal to women. Always query the editor before submitting.

Overall freelance potential: Good.

Fees: By negotiation.

PULSE

Cogora Ltd, 140 London Wall, London EC2Y 5DN.

Tel: 020 7332 2904. E-mail: nigelpraities@cogora.com

Editor: Nigel Praities. News Editor: Jaimie Kaffash.

Monthly magazine for family doctors covering all aspects of general practice medicine. Supported by news-based website at www.pulsetoday.co.uk.

Illustrations: Topical pictures with captions, involving GPs or illustrating relevant news stories. Commissions available for high quality portraiture, especially outside the London area.

Text: News and topical features about general practice and GPs.

Overall freelance potential: Good, especially for portrait specialists.

Editor's tips: Most interested in photographers who can produce original and creative portrait work.

Fees: Negotiable. £100 per half day for commissions.

Hobbies & Craft

CLOCKS

Splat Publishing Ltd, 141B Lower Granton Road, Edinburgh EH5 1EX.

Tel: 0131 331 3200. E-mail: editor@clocksmagazine.com

Editor: John Hunter.

Monthly magazine for clock enthusiasts generally, those interested in building, repairing, restoring and collecting clocks and watches.

Illustrations: Pictures of anything concerned with clocks, e.g. public clocks, clocks in private collections or museums, clock movements and parts, people involved in clock making, repairing or restoration. Detailed captions essential.

Text: Features on clockmakers, repairers or restorers; museums and collections; clock companies. 1,000–2,000 words.

Overall freelance potential: Around 90 per cent of the magazine is contributed by freelances. **Editor's tips:** Pictures unaccompanied by textual descriptions of the clocks, or articles about them, are rarely used.

Fees: By arrangement.

ENGINEERING IN MINIATURE

TEE Publishing Ltd, The Fosse, Fosse Way, Radford Semele, Learnington Spa, CV31 1XN. Tel: 01926 614101. E-mail: info@teepublishing.co.uk

Managing Editor: Chris Deith.

Monthly magazine concerned with model engineering and working steam models.

Illustrations: Photographs usually used in conjunction with specific news items or articles. Covers: Good images of model steam locomotives, engines or other model engineering subjects. Do not need to be associated with articles.

Text: Well-illustrated articles and features on all aspects of model engineering and serious

Are you working from the latest edition of The Freelance Photographer's Market Handbook? It's published on 1 October each year. Markets are constantly changing, so it pays to have the latest edition modelling, and on full size railways and steam road vehicles. Must be of a serious and technical nature.

Overall freelance potential: Some 80 per cent of contributions come from freelances.

Editor's tips: Ideally engines depicted should be true steam-operated, not electric steam outline. There is no coverage of model railways below"0" gauge, or of plastic models. Telephone contact is preferred in the first instance.

Fees: Negotiable.

FURNITURE & CABINETMAKING

GMC Publications Ltd, 86 High Street, Lewes, East Sussex BN7 1XN.

Tel: 01273 402843. E-mail: derekj@thegmcgroup.com

Editor: Derek Jones.

Monthly magazine for the serious furniture maker.

Illustrations: Mostly by commission to illustrate step-by-step projects and features on individual craftsmen– write with details of experience and samples of work. Good stock shots of fine furniture often required to illustrate specific styles. Topical single pictures may be considered if accompanied by detailed supporting text.

Text: Ideas for illustrated features always welcome. Submit a synopsis and one sample picture in the first instance.

Overall freelance potential: Good for experienced workers.

Fees: £25 per single picture inside; illustrated articles £50-£70 per page.

GIBBONS STAMP MONTHLY

Stanley Gibbons Publications, 7 Parkside, Christchurch Road, Ringwood, Hampshire BH24 3SH. Tel: 01425 481042. E-mail: dshepherd@stanleygibbons.co.uk

Editor: Dean Shepherd.

Monthly magazine for stamp collectors.

Illustrations: Pictures inside only as illustrations for articles. Covers: pictures of interesting or unusual stamps relating to editorial features.

Text: Features on stamp collecting. 500-3,000 words.

Overall freelance potential: Most of the editorial comes from freelance contributors.

Fees: From £60 per 1,000 words.

GIBBONS STAMP MONTHLY

Stanley Gibbons Publications, 7 Parkside, Christchurch Road, Ringwood, Hampshire BH24 3SH. Tel: 01425 481042. E-mail: dshepherd@stanleygibbons.co.uk

Editor: Dean Shepherd.

Monthly magazine for stamp collectors.

Illustrations: Pictures inside only as illustrations for articles. Covers: pictures of interesting or unusual stamps relating to editorial features.

Text: Features on stamp collecting. 500-3,000 words.

Overall freelance potential: Most of the editorial comes from freelance contributors. **Fees:** From $\pounds 60$ per 1,000 words.

GOOD WOODWORKING

MyTimeMedia Ltd, Enterprise House, Enterprise Way, Edenbridge, Kent TN8 6HF.

Tel: 01689 869848. E-mail: andrea.hargreaves@mytimemedia.com

Editor: Andrea Hargreaves.

Four weekly magazine for the serious amateur woodworker.

Illustrations: By commission only. Assignments available to cover specific projects.

Text: Ideas and suggestions welcome, but writers must have good technical knowledge of the subject. Commissions available to interview individual woodworkers.

Overall freelance potential: Good for those with experience of the subject.

Fees: Photography by negotiation. Text around £125 per 1,000 words.

MODEL ENGINEER

MyTimeMedia Ltd, Enterprise House, Enterprise Way, Edenbridge, Kent TN8 6HF. Tel: 01539 564750. E-mail: diane.carney@mytimemedia.com

Editor: Diane Carney.

Fortnightly magazine aimed at the serious model engineering enthusiast.

Illustrations: No stock shots required; all pictures must be part of an article. Covers: photographs depicting models of steam locomotives and traction engines; metalworking equipment and home workshop scenes; some full size vintage vehicles.

Text: Well-illustrated articles from specialists.

Overall freelance potential: Considerable for the specialist.

Fees: £50 per printed page.

PARROTS

Imax Visual Ltd, The Old Cart House, Applesham Farm, Coombes, West Sussex BN15 0RP. Tel: 01273 464777. E-mail: editorial@imaxweb.co.uk

Editor: Pauline James.

Monthly magazine for the parrot enthusiast.

Illustrations: High quality photographs of specific types of parrots and parakeets. Must be wellposed and well lit, showing clear details of plumage. Full and accurate caption information (preferably including scientific names) also essential. Amusing pictures involving parrots considered if accompanied by a good story.

Text: Articles aimed at the parrot enthusiast.

Overall freelance potential: Good for top-quality material.

Editor's tips: Do not submit unidentified generic pictures of the "parrot on a branch" variety, or shots taken from long distances in zoos or bird parks.

Fees: Dependent on quality.

PRACTICAL FISHKEEPING

Bauer Media Ltd, Media House, Lynchwood, Peterborough PE2 6EA.

Tel: 01733 395083. E-mail: angela.kenny@bauermedia.co.uk

Editor: Angela Kenny.

Monthly magazine for all tropical freshwater, marine, pond and coldwater fishkeepers, aimed at every level from hobbyist to expert.

Illustrations: Pictures of all species of tropical, marine and coldwater fish, plants, tanks, ponds and water gardens. Fish diseases, pond and tank maintenance, and pictures of things that have "gone wrong" are especially welcome. Prefer to hold material on file for possible future use.

Text: Emphasis on instructional articles on the subject. 1,000-2,000 words.

Overall freelance potential: Most is supplied by contributors with a specific knowledge of the hobby, but freelance material is considered on its merit at all times.

Editor's tips: Telephone first to give a brief on the intended copy and/or photographs available. Caption all fish clearly and get names right.

Fees: Negotiable.

PRACTICAL WIRELESS

PW Publishing Ltd, Tayfield House, 38 Poole Road, Westbourne, Bournemouth BH4 9DW.

Tel: 0845 803 1979. E-mail: steve@pwpublishing.ltd.uk

Editor: Don Field. Art Editor: Stephen Hunt.

Monthly magazine covering all aspects of radio of interest to the radio amateur and enthusiast. **Illustrations:** Usually only required to illustrate specific articles or covers.

Text: Articles on amateur radio or short wave listening, or on aspects of professional radio systems of interest to the enthusiast.

Overall freelance potential: Little scope for individual photographs, but complete, illustrated articles always welcome.

Fees: By negotiation.

RADIO USER

PW Publishing Ltd, Tayfield House, 38 Poole Road, Westbourne, Bournemouth BH4 9DW. Tel: 0845 803 1979. E-mail: andy@pwpublishing.ltd.uk

Editor: Andy Thomsett. Art Editor: Stephen Hunt.

Monthly magazine for the hobby radio enthusiast.

Illustrations: Pictures connected with radio and communications, including aviation, maritime and vehicles, but usually only required to illustrate specific articles.

Text: Features on radio systems or on other aspects of radio of interest to the enthusiast. News and reviews of equipment, clubs, etc.

Overall freelance potential: Between 60 and 75 per cent comes from freelances.

Editor's tips: The magazine is always on the lookout for features on new and novel uses for radio communications. Visual articles on all aspects of communications welcome. **Fees:** £50 per 1,000 words.

TREASURE HUNTING

Greenlight Publishing, The Publishing House, 119 Newland Street, Witham, Essex CM8 1NF. Tel: 01376 521900. E-mail: greg@acguk.com

Editor: Greg Payne.

Monthly magazine for metal detecting and local history enthusiasts.

Illustrations: Usually only as illustrations for features detailed below, but captioned news pictures may be of interest. Covers: pictures of people using metal detectors in a countryside or seaside setting.

Text: Illustrated stories and features on individual finds, club treasure hunts, lost property recovery, local history, etc. However, fees nominal.

Overall freelance potential: Approximately 50 per cent of the magazine comes from freelances. **Editor's tips:** Advisable to telephone the magazine before attempting a cover. **Fees:** Covers, £50; features £20 per 1,000 words.

WOODCARVING

Guild of Master Craftsman Publications Ltd, 86 High Street, Lewes, East Sussex BN7 1XN. Tel: 01273 477374. E-mail: markb@thegmcgroup.com

Editor: Mark Baker.

Magazine published six times per year and aimed at both amateur and professional woodcarvers. **Illustrations:** Mostly to illustrate specific articles, but some scope for news pictures and shots of interesting pieces of work accompanied by detailed captions. Covers: striking colour shots of exceptional woodcarvings or woodcarvers in action, relating to article inside.

Text: Illustrated articles on all aspects of serious woodcarving, including profiles of individual craftsmen.

Overall freelance potential: Good for the right material.

Fees: Negotiable for one-off reproductions inside. $\pounds70$ per published page for articles, including photos.

WOODTURNING

Guild of Master Craftsman Publications Ltd, 86 High Street, Lewes, East Sussex BN7 1XN. Tel: 01273 477374. E-mail: markb@thegmcgroup.com

Editor: Mark Baker.

Monthly magazine aimed at both amateur and professional woodturners.

Illustrations: Mostly to illustrate specific articles, but some scope for unusual or interesting single

Are you working from the latest edition of The Freelance Photographer's Market Handbook? It's published on 1 October each year. Markets are constantly changing, so it pays to have the latest edition pictures with full captions. Covers: striking colour shots of turned items, relating to article inside. **Text:** Illustrated articles on all aspects of woodturning, including profiles of individual craftsmen. **Overall freelance potential:** Good for the right material.

Fees: £25 for one-off reproductions inside. £50 per published page for articles, including photos.

THE WOODWORKER

MyTimeMedia Ltd, Enterprise House, Enterprise Way, Edenbridge, Kent TN8 6HF.

Tel: 01689 869876. E-mail: mark.cass@mytimemedia.com

Editor: Mark Cass.

Monthly magazine for all craftspeople in wood. Readership includes schools and woodworking businesses, as well as individual hobbyists.

Illustrations: Pictures relating to wood and wood crafts, mostly as illustrations for features. Covers: pictures of fine furniture.

Text: Illustrated features on all facets of woodworking crafts, including profiles of individual woodworkers, how-to articles and material on period furniture and woodworking through the ages. **Overall freelance potential:** Excellent; most content bought from outside contributors. **Editor's tips:** Clear, concise authoritative writing in readable, modern style essential. **Fees:** By negotiation.

Home Interest

COUNTRY HOMES & INTERIORS

Southbank Publishing Group, Blue Fin Building, 110 Southwark Street, London SE1 0SU. Tel: 020 3148 7190. E-mail: emma williams@ipcmedia.com

Editor: Rhoda Parry. Creative Director: Emma Williams.

Monthly magazine concerning up-market country homes, interiors, gardens and lifestyle.

Illustrations: Top quality coverage of homes, interiors, gardens and landscapes. Mostly by commission, but speculative submissions of picture features on specific country houses or gardens, or other country-based topics, may be considered if of the highest quality. Covers: always related to a major feature inside.

Text: Top level coverage of country home and lifestyle subjects, only by commission.

Overall freelance potential: Excellent for photographers who can provide the right sort of material.

Fees: Negotiable from a minimum of £100.

ELLE DECORATION

Hearst Magazines UK, 72 Broadwick Street, London W1F 9EP.

Tel: 020 7439 5000. E-mail: elledecoration@hearst.co.uk

Editor: Michelle Ogundehin. Picture Editor: Flora Bathurst.

Monthly interior decoration magazine aimed at a trend-setting readership.

Illustrations: By commission only, but always interested in hearing from photographers experienced in this field.

Text: Ideas for features always of interest.

Overall freelance potential: Plenty of scope for the experienced freelance.

Editor's tips: Particular projects must always be discussed in detail beforehand to ensure that the magazine's specific styling requirements are observed.

Fees: Photography according to commission.

Are you working from the latest edition of The Freelance Photographer's Market Handbook? It's published on 1 October each year. Markets are constantly changing, so it pays to have the latest edition

THE ENGLISH HOME

Archant Specialist, Archant House, 3 Oriel Road, Cheltenham GL50 1BB.

Tel: 01242 211080. E-mail: englishhome@archant.co.uk

Editor: Kerryn Harper-Cuss.

Monthly home interest title emphasising classic, elegant and country English style.

Illustrations: Mainly by commission. Opportunities for experienced architectural and interiors photographers to obtain assignments. Suggestions, with sample pictures, of suitable homes or beautiful regional localities to feature always welcome.

Text: Illustrated features on elegantly classic English homes, decoration, UK travel and events. Submit ideas in the first instance.

Overall freelance potential: Good.

Fees: By negotiation.

GOOD HOMES

Media 10 Limited, Crown House, 151 High Road, Loughton, Essex IG10 4LF. Tel: 020 3225 5200. E-mail: amy.curtis@goodhomes-magazine.com

Editor: Amy Curtis.

Glossy monthly aimed at people who love their homes and love to decorate.

Illustrations: Top quality photography of interiors, gardens, home products, etc, all by commission. Photographers who have previously worked on top quality homes publications should write with details of their experience.

Text: No scope.

Overall freelance potential: Limited to those experienced in producing the highest standard of work.

Editor's tips: Not interested in hearing from photographers who have not done editorial interiors work before, no matter how skilled in other fields. **Fees:** By negotiation.

HOMES & GARDENS

Time Inc (UK) Ltd, Blue Fin Building, 110 Southwark Street, London SE1 0SU.

Tel: 020 3148 7311. E-mail: deborah.barker@timeinc.com

Editor: Deborah Barker.

Monthly glossy magazine devoted to quality interior design and related matters.

Illustrations: High quality commissioned coverage of interior decoration, design, architecture, gardens, furnishings, food and travel. Emphasis on homes decorated in a tasteful style, up-market and attractive rather than wacky. Ideas for coverage always welcome.

Text: Heavily-illustrated features as above.

Overall freelance potential: Good for really top quality work.

Editor's tips: Out of London material particularly welcome.

Fees: By negotiation.

HOUSE BEAUTIFUL

Hearst Magazines UK, 72 Broadwick Street, London W1F 9EP.

Tel: 020 7439 5642. E-mail: barbora.hajek@hearst.co.uk

Editor: Julia Goodwin. **Art Director:** Barbora Hajek. Picture Researcher: Anita Isaacs Monthly magazine with the emphasis on practical home decorating ideas.

Illustrations: Usually by commission. Photographs of houses, interior decoration, furnishings, cookery and gardens. Complete picture features depicting houses and interiors of interest.

Text: Features on subjects as above, invariably commissioned, but possible scope for speculative features on suitable subjects.

Overall freelance potential: Quite good for experienced contributors in the home interest and interiors field.

Fees: By negotiation.

IDEAL HOME

Time Inc (UK) Ltd, Blue Fin Building, 110 Southwark Street, London SE1 0SU. Tel: 020 3148 7320. E-mail: hannah.talmage@timeinc.com

Editorial Director: Isobel McKenzie-Price. Art Editor: Caroline Creighton-Metcalf. Monthly devoted to interiors and decorating.

Illustrations: Major feature photography always by commission; make appointment to show portfolio. Some scope for good general home style and decorating images for stock and general illustration.

Text: No scope.

Overall freelance potential: Very good for experienced workers.

Editor's tips: Research past issues to see what subjects have already been covered and to anticipate the types of issues likely to be covered in the future.

Fees: By negotiation.

LANDLOVE

Hubert Burda Media UK, The Tower, Phoenix Square, Colchester, Essex CO4 9HU. Tel: 01206 851117. E-mail: anna-lisa@burdamagazines.co.uk

Editor: Anna-Lisa De'ath. Actine Assistant Editor: Natalie Mason.

Bi-monthly women's lifestyle magazine focused on traditional ways of life and the beauty of the British countryside.

Illustrations: Seasonal images of the British countryside, gardens and hedgerows, gardening, nature, wildlife and traditionals crafts. E-mail details of stock or specialisation in the first instance. **Text:** Scope for suitable well-illustrated articles on relevant topics; submit suggestions to the editor. **Overall freelance potential:** Limited, but scope for the experienced contributor.

Fees: By negotiation.

LANDSCAPE

Bauer Active Ltd, Media House, Lynchwood, Peterborough PE2 6EA.

Tel: 01733 468000. E-mail: editor@landscapemagazine.co.uk; alex.tapley@landscapemagazine.co.uk Editor: Sheena Harvey. Art Editor: Alex Tapley.

Bi-monthly magazine featuring seasonal content aimed primarily at women over 35.

Illustrations: Seasonal images of gardens, nature and wildlife, simple seasonal food/cookery and traditional British crafts. Photographers with relevant stock should initially e-mail details or a weblink to the art editor. Commissioned work also available to experienced workers in the areas of homes and crafts photography.

Text: Ideas for well-illustrated relevant features always considered.

Overall freelance potential: Excellent.

Fees: By negotiation.

PERIOD LIVING

Centaur Special Interest Media, 2 Sugar Brook Court, Aston, Birmingham B60 3EX.

Tel: 01527 834400. E-mail: period.living@centaur.co.uk

Editor: Rachel Watson. Art Editor: Michelle Cookson.

Monthly magazine covering traditional homes and gardens, antiques and renovation.

Illustrations: Commissions available to experienced architectural and interiors photographers, who should make appointment to show portfolios in the first instance.

Text: No scope.

Overall freelance potential: Good.

Fees: By negotiation.

REAL HOMES

Centaur Special Interest Media, 2 Sugar Brook Court, Aston, Birmingham B60 3EX. Tel: 01527 834454. E-mail: firstname.lastname@centaur.co.uk **Editor:** Caron Bronson. **Deputy Editor:** Beth Murton. Monthly aiming to help homeowners make the most of the home they have.

Illustrations: By commission only, but always interested in hearing from photographers experienced in this field. For those seeking house shoots, contact homes editor; for other images contact deputy editor.

Text: Ideas for features always considered, mainly practical, accessible solution-focused ideas. **Overall freelance potential:** Good scope for the experienced freelance.

Editor's tips: Feature ideas must always be discussed in detail beforehand to ensure that the magazine's specific styling requirements are observed.

Fees: By negotiation.

THE SIMPLE THINGS

Iceberg Press, Thorne House, Turners Hill Road, Crawley Down, West Sussex RH10 4HQ. Tel: 07787 123667. E-mail: lisa@icebergpress.co.uk

Editor: Lisa Sykes.

Monthly magazine celebrating"homemade values and simple living". Aimed predominantly at women with topics ranging from gardening, cooking and decorating to crafts and collecting vintage finds.

Illustrations: Opportunities for experienced freelances who can produce work suited to the magazine's particular style, photojournalistic instead of the "over-stylised" images seen in many home interest titles.

Text: Inspiring and accessible features on interiors, things to make, recipes, making the most of gardens or allotments, and original thoughts on the ideal of a simple lifestyle.

Overall freelance potential: Very good for those who can capture the magazine's ethos. Editor's Tips: We want our images to tell a story, not just sit there in isolation.

Fees: By negotiation.

25 BEAUTIFUL HOMES

Time Inc (UK) Ltd, Blue Fin Building, 110 Southwark Street, London SE1 0SU. Tel: 020 3148 1754. E-mail: penny.botting@timeinc.com

Editor-in-Chief: Deborah Barker. Commissioning Editor: Penny Botting.

Interior design magazine featuring 25 individual homes per issue.

Illustrations: Top quality interiors photography illustrating specific homes. Always looking for homes to feature: initially send a selection of recce snaps showing each room, plus an exterior shot, with brief details about the home and its owners; a commission to produce a full feature may follow. **Text:** Features as above.

Overall freelance potential: Very good for the experienced interiors photographer. **Fees:** Fee for complete feature package of words and pictures normally around £1,000.

THE WORLD OF INTERIORS

The CondÈ Nast Publications Ltd, Vogue House, Hanover Square, London W1S 1JU. Tel: 020 7152 3831. E-mail: mark.lazenby@condenast.co.uk

Editor-in-Chief: Rupert Thomas. Art Director: Mark Lazenby.

Monthly magazine showing the best interior decoration of all periods and in all countries. **Illustrations:** Mainly colour, occasional B&W. Subjects as above. Extra high standard of work required.

Text: Complete coverage of interesting houses; occasionally public buildings, churches, shops, etc. 1,000–2,000 words.

Overall freelance potential: Much of the work in the magazine comes from freelances. **Fees:** Negotiable.

Are you working from the latest edition of The Freelance Photographer's Market Handbook? It's published on 1 October each year. Markets are constantly changing, so it pays to have the latest edition

The Freelance Photographer's Market Handbook 2015

YOUR HOME

Hubert Burda Media UK, The Tower, Phoenix Square, Colchester, Essex CO4 9HU. Tel: 01206 851117. E-mail: vourhome@burdamagazines.co.uk Editor: Anna-Lisa De'ath.

Monthly home interest magazine concerned with real homes, decorating, makeovers, home improvements, DIY and creative projects.

Illustrations: Only as part of complete packages as detailed below.

Text: Scope for experienced interiors writers and photographers who can supply words/pictures packages on a First and Second Rights basis, mainly covering budget room makeovers and affordable real readers' homes.

Overall freelance potential: Only for the experienced contributor. Fees: By negotiation.

Industry

CLASSIC PLANT & MACHINERY

Kelsey Publishing Group, Cudham Tithe Barn, Berry's Hill, Cudham, Kent TN16 3AG. Tel: 01959 541444/01323 833125. E-mail: cpm.ed@kelsey.co.uk/peterlove@madasafish.com Editor: Peter Love.

Monthly magazine covering vintage construction and mining plant and ancillary equipment. Illustrations: Pictures of collectable, classic and vintage machinery, including dumptrucks, excavators, forklifts, road making and mining machinery. Must be accompanied by detailed and accurate captions. Contact editor before preparing a submission.

Text: Suggestions from those with suitable knowledge of these subjects always welcomed. **Overall freelance potential:** Good.

Fees: By arrangement.

ENERGY IN BUILDINGS & INDUSTRY

Pinede Publishing Ltd, PO Box 825, Guildford GU4 8WQ. Tel: 01483 452854. E-mail: markthrower@btinternet.com

Editor: Mark Thrower.

Monthly magazine concerned with the use and conservation of energy in large buildings and the industrial environment.

Illustrations: Pictures of relevant and interesting installations.

Text: Some scope for writer/photographers who have good knowledge of the energy business. Overall freelance potential: Limited unless contributors have connections within the field. Fees: £30-£40 per picture; £140 per 1,000 words for text.

ENGINEERING

Media Culture, Office 46, Pure Offices, Plato Close, Learnington Spa, Warwickshire CV34 6WE. Tel: 01926 671338. E-mail: steve@engineeringnet.co.uk

Managing Editor: Steve Welch.

Monthly magazine dealing with all areas of manufacturing engineering from a design viewpoint. Illustrations: Photographs depicting all aspects of design in industrial engineering, from aerospace and computers to energy management and waste disposal. Much from manufacturers but some by commission. Covers: Abstract and"artistic" photography.

Text: Short illustrated news items up to major design features. 250-2,000 words.

Overall freelance potential: Good for commissioned work.

Fees: £100 per published page for text. Covers £300-£400. Other commissioned photography around £120 per day.

Magazines: Industry

FIRE & RESCUE/INDUSTRIAL FIRE JOURNAL

Hemming Information Services, No 8, The Old Yarn Mills, Westbury, Sherborne, Dorset DT9 3RG. Tel: 01935 374011. E-mail: j.sanchez@hgluk.com; am.knegt@hisdorset.com

Group Editor: Jose Sanchez. Editor: Ann Marie Knegt.

Quarterly magazines for firefighting professionals. Fire & Rescue covers the municipal sector; IFJ concerns firefighting in oil, gas, chemical, power and other high-risk industries.

Illustrations: Images concerning or involving firefighting services in the municipal or industrial context, including firefighting personnel in action. But not photos of ordinary car fires or firefighters/engines at domestic home/high street fires.

Text: No scope for non-specialists.

Overall freelance potential: Fair.

Editor's tips: Seek editor's agreement before submitting. Looking for racy, exciting and explicit shots to interest and educate a readership of fire professionals who've "seen it all before". **Fees:** Negotiable, but generally good. Up to £200 for a really good cover picture.

MANUFACTURING CHEMIST

HPCi Media Limited, Unit 1 Vogans Mill Wharf, 17 Mill Street, London SE1 2BZ

Tel: 020 7193 1279. E-mail: pharma@hpcimedia.com

Editor: Hilary Ayshford.

Monthly journal for the pharmaceutical industry. Read by senior management involved in research, development, manufacturing and marketing of pharmaceuticals.

Illustrations: Pictures of any aspect of the pharmaceutical industry.

Text: Features on any aspect of the pharmaceutical industry as detailed above. 1,000–2,000 words. **Overall freelance potential:** Approximately 30 per cent is contributed by freelances.

Fees: Text, £170 per 1,000 words for features, £15 per 100 words for news stories; pictures by agreement.

MARINE ENGINEERS REVIEW

Institute of Marine Engineering, Science & Technology, 80 Coleman Street, London EC2R 5BJ. Tel: 020 7382 2600. E-mail: namrata.nadkarni@imarest.org

Editor: Namrata Nadkarni.

Monthly publications for marine engineers.

Illustrations: Interesting topical photographs of ships and marine machinery.

Text: Articles on shipping and marine engineering, including naval and offshore topics.

Overall freelance potential: Good, but enquire before submitting.

Fees: By negotiation.

NEW CIVIL ENGINEER

EMAP Publishing Limited, Telephone House, 69-77 Paul Street, London EC2A 4NQ.

Tel: 020 3033 2822. E-mail: alexandra.wynne@emap.com

Editor: Mark Hansford. News Editor: Alexandra Wynne.

Weekly news magazine for professional civil engineers.

Illustrations: Up-to-date pictures depicting any civil engineering project. Must be well captioned and newsworthy.

Text: By commission only.

Overall freelance potential: Limited.

Fees: On a rising scale according to size of reproduction or length of text.

NEW DESIGN

Media Culture, Office 46, Pure Offices, Plato Close, Leamington Spa CV34 6WE. Tel: 01926 671338. E-mail: info@newdesignmagazine.co.uk

Managing Editor: Steve Welch.

Monthly for professional designers and manufacturers, covering developments in industrial and product design.

Illustrations: Photographs depicting new or current product, industrial and interior design, including architecture, theatre, textile, medical and transport design. Pictures should either have a news angle or be particularly strong images in their own right that might be used for covers. **Text:** Illustrated news stories or features on any aspect of contemporary commercial design.

Overall freelance potential: Good.

Fees: Dependent on use, up to £300-£400 for covers.

PRO SOUND NEWS EUROPE

Intent Media Ltd, 1st Floor, Suncourt House, 18-26 Essex Road, London N1 8LN. Tel: 020 7354 6002. E-mail: david.robinson@intentmedia.co.uk

Editor: Dave Robinson.

Monthly news magazine for professionals working in the European sound production industry. Covers recording, live sound, post-production, mastering and broadcasting.

Illustrations: News pictures on all aspects of the industry, from equipment manufacture to live sound shows and concert performances to recording studios.

Text: Illustrated news items and features (800-1,000 words) on any aspect of the industry, but always check with the editor before submitting.

Overall freelance potential: Good for those with contacts in the audio and music business. **Fees:** £140 per 1,000 words for text; photographs from £25.

PROFESSIONAL ENGINEERING

Caspian Publishing, Unit G4, Harbour Yard, Chelsea Harbour, London SW10 0XD. Tel: 020 7045 7500. E-mail: pe@caspianmedia.com

Editor: Lee Hibbert.

Fortnightly publication for members of the Institution of Mechanical Engineers and decision-makers in industry.

Illustrations: Pictures of relevant people, locations, factories, processes and specific industries. **Text:** Features with a general engineering bias at a fairly high management level, eg management

techniques, new processes, materials applications, etc. 1,500 words maximum.

Overall freelance potential: Limited, and usually commissioned specifically.

Fees: Not less than around £200 per 1,000 words; pictures by agreement.

URETHANES TECHNOLOGY INTERNATIONAL

Crain Communications Ltd, Fourth Floor, Carolyn House, 26 Dingwall Road, Croydon CRO 9XF. Tel: 020 8253 9600. E-mail: srobinson@crain.com.

Editor: Simon Robinson.

Bi-monthly publication for the polyurethane producing, processing, and using industries.

Illustrations: Pictures of production, equipment, and application of polyurethane materials. Also news pictures and shots of trade personalities. Covers: top quality and graphically striking medium format colour of polyurethane-related subjects.

Text: Features on new applications of polyurethanes; new products; new equipment and processing. Business, marketing, personnel and technical news items. Up to 2,000 words.

Overall freelance potential: Good scope for those with access to the industries involved. **Fees:** By arrangement.

UTILITY WEEK

Faversham House Ltd, Windsor Court, Wood Street, East Grinstead RH19 1UZ. Tel: 01342 332084. E-mail: ellen.bennett@fav-house.com

Editor: Ellen Bennett. News Editor: Jillian Ambrose.

Weekly business magazine for the three major supply utilities: electricity, gas and water.

Illustrations: News pictures concerning the major utilities. Possible scope for good stock coverage

of industry subjects. Commissions often available to experienced portrait and business/industry workers.

Text: Contributors with expert knowledge always welcomed. Submit details of experience in the first instance.

Overall freelance potential: Very good for industrial specialists. **Fees:** By negotiation.

WORKS MANAGEMENT

Findlay Publications Ltd, Hawley Mill, Hawley Road, Dartford, Kent DA2 7TJ. Tel: 01322 626962. E-mail: ivallely@findlay.co.uk

Editor: Ian Vallely. Art Editor: Neil Young.

Monthly publication for managers and engineers who directly control or perform the works management function in selected manufacturing concerns.

Illustrations: Occasional need for regional coverage of managers and workers in realistic work situations in factories. Mostly pictures are used only to illustrate features.

Text: Illustrated features of interest to management, eg productivity, automation in factories, industrial relations, employment law, finance, energy, maintenance, handling and storage, safety and welfare. Around 1,500 words.

Overall freelance potential: Up to 30 per cent is contributed by freelances. **Fees:** By agreement.

Local Government & Services

CHILDREN & YOUNG PEOPLE NOW

Mark Allen Group, St Jude's Church, Dulwich Road, London SE24 0PB.

Tel: 020 7501 6795. E-mail: cypnow@markallengroup.com

Editor: Ravi Chandiramani.

Weekly publication for youth workers, social workers, careers officers, teachers, counsellors and others working in the the children's service and youth affairs sectors.

Illustrations: Mainly commissioned shoots to cover youth work and youth workers around the country. Contact art editor with details and samples in the first instance.

Text: Small proportion of copy is from freelance contributors.

Overall freelance potential: Occasional news pictures and one or two features using freelance photos per issue.

Fees: According to use.

FIRE RISK MANAGEMENT

Fire Protection Association, London Road, Moreton in Marsh, Gloucestershire GL56 0RH. Tel: 01608 812518. E-mail: msennett@thefpa.co.uk

Editor: Mark Sennett.

Monthly technical publication on fire safety. Aimed at fire brigades, fire equipment manufacturers, architects, insurance companies, and those with responsibility for fire safety in public sector bodies, commerce and industry.

Illustrations: Pictures of large and small fires to illustrate reports. Also pictures showing different types of building design and occupancy (offices, commercial premises, warehouses, etc), and of emergency services at work.

Text: Technical articles on fire prevention and protection.

Overall freelance potential: Good pictures of fires and unusual fire safety experiences are always welcome.

Fees: Pictures, negotiable from £15.

LEGAL ACTION

The Legal Action Group, Universal House, 88-94 Wentworth Street, London, E1 7SA. Tel: 020 7833 2931. E-mail: vwilliams@lag.org.uk

Editor: Valerie Williams.

Monthly publication for lawyers, advice workers, law students and academics.

Illustrations: Pictures of lawyers and judges, especially other than the standard head and shoulders shot. Plus stock pictures to illustrate features covering a wide range of subjects (e.g. housing, police, immigration, advice services).

Text: Features on legal services and professional issues, including the courts. High technical detail required. Also information for news and feature material that can be written in-house.

Overall freelance potential: Always interested in hearing from photographers holding suitable material.

Fees: By negotiation.

THE MJ (MUNICIPAL JOURNAL)

Hemming Group Ltd, 32 Vauxhall Bridge Road, London SW1V 2SS.

Tel: 020 7973 6691. E-mail: hr.jameson@hgluk.com

Editor: Heather Jameson.

Weekly publication for senior local government officers, councillors, Whitehall departments and academic and other institutions.

Illustrations: News pictures; relevant personalities, vehicles, buildings, etc; general stock shots of local government subjects and situations to illustrate features.

Text: Features on local government issues. 750–1,000 words.

Overall freelance potential: Very good for relevant material.

Fees: On a rising scale according to size of reproduction or length of feature.

SCHOLASTIC MAGAZINES

Scholastic Ltd, Windrush Park, Witney, Oxfordshire, OX29 0YD.

Tel: 01926 813910. Email: sgarbett@scholastic.co.uk

Design Manager: Sarah Garbett.

Range of monthly publications for teachers in primary and nursery education.

Illustrations: News pictures and good, unposed pictures of school children from 3-12 years, in classrooms and other school situations. Cover pictures as above often commissioned. Pictures are retained within a large in-house library.

Text: No scope.

Overall freelance potential: Good.

Fees: By agreement.

THE TEACHER

National Union of Teachers, Hamilton House, Mabledon Place, London WC1H 9BD.

Tel: 020 7380 4708. E-mail: teacher@nut.org.uk

Acting Editor: Dan Humphrey.

Official magazine of the National Union of Teachers.

Illustrations: News pictures concerning any educational topic, especially those taken in schools and colleges. Coverage of union activities, personalities, demonstrations, etc.

Text: Short articles and news items on educational matters.

Overall freelance potential: Limited; interested in good pictures though.

Editor's tips: Consult the editor before submitting.

Fees: According to use.

As a member of the Bureau of Freelance Photographers, you'll be kept up-to-date with markets through the BFP Market Newsletter, published monthly. For details of membership, turn to page 9

Male Interest

ATTITUDE

Attitude Media Ltd, 33 Pear Tree Street, London EC1V 3AG.

Tel: 020 7608 6300. E-mail: matthew.todd@attitude.co.uk

Editor: Matthew Todd. Deputy Editor: Andrew Fraser.

Monthly style magazine aimed primarily, but not exclusively, at gay men.

Illustrations: Mostly by commission to illustrate specific features. Some opportunities for experienced fashion and style workers. Also some scope for travel, reportage and popular culture material.

Text: Ideas for features– human interest, travel, celebrities– always considered; submit an outline first. Should appeal to a gay readership even if written from a "straight" perspective.

Overall freelance potential: Fair.

Fees: £100 per page for photography; text £150 per 1,000 words.

CLUB INTERNATIONAL

Paul Raymond Publications, 23 Lyon Road, Hersham, Surrey KT12 3PU. Tel: 020 8873 4408. E-mail: clubint@paulraymond.com

Editor: Andrew Emery.

Popular glamour monthly for men.

Illustrations: Requires top quality glamour sets of very attractive girls (aged 18-25).

Text: Articles on sexual or humorous topics, or factual/investigative pieces. 1,000–2,000 words. **Overall freelance potential:** Most of the published glamour material comes from freelances, but they are normally experienced glamour photographers.

Editor's tips: Study the magazine to appreciate style. As well as being very attractive, girls featured must look contemporary and fashionable.

Fees: £300+ for glamour sets.

ESCORT

Paul Raymond Publications, 23 Lyon Road, Hersham, Surrey KT12 3PU

Tel: 020 8873 4408. E-mail: escort@paulraymond.com

Editor: James Hundleby.

Monthly glamour magazine; less sophisticated than the other Paul Raymond publications, Men Only and Club International.

Illustrations: Transparency or digital. Looks for glamour sets of "normal, healthy, girl-next-door" types. Each issue contains about 10 glamour sets running to 2–5 pages each.

Text: Purely "readers' contributions".

Overall freelance potential: Good.

Fees: £300+ for glamour sets, or from £25 per picture.

ESQUIRE

Hearst Magazines UK, 72 Broadwick Street, London W1F 9EP.

Tel: 020 7439 5000. E-mail: henny.manley@hearst.co.uk

Editor: Alex Bilmes. Photo Director: Henny Manley.

Up-market general interest monthly for intelligent and affluent men in the 25-44 age group.

Illustrations: Top-quality material only, invariably by commission. Mostly portraiture, fashion and photojournalism.

Text: Scope for "name" writers only.

Overall freelance potential: Good for photographers, but restricted to those experienced at the highest level of magazine work.

Fees: By negotiation.

FHM

Bauer Media, Academic House, 24-28 Oval Road, London NW1 7DT.

Tel: 020 7241 8000. E-mail: rachael.clark@fhm.com

Editor: Joe Barnes. Director of Photography: Rachael Clark.

Monthly lifestyle and fashion magazine for young men.

Illustrations: Main feature and fashion photography always by commission. Stock images relating to subjects of major interest (sports, travel, adventure, cars, sex) often required—send details of coverage available.

Text: Will consider interesting short items of interest to a young male readership, and feature ideas from experienced workers.

Overall freelance potential: Good for the experienced contributor.

Fees: By negotiation.

GQ

Conde Nast Publications Ltd, Vogue House, Hanover Square, London W1S 1JU.

Tel: 020 7499 9080. E-mail: james.mullinger@condenast.co.uk

Editor: Dylan Jones. Photographic Director: James Mullinger. Deputy Photo Editor: Georgina Breitmeyer.

Up-market general interest magazine for men in the 20-45 age group.

Illustrations: Top-quality illustrations for articles on a range of male interest topics, invariably by commission.

Text: Top level investigative, personality, fashion and style features, plus articles on other subjects likely to be of interest to successful and affluent men.

Overall freelance potential: Only for the contributor experienced at the top level of magazine work.

Editor's tips: See from the magazine itself what sort of style and quality is required. **Fees:** By negotiation.

LOADED

Simian Publishing Ltd, 1 Leicester Square, London WC2H 7NA.

Tel: 020 7432 2392. E-mail: aaron@loaded.co.uk

Editor: Aaron Tinney.

General interest monthly for men in their 20s. Covers music, sport, humour, fashion and popular culture in a down-to-earth and irreverent manner.

Illustrations: Mostly by commission to accompany features, but speculative submissions always considered.

Text: Fashion features, reportage (clubs, drugs, crime, etc), interviews, humour and "anything off the wall".

Overall freelance potential: Always open to fresh and original photography and ideas. **Fees:** By negotiation.

MAYFAIR

Paul Raymond Publications, 23 Lyon Road, Hersham, Surrey KT12 3PU. Tel: 020 8873 4408. E-mail: mayfair@paulraymond.com Editor: Matt Berry. Glamour-based monthly for men.

Are you working from the latest edition of The Freelance Photographer's Market Handbook? It's published on 1 October each year. Markets are constantly changing, so it pays to have the latest edition **Illustrations:** Only top quality material will be considered. Glamour sets taken in up-market surroundings and real-life locations, such as a luxury furnished flat. Outdoor material needs strong sunlight.

Text: No scope.

Overall freelance potential: Only for high-quality material; much is produced by regular contributors.

Editor's tips: For glamour thought should be given to the erotic use of clothing and suggestion of sex appeal or sexual situation, together with striking but simple colour co-ordination. Always call before submitting.

Fees: £250-£500 for glamour sets, or dependent on use.

MEN ONLY

Paul Raymond Publications, 23 Lyon Road, Hersham, Surrey KT12 3PU.

Tel: 020 8873 4408. E-mail: mattb@paulraymond.com

Editor: Matt Berry.

Sophisticated erotic monthly for men.

Illustrations: Imaginative glamour sets featuring"the most beautiful women". Models must be young, fresh, athletic and natural. Sets welcomed from new photographers as well as established contributors. Also picture-led supporting features.

Text: Laid-back humour, sport, male interests etc.

Overall freelance potential: Excellent.

Editor's tips: Attention to detail in clothes and make-up, a wide variety of poses, and imaginative locations will always set you apart. New ideas and faces always welcome.

Fees: £300-£500 for glamour sets. Other pictures by negotiation.

MEN'S HEALTH

Hearst-Rodale UK, 72 Broadwick Street, London W1F 9EP.

Tel: 020 7339 4400. E-mail: alex.kelly@hearst.co.uk

Editor: Toby Wiseman. Picture Editor: Alex Kelly.

Health-focused men's magazine covering sports, fitness, nutrition, grooming and other aspects of male lifestyle.

Illustrations: Mostly by commission to illustrate features as above, though possible scope for good generic stock shots of fitness and allied subjects.

Text: Articles on male lifestyle subjects, especially health and fitness. Write with ideas and details of experience in the first instance.

Overall freelance potential: Only for the experienced contributor.

Fees: By negotiation.

ZOO

Bauer Media, Academic House, 24-28 Oval Road, London NW1 7DT.

Tel: 020 7241 8000. E-mail: zoopictures@zootoday.com

Editor: Damien McSorley. Features Editor: Richard Innes. Picture Editor: Gemma Parker. Weekly general interest magazine for young men.

Illustrations: Always need topical, unusual and visually striking images for the magazine's news section— several double-page spreads per issue displaying spectacular or unusual images of all kinds. Also unusual or exclusive sports images. Commissions in relevant areas may be available. **Text:** Will consider ideas for topical features and real life stories. Material should have a laddish/humorous approach but be backed with genuine knowledge of the subject. Submit suggestions to features editor in the first instance.

Overall freelance potential: Excellent.

Fees: Negotiable, dependent on the nature of images and their exclusivity.

Motoring

CSMA CLUB MAGAZINE

CSMA Club, Britannia House, 21 Station Street, Brighton BN1 4DE.

Tel: 01273 744721. E-mail: jeremv.whittle@csmaclub.co.uk

Editor: Jeremy Whittle.

Monthly journal of the CSMA Club, whose members are drawn from the civil service and public sector companies. Covers motoring, travel and leisure activities.

Illustrations: General car-related subjects and Continental travel.

Text: Illustrated articles on motoring, travel, camping and caravanning. 750–1,000 words.

Overall freelance potential: Fair.

Fees: By arrangement.

AMERICAN CAR MAGAZINE

Project Viva Ltd, 6 Samsome Walk, Worcester WR1 1LH. Tel: 07854 138928. E-mail: editor@americancarmagazine.com

Editor: Dave Smith.

Monthly magazine for British enthusiasts of American cars, standard and custom, up to the present day.

Illustrations: Newsy and well-captioned single pictures depicting happenings on the UK custom and American car scene. Other pictures usually as part of a story/picture package on subjects detailed below. Prefers British-sourced material.

Text: Well-illustrated features on completed cars, step-by-step illustrated material on how to do it, track tests of modified cars and coverage of shows and events. Always phone or write first to discuss ideas.

Overall freelance potential: Good for the right sort of material.

Editor's tips: Not interested in front-wheel drive.

Fees: Text £125 per 1,000 words.

AUTO EXPRESS

Dennis Publishing, 30 Cleveland Street, London W1T 4JD.

Tel: 020 7907 6000. E-mail: editorial@autoexpress.co.uk

Editor: Steve Fowler. Picture Editor: Dawn Grant.

Popular weekly magazine, aimed at the average motorist rather than the car enthusiast.

Illustrations: Hard news pictures and topical motoring subjects with impact may be considered on spec, but most is by commission.

Text: Features on any motoring topic, to appeal to a general readership. May be practical but should not be too technical. 1,000–2,000 words. Always submit a synopsis in the first instance.

Overall freelance potential: Limited for the non-specialist.

Editor's tips: Although a popular non-technical title, accuracy is essential.

Fees: Photographs according to size of reproduction. Text usually £200 per 1,000 words.

AUTOCAR

Haymarket Publishing Ltd, Teddington Studios, Broom Road, Teddington, Middlesex TW11 9BE. Tel: 020 8267 5630. E-mail: amar.hussain@haymarket.com

Editor: Chas Hallett. Art Editor: Amar Hussain.

High quality general interest motoring weekly. Includes road tests, new car descriptions, international motor sport, motor shows, etc.

Illustrations: Mostly by commission for top quality general car coverage, test reports, performance cars, industry picture stories and portraits- submit CV/portfolio to the Art Editor. Always interested in scoop pictures of pre-production models under test or any other exclusive motor industry photo items.

Text: Illustrated features on motoring subjects, by prior arrangement with the editor. 1,000-2,000 words.

Overall freelance potential: Good for those with experience.

Editor's tips: Technical accuracy and full information on the cars featured is essential. Familiarise yourself with the magazine first; too much material received is unsuitable.

Fees: Features by negotiation.

THE AUTOMOBILE

Enthusiast Publishing Ltd, King's Farm, Dorking Road, Kingsfold, West Sussex RH12 3SA. Tel: 01306 628339. E-mail: jonathan.rishton@theautomobile.co.uk

Editor: Jonathan Rishton.

Monthly publication featuring veteran, vintage, and pre-1960s motor vehicles.

Illustrations: Not much scope for single pictures unless of particular interest. Main requirement is for well-illustrated articles concerning any pre-1960s motor vehicle; not only cars but also

commercial vehicles. Also limited room for coverage of race meetings, exhibitions or other events at which old motor vehicles are present. All images must be accompanied by detailed captions.

Text: Informative illustrated articles as above. Of particular interest are good restoration features, with both"before" and "after" pictures showing what can be achieved.

Overall freelance potential: Although limited there is scope for illustrated features- consult the editor before starting on feature.

Editor's tips: Do not submit material concerning post-1960s vehicles.

Fees: By negotiation.

CAR & ACCESSORY TRADER

Haymarket Publishing Ltd, Teddington Studios, Broom Road, Teddington, Middlesex TW11 9BE. Tel: 020 8267 5906. E-mail: greg.whitaker@haymarket.com

Editor: Greg Whitaker.

Monthly magazine for traders involved in the selling of car parts and accessories.

Illustrations: Captioned news pictures concerning new products, openings of new premises, handover of sales awards, etc. Much is commissioned. Covers: excellent relevant photographs considered.

Text: Varied subjects of interest to the trade, by commission only.

Overall freelance potential: About 50 per cent of contributions are from freelance sources. **Fees:** £100 per £1,000 words. Photographs negotiable.

CLASSIC AMERICAN

Mortons Media Group Ltd, Media Centre, Morton Way, Horncastle, Lincs LN9 6JR.

Tel: 01507 529503. E-mail: editor@classic-american.com

Editor: Ben Klemenzson.

Monthly magazine concerning American cars mainly of the '50s, '60s and '70s.

Illustrations: Striking or unusual pictures of classic US vehicles. However, much of the photography is commissioned from regulars or staff-produced.

Text: Illustrated articles on specific cars or bikes and their owners, plus features on other aspects of American-style youth culture such as clothing, music, sport, etc. 1,000–2,000 words. Always check with the editor before submitting.

Overall freelance potential: Car coverage welcome, but best scope is for lifestyle features. **Fees:** Pictures by negotiation. £150 per 1,000 words for text.

CLASSIC CARS

Bauer Automotive Ltd, Media House, Lynchwood, Peterborough PE2 6EA. Tel: 01733 468000. E-mail: classic.cars@bauermedia.co.uk/tony.turner@bauermedia.co.uk **Editor:** Phil Bell. Picture Researcher: Tony Turner.

Glossy, heavily-illustrated monthly covering classic cars of all eras.

Illustrations: Will consider on-spec reportage-style coverage of classic car events worldwide. Major

feature photography mostly handled by a team of regulars. E-mail picture researcher in the first instance.

Text: Will consider approaches from experienced motoring journalists.

Overall freelance potential: Very good for the right sort of material.

Editor's tips: Detailed captions and a contact number for each car's owner are essential.

Fees: On a rising scale according to size of reproduction, up to £150 for a full-bleed page.

CLASSIC LAND ROVER

Key Publishing Ltd, PO Box 100, Stamford, Lincs PE9 1XQ.

Tel: 01780 755131. E-mail: john.carroll@keypublishing.com

Editor: John Carroll.

Monthly magazine for Land Rover enthusiasts. Focus is on pre-1989 Land Rovers with special emphasis on Series 1,2, 3 and military models.

Illustrations: Images to illustrate range of features on relevant vehicles and their recreational use, especially restoration features, off-roading, greenlaning and overseas journeys.

Text: Will consider ideas for articles on subjects as above. Contributors should have strong knowledge of their subject.

Overall freelance potential: Good for truly suitable material. **Fees:** By negotiation.

CLASSIC & SPORTS CAR

Haymarket Publishing Ltd, Teddington Studios, Broom Road, Teddington, Middlesex TW11 9BE. Tel: 020 8267 5301. E-mail: james.page@haymarket.com

Editor: James Page.

Monthly magazine covering mainly post-1945 classic cars, generally of a sporting nature. Strong coverage of the owners' scene.

Illustrations: Colour; B&W archive material. Mainly interested in coverage of club or historic car gatherings, unless staff photographer is present. Feature photography always commissioned. **Text:** Articles of interest to the classic car enthusiast and collector, up to 2,500 words.

Overall freelance potential: Small, as much material is staff produced.

Editor's tips: Always get in touch before submitting.

Fees: According to merit.

CLASSICS MONTHLY

Beauford Court, 30 Monmouth Street, Bath BA1 2BW.

Tel: 01225 442244. E-mail: classicsmonthly@futurenet.co.uk

Editor: Gary Stretton.

Practical monthly for classic car owners.

Illustrations: Captioned pictures of newsworthy cars and events, including relevant motorsport coverage, always considered on spec. Also scope for commissions to do photo shoots of featured cars; send samples of previous work in the first instance.

Text: Well-illustrated features about restoring classic cars; reports from events.

Overall freelance potential: Good.

Editor's tips: Look at mag carefully before submitting work, particularly the editorial profile and style. Always interested in hearing about cars which might make a good feature subject. Send a sample shot with some details about the car and a commission to shoot may be offered.

Fees: Pictures, typically £100 per feature; £120 per 1,000 words; commissioned photography, £200 per day.

EVO

Dennis Publishing Ltd, Tower Court, Irchester Road, Wollaston, Northants NN29 7PJ. Tel: 020 7907 6310. E-mail: nick@evo.co.uk

Editor: Nick Trott. Art Director: Paul Lang.

Glossy monthly covering the high-performance end of the car market.

Illustrations: All by commission. Will consider approaches from freelances who can produce good action photography of cars on the move.

Text: No scope.

Overall freelance potential: Good for the experienced car photographer.

Fees: By negotiation.

FLEET NEWS

Bauer Automotive Ltd, Media House, Lynchwood, Peterborough Business Park, Peterborough PE2 6EA.

Tel: 01733 468000. E-mail: fleetnews@bauermedia.co.uk

Editor: Stephen Briers.

Weekly newspaper aimed at those responsible for running company car and light commercial vehicle fleets.

Illustrations: Captioned news pictures concerning company car operations, handover of car fleets to companies, appointments in the trade, etc.

Text: News, articles on business car management and related subjects.

Overall freelance potential: Excellent.

Editor's tips: Always write or e-mail first.

Fees: Negotiable.

4X4

Kelsey Publishing Group, Cudham Tithe Barn, Berry's Hill, Cudham, Kent TN16 3AG.

Tel: 01959 541444. E-mail: 4x4.ed@kelsey.co.uk

Editor: Nigel Fryatt.

Monthly magazine devoted to four-wheel-drive vehicles.

Illustrations: Pictures of new vehicles, travel and other "off road" events. Must be captioned with full details of driver, event and location.

 ${\bf Text:} \ Illustrated \ articles \ concerning \ four-wheel-drive \ vehicles \ and \ off-road \ activities. \ 1,000-2,000 \ words.$

Overall freelance potential: Limited, but there is room for new contributors.

Fees: By negotiation.

LAND ROVER MONTHLY

Dennis Publishing Ltd, Tower Court, Irchester Road, Wollaston, Northants NN29 7PJ.

Tel: 020 7907 6000. E-mail: editorial@lrm.co.uk

Editor: Dave Phillips.

Monthly magazine for Land Rover enthusiasts.

Illustrations: Little scope for individual photographs unless accompanied by extended captions or background text.

Text: Well-illustrated articles on all matters relating to Land Rover, Range Rover, Discovery and Freelander vehicles; travel/adventure stories, features on interesting individual vehicles and offroading personalities, competition and club event reports. Limited scope for vehicle test reports. **Overall freelance potential:** Excellent for those who can add words to their pictures, and have good knowledge of Land Rover products.

Fees: By negotiation.

LAND ROVER OWNER INTERNATIONAL

Bauer Automotive Ltd, Media House, Lynchwood, Peterborough PE2 6EA.

Tel: 01733 468000. E-mail: info@lro.com

Editor: Mike Goodbun.

Magazine for Land Rover owners and enthusiasts. 13 issues a year.

Illustrations: Interesting or unusual pictures of Land Rovers, Range Rovers, Freelanders,

Defenders and Discoverys. Celebrities pictured with such vehicles.

Text: Illustrated articles on overland expeditions using Land Rovers. Length 1,000 words, plus

around six pictures. **Overall freelance potential:** Good. **Fees:** Text, £100 per 1,000 words; pictures by negotiation.

MOTOR SPORT

38 Chelsea Wharf, 15 Lots Road, London SW10 0QJ.

Tel: 020 7349 8484. E-mail: editorial@motorsportmagazine.co.uk

Editor: Damien Smith. Deputy Editor: Gordon Cruickshank.

Monthly devoted to motor sport and sports cars, both old and new.

Illustrations: Colour; B&W archive material. Will always consider coverage of classic or vintage sports car meetings and racing. Archive collections always of interest.

Text: No scope.

Overall freelance potential: Fair.

Fees: From around £35 upwards.

911 & PORSCHE WORLD

CH Publications Ltd, Nimax House, 20 Ullswater Crescent, Ullswater Business Park, Coulsdon, Surrey CR5 2HR.

Tel: 020 8655 6400. E-mail: porscheworld@chpltd.com

Editor: Steve Bennett.

Monthly publication devoted to Porsche or Porsche-derived cars.

Illustrations: All commissioned, with opportunities for those who have original ideas and can produce top quality car photography.

Text: Ideas for articles always of interest; write with details in the first instance.

Overall freelance potential: Very good for specialist coverage.

Fees: Photography by arrangement; around £100 per 1,000 words.

OCTANE

Dennis Publishing Ltd, Tower Court, Irchester Road, Wollaston, Northants NN29 7PJ. Tel: 020 7907 6585. E-mail: marks@octane-magazine.com

Editor: David Lillywhite. Art Editor: Mark Sommer.

Monthly covering both contemporary high-performance cars and prestige classics from all eras. **Illustrations:** Colour and historic B&W. Mostly by commission with good opportunities for experienced car photographers. Possible on-spec scope for picture stories covering specific events such as meets, rallies, races, etc. Relevant archive material also of interest.

Text: Suggestions always considered.

Overall freelance potential: Good.

Fees: By negotiation.

PERFORMANCE FORD

Project Viva Ltd, The Outlook, 6 Sansome Walk, Worcester WR1 1LH. Tel: 01905 330177. E-mail: ben@performancefordmag.com Editor: Ben Morley. Monthly magazine devoted to Ford and Ford-based vehicles, with the emphasis on

Are you working from the latest edition of The Freelance Photographer's Market Handbook? It's published on 1 October each year. Markets are constantly changing, so it pays to have the latest edition high-performance road use.

Illustrations: Pictures commissioned to illustrate features, or topical single pictures of particular quality, i.e. prototypes, one-offs, etc.

Text: Illustrated articles on maintenance and modification of Ford-based cars. Personality profiles with a direct relevance to Ford products.

Overall freelance potential: Fair.

Editor's tips: Always raise ideas with the editor before submitting material.

Fees: Pictures according to size of reproduction or day rate by arrangement.

TOP GEAR MAGAZINE

Immediate Media Company Ltd, Vineyard House, 44 Brook Green, London W6 7BT.

Tel: 020 7150 5000. E-mail: queries.tgmag@bbc.co.uk

Editor-in-Chief: Charlie Turner.

General interest motoring magazine designed to complement the BBC TV programme of the same name.

Illustrations: All by commission and much from known specialists, but photographers with a fresh approach and a good portfolio are welcomed. Send samples and details of previous experience in the first instance, or call for appointment. Stock images of pre-1990 cars often needed to illustrate articles.

Text: Motoring-related features considered, preferably out of the ordinary.

Overall freelance potential: Good opportunities for talented car photographers.

Fees: By negotiation.

TOTAL 911

Imagine Publishing Ltd, Richmond House, 33 Richmond Hill, Bournemouth BH2 6EZ.

Tel: 01202 586291. E-mail: lee.sibley@imagine-publishing.co.uk

Editor: Lee Sibley. Art Editor: Kaite Peat.

Monthly for Porsche 911 car enthusiasts, covering both classic and modern models.

Illustrations: All by commission only. Interested in hearing from professional car photographers who can offer something different. Write first enclosing samples of work.

Text: Ideas from professional motoring writers always welcome- apply in writing only. **Overall freelance potential:** Good.

Editor's tips: Study the magazine before getting in touch; expertise and enthusiasm required! **Fees:** Negotiable, but from around £250 for photo assignments, £150 per 1,000 words for text.

Music

CLASSICAL MUSIC

Rhinegold Publishing Ltd, 20 Rugby Street, London, WC1N 3QZ.

Tel: 07785 613 147. E-mail: classical.music@rhinegold.co.uk

Editor: Kimon Daltas. Deputy Editor: Alex Stevens.

Fortnightly news and feature magazine for classical music professionals and the interested general public.

Illustrations: Very limited scope as most pictures are supplied by promoters, etc, but always happy to look at portfolios, subject to appointment. Occasional urgent need for a musician or group in the news- most easily met if freelances can supply lists of photographs they hold.

Text: Short news items and news stories about events in the music/arts world, including politics and performance, up to 800 words. Longer background features about musicians, usually relating to a forthcoming event, up to 2,000 words. All work is commissioned.

Overall freelance potential: Limited for photographers, but most text is from commissioned freelance sources.

Fees: Pictures by negotiation; text from £125 per 1,000 words.

FROOTS

Southern Rag Ltd, PO Box 3072, Bristol BS8 9GF.

Tel: 0117 317 9020. E-mail: froots@frootsmag.com

Editor: Ian Anderson.

Monthly publication concerned with folk and world roots music.

Illustrations: Pictures to be used in conjunction with interviews, reviews of records or reports on events. Mostly commissioned.

Text: Interviews and reviews concerned with folk and world music.

Overall freelance potential: Limited for the contributor unknown in this field. The magazine favours its regular contributors.

Fees: By agreement.

KERRANG!

Bauer Media, Endeavour House, 189 Shaftesbury Avenue, London WC2H 8JG.

Tel: 020 7295 5000. E-mail: scarlet.borg@kerrang.com

Editor: James McMahon. News Editor: John Longbottom. Picture Editor: Scarlet Borg. Weekly magazine covering a wide range of hard rock.

Illustrations: May consider exclusive pictures of relevant bands. On-stage performance shots preferred, with the emphasis on action. Some posed shots and portraits of top performers also used. **Text:** Little freelance market.

Overall freelance potential: Limited, most content is supplied by regulars.

Fees: By negotiation.

KEYBOARD PLAYER

Bookrose Ltd, 100 Birkbeck Road, Enfield, Middlesex EN2 0ED.

Tel: 020 8245 5840. E-mail: steve@keyboardplayer.com

Editor: Steve Miller.

Monthly magazine for players of all types of keyboard instrument. Covers pianos, organs, keyboards and synthesisers; and all forms of music, from pop to classical.

Illustrations: Photographs of keyboard instruments and their players, preferably accompanied by a newsy caption. Covers: striking images of keyboard instruments.

Text: Articles of around 1,000 words on any topic of interest to keyboard players.

Overall freelance potential: Fairly limited, but scope is there for the right type of material.

Editor's tips: Run-of-the-mill pictures of players seated at their instruments will not be met with much enthusiasm– a strikingly different approach is required.

Fees: By negotiation.

METAL HAMMER

Team Rock Ltd, 2 Balcombe Street, London NW1 6NW.

Tel: 020 7042 4000. E-mail: james.isaacs@futurenet.co.uk

Editor: Alexander Milas. Art Director: James Isaacs. Art Editor: Lewis Somerscales.

Monthly for heavy metal and hard rock fans.

Illustrations: Good action and group portrait photographs of hard rock or heavy metal performers– send lists of subjects available. Commissions available to experienced rock photographers.

Text: Illustrated articles, interviews and reviews. Submit suggestions only in the first instance.

Overall freelance potential: Excellent for those in touch with this scene.

Fees: By negotiation.

MIXMAG

Development Hell, 90-92 Pentonville Road, London N1 9HS.

Tel: 020 7078 8400. E-mail: mixmag@mixmag.net

Editor: Nick de Cosemo.

Monthly covering the dance music and clubbing scene.

Illustrations: Photographs of clubs and clubbers throughout the country; portraits of musicians;

photo features. Fresh young photographers always welcome.

Text: Reports from clubs nationwide; young writers welcome.

Overall freelance potential: Very good.

Editor's tips: Contributors don't have to have experience, just a good sense of what the dance scene is about.

Fees: By negotiation.

MOJO

Bauer Media, Endeavour House, 189 Shaftesbury Avenue, London WC2H 8JG.

Tel: 020 7295 5000. E-mail: matt.turner@bauermedia.co.uk

Editor: Danny Eccleston. Picture Editor: Matt Turner.

Monthly rock music magazine aimed at fans of all ages.

Illustrations: Colour and archive B&W. Photographs of leading rock artists, both contemporary and from earlier eras. Archive material from the '50s, '60s and '70s always of interest. Good opportunities for commissioned work.

Text: In-depth profiles of individual artists and bands, but scope mainly for established writers. **Overall freelance potential:** Good.

Editor's tips: Previously unpublished or unseen photographs, or those that have not been used for some years, are of particular interest.

Fees: According to use.

NME (NEW MUSICAL EXPRESS)

Time Inc (UK) Ltd, Blue Fin Building, 110 Southwark Street, London SE1 0SU.

Tel: 020 3148 6864. E-mail: nmepics@timeinc.com

Editor: Mike Williams. **Picture Director:** Marian Paterson. **Picture Editor:** Zoe Capstick. Weekly magazine covering all aspects of popular music and allied youth culture.

Illustrations: All aspects of contemporary popular music, but see below.

Text: Scope for exclusive news stories or interviews with rock musicians, film stars, or other personalities of interest to a young and aware readership. Always write or phone with suggestions first.

Overall freelance potential: Good, but very dependent on subject matter.

Editor's tips: NME only covers those parts of the music scene considered worthwhile by the editorial team- study recent issues.

Fees: On a rising scale according to size of reproduction.

Q

Bauer Media, Endeavour House, 189 Shaftesbury Avenue, London WC2H 8JG.

Tel: 020 7295 5000. E-mail: russ.oconnell@qthemusic.com

Editor: Matt Mason. Picture Director: Russ O'Connell.

Monthly rock music magazine aimed at the 18-35 age group.

Illustrations: Most pictures staff-produced or commissioned from a pool of regular contributors, but suitable stock pictures of relevant personalities will always be considered.

Text: Top quality profiles, interviews and feature articles of interest to a rock-oriented readership, invariably by commission.

Overall freelance potential: 50 per cent is commissions; good for library/stock shots. **Fees:** Set rates.

As a member of the Bureau of Freelance Photographers, you'll be kept up-to-date with markets through the BFP Market Newsletter, published monthly. For details of membership, turn to page 9

RHYTHM

Future Publishing Ltd, Beauford Court, 30 Monmouth Street, Bath BA1 2BW. Tel: 01225 442244. E-mail: chris.barnes@futurenet.com

Editor: Chris Barnes.

Monthly magazine for drummers and percussionists in the rock and pop music field.

Illustrations: Interesting photographs relating to contemporary percussion instruments and their players, including the use of electronic and computer-aided equipment.

Text: Illustrated profiles, interviews and features about leading contemporary drummers and percussionists. Articles on technique and programming from knowledgeable contributors. **Overall freelance potential:** Limited.

Fees: £110 per 1,000 words for text; photographs according to use.

TOTAL GUITAR

Future Publishing Ltd, Beauford Court, 30 Monmouth Street, Bath BA1 2BW.

Tel: 01225 442244. E-mail: totalguitar@futurenet.co.uk

Editor: Stewart Williams. Art Editor: Leanne O'Hara.

Monthly magazine for guitar players at all levels, concentrating on practical advice.

Illustrations: Mostly commissioned to accompany features and reviews. Stock shots of well-known players and individual instruments always of interest; send lists first.

Text: Profiles and interviews with leading guitarists, and practical articles. Submit ideas only in the first instance.

Overall freelance potential: Limited.

Fees: By negotiation.

Parenting

GURGLE

Media 10 Limited, Crown House, 151 High Road, Loughton IG10 4LF.

Tel: 020 3225 5200. E-mail: rachel@gurglemagazine.com; lara.evans@gurgle.com

Editor: Scarlet Brady. Deputy Editor: Rachel Price. Art Director: Lara Evans.

Monthly magazine aimed primarily at mothers of children aged six months up to six years. Includes children's fashion content and parenting issues as well as features on both celebrity and ordinary mums.

Illustrations: Opportunities for photographers experienced in mother and child shoots, children's fashion and stylish product photography. Photographers should initially contact the art director. **Text:** Will consider approaches from experienced freelances who have good ideas for illustrated stories and features. Initial contact should be with the deputy editor.

Overall freelance potential: Limited at present.

Fees: By negotiation.

MOTHER & BABY

Bauer Consumer Media, Endeavour House, 189 Shaftesbury Avenue, London WC2H 8JG. Tel: 020 7295 5560. E-mail: amanda.lancaster@bauermedia.co.uk

Editor: Kathryn Blundell. Art Editor: Amanda Lancaster.

Monthly aimed at pregnant women and mothers of young children.

Illustrations: May consider high quality photographs of mothers with babies, or babies (under one year) on their own, but the magazine is closely linked with the Mother & Baby Picture Library so has ready access to stock images. Experienced child photographers may be able to obtain commissions for editorial features and real life stories.

Text: Articles on all subjects related to pregnancy, birth, baby care and the early years. **Editor's tips:** Looking for top quality pictures with a fresh eye on parenting.

Fees: From £30 upwards for stock shots, negotiable for commissions.

NURSERY WORLD

MA Education Ltd, St Jude's Church, Dulwich Road, London SE24 0PB. Tel: 020 7738 5454. E-mail: calvin.mckenzie@markallengroup.com

Editor: Liz Roberts. Picture Editor: Calvin McKenzie.

Weekly publication on child care. Aimed at professional baby and child care workers such as teachers, nursery nurses and nannies.

Illustrations: Pictures of babies and young children (up to five years old) involved in various activities in childcare settings. Covers: Location shots of children, always linked to a feature inside. **Text:** Features on child care, education, health, and any aspect of bringing up children, e.g. physical, intellectual, emotional etc. Ideas for nurseries and playgroups.

Overall freelance potential: Many features come from freelance contributors. **Fees:** By arrangement.

rees. by arrangement.

PRIMA BABY & PREGNANCY

Immediate Media Company Ltd, Vineyard House, 44 Brook Green, London W6 7BT. Tel: 020 7150 5000. E-mail: lisa.mcsorley@immediatemedia.co.uk

Editor: Kelly Beswick. Art Director: Lisa McSorley.

Glossy monthly covering pregnancy, babies, toddlers up to four years and all aspects of family life. **Illustrations:** Top quality pictures of babies and toddlers, with/without parents, in situations, engaged in activities, etc. Must be warm, natural lifestyle images rather than posed"stock" shots. Write with details in the first instance. Some commissions available, mainly for studio photographers; call first to discuss possibilities.

Text: Limited freelance scope.

Overall freelance potential: Very good for quality material.

Fees: Variable; day rate around £400.

RIGHT START

Needmarsh Publishing, PO Box 481, Fleet, Hants GU51 9FA

Tel: 07867 574590. E-mail: lynette@rightstartmagazine.co.uk

Editor: Lynette Lowthian.

Bi-monthly magazine for parents of pre-school and primary school age children, covering health, behaviour, education and family life.

Illustrations: Mostly by commission but some scope for good stock coverage of children in educational and learning situations; send only lists or details of coverage available in the first instance.

Text: Opportunities for education and child care specialists. Approach with details of ideas and previous experience.

Overall freelance potential: Limited.

Fees: By negotiation.

SMALLISH

Exclusive Magazines, Media House, 5 Broadway Court, Chesham, Bucks HP5 1EG.

Tel: 01494 771144. E-mail: elee@exclusivemagazines.co.uk

Editor: Estelle Lee. Art Editor: Catherine Duffy.

Upmarket parenting title for discerning mothers who want more from a parenting magazine". **Illustrations:** Top quality fashion shoots, upmarket interiors and product photography. Some potential for stock images illustrating relevant topics such as childcare, development, health and education.

Text: Articles on issues listed above. Also some lifestyle and travel features. Submit ideas in the first instance.

Overall freelance potential: Fair scope for experienced parenting and child photography specialists.

Fees: By negotiation.

Photography & Video

AV

Metropolis Business Publishing, 6th Floor, Davis House, 2 Robert Street, Croydon CR0 1QQ. Tel: 020 8253 8643. E-mail: clive.couldwell@metropolis.co.uk

Editor: Clive Couldwell. Assistant Editor: Zoe Mutter.

Monthly magazine for managers in industry and commerce, public services, government etc who use audiovisual communication techniques, eg slides, film, video, overhead projection and filmstrips, plus the new technologies of computer graphics and telecommunication.

Illustrations: Pictures of programmes being shown to audiences, preferably supported by case history details; relevant news; new products or location shooting pictures. All must be backed with solid information.

Text: Case histories of either shows, conferences or studies of a particular company's use of AV techniques. Good location/conference stories always welcome. 1,000–2,500 words.

Overall freelance potential: Up to 25 per cent comes from freelances.

Fees: Text, £180-£200 per 1,000 words; pictures by agreement.

ADVANCED PHOTOGRAPHER

Bright Publishing, 82 High Street, Sawston, Cambs CB22 3HJ.

Tel: 01223 499459. E-mail: willcheung@bright-publishing.com

Editor: Will Cheung.

Magazine for the experienced photo enthusiast seeking serious information and inspiration. **Illustrations:** Top quality photography of all kinds, but especially images that display advanced techniques in action. Submit samples in the first instance, preferably a few low-res JPEG images by e-mail. This is preferred to links to websites or Flickr.

Text: Expert articles on advanced photographic techniques always welcomed.

Overall freelance potential: Excellent for highly-skilled workers.

Editor's Tips: Not interested in pretty pictures of stock landscapes, looking for something more challenging- be it panoramics or HDR- something readers can really aspire to. **Fees:** By negotiation.

AMATEUR PHOTOGRAPHER

Time Inc (UK) Ltd, Blue Fin Building, 110 Southwark Street, London SE1 0SU.

Tel: 020 3148 4138. E-mail: amateurphotographer@timeinc.com

Editor: Nigel Atherton.

Weekly magazine for all photographers, from beginners to experienced enthusiasts.

Illustrations: B&W and colour. Pictures to illustrate specific photo techniques and general photo features. General portfolios in B&W and colour. Send no more than 10 pictures, prints unmounted, slides in a plastic slide wallet. Digital files on CD should be saved as JPEG or TIFF and accompanied by contact sheet.

Text: Little scope.

Overall freelance potential: Good.

Fees: £50 per published page, pictures and text, except"Reader Portfolio".

BLACK+WHITE PHOTOGRAPHY

GMC Publications Ltd, 86 High Street, Lewes, East Sussex BN7 1XN.

Tel: 01273 477374. E-mail: elizabethr@thegmcgroup.com

Editor: Elizabeth Roberts.

Published 13 times a year, the magazine is devoted to showcasing the best in black and white photography. Also runs the annual Black+White Photographer of the Year competition.

Illustrations: B&W only. Features and portfolios showcasing the work of individual photographers, usually a cohesive body of work on a specific subject or theme. Regular"Reader Portfolio" feature devotes up to two pages per reader/contributor. Photojournalistic work of particular interest,

especially long-term projects produced over an extended period. Also step by step features showing all stages from a straight print to the final print. Digital techniques also covered. Little scope for single images.

Text: Illustrated articles on printing techniques, film/paper combinations, equipment choices, etc. Submit sample prints and synopsis in the first instance.

Overall freelance potential: Excellent for the dedicated B&W worker.

Fees: According to subject and use.

THE BRITISH JOURNAL OF PHOTOGRAPHY

Apptitude Media Ltd, Ground Floor Unit A, Zetland House, 5-25 Scrutton Street, London EC2A 4HJ.

Tel: 020 8123 6873. E-mail: bjp.editor@bjphoto.co.uk

Editor: Simon Bainbridge. Deputy Editor: Diane Smyth.

Monthly magazine for professional and semi-professional photographers, students, advanced amateurs and all those engaged in professional photography.

Illustrations: Portfolios along with some biographical notes about the photographer concerned. Contact deputy editor in the first instance.

Text: Interested in anything related to professional photography, particularly the more unusual and technical aspects.

Overall freelance potential: Good for bringing freelances to the attention of potential clients. **Editor's tips:** Contributors do need to offer something special. Remember the magazine is aimed at those engaged in professional and semi-professional photography– technical features must therefore be of the highest calibre.

Fees: Portfolios not normally paid for; exposure in the magazine frequently leads to commissions elsewhere. Negotiable for text.

DIGITAL CAMERA

Future Publishing Ltd, Quay House, The Ambury, Bath BA1 1UA.

Tel: 01225 442244. E-mail: editor.dcm@futurenet.com

Editor: Ben Brain.

Monthly for the mid-market of digital camera users, those mainly using digital SLRs in the $\pounds 600-\pounds 1400$ price range.

Illustrations: Good single images required to illustrate seasonal subjects and topical events, and as examples of creative digital manipulations/compositions. Should be accompanied by detailed captions.

Text: Well-illustrated "how to" articles on digital photography and image editing. Contributors need to have some prior experience of producing such material.

Overall freelance potential: Good.

Editor's tips: Contributors should supply as much background detail about their images as they can.

Fees: Single images by negotiation and according to use; features £80 per published page.

DIGITAL PHOTO

Bauer Active Ltd, Media House, Lynchwood, Peterborough PE2 6EA.

Tel: 01733 468000. E-mail: jon.adams@bauermedia.co.uk

Editor: Jon Adams.

Monthly aimed at photographers keen to use their computer to enhance their pictures.

Illustrations: Need for high-quality- technically and pictorially- original images that inspire readers to produce similar work. Ideally submissions should be accompanied by step-by-step screengrabs and words illustrating the thought processes and the stages involved in producing the work. Creative work always needed for the portfolio pages; require ten outstanding digitally manipulated images.

Text: Good potential for quality, step-by-step tutorials, but the final image must be outstanding and relevant. Contact editor in the first instance.

Overall freelance potential: Excellent for step-by-step tutorials.

Editor's tips: Look at and read the magazine first, then e-mail ideas and low-resolution JPEGs to illustrate. If submitting on CD always enclose high-quality inkjet prints too. **Fees:** Negotiable, but typically £50 per page or £120 per 1,000 words.

DIGITAL PHOTOGRAPHER

Imagine Publishing Ltd, Richmond House, 33 Richmond Hill, Bournemouth BH2 6EZ.

Tel: 01202 586210. E-mail: amy.squibb@imagine-publishing.co.uk

Editor: Amy Squibb.

Digital photography magazine for the more advanced user, aimed at serious enthusiasts and professionals.

Illustrations: Pictures mainly required to illustrate features on contemporary digital photography. Opportunities best for photographers using digital for specialist subjects (landscape, wildlife, portraiture, etc) or those experienced in Photoshop techniques.

Text: Practical illustrated articles and features on topics as above.

Overall freelance potential: Good for those with well-developed skills in digital work. **Fees:** Negotiable, depending on what is on offer.

DIGITAL SLR

Bright Publishing Ltd, Bright House, 82 High Street, Sawston, Cambridge CB2 4HJ. Tel: 01223 499450. E-mail: editorial@bright-publishing.com

Editor: Matty Graham.

Monthly magazine for owners of digital SLR cameras, aimed at beginners and semi-proficient users. Emphasis on photographic technique, digital workflow and all things digital.

Illustrations: Normally images and articles as a package, but always interested in hearing from new photographers.

Text: Ideas, suggestions or draft articles on all aspects of digital SLR photography-technique,

software reviews, location guides etc- are always welcome. Check with the editor before submitting. **Overall freelance potential:** Excellent.

Fees: By negotiation.

DIGITAL SLR PHOTOGRAPHY

Dennis Publishing, 6 Swan Court, Cygnet Park, Hampton, Peterborough PE7 8GX. Tel: 01733 567401. E-mail: jo_lezano@dennis.co.uk

Editor: Daniel Lezano. Editorial Co-ordinater: Jo Lezano.

Monthly for all photographers who use digital SLRs.

Illustrations: Regular requirement for high-quality images produced on digital SLRs. Most interested in seeing portfolios of between 20-100 images. For all submissions, supply TIFFs or maximum-quality JPEGs on CD/DVD, with thumbnail printouts (maximum 20 images per A4 sheet).

Text: Mostly produced by regulars, but ideas always considered.

Overall freelance potential: Excellent.

Editor's tips: See website at www.digitalslrphoto.com for a flavour of the content of the magazine along with details of picture requirements and submission guidelines.

Fees: On a standard scale according to use.

EOS MAGAZINE

Robert Scott Publishing Ltd, The Old Barn, Ball Lane, Tackley, Kidlington, Oxon OX5 3AG. Tel: 01869 331741. E-mail: editorial@eos-magazine.com

Editor: Robert Scott.

Quarterly magazine for users of Canon EOS cameras.

Illustrations: Top quality photographs of any subject taken with Canon EOS cameras. Should demonstrate some aspect of photographic technique or the use of equipment. Comparison shots always of interest.

Text: Contributions are welcomed, but always phone or e-mail first to discuss.

Overall freelance potential: Very good.

Editor's tips: Current requirements and other information are posted at www.eos-magazine-forum.com.

Fees: Minimum fee for pictures is £15, but most are paid at between £20 and £60 depending on usage. Cover and dps, £100-£250. Text £90-£150 per 1,000 words (higher rates are for technique material which is comprehensive and well researched).

HOTSHOE INTERNATIONAL

World Illustrated Ltd, 29-31 Saffron Hill, London EC1N 8SW.

Tel: 020 7421 6009. E-mail: melissa.dewitt@photoshot.com

Editor: Melissa De Witt.

Bi-monthly contemporary photography magazine covering all genres.

Illustrations: High-quality photography and portfolios of all kinds, including fine art, documentary, reportage, photojournalism and creative photography.

Text: Only in support of material as above.

Overall freelance potential: Very good for high-quality, original material.

Editor's tips: Contributions need to be of real interest to other working photographers. **Fees:** By negotiation.

MARKET NEWSLETTER

Bureau of Freelance Photographers, Vision House, PO Box 474, Hatfield AL10 1FY. Tel: 01707 651450. E-mail: eds@thebfp.com

Editor: John Tracy. Deputy Editor: Stewart Gibson.

Monthly journal of the BFP, mainly devoted to detailing markets for photography. For members only.

Illustrations: Photographs required for"Pictures that Sell" feature– photographs taken by BFP members that have proven commercial success, having earned high fees and/or having sold to a wide range of markets.

Text: 200 word story required to accompany each image in above feature.

Overall freelance potential: Limited.

Fees: £30 per image for"Pictures that Sell".

MASTER PHOTOGRAPHY

Icon Publications Ltd, Maxwell Lane, Kelso, Roxburghshire TD5 7BB.

Tel: 01573 226032. E-mail: editor@iconpublications.com

Editor: David Kilpatrick.

Magazine for the UK's commercial and studio photographers, with the emphasis on photographing people for profit. Official journal of the Master Photographers Association (MPA). Ten issues per year.

Illustrations: Images only required to accompany and illustrate specific articles mainly relating to commercial studio or events photography.

Text: Illustrated articles and features on topics as above, mainly profiles/interviews with successful practitioners. Some technical articles.

Overall freelance potential: Limited; most material is contributed on a voluntarary basis by MPA members.

Fees: Interviews and technical material, £60-£90 per published page.

N-PHOTO

Future Publishing Ltd, Beauford Court, 30 Monmouth Street, Bath BA1 2BW.

Tel: 01225 442244. E-mail: chris.george@futurenet.com

Editor: Chris George.

Monthly magazine for photographers using Nikon cameras and equipment.

The Freelance Photographer's Market Handbook 2015

Illustrations: Mainly only required to illustrate photographic techniques, and must be shot on Nikon DSLR bodies. Images considered for gallery section showcasing the best of Nikon photography. Creative images preferred– landscapes, portraits, wildlife, macro work, etc. **Text:** Will consider illustrated articles on technique from experienced Nikon users, including digital darkroom skills and Photoshop.

Overall freelance potential: Very good for appropriate material. **Fees:** From £20 minimum to £60 full-page, £120 DPS, £200 covers.

OUTDOOR PHOTOGRAPHY

GMC Publications, 86 High Street, Lewes, East Sussex BN7 1XN.

Tel: 01273 477374. E-mail: stevew@thegmcgroup.com

Editor: Steve Watkins.

Monthly devoted to the photography of all types of outdoor subject matter.

Illustrations: Digital files or transparencies. Top-quality landscape, wildlife, nature and adventure photography, from Britain and beyond. Scope for good single images in the reader gallery section, but prefer packages of both words and pictures.

Text: Well-illustrated articles on all aspects of outdoor photography, accompanied by full background details on location or subject.

Overall freelance potential: Excellent; the magazine relies on freelances contributors.

Editor's tips: The magazine is seasonally-led, so subject matter needs to be relevant to the month of publication. Don't send on-spec pictures by e-mail.

Fees: By negotiation.

PENTAX USER

Magezine Publishing Ltd, The Turbine, Coach Close, Shireoaks S81 8AP.

Tel: 01909 512100. E-mail: support@pentaxuser.co.uk

Editor: Peter Bargh.

Quarterly online magazine for members of Pentax User Plus. Features techniques reviews and howto articles on all areas of photography with an emphasis on Pentax equipment.

Illustrations: B&W or colour, must be taken on a Pentax camera. Images usually only used as part of a complete package of words and pictures.

Text: Well-illustrated articles on all aspects of photography with an emphasis on Pentax camera equipment. How-to articles on using modes of compacts and DSLRs particularly sought after, along with techniques on using flash, lenses, filters etc. Please submit suggestions in writing in first instance. The editor will then phone or reply to discuss commission.

Overall freelance potential: Most of the content is based on articles from club members or freelances.

Fees: By negotiation.

PHOTO PROFESSIONAL MAGAZINE

Bright Publishing Ltd, Bright House, 82 High Street, Sawston, Cambridge CB2 4HJ. Tel: 01223 499450. E-mail: editorial@bright-publishing.com

Editor: Terry Hope.

Monthly magazine dedicated to aspiring professional photographers and established pros. Strong emphasis on business, technique and the life of a modern professional.

Illustrations: Normally images and articles submitted as a package, but always interested in brilliant one-offs or portfolios of images.

Text: Ideas, suggestions or draft articles on all aspects of professional photography– equipment, workflow, technique– are always welcome. Check with the editor before submitting.

Overall freelance potential: Excellent.

Fees: By negotiation.

PHOTOGRAPHY FOR BEGINNERS

Imagine Publishing Ltd, Richmond House, 33 Richmond Hill, Bournemouth BH2 6EZ. Tel: 01202 586283. E-mail: dan.hutchinson@imagine-publishing.co.uk

Editor-in-Chief: Dan Hutchinson.

Magazine for those new to photography and mainly interested in sharing photos via technologies like social networking websites and tablets, focusing on basic"how to" advice.

Illustrations: Will consider images suitable to illustrate simple and popular digital photo techniques, but preferably supplied as part of a feature.

Text: Always interested in complete illustrated"how-to" features on basic digital photography techniques and applications.

Overall freelance potential: Main scope is for complete illustrated articles.

Editor's Tips: Initial approach should be by e-mail, including a few examples of both photographic and written work.

Fees: By negotiation.

PHOTOGRAPHY MONTHLY

Archant Specialist, Archant House, Oriel Road, Cheltenham GL50 1BB.

Tel: 01242 211080. E-mail: pm@photographymonthly.co.uk

Group Editor: Adam Scorey. Deputy Editor: Lorna Dockerill.

Magazine for the beginner and enthusiast, with the emphasis on helping readers improve their images using the latest imaging techniques and equipment.

Illustrations: High quality photography of all types, especially images that illustrate specific points of camera and computing technique. All subjects welcome but in particular landscapes, nature and people. Step-by-step digital tutorials are also of interest.

Text: Much is produced by regular writers but the magazine is always on the lookout for new contributors and ideas.

Overall freelance potential: Excellent.

Editor's tips: Best scope is for well-conceived ideas that tie in with the existing style of the title. Fees: According to use.

PHOTOGRAPHY WEEK

Beauford Court, 30 Monmouth Street, Bath BA1 2BW.

Tel: 01225 442244. E-mail: paul.grogan@futurenet.co.uk

Editor: Paul Grogan.

Weekly photography title designed specifically for the iPad. Aims to showcase the best international photography alongside interviews with pro photographers worldwide.

Illustrations: Always seeking stunning and original imagery for various sections in the magazine and for the blog at photographyweek.tumblr.com.

Text: Image-led features on a wide variety of themes/subjects; photo-related news stories from around the world; photographer interviews Q&A style, usually to tie in with a book or exhibition; short articles offering advice and/or tips on specific techniques.

Overall freelance potential: Excellent for single images. For features much is staff-produced but original freelance material welcomed.

Editor's Tips: Freelances should familiarise themselves with the magazine and its various sections. **Fees:** Features by negotiation.

PHOTOPLUS

Future Publishing Limited, 30 Monmouth Street, Bath BA1 2BW. Tel: 01225 442244. E-mail: peter.travers@futurenet.com

Editor: Peter Travers.

Photography magazine aimed at users of Canon digital SLRs. 13 issues a year.

Illustrations: Always happy to consider good images taken with Canon DSLR cameras. Subjects should be those of general appeal to the keen photo enthusiast, such as landscapes, nature, portraiture, etc. Send a few low-res samples via e-mail, weblink or on CD/DVD in the first instance.

Text: Mostly staff-produced.

Overall freelance potential: Good for strong enthusiast-type material.

Fees: According to use, but typically around £60 half page, £120 full page, £200 dps or cover.

PRACTICAL PHOTOGRAPHY

Bauer Media, Media House, Lynchwood, Peterborough PE2 6EA.

Tel: 01733 468000. E-mail: practical.photography@bauermedia.co.uk

Editor: Ben Hawkins.

Monthly magazine aimed at all photographers, combining inspirational images and expert hands-on advice.

Illustrations: Always looking for new and exciting photography of any subject. Images should be technically and creatively outstanding. Landscapes, portraits, travel, wildlife, still life and action images are of particular interest.

Text: Lots of potential, but contact editor with a short synopsis and sample images in the first instance. Always looking for writers who can offer something the staff writers can't.

Overall freelance potential: Excellent for photographs and feature ideas

Editor's tips: Look at the magazine very carefully; if you can produce comparable work, get in touch.

Fees: Typically £60 per page pro rata for imagers and £120 per 1,000 words.

PRACTICAL PHOTOSHOP

Future Publishing Ltd, Beauford Court, 30 Monmouth Street, Bath BA1 2BW.

Tel: 01225 442244. E-mail: practicalphotoshop@futurenet.com

Editor: TBA.

Monthly magazine for photographers and other computer creatives. Contains tutorial features on improving and manipulating digital images for a broad range of Photoshop users. Includes an interactive cover-mounted disc providing accompanying video tutorials for each technique featured in the magazine.

Illustrations: Mainly only required to illustrate tutorials, preferably supplied as part of a tutorial package. Gallery section showcasing individual images offers no payment but will provide website details and full credits, possibly of value to emerging photographers rather than the established. Would especially like to hear from accomplished Photoshop users who can not only produce great images and write well, but provide video tutorials too.

Text: Always seeking skilled Photoshop users who can communicate their knowledge to others. **Overall freelance potential:** Good for those with serious Photoshop skills.

Editor's Tips: Look at the magazine before contacting us and ask yourself if your work really is a good fit.

Fees: By negotiation.

PROFESSIONAL PHOTOGRAPHER

Archant Specialist, Archant House, Oriel Road, Cheltenham GL50 1BB. Tel: 01242 264767. E-mail: adam.scorey@archant.co.uk

Editor: Adam Scorey.

13 issues a year for professional photographers.

Illustrations: Images only used as part of features.

Text: Informative and current affairs articles of interest to working professional photographers. Submit all initial ideas to the editor.

Overall freelance potential: Always happy to hear from freelances regarding feature ideas, but must be relevant to the audience.

Editor's tips: Read previous issues to examples of features.

Fees: By negotiation.

WHAT DIGITAL CAMERA

Time Inc (UK) Ltd, Blue Fin Building, 110 Southwark Street, London SE1 0SU. Tel: 020 3148 4790. E-mail: wdc@timeinc.com

Editor: Nigel Atherton.

Monthly consumer magazine for digital photography enthusiasts.

Illustrations: Will consider original, creative, digital images and portfolios, either digitally originated or manipulations from conventional film.

Text: Illustrated features about digital cameras, lenses and accessories, including informed reviews and interesting applications. Contact editor with suggestions first.

Overall freelance potential: Fair.

Fees: Pictures by negotiation and according to use. Text £100 per 1,000 words.

Politics & Current Affairs

AD LIB

Liberal Democrats, 8-10 Great George Street, London, SW1 3AE Tel: 020 7227 1355. E-mail: adlib@libdems.org.uk Editor: Abigail Gliddon. Monthly magazine of the Liberal Democrats. Illustrations: Prints or digital files accepted. Pictures of Liberal Democrat activities around the country and general political news pictures. Text: Features on politics and current affairs, from a Lib Dem perspective. Overall freelance potential: Limited. Fees: By negotiation. THE BIG ISSUE 43 Bath Street, Glasgow G2 1HW.

Tel: 0141 352 7260. E-mail: editorial@bigissue.com

Editor: Paul McNamee. Deputy Editor: Vicky Carroll.

Current affairs weekly sold in support of the homeless.

Illustrations: Requires a broad range of mainly news-based images covering politics, social issues and the arts.

Text: Suitable reportage-type features always considered. usually around 1,200 words with 2-3 illustrations.

Overall freelance potential: Very good for the right sort of material. **Fees:** By negotiation.

JANE'S DEFENCE WEEKLY

IHS Jane's, Sentinel House, 163 Brighton Road, Coulsdon, Surrey CR5 2YH.

Tel: 020 8700 3700. E-mail: jdw@janes.com

Editor: Peter Felstead.

News magazine concentrating on developments in all military fields.

Illustrations: News pictures of defence subjects worldwide- exercises, deployments, equipment, etc. Contact the editor initially.

Text: News items and informed articles on the military, industrial and political aspects of global defence.

Overall freelance potential: Limited for those without contacts in the forces or defence industry, but work submitted here may also be published in the various annuals produced by the IHS Jane's Group.

Fees: Photographs £40 inside; covers negotiable; text from £200 per 1,000 words.

THE JEWISH CHRONICLE

Jewish Chronicle Newspapers Ltd, 28, St Albans Lane, London, NW11 7QE Tel: 020 7415 1500. E-mail: editorial@thejc.com

Editor: Stephen Pollard.

Weekly newspaper publishing news and features concerning, and of interest to, the British Jewish community.

Illustrations: Any topical pictures related to the purpose stated above. Also material for the paper's wide range of supplements that deal with subjects such as holidays, fashion, interior decoration, regional development, etc.

Text: Features on topics detailed above. 600-2,500 words.

Overall freelance potential: At least 30 per cent of the content comes from freelance sources. **Fees:** By negotiation.

THE MIDDLE EAST

TME Media 21 Ltd, 46 Cleveland Road, London E18 2AL.

Tel: 020 8989 9551. E-mail: tmemedia21@gmail.com

Editor-in-Chief: Pat Lancaster. Deputy Editor: Rhona Wells.

Monthly publication directed at senior management, governmental personnel and universities.

Covers Middle Eastern current affairs of a political, cultural and economic nature.

Illustrations: Pictures of all topical Middle Eastern subjects, personalities and scenes.

Text: Features on Middle Eastern subjects or world subjects that relate to the area. 1,000–3,000 words.

Overall freelance potential: Most of the pictures come from freelances and around 75 per cent of the overall editorial.

Fees: Pictures £15-£35; covers by agreement. Text, from £100 per 1,000 words.

NEW INTERNATIONALIST

55 Rectory Road, Oxford OX4 1BW.

Tel: 01865 811400. E-mail: ni_ed@newint.org

Co-Editors: (UK) Vanessa Baird, Dinyar Godrej, Hazel Healy.

Monthly magazine covering global issues from a mainly Southern (Africa, Asia, Latin American) perspective.

Illustrations: Pictures to illustrate news stories and topical features on subjects such as social justice, human rights, environmental issues, poverty, sustainable development, etc.

Text: Illustrated stories and features on relevant topics as above.

Overall freelance potential: Good.

Editor's tips: Each editor edits individually themed issues and is responsible for his/her own picture research.

Fees: Pictures, from a minimum of £40 to £250 for front cover.

PCS PEOPLE

The Public & Commercial Services Union, 160 Falcon Road, Clapham, London SW11 2LN. Tel: 020 7924 2727. E-mail: editor@pcs.org.uk

Editor: Jonathan Lovett.

Monthly publication for members of the PCS Union, the biggest civil service union. Also has large private sector membership.

Illustrations: News pictures of trade union activity, especially involving members of PCS. Other topical pictures of current affairs that may impinge on Union members may also be of interest. **Text:** No scope.

Overall freelance potential: Good, 75 per cent of pictures come from outside contributors. **Fees:** Good; on a rising scale according to size of reproduction.

RESURGENCE & ECOLOGIST

Ford House, Hartland, Bideford, Devon EX39 6EE.
Tel: 01237 441293. E-mail: editorial@resurgence.org
Editor: Satish Kumar. Assistant Editor/Picture Researcher: Emma Cocker.
Bi-monthly magazine covering all ecological and environmental topics.
Illustrations: News pictures and creative images to illustrate features on current green issues, activism, social justice, environmental art and ethical living.
Text: News items and timeless articles on relevant topical issues and longstanding concerns.
Contributors must have good, in-depth knowledge of their subject.
Overall freelance potential: Fair.
Fees: According to use.

Railways

HERITAGE RAILWAY

Mortons Media Group Ltd, Media Centre, Morton Way, Horncastle, Lincs LN9 6JR. Tel: 01507 529305. E-mail: rjones@mortons.co.uk Editor: Robin Jones.

Monthly magazine devoted to railway preservation-steam, diesel and electric.

Illustrations: Captioned news pictures depicting restoration projects, restored locomotives on their first runs, special events etc, especially from less well-known lines and museums. Mainly UK-based but will also consider overseas coverage of locomotives with a British connection, especially really "stunning and attractive" pictures.

Text: Well-illustrated features on preservation and restoration topics; write with suggestions first. **Overall freelance potential:** Very good.

Fees: By negotiation.

INTERNATIONAL RAILWAY JOURNAL

Simmons-Boardman Publishing Corporation, 46 Killigrew Street, Falmouth, Cornwall TR11 3PP. Tel: 01326 313945. E-mail: irj@railjournal.co.uk

Editor: David Briginshaw. Associate Editor: Keith Barrow.

Monthly publication for the principal officers of the railways of the world (including metro and light rail systems), ministers and commissioners of transport, railway equipment manufacturers and suppliers.

Illustrations: Pictures of new line construction projects, electrification projects, track or signalling improvements, new locomotives, passenger coaches and freight wagons. Interesting pictures of railway operations from far-flung corners of the world. No steam or nostalgia material. Covers: colour shots tied in with the theme of a particular issue.

Text: Features on any sizeable contracts for railway equipment; plans for railway developments, eg new line construction, track or signalling improvements; almost anything which involves a railway spending money or making improvements and techniques. No padding or speculation.

Overall freelance potential: Quite good for the right business-oriented material.

Fees: Rising scale according to size of pictures; text, £120 per 1,000 words.

RAIL

Bauer Media Ltd, Media House, Lynchwood, Peterborough PE2 6EA.

Tel: 01733 468000. E-mail: rail@bauermedia.co.uk

Managing Editor: Nigel Harris.

Fortnightly magazine dealing with modern railways.

Illustrations: Single photographs and up-to-date news pictures on any interesting railway topic in Britain, particularly accidents and incidents of all kinds. Covers: Interesting shots with strong impact.

Text: Illustrated articles of up to 1,500 words on any railway topic. Check recent issues for style. **Overall freelance potential:** Excellent.

Editor's tips: Topicality is everything for news coverage. For other pictures try to get away from straightforward shots of trains; be imaginative. Always looking for something different. **Fees:** Pictures range from £20–£100; illustrated articles around £90–£150. Will pay more for high-

impact special pics that give the magazine a commercial advantage.

RAIL EXPRESS

Mortons Media Group Ltd, Media Centre, Morton Way, Horncastle, Lincs LN9 6JR. Tel: 01507 529540. E-mail: railexpresseditor@mortons.co.uk

Editor: Paul Bickerdyke.

Monthly magazine for modern railway enthusiasts.

Illustrations: Any good or unusual photographs of the contemporary railway scene, but really need to be of current and newsworthy interest (new locomotives, new colour schemes, etc). Some scope for historic diesel/electric coverage.

Text: Suggestions for articles welcome, from anyone with good background knowledge of the subject, especially traction. Consult with the editor first.

Overall freelance potential: The magazine features lots of photography and always needs more. **Editor's tips:** Topicality is the key, and images should always be taken in sunshine. **Fees:** Range from £15 - £50 per picture.

RAILNEWS

Railnews Ltd, Business & Technology Centre, Bessemer Drive, Stevenage, Herts SG1 2DX. Tel: 01438 310011. E-mail: sim@railnews.co.uk

Managing Editor: Sim Harris.

Monthly newspaper for people in the rail industry, covering the modern railway scene in the UK. **Illustrations:** Digital files preferred, B&W and colour prints accepted. Railway news pictures, unusual pictures of events, operations, activities, with good captions.

Text: No scope.

Overall freelance potential: Good.

Editor's tips: Approach before submitting.

Fees: By negotiation.

THE RAILWAY MAGAZINE

Mortons Media Group Ltd, Media Centre, Morton Way, Horncastle, Lincs LN9 6JR. Tel: 01507 529589. E-mail: railway@mortons.co.uk

Editor: Nick Pigott.

Monthly for all rail enthusiasts and profrssionals, covering both main line and heritage railways, modern and historic.

Illustrations: News pictures concerning the current rail network, as well as images from recent heritage events, galas or rail tours. Also pictures of new liveries, new trains on test,

accidents/derailments, and rare or unusual workings. Previously unpublished material from the 1940s onwards always of interest for historical features. Top quality non-news pictures may be used for spreads and/or occasional calendars. For digital, e-mail thumbnails (10 images max) in first instance; CDs (50 images max) must have thumbnail sheet. For film submissions, captions should be supplied on individual slide mounts or prints, not on separate caption sheet.

Text: Well-researched illustrated articles on any British railway topic, current or historic; discuss ideas with the editor first.

Overall freelance potential: Excellent.

Editor's tips: News pictures must be recent- no more than six weeks old.

Fees: From £10 minimum for news pictures, to £50+ for larger reproductions.

STEAM RAILWAY

Bauer Active Ltd, Media House, Lynchwood, Peterborough PE2 6EA. Tel: 01733 468000. E-mail: steam.railway@bauermedia.co.uk

Editor: TBA.

Four-weekly magazine for the steam railway enthusiast. Closely concerned with railway preservation.

Illustrations: Mostly colour; archive B&W. Accurately captioned photographs depicting steam trains and railways past and present, preserved railway lines, and railway museums (topical subjects especially welcomed).

Text: Illustrated articles on relevant subjects.

Overall freelance potential: Most of the photographic content is contributed by freelances. **Editor's tips:** Material should be lively, topical and newsworthy, although some nostalgic or historic material is accepted. Always query the editorial team before submitting. **Fees:** By arrangement.

TODAY'S RAILWAYS UK

Platform 5 Publishing, 3 Wyvern House, Sark Road, Sheffield S2 4HG.

Tel: 0114 255 2625. E-mail: editorial@platform5.com

Editor: Paul Abell.

Monthly covering the contemporary British railway scene, aimed at both rail professionals and enthusiasts.

Illustrations: News pictures relating to current or planned UK rail operations, accompanied by detailed captions or stories. Stock material may be of interest– send detailed lists in the first instance.

Text: Feature suggestions always considered, but only from writers who have in-depth knowledge of their subject.

Overall freelance potential: Limited, as much is obtained from industry sources.

Editor's tips: Always contact editor before submitting as many stories may already be covered. Fees: Pictures from £12.50; text £50 per page.

TRACTION

Atlantic Publishers. Editorial: 120 Churchill Road, Middlesbrough TS6 9NS.

Tel: 07794 773697. E-mail: steverabone@hotmail.com

Editor: Stephen Rabone.

Monthly magazine dedicated to classic diesel and electric locomotives.

Illustrations: Mostly colour; B&W archive material. Photographs of classic diesels and electrics operating on British railways from the 1940s to the present day. Particular interest in archive shots from the earlier eras up to the early 1980s.

Text: Limited scope at present.

Overall freelance potential: Good.

Fees: From £5-£15 according to size of reproduction.

Religion

THE CATHOLIC HERALD

Herald House, 15 Lamb's Passage, Bunhill Row, London EC1Y 8TQ.

Tel: 020 7448 3602. E-mail: editorial@catholicherald.co.uk

Editor: Luke Coppen.

Weekly newspaper reflecting on Catholicism/Christianity and its place in the wider world, plus church news.

Illustrations: Principal need for news photographs of events involving churches, clerics or prominent Catholics.

Text: Articles of up to 1,200 words on the social, economic and political significance of the church domestically and internationally, plus spiritual and reflective writings. **Overall freelance potential:** Better for features than other material. **Fees:** By arrangement but not high.

THE CATHOLIC TIMES

Universe Media Group, Alberton House, St Mary's Parsonage, Manchester M3 2WJ. Tel: 0161 214 1200. E-mail: kevin.flaherty@totalcatholic.com

Editor: Kevin Flaherty.

Weekly newspaper covering Catholic affairs.

Illustrations: Topical news pictures of Catholic interest. Also off-beat devotional shots.

Text: News stories and short features. 900 words maximum.

Overall freelance potential: Very good.

Fees: Text around £40 per 1,000 words; pictures by negotiation.

CHURCH OF ENGLAND NEWSPAPER

Religious Intelligence Ltd, 14 Great College Street, London SW1P 3RX.
Tel: 020 7222 8700. E-mail: colin.blakely@churchnewspaper.com
Editor: Colin Blakely.
Weekly newspaper covering Anglican news and views.
Illustrations: Colour print and digital accepted. Will consider any news pictures that relate to the Church of England.
Text: News stories, plus features that relate Christian faith to politics, the arts and everyday life.
Up to 1,000 words, but submit ideas only in the first instance.
Overall freelance potential: Good for those with Church connections.

Fees: $\pounds 20 - \pounds 40$ per published picture; text about $\pounds 40$ per 1,000 words.

CHURCH TIMES

Hymns Ancient & Modern Ltd, 3rd Floor, Invicta House, 108-114 Golden Lane, London EC1Y 0TG. Tel: 020 7776 1064. E-mail: news@churchtimes.co.uk

Editor: Paul Handley.

Weekly newspaper covering Church of England affairs.

Illustrations: Up-to-the-minute news pictures of Anglican events and personalities. Detailed captions essential.

Text: Short articles on current religious topics; up to 1,000 words.

Overall freelance potential: Fair.

Fees: Photographs according to use, average £70; text £100 per 1,000 words.

Science & Technology

EDUCATION IN CHEMISTRY

The Royal Society of Chemistry, Thomas Graham House, Science Park, Cambridge, CB4 0WF. Tel: 01223 420066. E-mail: eic@rsc.org

Editor: Karen J Ogilvie.

Bi-monthly publication for teachers, lecturers in schools and universities, concerning all aspects of chemical education.

Illustrations: Pictures that deal with chemistry in the classroom, laboratories or the chemical industry.

Text: Features concerned with chemistry or the teaching of it. Under 2,500 words.

Overall freelance potential: Limited.

Fees: By agreement.

FOCUS

Immediate Media Company Bristol, 14th Floor, Tower House, Fairfax Street, Bristol BS1 3BN. Tel: 0117 927 9009. E-mail: james.cutmore@immediate.co.uk

Editor: Graham Southorn. Picture Editor: James Cutmore.

Popular science monthly, aimed at both adults and teenagers.

Illustrations: Will consider photo essays on popular science, technology, space exploration, medicine, nature and the environment. Should have a news angle or be linked to a significant current/forthcoming event or anniversary.

Text: Interesting features on subjects above always considered. Submit a synopsis first. **Overall freelance potential:** Fair.

Editor's tips: Only top quality material is considered; study the magazine before submitting. **Fees:** Negotiable; generally good.

HOW IT WORKS

Imagine Publishing Ltd, Richmond House, 33 Richmond Hill, Bournemouth BH2 6EZ. Tel: 01202 586200. E-mail: dave.harfield@imagine-publishing.co.uk

Editor-in-Chief: Dave Harfield.

Heavily-illustrated popular science and technology monthly for the general reader.

Illustrations: Images of any subject that broadly falls within the magazine's remit, including science, technology, transportation, space, history and the environment, but usually tied-in with specific articles or features.

Text: Illustrated articles on any up-to-date science and technology topic, with the emphasis on explaining"how it works" to the lay reader.

Overall freelance potential: Very good for the right kind of material.

Editor's Tips: Ensure all facts are fully checked and correct before submitting. **Fees:** By negotiation, dependent on what is being offered.

NEW SCIENTIST

Reed Business Information, Lacon House, 84 Theobalds Road, London WC1X 8RR. Tel: 020 7611 1200. E-mail: adam.goff@rbi.co.uk

Editor: Sumit Paul-Choudhury. Picture Editor: Adam Goff.

Weekly magazine about science and technology for people with some scientific or technical education and also for the intelligent layman.

Illustrations: Pictures on any topic that can be loosely allied to science and technology. Particularly interested in news photographs related to scientific phenomena and events. Covers: usually connected with a feature inside.

Text: News and features on scientific/technical subjects that might appeal to a wide audience. **Overall freelance potential:** A lot of freelance work used, but consult the magazine before submitting.

Fees: Photographs on a rising scale according to size of reproduction. Text £150 per 1,000 words.

T3

Future Publishing Ltd, 2 Balcombe Street, London NW1 6NW.

Tel: 020 7042 4000. E-mail: stuart.james@futurenet.com

Editor: Matt Hill. Senior Art Editor: Matthew Kendall.

Monthly technology and gadget magazine aimed primarily at young men.

Illustrations: Always interested in pictures of new technology and new designs for consumer

durables, especially exclusive shots of latest developments, pre-production models, new releases etc. Also general stock of any technology-related subject.

Text: Mainly staff produced but exclusive news items on new products always of interest.

Overall freelance potential: Fair

Fees: By negotiation. Will pay top rates for exclusives.

Sport

ALL OUT CRICKET

Unit 3.40, Canterbury Court, Kennington Park Business Centre, 1-3 Brixton Road, London SW9 6DE.

Tel: 020 3176 0187. E-mail: phil@alloutcricket.co.uk

Editor: Phil Walker.

Official magazine of the Professional Cricketer's Association. Published 10 times a year.

Illustrations: Assignments available to shoot individual cricketers or teams for profiles— submit details of experience and areas covered by e-mail in the first instance. No scope for stock images, which are supplied via agency contract.

Text: Suggestions for profiles and features always considered.

Overall freelance potential: Fair.

Fees: By negotiation.

ATHLETICS WEEKLY

Athletics Weekly Ltd, PO Box 614, Farnham, Surrey GU9 1GR.

Tel: 01733 808550. E-mail: jason.henderson@athleticsweekly.com

Editor: Jason Henderson.

Weekly news magazine for the competitive and aspiring athlete. Focuses on events and results. **Illustrations:** Coverage of athletics events at grass roots level, such as area championships, rather than top events (the latter are supplied by agency photographers). Always interested in anything out of the ordinary, such as well-known athletes off the track or in unusual situations. **Text:** No scope.

Overall freelance potential: Fair.

Editor's tips: Freelances aware of what is happening locally can often obtain coverage missed by the nationals and agencies— top athletes" dropping in" to take part in local events etc.

Fees: According to size of reproduction, from £15–£30. Published pictures frequently gain extra sales via reader requests.

BOXING MONTHLY

Topwave Ltd, 40 Morpeth Road, London E9 7LD.

Tel: 020 8986 4141. E-mail: mail@boxing-monthly.co.uk

Editor: Glyn Leach.

Heavily illustrated publication for boxing enthusiasts, covering both professional and amateur boxing.

Illustrations: Coverage of boxing at all levels, including the amateur scene.

Text: Knowledgeable articles, features, interviews, etc. on any aspect of the boxing scene. Always contact the editor in the first instance.

Overall freelance potential: Excellent scope for boxing specialists, and for good amateur boxing coverage.

Fees: By negotiation.

THE CRICKET PAPER

The Cricket Paper Ltd, Tuition House, St George's Road, London SW19 4DS. Tel: 020 8971 4332. Fax: 020 8971 4366. E-mail: newsdesk@thecricketpaper.com Editor: David Emery. Deputy Editor: Craig Chisnall.

Are you working from the latest edition of The Freelance Photographer's Market Handbook? It's published on 1 October each year. Markets are constantly changing, so it pays to have the latest edition Weekly tabloid covering cricket at both national and international levels, published every Wednesday.

Illustrations: Always interested in hearing from capable photographers able to produce regular coverage, from grass roots level up to professional cricket. Submit details of experience and area covered in the first instance, to the deputy editor.

Text: Some scope for local match reports; write with details of coverage offered.

Overall freelance potential: Good for those with access to local clubs and matches.

Fees: According to assignment and/or use.

THE CRICKETER

The Cricketer Publishing Ltd, 70 Great Portland Street, London W1W 7NH.

Tel: 020 7460 5208. E-mail: magazine@thecricketer.com

Editor: Alec Swann.

Monthly publication aimed at all cricket lovers. Concentrates on the game at first-class and especially international level, with some coverage of club cricket.

Illustrations: Exceptional photographs of the above always considered. Portrait/feature photography also used and some commissions available.

Text: Possible scope for exclusive news stories and features, but check first before submitting. **Overall freelance potential:** Fair.

Fees: On a rising scale according to size of pictures or length and significance of article. Fees for commissioned shoots by negotiation.

DARTS WORLD

25 Orlestone View, Ham Street, Ashford TN26 2LB.

Tel: 01233 733558. E-mail: mb.graphics@virgin.net

Editor: Michael Beeken.

Monthly magazine for darts players and tournament organisers.

Illustrations: Pictures on any darts theme, action shots and portraits of leading players. Similar material also required for the annual Darts Player.

Text: Features on all darts subjects.

Overall freelance potential: Most of the copy and pictures comes from freelances.

Editor's tips: The darts-playing environment is often dim and smoky, which can make it difficult to produce bright, interesting pictures. Photographers who can come up with colourful shots that catch the eye are welcomed.

Fees: Good, on a rising scale according to size of reproduction or length of feature.

DIVE

Syon Publishing, Suite 3.20, Q West, Great West Road, Brentford, Middlesex TW8 0GP. Tel: 020 8332 8400. E-mail: marion@dive.uk.com

Editor: Marion Kutter.

Digital magazine for divers and underwater enthusiasts.

Illustrations: Top-quality underwater photography, usually published within photojournalistic features. Most interested in material that tells a story and involves people, with images showing divers in action.

Text: Features as above.

Overall freelance potential: Excellent for underwater specialists.

Editor's tips: Good quality material from British waters stands a good chance of being published, as this is harder to find than that from clearer waters abroad.

Fees: £150 per published page.

F1 RACING

Haymarket Publishing Ltd, Teddington Studios, Broom Road, Teddington TW11 9BE. Tel: 020 8267 5806. E-mail: editorial@f1racing.co.uk **Managing Editor:** Stewart Williams. **Art Editor:** Frank Foster. Glossy monthly devoted to Formula One motor racing.

Illustrations: All coverage of Formula One, past and present; professionals with collections of relevant material should send lists. Commissions available to experienced portrait and reportage photographers who can deliver high quality whatever the circumstances- contact picture editor by email.

Text: Will always consider ideas for any F1 related material, which should always be discussed with the editor before submission.

Overall freelance potential: Fair.

Editor's tips: Write or e-mail first, don't phone.

Fees: Set rates, from £60 minimum to £230 full page, £320 dps, £400 cover.

FIELDSPORTS

BPG Media, 1-6 Buckminster Yard, Main Street, Buckminster, Grantham, Lincs NG33 5SA. Tel: 01476 859840. E-mail: m.barnes@bpgmedia.co.uk

Editor: Marcus Jansseu.

Heavily-illustrated quarterly for the serious game shooter who also enjoys a spot of fishing in the summer months.

Illustrations: High-quality images depicting all aspects of game shooting and fishing, for general illustration purposes. Commissioned photography generally handled by regulars.

Text: Will consider illustrated articles from contributors who really know their subject and can write in depth with real enthusiasm.

Overall freelance potential: Fair.

Editor's tips: Readers are not casual sportsmen but people who spend heavily on the sport and have a real passion for it.

Fees: By negotiation.

FOREVER SPORTS

Haymarket Network, Teddington Studios, Broom Road, Teddington TW11 9BE.

Tel: 020 8267 5211/5247. E-mail: gershon.portnoi@haymarket.com

Editor: Nikki Wicks. Deputy Editor: Gershon Portnoi.

General sports title produced by Haymarket Network on behalf of the Sports Direct store chain, aimed at men aged 18-25.

Illustrations: Limited scope as already has an established pool of specialists, but anyone with original ideas to offer is welcome to get in touch.

Text: Will always consider exclusive news, stories or features focused on leading sporting stars. **Overall freelance potential:** Limited to those experienced in producing the highest standard of work.

Fees: By negotiation.

FORTY-20

Scratching Shed Publishing Limited, 47 Street Lane, Leeds LS8 1AP.

Tel: 0113 225 9797. E-mail: philcaplan@forty-20.com

Managing Editor: Phil Caplan.

Monthly devoted to Rugby League, aiming to reflect the excitement of the modern game. Coverage extends across all club levels and all playing nations.

Illustrations: Top quality coverage of the game, but on-spec images not required. Send a few samples and CV in the first instance. Interested in hearing from talented newcomers who have a feel for capturing the sport.

Text: Ideas for articles considered and commissions may be offered.

Overall freelance potential: Fair, but much is sourced from regular contributors. **Fees:** By negotiation.

FOURFOURTWO

Haymarket Publishing, Teddington Studios, Broom Road, Teddington, Middlesex TW11 9BE. Tel: 020 8267 5339. E-mail: jeff.beasley@haymarket.com

Editor: David Hall. Picture Editor: Jeff Beasley.

Monthly magazine aimed at the adult soccer fan.

Illustrations: Some scope for portrait photographers based outside of London...

Text: Some scope for specialists.

Overall freelance potential: Quite good but best for specialists.

Fees: According to size of reproduction. Text £100-£175 per 1,000 words.

GP INTERNATIONAL

Bright Publishing Ltd, Bright House, 82 High Street, Sawston, Cambridge CB22 3HJ. Tel: 01223 499450. E-mail: hansseeberg@bright-publishing.com

Editor: Hans Seeberg.

Up-market monthly magazine and app designed to reflect the glamour and luxurious lifestyle the F1 racing scene.

Illustrations: Possible market for rare, unusual or exclusive coverage, though the magazine has good contacts with established F1 photographers and both historic and contemporary photo needs are well covered.

Text: Would consider exclusive material offering great writing, entertainment and insider knowledge.

Overall freelance potential: Limited.

Fees: By negotiation.

GOLF MONTHLY

Time Inc (UK) Ltd, Blue Fin Building, 110 Southwark Street, London SE1 0SU.

Tel: 020 3148 4530. E-mail: golfmonthly@timeinc.com

Editor: Michael Harris. Art Editor: Paul Duggan.

Monthly international consumer magazine for golfers.

Illustrations: Mainly for use as illustrations to articles. Small market for one-off pictures from golf tournaments of golf-related events.

Text: Illustrated features on instruction and other golf-related topics. Also in-depth profiles of leading world players. Around 2,000 words, but not critical.

Overall freelance potential: Most of the magazine is commissioned. Room for more material of the right type from freelances.

Editor's tips: This is an international magazine so material must have a wide appeal. No features of a parochial nature.

Fees: By agreement.

GOLF WORLD

Bauer Media, Media House, Lynchwood, Peterborough PE2 6EA. Tel: 01733 468243. E-mail: paul.ridley@bauermedia.co.uk

Editor: Chris Jones. Art Director: Paul Ridley.

Monthly publication for golfers, covering all aspects of the sport.

Illustrations: Unusual golfing pictures always of interest.

Text: Profiles of leading golfers and general or instructional features. 1,500-2,000 words.

Overall freelance potential: Around 20 per cent comes from freelance sources.

Fees: By agreement.

As a member of the Bureau of Freelance Photographers, you'll be kept up-to-date with markets through the BFP Market Newsletter, published monthly. For details of membership, turn to page 9

INTERNATIONAL BADMINTON MAGAZINE

iSPORTgroup, No.4 The Spinney, Chester Road, Poynton, Cheshire SK12 1HB.

Tel: 07973 544719. E-mail: rachel.pullan@isportgroup.com

Editor: Paul Walters. Managing Editor: Rachel Pullan.

Quarterly magazine devoted to badminton, aimed at enthusiasts and players of all standards.

Illustrations: Will consider good action coverage, sports fashion, health material.

Text: Little scope for writing on the sport itself, but may consider articles on sports fashion, health, fitness and diet. 750–1,000 words.

Overall freelance potential: Limited.

Fees: By agreement.

MARTIAL ARTS ILLUSTRATED

Martial Arts Ltd, Revenue Chambers, St Peter Street, Huddersfield, West Yorkshire HD1 1DL. Tel: 01484 435011. E-mail: bobsykes@outlook.com

Editor: Bob Sykes.

Monthly magazine covering all forms of Oriental fighting and self-defence techniques.

Illustrations: Will always consider single pictures or sets depicting well-known martial artists, club events, tournament action and aspects of technique.

Text: Well-illustrated articles on any relevant subject- profiles of leading figures and individual clubs, interviews, technique sequences and self-defence features.

Overall freelance potential: Excellent for those with access to the martial arts scene. **Editor's tips:** Always write in the first instance with suggestions.

Euror's tips. Always write in the first instance with suggestions.

Fees: Should be negotiated before submission, as many contributions are supplied free of charge.

MATCH

Bauer Media, Media House, Lynchwood, Peterborough PE2 6EA.

Tel: 01733 468000. E-mail: james.bandy@bauermedia.co.uk

Editor: James Bandy.

Weekly publication for younger readers, looking at the whole spectrum of soccer. Aimed at the 8–16 age group.

Illustrations: Action shots all agency-supplied, but will consider unusual non-action images featuring top players. Usually bought only after consultation with the editor.

Text: Profiles and interviews concerning personalities in the soccer field. Length by arrangement. **Overall freelance potential:** Limited– most is staff or agency produced.

Fees: By agreement.

THE NON-LEAGUE PAPER

Greenways Publishing, Tuition House, St George's Road, Wimbledon, London SW19 4DS. Tel: 020 8971 4333. ISDN: 020 8605 2391. E-mail: nlp@greenwayspublishing.co.uk

Editor: David Emery. News Editor: Sam Elliott.

Weekly tabloid covering the non-League soccer scene, published every Sunday.

Illustrations: Always interested in hearing from capable football photographers able to produce regular coverage of their local teams, but must have the ability/facilities to send material direct via modem on the Saturday night. Submit details of experience and area covered in the first instance. **Text:** No scope- all staff or agency produced.

Overall freelance potential: Much is produced by freelance regulars but replacements are often needed.

Fees: According to assignment and/or use.

OUTDOOR FITNESS

Kelsey Media, 14 Priestgate, Peterborough PE1 1JA.

Tel: 01733 353388. E-mail: ofed@kelsey.co.uk

Editor: Jonathan Manning.

Monthly for those interested in outdoor sporting challenges, covering such activities as triathlons,

cycle racing, sea kayaking, open-water swims, mountain climbing and similar outdoor events. **Illustrations:** Keen to hear from photographers who have good portfolios of outdoor challenge activities such as those above. Also photographs from specific events to illustrate features, including portraiture of participants. These do not have to be solely UK-based— coverage of major events from around the world also of interest. Commissions may be available to photographers who have proven skill in covering relevant activities. Initial approach should be via e-mail, with a few samples or link to a portfolio/website.

Text: Ideas for illustrated features on events and participants always considered

Overall freelance potential: Very good.

Fees: By negotiation.

THE RACING PIGEON/RACING PIGEON PICTORIAL INTERNATIONAL

The Racing Pigeon Co Ltd, Unit G5, The Seedbed Centre, Wyncolls Road, Colchester CO4 9HT. Tel: 01206 843456. E-mail: racing123@btconnect.co.uk

Editor: Lee Fribbins.

Weekly and monthly magazines for pigeon fanciers. News items and in-depth articles on methods, successful fanciers, breeding, etc.

Illustrations: News pictures and pictures to illustrate features, plus some one-off pictures of pigeons, pigeon lofts, pigeon fanciers and related subjects.

Text: Illustrated news items and features on subjects as above, from contributors with serious knowledge of the sport.

Overall freelance potential: Around 10–15 per cent of the pictures come from freelance photographers. Articles are mostly by specialist writers.

Editor's tips: Short, colourful, exotic articles with good illustrations stand a reasonable chance. Fees: £20 per published page minimum.

THE RUGBY PAPER

Greenways Publishing, Tuition House, St George's Road, Wimbledon, London SW19 4DS. Tel: 020 8971 4330. E-mail: david.emery@greenwayspublishing.co.uk

Editor: David Emery. News Editor: Matt Emery

Weekly tabloid covering Rugby Union from international level down to grass roots with comprehensive match reports.

Illustrations: Always interested in hearing from capable rugby photographers/reporters. Submit details of experience and area covered in the first instance.

Text: Possible scope for match reports.

Overall freelance potential: Much is produced by regulars but replacements often needed. **Fees:** According to assignment and/or use.

RUGBY WORLD

Time Inc (UK) Ltd, Blue Fin Building, 110 Southwark Street, London SE1 0SU.

Tel: 020 3148 4702. E-mail: kevin.eason@timeinc.com

Editor: Owain Jones. Art Editor: Kevin Eason.

Britain's biggest selling monthly rugby magazine giving general coverage of Rugby Union. **Illustrations:** Main scope is for regional/local coverage, since the top level matches are covered by regulars. Photographs of Cup matches, County championships, personalities, off-beat shots, etc. Covers: Good action shots of top players.

Text: Good articles with different angles are always of interest.

Overall freelance potential: Dependent on quality and appeal.

Fees: On a rising scale according to size of reproduction or length of text.

RUNNER'S WORLD

Hearst-Rodale UK, 6th Floor, 33 Broadwick Street, London W1F 0DQ. Tel: 020 7339 4409. E-mail: graham.taylor@natmag-rodale.co.uk **Editor:** Andy Dixon. Senior Designer: Graham Taylor. Monthly publication for running enthusiasts. **Illustrations:** Pictures relating to sports, recreational and fitness running. Consult design department before submitting. **Text:** Feature material considered, but only by prior consultation with the editor. **Overall freelance potential:** Fair. **Fees:** By agreement.

RUNNING FITNESS

Kelsey Publishing, 14 Priestgate, Peterborough PE1 1JA. Tel: 01733 347559. E-mail: rf.ed@kelsey.co.uk

Editor: Natasha Shiels.

Monthly magazine for active running enthusiasts, those who run for health or recreation. **Illustrations:** Coverage of competitions and running events at local or regional level, off-beat pictures, and general stock shots of runners. Both racing and training pictures are welcome. Some scope for general atmospheric pictures incorporating runners and athletic-looking subjects in picturesque and inspirational settings. Possible commission scope for "fashion" features. Covers:

usually by commission- interested in hearing from photographers who can bring a creative approach to the subject.

Text: Illustrated articles of a practical nature, giving advice on training, diet, etc., and on unusual or exciting running events worldwide 1,000–1,500 words. Features of an inspirational nature also welcome– well-written and illustrated pieces on elite athletes, or other sportspeople who run as part of their training. Discuss ideas with the editor first.

Overall freelance potential: Good.

Fees: From a minimum of £20 up to £80 for a full page; text £70 per 1,000 words.

SGB (SPORTING GOODS BUSINESS)

Datateam Publishing Ltd, London Road, Maidstone ME16 8LY. Tel: 01622 699159. E-mail: afordham@datateam.co.uk **Editor:** Alex Fordham.

Monthly magazine for the UK sports retail trade.

Illustrations: Topical pictures concerning the retail trade, usually to illustrate specific news stories, features and new products.

Text: Illustrated features and news stories on anything to do with the sports retail industry, including manufacturer and retailer profiles etc.

Overall freelance potential: Limited.

Fees: Text, £150 per 1,000 words; pictures by negotiation.

THE SCOTTISH SPORTING GAZETTE

BPG Media, 1-6 Buckminster Yard, Main Street, Buckminster, Grantham, Lincs NG33 5SA. Tel: 01476 859840. E-mail: m.barnes@bpgmedia.co.uk

Editor: Marcus Jansseu.

Annual publication to market Scottish shooting, fishing, stalking and associated services, hotels and restaurants. Aimed at the upper income bracket in the UK, Europe and America.

Illustrations: High quality scenic photography, plus pictures of shooting, fishing, stalking, live game animals, whisky production, antique Scottish weapons, tartans, castles and hunting lodges. Covers: exceptional colour pictures of game animals or action sporting shots.

Text: Features on shooting, fishing and stalking in Scotland or articles on other topics that are particularly Scottish, as above. 600–2,000 words.

Overall freelance potential: Good.

Editor's tips: Pictures and text must be unusual, not the normal anecdotes associated with this field. Material should have a good Scottish flavour. It does not have to be essentially sporting, but should be allied in some way.

Fees: Open to negotiation.

THE SHOOTING GAZETTE

Time Inc (UK) Ltd, Blue Fin Building, 110 Southwark Street, London SE1 OSU. Tel: 020 3148 4741. E-mail: will.hetherington@timeinc.com

Editor: Will Hetherington.

Britain's only monthly magazine covering exclusively game and rough shooting, wildlife, countryside.

Illustrations: Pictures for general illustration, including countryside scenes, hunting, shooting, fishing, farming, birds and animals– quarry and non-quarry species.

Text: Well-illustrated articles from those with specialist knowledge, and profiles or interviews. Up to 2,000 words.

Overall freelance potential: Good.

Fees: By negotiation.

SHOOTING TIMES AND COUNTRY MAGAZINE

Time Inc (UK) Ltd, Blue Fin Building, 110 Southwark Street, London SE1 0SU. Tel: 020 3148 4740. E-mail: steditorial@timeinc.com

Editor: Alastair Balmain.

Weekly magazine concentrating on all aspects of quarry shooting (game, pigeon, rough shooting, wildfowling and stalking). Also covers clay shooting, other fieldsports and general country topics. **Illustrations:** Good photographs of shooting subjects plus gundogs, wildlife, rural crafts, country food. Some scope for good generic photographs of British counties, showing known landmarks. Covers: shots should be vertical in shape with room for title at the top.

Text: Illustrated features on all aspects of quarry shooting and general country topics as above. In the region of 900 words.

Overall freelance potential: Excellent; plenty of scope for new contributors.

Editor's tips: The magazine likes to keep pictures on file as it is not always possible to know in advance when a picture can be used. For features, remember that the readers are real country people.

Fees: Pictures £10-£60 according to size; covers £70-£90. Features £40 per 500 words.

SKI + BOARD

Ski Club of Great Britain Ltd, The White House, 57-63 Church Road, Wimbledon Village, London SW19 5SB.

Tel: 020 8410 2010. E-mail: colin.nicholson@down-hill.co.uk

Editor: Colin Nicholson.

Published four times a year. Official magazine of Ski Club of Great Britain, covering the sport at all levels.

Illustrations: Pictures for general illustration and for special gallery section, including holiday skiing, ski-touring, racing and equipment, good adventure/action shots, shots illustrating snowcraft and particular techniques. Also good, attractive pictures of specific ski resorts and ski slopes in season.

Text: Will consider adventure skiing articles, especially with a good selection of images. **Overall freelance potential:** Fair, but with many regular contributors space is tight. **Fees:** By arrangement.

THE SKIER & SNOWBOARDER MAGAZINE

Mountain Marketing Ltd, PO Box 386, Sevenoaks, Kent TN13 1AQ.

Tel: 0776 867 0158. E-mail: frank.baldwin@skierandsnowboarder.co.uk

Editor: Frank Baldwin.

Published five times a year: July, Sep/Oct, Nov/Dec, Jan/Feb, Mar/Apr. Covers all aspects of skiing and snowboarding.

Illustrations: Good action pictures and anything spectacular, odd or humorous that summons up the spirit of skiing. Also a special"Photo File" section in which photographers can submit up to three

favourite shots backed by text which tells the reader about the set-ups/techniques used, linked with a short biog of the photographer.

Text: Original ideas for illustrated features always welcome. Possible scope for resort reports and news items.

Overall freelance potential: Very good. **Fees:** By negotiation.

SNOOKER SCENE

Hayley Green Court, 130 Hagley Road, Hayley Green, Halesowen B63 1DY.
Tel: 0121 585 9188. E-mail: clive.everton@talk21.com
Editor: Clive Everton.
Monthly publication for snooker players and enthusiasts.
Illustrations: Snooker action pictures and coverage related to tournaments, or material of historical interest.
Text: Features on snooker and billiards. 250–1,000 words.
Overall freelance potential: Small.
Fees: By arrangement.

SPORTING SHOOTER

Archant Specialist, 3 The Courtyard, Denmark Street, Wokingham, Berkshire RG40 2AZ. Tel: 01189 771677. E-mail: editor@sportingshooter.co.uk

Editor: Dominic Holtam.

Monthly aimed at sports shooters and gamekeepers.

Illustrations: Will consider good stock images depicting pigeon, clay and pheasant shooting, deer stalking, gun dogs, gamekeeping and relevant wildlife. Some commissions possible to photograph specific features.

Text: News items always considered. Also illustrated articles on shooting topics

Overall freelance potential: Good.

Editor's tips: The magazine has a very specific style so always call to discuss ideas first. **Fees:** By negotiation

SWIMMING TIMES

Pavilion 3, SportPark, 3 Oakwood Drive, Loughborough University, Leics LE11 3QF. Tel: 01509 640230. E-mail: swimmingtimes@swimming.org

Editor: Peter Hassall.

Official monthly magazine of the Amateur Swimming Association, British Swimming, and the Institute of Swimming. Covers all aspects of swimming including diving, synchro-swimming, water polo, etc.

Illustrations: News pictures of swimmers at major events and any off-beat or particularly interesting shots of swimming-related activity.

Text: Human interest stories about individual swimmers.

Overall freelance potential: Limited.

Fees: Negotiable.

TODAY'S GOLFER

Bauer Media, Media House, Lynchwood, Peterborough PE2 6EA.

Tel: 01733 468000. E-mail: mal.bailey@bauermedia.co.uk

Editor: Chris Jones. Art Editor: Mal Bailey.

Monthly for golfing enthusiasts.

Illustrations: Stock shots of leading players and courses, and anything off-beat, considered on spec. **Text:** Instructional material; player profiles; equipment features; course tests.

Overall freelance potential: Limited.

Fees: By negotiation.

Trade

AM (AUTOMOTIVE MANAGEMENT)

Bauer Automotive Ltd, Media House, Lynchwood, Peterborough PE2 6EA.

Tel: 01733 468261. E-mail: jeremy.bennett@bauermedia.co.uk

Editor: Jeremy Bennett.

Fortnightly publication for the motor industry, mainly franchised dealers.

Illustrations: News photographs covering the motor trade generally. Some scope for commissions to photograph industry figures and premises.

Text: News items and news features of interest to industry executives.

Overall freelance potential: Good for those with contacts in the trade and local freelances. **Fees:** By negotiation.

THE BOOKSELLER

The Bookseller Media Ltd, Endeavour House, 189 Shaftesbury Avenue, London WC2H 8TJ. Tel: 020 3358 0360. E-mail: philip.jones@bookseller.co.uk

Editor: Philip Jones. News Editor: Benedicte Page.

Weekly trade magazine for booksellers, publishers, librarians and anyone involved in the book industry. Covers trade trends and events, authors, etc.

Illustrations: Pictures of bookshops and book-related activities outside London. Busy book fairs, busy book shops, etc. Portraits of authors and book trade figures.

 ${\bf Text:}$ Serious, humorous, analytical, descriptive articles connected with the book trade, plus author interviews.

Overall freelance potential: Only for those freelances who have good access to the book trade. **Fees:** Variable; depends on material.

BRITISH BAKER

William Reed Business Media Ltd, Broadfield Park, Crawley, West Sussex RH11 9RT.

Tel: 01293 846595. E-mail: bb@wrbm.com

Editor: Martyn Leek.

Fortnightly business-to-business news magazine covering the entire baking industry.

Illustrations: Interesting photographs relating to working bakeries, especially news items such as shop openings, promotions, charity events, etc. Also good stock shots of bakery products.

Text: Short news stories (300 words) or features (500–1,000 words) on any baking industry topic. **Overall freelance potential:** Fair, for those who can supply relevant material.

Example 1000 mends for texts photomers have a supply relevant m

Fees: $\pounds 125$ per 1,000 words for text; photographs by negotiation.

C+D (CHEMIST & DRUGGIST)

UBM Medica, Ludgate House, 245, Blackfriars Road, London, SE1 9UY.

Tel: 020 7921 8240. E-mail: richard.coombs@ubm.com

Editor: Jennifer Richardson. Head of Design: Richard Coombs.

News publication, website, events and services for community pharmacists and pharmacy-related industries.

Illustrations: Images to illustrate new items and features as below.

Text: News stories, in-depth features and interviews relating to community pharmacy.

Overall freelance potential: Occasional.

Fees: According to contribution.

Are you working from the latest edition of The Freelance Photographer's Market Handbook? It's published on 1 October each year. Markets are constantly changing, so it pays to have the latest edition

CATERER & HOTELKEEPER

TWGCA LLP, 52 Grosvenor Gardens, London SW1W 0AU.

Tel: 020 7881 4803. E-mail: amanda.afiya@catererandhotelkeeper.co.uk

Editor: Amanda Afiya.

Weekly magazine for the hotel and catering trade.

Illustrations: News pictures relevant to hotel and catering establishments- openings, extensions, refurbishments, people, etc. Special interest in regional material. Commissions possible to cover establishments, equipment and food.

Text: Specialist articles of interest to the trade, by commission only.

Overall freelance potential: Mainly limited to those with connections within the trade. **Fees:** On a rising scale according to size of reproduction or length of text.

CONVENIENCE STORE

William Reed Business Media Ltd, Broadfield Park, Crawley, West Sussex RH11 9RT. Tel: 01293 610218. E-mail: david.rees@wrbm.com

Editor: David Rees. Features Editor: Sarah Britton.

Fortnightly magazine for independent neighbourhood retailers and convenience stores, and their wholesale suppliers.

Illustrations: Photographs usually to illustrate specific features; little scope for pictures on their own.

Text: Illustrated features or stories concerning late-night, local, food-based stores. Should ideally feature a retailer who is doing something a bit different, or who has been highly successful in some way.

Overall freelance potential: Modest.

Fees: By negotiation.

CRAFT BUTCHER

National Federation of Meat & Food Traders, 1 Belgrove, Tunbridge Wells, Kent TN1 1YW. Tel: 01892 541412. E-mail: roger@nfmft.co.uk

Editor: Roger Kelsey. Deputy Editor: Jayne Cottrell.

Magazine of the National Federation of Meat & Food Traders. Published 10 times a year.

Illustrations: Topical pictures related to news and issues in the meat and related food industry.

Text: Topical features on the food industry, primarily the meat trade.

Overall freelance potential: Fair for those in close contact with the trade.

Editor's tips: Only exclusive material will be considered.

Fees: By negotiation.

DRAPERS

EMAP Publishing Limited, Telephone House, 69-77 Paul Street, London EC2A 4NQ. Tel: 020 3033 2600. E-mail: alison.fisher@emap.com

Editor-in-Chief: Caroline Nodder. News Editor: Catherine Neilan. Art Director: Alison Fisher.

Weekly news publication for clothing and textile retailers.

Illustrations: News pictures of interest to the clothing and fashion trade. Some scope for portraits and fashion shoots by commission.

Text: Features, fashion and news items of relevance to retailers in the fashion and textile fields.

Overall freelance potential: Limited for news; fair for commissioned work.

Editor's tips: Do not send unsolicited material- call the art department first.

Fees: Good; on a rising scale according to size of illustration or length of feature.

EUROFRUIT MAGAZINE

Market Intelligence Ltd, 132, Wandsworth Road. Vauxhall, London, SW8 2LB Tel: 020 7501 3700. E-mail: michael@fruitnet.com **Editor:** Mike Knowles.

Monthly magazine of the European fresh fruit and vegetable trade. Aimed at producers, exporters,

importers, merchants and buyers.

Illustrations: Subjects such as harvesting fruit, loading on to ships or lorries, quality checks on fruit, packing etc. Photographs accepted mostly for the magazine's own picture library.

Text: Topical features on fruit and vegetables, e.g. Chilean apples in Europe, French Iceberg lettuce, Egypt's expanding export range, Norway as an alternative market, etc. 1,250–2,000 words.

Overall freelance potential: Quite good. Some regular contributors, but scope for the freelance writer who can also supply pictures.

Editor's tips: It is best to work in close contact with the editorial department to get names of people who would be of interest to the publication.

Fees: Negotiable.

FISHING NEWS/FISHING NEWS INTERNATIONAL

IntraFish Media, Nexus Place, 25 Farringdon Street, London EC4A 4AB.

Tel: 020 7029 5700. E-mail: cormac.burke@intrafish.com

Editor: Cormac Burke.

Fishing News is a weekly newspaper for the commercial fishing industry in Britain and Ireland. Fishing News International is the leading monthly newspaper for the global commercial fishing industry.

Illustrations: Captioned news pictures covering any subject relating to the UK/Irish and international commercial fishing industries.

Text: Illustrated news stories always considered.

Overall freelance potential: Very good; a lot of photographs are used.

Fees: Standard £25 per picture.

THE FLORIST

Wordhouse Publishing Group Ltd, 68 First Avenue, Mortlake, London SW14 8SR. Tel: 020 8939 6470. E-mail: info@thewordhouse.co.uk

Editor: Caroline Marshall-Foster.

Quarterly publication for retail florists.

Illustrations: Interesting pictures of floristry in the retail context, special displays, promotions, etc. **Text:** Features on anything relating to floristry and retailing, shop profiles, practical aspects, advertising and promotion.

Overall freelance potential: Limited to those with good contacts in the trade. **Fees:** By agreement.

FORECOURT TRADER

William Reed Business Media Ltd, Broadfield Park, Crawley, West Sussex RH11 9RT. Tel: 01293 610219. E-mail: merril.boulton@wrbm.com

Editor: Merril Bolton.

Monthly magazine for petrol station operators.

Illustrations: News pictures relating to petrol stations and the petrol sales business generally. **Text:** News and features relating to all areas of petrol retailing.

Overall freelance potential: Fair.

Fees: Text, £120 per 1,000 words; pictures according to use.

FORESTRY JOURNAL

PO Box 7570, Dumfries DG2 8YD.

Tel/fax: 01387 702272. E-mail: subed@forestryjournal.co.uk

Editor: Mark Andrews.

Monthly magazine covering all aspects of forestry and timber production- arboriculture, estate management, harvesting, haulage, and recreational use of forests and woodland.

Illustrations: Plenty of photographs used, but usually only as accompaniment to features on topics as above/below.

Text: Always seeking freelances to produce well-illustrated local stories on forestry topics, and for

profiles of individual contractors etc. Write or e-mail the editor with suggestions and/or details of areas covered.

Overall freelance potential: Good for complete illustrated features. **Fees:** £150 per published page.

INDEPENDENT RETAIL NEWS

Metropolis Business Publishing, 6th Floor Davis House, 2 Robert Street, Croydon CR0 1QQ. Tel: 020 8253 8704. E-mail: david.shrimpton@metropolis.co.uk

Editor: David Shrimpton.

Fortnightly publication for independent, convenience, licensed and CTN retailers. Assists them in being more profitable and aware of new products and campaigns.

Illustrations: Captioned news pictures and picture stories of interest to independent grocery and convenience store traders. Stock images to illustrate people buying goods in independent/corner stores, retail crime, under-age sales, bootlegging, national lottery sales, etc.

Text: Articles and stories relevant to small retailers.

Overall freelance potential: Fair.

Editor's tips: A sample copy of the magazine is available to potential contributors. Always phone first with ideas.

Fees: Photographs according to how sourced, but up to £150 for features and £50-£100 for news stories. For commissioned features £170 per 1,000 words and negotiable for news stories.

MEAT TRADES JOURNAL

William Reed Business Media Ltd, Broadfield Park, Crawley, West Sussex RH11 9RT.

Tel: 01293 846567. E-mail: ed.bedington@wrbm.com

Editor: Ed Bedington. Art Editor: Wesley Stephens.

Fortnightly journal for the whole meat and poultry trade.

Illustrations: Pictures relating to any current meat trade issue, including legislation, food scares, court cases, etc.

Text: Stories on current issues as above. Illustrated features on current food issues, research, technology, and profiles of individual businesses.

Overall freelance potential: Good for those in a position to cover this industry.

Editor's tips: It is much preferred if material offered is exclusive.

Fees: Negotiable, according to use.

PET PRODUCT MARKETING

Bauer Active Ltd, Media House, Lynchwood, Peterborough PE2 6EA.

Tel: 01733 468000. E-mail: angela.kenny@bauermedia.co.uk

Editor: Angela Kenny.

Monthly publication for the pet trade, supplying information about new products, pet market news and business advice.

Illustrations: Will consider high-quality portfolios of common pets, companion animals and exotic pet species, including portrait or action shots.

Text: Will consider features written by those with experience in the pet trade. **Fees:** Negotiable.

WORLD FISHING

Mercator Media Limited, The Old Mill, Lower Quay, Fareham, Hampshire PO16 0RA. Tel: 01329 825335. E-mail: editor@worldfishing.net

Editor: Carly Wills.

Monthly journal for the commercial fishing industry. Covers fisheries and related industries from an international perspective.

Illustrations: Mainly to accompany specific articles, but some scope for scene-setting shots of commercial fishing activity in specific locations worldwide.

Text: Illustrated articles on any commercial fishing topic. Should always contain some international interest. Maximum 1,500 words.

Overall freelance potential: Good for those with connections in the industry. **Fees:** By negotiation.

Transport

COACH & BUS WEEK

Coach and Bus Week Ltd, 3 The Office Village, Cygnet Park, Forder Way, Hampton, Peterborough PE7 8GX.

Tel: 01733 293243. E-mail: gareth.evans@coachandbusweek.com

Editor: Gareth Evans. Editor ëMinibus': Martin Cole.

Weekly news magazine covering coach and bus operations. Aimed at licensed coach, bus and tour operators. Includes monthly ëMinibus' supplement for minbus operators.

Illustrations: Pictures as illustrations to features mentioned below; coach and bus related news items. Places of interest to coach parties.

Text: Features on coach and bus operators, transport authorities, suppliers and manufacturers; anything that would be of interest to a coach party or an operator. Articles on subjects that an operator might find useful in their day-to-day business.

Overall freelance potential: Always interested in seeing work from freelances. **Fees:** By negotiation.

COMMERCIAL MOTOR

Road Transport Media Ltd, 2nd Floor, 9 Sutton Court Road, Sutton SM1 4SZ.

Tel: 020 8912 2157. E-mail: will.shiers@roadtransport.com

Editor: Will Shiers. Group Content Editor: Laura Hailstone.

Weekly publication devoted to the road haulage industry. Aimed at vehicle enthusiasts as well as industry readers.

Illustrations: Mostly commissioned; arrange to show portfolio to the art editor first. Possible interest in professional stock photographs of commercial vehicles and aspects of road haulage- send lists of subjects available.

Text: Technical articles on road haulage topics, from expert contributors only.

Overall freelance potential: Only for experienced contributors.

Fees: Day rate around £250-£300 plus expenses. Other material by negotiation.

OLD GLORY

Mortons Media Group Ltd, PO Box 43, Horncastle, Lincs LN9 6JR.

Tel: 01507 529306. E-mail: ctyson@mortons.co.uk

Editor: Colin Tyson.

Monthly devoted to industrial/commercial transport and machinery heritage and vintage restoration including traction engines, tractors, etc.

Illustrations: Pictures of all forms of traction engines, tractors, buses, commercial vehicles, fairground machinery and maritime subjects such as old steamboats. News pictures of individual machines, restoration projects, etc. Detailed captions necessary including where and when picture taken. Covers: colourful pictures of traction engines in attractive settings.

Text: Illustrated articles on subjects as above.

Overall freelance potential: A lot of scope for good colour material.

Fees: Pictures £20-£75 dependent on size used.

TOWPATH TALK

Mortons Media Group Ltd, Media Centre, Morton Way, Horncastle, Lincs LN9 6JR. Tel: 01507 529466. E-mail: jrichardson@mortons.co.uk

Editor: Janet Richardson.

Specialist monthly newspaper covering all aspects of Britain's waterways.

Illustrations: News pictures and picture stories relevant to all forms of waterways and towpath use, including boating, cycling, horse riding, angling or walking.

Text: Will consider news stories and features on anything concerning the UK's waterways, such as the environment, canal restoration and heritage. Also specialist articles on technical matters such as engine maintenance and boat care.

Overall freelance potential: Good.

Fees: According to use.

TRACTOR

Mortons Media Group Ltd, Media Centre, Morton Way, Horncastle, Lincs LN9 6JR. Tel: 01507 529304. E-mail: thoyland@mortons.co.uk

Editor: Tony Hoyland.

Monthly magazine celebrating the farm tractor and its development.

Illustrations: Mainly colour; archive B&W. Images of interesting classic or vintage tractors, restoration projects, tractor rallies and events. Detailed captions about individual machines and their history always essential. Also archive pictures depicting farm life and machinery from WW1 to the 1960s.

Text: Well-illustrated articles on relevant subjects always considered.

Overall freelance potential: Very good.

Fees: By negotiation.

TRACTOR & MACHINERY

Kelsey Publishing Group, Cudham Tithe Barn, Berry's Hill, Cudham, Kent TN16 3AG. Tel: 01959 541444. E-mail: martin.oldaker@kelsey.co.uk

Editor: Martin Oldaker.

Monthly magazine for tractor enthusiasts, covering classic, vintage and contemporary machines from all parts of the world.

Illustrations: Pictures of tractors in the news, classic and vintage gatherings, unusual and interesting tractors, and related machinery. Captions must include details of type, model and year of tractor and name of driver. Contact editor before preparing a submission.

Text: Those who can add words to their images are welcomed.

Overall freelance potential: Good.

Fees: By arrangement.

TRUCK & DRIVER

Road Transport Media Ltd, 2nd Floor, 9 Sutton Court Road, Sutton SM1 4SZ.

Tel: 020 8912 2141 E-mail: colin.barnett@roadtransport.com

Editor: Colin Barnett. Group Content Editor: Laura Hailstone.

Monthly magazine for truck drivers.

Illustrations: Interesting individual trucks, unusual situations involving drivers and their vehicles, news items and some studio work.

Text: Commissioned features on anything of interest to truck drivers. Looks for freelances with ideas.

Overall freelance potential: Very good.

Fees: By negotiation.

Travel

AUSTRALIA & NEW ZEALAND

Evolve Digital Publishing Ltd, Unit 3, The Old Estate Yard, North Stoke Lane, Upton Cheyney, Bristol BS30 6ND.

Tel: 0117 932 3586. E-mail: liane.voisey@edpltd.co.uk

Editor: Liane Voisey.

Monthly magazine aimed at both holidaymakers and migrants.

Illustrations: Very limited scope for photography on its own as much is sourced from the travel and migration trade. Pictures only required as part of complete feature packages as below, or possibly for covers which usually feature action shots of people on beaches.

Text: Well-illustrated travel features of around 1,200–2,000 words, including coverage of specific locations, cities, activities, food and culture. Should have wide rather than niche appeal. Submit ideas only in the first instance, along with examples of previous work.

Overall freelance potential: Good for experienced travel freelances who can provide the complete package.

Editor's tips: Looking for material that strikes a good balance between inspiration and information.

Fees: Up to £200 for cover images. Features £180 per 1,000 words inclusive of pictures.

BUSINESS TRAVELLER

Panacea Publishing, 5th Floor, Warwick House, 25 Buckingham Palace Road, London SW1W 0PP. Tel: 0207 821 2700. E-mail: editorial@businesstraveller.com

Editor-in-Chief: Tom Otley.

Monthly consumer publication aimed at the frequently travelling business executive, both internationally and domestic.

Illustrations: Pictures to illustrate destination features on a wide variety of cities around the world– request features list of upcoming destinations.

Text: Illustrated features on business travel, but only by prior consultation with the editor. **Overall freelance potential:** Around 65 per cent of the magazine is contributed by freelances. **Editor's tips:** Submit low-res digital or dupes in the first instance.

Fees: Pictures from £50 up to £180 for a full page; covers £250. Text, £200 per 1,000 words.

CONDE NAST TRAVELLER

The Condé Nast Publications Ltd, Vogue House, Hanover Square, London W1S 1JU.

Tel: 020 7499 9080. E-mail: cntraveller@condenast.co.uk

Editor: Melinda Stevens. Director of Photography: Caroline Metcalfe. Picture Editor: Karin Mueller.

Heavily-illustrated glossy monthly for the discerning, independent traveller.

Illustrations: Top quality photo-feature material covering all aspects of travel, from luxury hotels and food, restaurant interiors to adventure travel, ecological issues, and reportage, etc. Very stylish and striking B&W photography also sought. Always interested in hearing from experienced photographers who are planning specific trips.

Text: Mostly commissioned from top name writers.

Overall freelance potential: Very good for material of the highest quality.

Editor's tips: The magazine seeks to use material with an original approach. Particularly interested in hearing from photographers who can produce excellent work but who are not necessarily travel specialists.

Fees: Variable depending on what is offered, but top rates paid for suitable material.

As a member of the Bureau of Freelance Photographers, you'll be kept up-to-date with markets through the BFP Market Newsletter, published monthly. For details of membership, turn to page 9

FR FRANCE TRAVEL MAGAZINE

France Media Group, 2 Seven Dials, Bath BA1 2EN.
Tel: 01225 463752. E-mail: justin@frenchentree.com
Editor: Justin Postlethwaite.
Monthly digital magazine for tablet users, celebrating the attractions of regional France.
Illustrations: Photo features on quirky or unusual French destinations or subjects. Up to 15 images used per feature so a good selection is required to choose from.
Text: As above.
Editor's tips: Looking for material that gets under the skin of the country, not just simple scenic shots.

Overall freelance potential: Excellent.

Fees: By negotiation.

FOOD AND TRAVEL

Green Pea Publishing, Suite 51, The Business Centre, Ingate Place, Queenstown Road, London SW8 3NS.

Tel: 020 7501 0511. E-mail: edits@foodandtravel.com

Editor: Renate Ruge. Creative Director: Angela Dukes.

Up-market monthly for affluent people interested in food, wine and travel.

Illustrations: High quality food and travel photography, invariably produced on commission.

Specialist photographers are advised to contact the creative director with website details and/or CD of images. No scope for travel stock material since most is commissioned.

Text: Ideas for articles always considered, but invariably produced on commission by specialist writers.

Overall freelance potential: Good for specialists; better for travel than for food. **Fees:** By negotiation.

FRANCE

Archant House, Oriel Road, Cheltenham, Gloucestershire GL50 1BB.

Tel: 01242 216050. E-mail: editorial@francemag.com

Editor: Carolyn Boyd. Art Editor: Adam Vines.

Monthly magazine for Francophiles, covering travel, culture, food, wine and language.

Illustrations: Picture stories, and top quality individual pictures to illustrate articles, on French regions, events, cuisine, travel, arts and history. Covers: pictures of recognisable French

destinations, that capture the essence of the country and have a strong focal point. Landscape photographs also required for annual calendar– selected early in each new year.

Text: Will consider lively and colourful illustrated features on the life, culture and history of France, normally around 1,200 words. Factual accuracy essential.

Editor's tips: Has preference for photographers with an online library.

Overall freelance potential: Good for top quality material but much is supplied by regulars. **Fees:** By negotiation.

FRANCE TODAY

France Media Group, 2 Seven Dials, Bath BA1 2EN.

Tel: 01225 463752. E-mail: guy@francemedia.com

Editor-in-Chief: Guy Hibbert.

Up-market bi-monthly magazine for an international readership, showcasing the best of French travel, cuisine, culture, shopping and property.

Illustrations: Mainly required to illustrate specific features. Send details of coverage/material available in the first instance.

Text: Possible scope for high-quality illustrated articles on suitable subjects.

Overall freelance potential: Fair.

Fees: By negotiation.

FRENCHENTREE MAGAZINE

France Media Group, 2 Seven Dials, Bath BA1 2EN. Tel: 01225 463752. E-mail: editor@frenchentree.com

Editor: Justin Postlethwaite.

Monthly magazine for regular travellers to France and those with, or seeking, property there. **Illustrations:** Typical French images for general illustration purposes—historic sites, vineyards, food/restaurants, activities, and homes and interiors etc. Submit lists of subjects available in the first instance. Commissions may be available to photographers with high-end digital equipment. **Text:** Well-illustrated articles always welcomed, especially on gastronomy, buying property and regional features. Around 1,500 words plus 8-10 illustrations.

Overall freelance potential: Excellent.

Fees: Single pictures according to use; features from £150 per 1,000 words; packages negotiable.

GEOGRAPHICAL

Royal Geographical Society (with IBG), Room 320, Q West, Great West Road, London TW8 0GP. Tel: 020 8332 8434. E-mail: magazine@geographical.co.uk

Editor: Paul Presley. Art Editor: Angela Finnegan

Monthly magazine of the Royal Geographical Society. Covers a wide spread of topics including travel, culture, environment, wildlife, conservation, history and exploration.

Illustrations: Mainly looking for photo-stories on geographical topics– human, political, ecological, economic and physical. Relevant news pictures always considered.

Text: Well-illustrated articles on any geographical subject, written in an informative but accessible way. Feature proposals should be sent to proposals@geographical.co.uk in the form of a 150-200 word synopsis.

Overall freelance potential: Excellent for the right type of material.

Fees: Negotiable, but in the region of £100 per published page. Single pictures according to use.

ITALIA!

Anthem Publishing Limited, Suite 6, Piccadilly House, London Road, Bath BA1 6PL.

Tel: 01225 489984. E-mail: paul.pettengale@anthem-publishing.com

Editor: Paul Pettengale. Art Editor: Sam Grover.

Highly-pictorial monthly covering regional travel and property in Italy. Also Italian food and drink. **Illustrations:** Happy to hear from photographers, particularly those based in or regularly visiting Italy, and those with large collections of existing images. Pictures used mainly scenic/landscape and people/local colour images.

Text: Limited scope as the magazine generates most topics in-house and commissions from known writers.

Overall freelance potential: Fair.

Fees: By negotiation.

LIVING FRANCE

Archant Life, Archant House, Oriel Road, Cheltenham GL50 1BB.

Tel: 01242 216050. E-mail: editorial@livingfrance.com

Editor: Eve Middleton.

Monthly magazine for those thinking of buying property in or moving to France, or hoping to work there.

Illustrations: Images reflecting working and living in France– property, French lifestyle, working life in France, retirement in France, children's education. Submit subject lists to deputy editor in the

Are you working from the latest edition of The Freelance Photographer's Market Handbook? It's published on 1 October each year. Markets are constantly changing, so it pays to have the latest edition first instance. Covers: Images showing an aspirational and obviously French house, with space for coverlines.

Text: Suggestions for articles always considered. Main scope for destination pieces,

interviews/profiles with expats in France, practical articles on buying property, living and working in France. E-mail synopsis in the first instance.

Overall freelance potential: Fair.

Fees: Individual pictures according to use; illustrated articles £300 for 1,000-1,500 words.

NATIONAL GEOGRAPHIC TRAVELLER (UK)

Absolute Publishing Ltd, 197-199 City Road, London EC1V 1JN.

Editor: Pat Riddell. Art Editor: Chris Hudson.

Tel: 020 7553 7374. E-mail: chris.hudson@natgeotraveller.co.uk

UK edition of the US National Geographic Traveler, "the world's most widely read travel magazine". Aims to adhere to the core principles of the US edition- culture, authenticity and sustainabilitywhile also incorporating local editorial flavour.

Illustrations: Top quality travel photography from all parts of the world regularly required to illustrate features. Send details of experience and coverage to the art editor in the first instance. **Text:** Well-written illustrated articles that focus on travel rather than tourism. Seeks inspiring narratives that emphasise sustainable and "authentic" travel.

Overall freelance potential: Good.

Editor's Tips: The magazine makes a distinction between tourism and travel by "celebrating place, experience, culture, authenticity, and living like the locals".

Fees: By negotiation.

A PLACE IN THE SUN

APITS Ltd, 2nd Floor, Rear West Office, 16 Winchester Walk, London, SE1 9AQ Tel: 020 3207 2920. E-mail: simon.grover@aplaceinthesun.com

Editor: Liz Rowlinson. Art Director: Simon Grover.

Glossy quarterly for prospective buyers of overseas property. Official magazine of the C4 TV series of the same name.

Illustrations: Mostly by commission, though some stock images are used. Will consider sets of images based around people moving or living abroad, or suggestions for subjects, which could lead to a full-scale commission. Other general commissions also possible– submit details of experience and a few samples in the first instance.

Text: Illustrated feature stories as above.

Overall freelance potential: Good for the more experienced worker. **Fees:** By negotiation.

THE SUNDAY TIMES TRAVEL MAGAZINE

Times Newspapers Ltd, 1 Pennington Street, London E98 1ST.

Tel: 020 7782 5000. E-mail: firstname.surname@sundaytimes.co.uk

Editor: Ed Grenby. Picture Editor: Polly Teller.

Monthly glossy aimed at up-market travellers. Published on behalf of The Sunday Times. **Illustrations:** Will always consider high-quality travel material on spec, including especially striking single images for use in double-page spreads. Lists of stock material always of interest. Only limited scope for commissions.

Text: Will always consider suggestions for original illustrated travel features.

Overall freelance potential: Good for top-quality work.

Fees: Negotiable and according to use.

Are you working from the latest edition of The Freelance Photographer's Market Handbook? It's published on 1 October each year. Markets are constantly changing, so it pays to have the latest edition

TRAVELLER

& Publishing for WEXAS International Ltd, 45-49 Brompton Road, London SW3 1DE. Tel: 020 7581 6156. E-mail: traveller@and-publishing.co.uk

Editor: Amy Sohanpaul. Deputy Editor: Duncan Mills.

Three issues annually, containing narrative features on unusual and adventurous travel, often in the developing countries of the world. Aimed at the independent traveller who prefers to travel off the beaten track.

Illustrations: High quality documentary travel pictures, usually required as an integral part of illustrated articles as below, but there is also a four-page photo-essay (action/reportage) in each issue. No tourist brochure-type shots.

Text: Well-illustrated travel articles from contributors with in-depth knowledge of the area/subject covered. Around 1000 words, plus about 10 pictures. Unusual subject matter preferred.

Overall freelance potential: Good, but limited by the magazine's frequency.

Editor's tips: Excellent photographic work is essential.

Fees: Photographs, From £50, full-page £80, £150 for cover. Text, £200 per 1,000 words.

WANDERLUST

Wanderlust Publications Ltd, PO Box 1832, Windsor, Berks SL4 1EB.

Tel: 01753 620426. E-mail: submissions@wanderlust.co.uk

Editor: Phoebe Smith. Art Director: Graham Berridge.

Magazine for the "independent-minded" traveller, published eight times a year.

Illustrations: Majority of images required for use in conjunction with features. Send a summary stock list in the first instance with a small selection of sample work. Covers: Always looking for bold, bright and uncluttered images that shout "travel", preferably with strong colours such as blue/yellow or red/orange.

Text: Well-illustrated features on independent and special interest travel at any level and in any part of the world. Contributors must have in-depth knowledge of their subject area and be prepared to cover both good and bad aspects. Short pieces up to 750 words; longer articles from 1,800–2,500 words.

Overall freelance potential: Excellent for complete packages of words and pictures.

Editor's tips: Detailed submission guidelines can be viewed on website: www.wanderlust.co.uk. **Fees:** Photographs by negotiation and according to use; text £200 per 1,000 words.

Women's Interest

BELLA

H. Bauer Publishing Ltd, Academic House, 24-28 Oval Road, London NW1 7DT.

Tel: 020 7241 8000. E-mail: lizzie.rowe@bauerconsumer.co.uk

Editor: Julia Davis. Picture Editor: Lizzie Rowe.

Weekly magazine for women, covering human interest stories, fashion, cookery and celebrities. **Illustrations:** Pictures of celebrities and royalty, off-beat pictures and curiosities considered on spec. Fashion and food, mostly commissioned.

Text: Some scope for exclusive human interest features and celebrity interviews. Always check with the editor first.

Overall freelance potential: Limited for speculative work.

Fees: By negotiation.

BEST

Hearst Magazines UK, 72 Broadwick Street, London W1F 9EP. Tel: 020 7439 5000. E-mail: larry.meyler@hearst.co.uk Editor: Jackie Hatton. Picture Editor: Larry Meyler. Deputy Picture Editor: Lauren Selby. Picture Researcher: Harry Gilmour. Weekly magazine for women, covering affordable fashion, health matters, cookery, home improvements, celebrity features.

Illustrations: Scope for off-beat, general human interest and curiosity shots, and informal celebrity material. Commissioned coverage of fashion, food, features, etc.

Text: Articles with a practical slant, aimed at working women.

Overall freelance potential: Quite good.

Fees: Commissioned photography by negotiation; other material according to use.

CLOSER

Bauer Consumer Media, Endeavour House, 189 Shaftesbury Avenue, London WC2H 8JG. Tel: 020 7859 8463. E-mail: sal.jackson@closermag.co.uk

Editor: Lisa Burrow. Picture Editor: Sal Jackson.

Weekly women's magazine with the emphasis on celebrities and true-life stories.

Illustrations: Mainly by commission. Opportunities for experienced photographers to shoot a range of celebrity material, from paparazzi street photography to studio work. Exclusive paparazzi material also considered on spec, but much is sourced from agencies. Photographers in all parts of the UK also needed to shoot portraits to illustrate true-life stories— submit details of experience and area of the country covered.

Text: True-life stories about ordinary people always wanted- submit brief details in the first instance.

Overall freelance potential: Good for those with some experience in these areas.

Fees: Photography by negotiation or according to job. True-life stories, up to £500.

COMPANY

Hearst Magazines UK, 72 Broadwick Street, London W1F 9EP.

Tel: 020 7439 5000. E-mail: chloe.trayler-smith@hearst.co.uk

Editor: Victoria White. Picture Editor: Chloe Trayler-Smith.

Digital-only webzine aimed at up-market young women in their twenties.

Illustrations: Photographs to illustrate features on fashion, beauty, relationships, careers, travel and personalities, invariably by commission.

Text: Articles on the above topics, of varying lengths. Also, more topical and "newsy" features.

Overall freelance potential: Fair scope for experienced contributors.

Fees: By negotiation.

COSMOPOLITAN

Hearst Magazines UK, 72 Broadwick Street, London W1V 2BP.

Tel: 020 7439 5000. E-mail: joan.tinney@hearst.co.uk

Editor: Louise Court. Creative Director: Stuart Selner. Picture Editor: Joan Tinney. Monthly magazine for women in the 18–34 age group.

Illustrations: Photographs to illustrate features on fashion, style and beauty, by commission only. Some top quality stock situation pictures may be used to illustrate more general features on emotional, sexual or social issues.

Text: Articles of interest to sophisticated young women. Always query the editor first **Overall freelance potential:** Only for the experienced contributor to the women's press. **Fees:** By negotiation.

ELLE

Hearst Magazines UK, 72 Broadwick Street, London W1F 9EP.

Tel: 020 7439 5000. E-mail: flora.bathurst@hearst.co.uk

Editor: Lorraine Candy. Photo Director: Hayley Caradoc-Hodgkins. Picture Editor: Flora Bathurst.

Up-market monthly magazine with the emphasis on fashion.

Illustrations: Top quality images of fashion and style subjects, portraiture and still life, always by commission.

 ${\bf Text:}$ Some scope for top quality feature articles, usually by commission and from established contributors.

Overall freelance potential: Good for contributors experienced at the top level of magazine journalism.

Fees: By negotiation.

ESSENTIALS

Time Inc (UK) Ltd, Blue Fin Building, 110 Southwark Street, London SE1 0SU. Tel: 020 3148 5000. E-mail: sarah.gooding@timeinc.com

Editor: Sarah Gooding. Creative Director: Stuart Thomas.

Monthly mass-market magazine for women with the emphasis on practical matters.

Illustrations: Images of health, interior decoration, travel, food, etc. Some commissioned work available.

Text: Practical articles, health, features of interest to women. Synopsis essential in first instance. **Overall freelance potential:** Good for experienced contributors to quality women's magazines. **Fees:** By negotiation.

GLAMOUR

The Condé Naste Publications Ltd, 6-8 Old Bond Street, London W1S 4PH.

Tel: 020 7499 9080. E-mail: lucy.slade@condenast.co.uk

Editor: Jo Elvin. Features Editor: Corrie Jackson. Picture Director: Lucy Slade.

Mid-market general interest monthly for the 18-32 age group.

Illustrations: Mostly by commission to shoot features, portraiture, still life and interiors; make an appointment to show portfolio. Possible but limited scope for stock, including celebrity material. **Text:** Always interested in celebrity interviews, investigative articles and features on relationships,

careers, fashion, health and fitness. Send short synopsis in the first instance.

Overall freelance potential: Good for the experienced worker.

Fees: By negotiation.

GOOD HOUSEKEEPING

Hearst Magazines UK, 72 Broadwick Street, London W1V 2BP.

Tel: 020 7439 5000. E-mail: laura.beckwith@hearst.co.uk

Editorial Director: Lindsay Nicholson. Picture Editor: Laura Beckwith.

General interest magazine for up-market women. Concentrates on home and family life.

Illustrations: Interiors, gardening, food, fashion, travel and reportage. Usually by commission to illustrate specific articles.

Text: Articles of interest to up-market women-interesting homes (with photos), gardening,

personality profiles, emotional features, humorous articles, etc.

Overall freelance potential: Good scope for the highest quality material. **Fees:** By negotiation.

GRAZIA

Bauer Media, Endeavour House, 189 Shaftesbury Avenue, London WC2H 8JG.

Tel: 020 7437 9011. E-mail: marc.morgan@graziamagazine.co.uk

Editor: Jane Bruton. **Picture Director:** TBA. **Deputy Picture Director:** Marc Morgan. Britain's first women's glossy to be published on a weekly basis, offering a mixture of celebrity coverage, real life stories, reportage, fashion and beauty.

Illustrations: Pictures of leading personalities at premieres, parties and generally out and about, plus paparazzi street shots. Pictures also required for news section containing hard news with the focus on women's issues and interests alongside celebrity stories. News pictures can be submitted on spec to graziapics1@graziamagazine.co.uk. Opportunities for experienced workers in portraiture, beauty, still life and interiors; contact the picture director in the first instance with details of prior experience and coverage offered.

Text: Little freelance scope.

Overall freelance potential: Wide range of opportunities for experienced photographers. **Editor's tips:** Celebrity coverage must be strictly A list, not C or D list. A short lead time means the magazine goes to press on Friday for sale the following Tuesday. **Fees:** By negotiation.

HARPER'S BAZAAR

Hearst Magazines UK, 72 Broadwick Street, London W1F 9EP.

Tel: 020 7439 5000. E-mail : chloe.limpkin@hearst.co.uk

Editor-in-Chief: Justine Picardie. Picture Director: Chloe Limpkin. Picture Editor: Liz Pearn. Monthly glossy magazine featuring fashion, design, travel, interiors, beauty and health.

Illustrations: Top quality photography to illustrate subjects as above, only by commission.

Text: General interest features of very high quality, only by commission.

Overall freelance potential: Good for those who can produce the right material.

Fees: Good; on a rising scale according to length of feature.

HELLO!

Hello Ltd, Wellington House, 69/71 Upper Ground, London SE1 9PQ.

Tel: 020 7667 8700. E-mail: pictures@hellomagazine.com

Editors: Ruth Sullivan/Rosie Nixon. Picture Editor: Freddie Sloan.

Weekly magazine for women covering people and current events.

Illustrations: Pictures and picture stories on personalities and celebrities of all kinds. People in the news and current news events. Off-beat pictures. Dramatic picture stories of bravery, courage or rescue.

Text: Interviews and/or reports to accompany photos.

Overall freelance potential: Excellent for quality material.

Editor's tips: The magazine has short lead times which it likes to exploit to the full- can include late stories in colour up to the Friday of the week before publication.

Fees: By negotiation.

HELLO! FASHION MONTHLY

Hello Ltd, Wellington House, 69/71 Upper Ground, London SE1 9PQ.

Tel: 020 7667 8700. E-mail: dcastle@hellomagazine.com

Editor: Juliet Herd. Picture Director: Deborah Castle.

Monthly fashion magazine bridging the gap between a monthly and a weekly, covering both designer and high street fashion, aimed at 18-35 year old women.

Illustrations: Photographic coverage of the latest fashion news and celebrity style. Commissions available to experienced fashion photographers.

Text: Always interested in interviews and profiles concerning trendsetters, designers and industry insiders.

Overall freelance potential: Good for experienced workers.

Editor's tips: The magazine has a short 21-day print deadline which it likes to exploit with up-tothe-minute coverage.

Fees: By negotiation.

THE LADY

The Lady, 39-40 Bedford Street, Strand, London WC2E 9ER.

Tel: 020 7379 4717. E-mail: editors@lady.co.uk

Editor: Matt Warren. Deputy Editor: Sam Taylor. Picture Editor: Samantha Reilly.

Weekly general interest magazine for women.

Illustrations: Photographs only required to accompany particular articles. Covers: Lifestyle images of women aged 35–50 years, travel or occasional famous faces.

Text: Illustrated articles on British and foreign travel, the countryside, human interest, wildlife, pets, cookery, gardening, fashion, beauty, British history and commemorative subjects. 700–850 words.

Overall freelance potential: Excellent for complete illustrated articles. **Fees:** Pictures from £18, text £80 per 1,000 words.

LOOK

Time Inc (UK) Ltd, Blue Fin Building, 110 Southwark Street, London SE1 0SU.

Tel: 020 3148 6668. E-mail: tomasina.brittain@timeinc.com

Editor: Ali Hall. Picture Editor: Tomasina Brittain.

Young women's weekly offering a mix of affordable fashion, celebrity style and gossip, and true life stories.

Illustrations: Mostly by commission. Those seeking fashion or portrait work should make an appointment to show their portfolio. Those experienced in"real-life" work should make initial contact by e-mail. Celebrity images or other material that may be relevant to the target readership will be be considered on spec.

Text: Little scope.

Overall freelance potential: Good opportunities for experienced workers in this field. **Fees:** By negotiation.

LOVE IT!

Pep Publishing, The Twist, 25 Military Road, Colchester CO1 2AD.

Tel: 01206 713863. E-mail: amy.ward@loveitmagazine.co.uk

Editor: David Claridge. **Commissioning Editor:** Eve Wagstaff. **Picture Editor:** Amy Ward. Real life weekly aimed at younger women.

Illustrations: Freelances around the country needed to shoot reportage, portraits and some studio work. Sample portfolios or CDs should be sent by post or e-mail to the picture desk.

Text: Original and exclusive real life stories always required, contact commissioning editor with ideas.

Overall freelance potential: Excellent for the experienced worker.

Fees: Dependent on the nature of the job, but full day rate is £350, more typically £250 For shorter shoots.

MARIE CLAIRE

European Magazines Ltd, Blue Fin Building, 110 Southwark Street, London SE1 0SU. Tel: 020 3148 5000. E-mail: sian_parry@timeinc.com

Editor-in-Chief: Trish Halpin. Photography Director: Sian Parry. Picture Editor: Kelly Preedy.

Fashion and general interest monthly for sophisticated women in the 25–35 age group.

Illustrations: Top quality fashion, beauty, portraits, reportage, interiors, still life, etc, usually by commission.

Text: In-depth articles, features and profiles aimed at an intelligent readership. Up to 4,000 words. **Overall freelance potential:** Very good for experienced contributors in this field. **Fees:** By negotiation.

NOW

Time Inc (UK) Ltd, Blue Fin Building, 110 Southwark Street, London SE1 0SU.

Tel: 020 3148 6373. E-mail: nowpictures@timeinc.com

Editor: Sally Eyden. Picture Editor: Francesca D'Avanzo.

Weekly entertainment for women with the focus on celebrities and"true-life" stories.

Illustrations: Topical coverage of current film and TV stars, both formal and informal shots. Some

As a member of the Bureau of Freelance Photographers, you'll be kept up-to-date with markets through the BFP Market Newsletter, published monthly. For details of membership, turn to page 9

The Freelance Photographer's Market Handbook 2015

commissions available to illustrate fashion, true-life stories and general features. Text: Ideas for stories and interviews always considered.

Overall freelance potential: Limited.

Fees: Variable according to the material or assignment; top rates paid for good exclusives.

OK!

Northern & Shell plc, Northern & Shell Building, Number 10 Lower Thames Street, London EC3R 6EN.

Tel: 020 8612 7000. E-mail: tarkan.algin@ok.co.uk

Editor: Kirsty Tyler. Picture Editor: Tarkan Algin. Deputy Picture Editor: Sophie Mutter. Picture Researcher: Lina Darton.

Weekly, picture-led magazine devoted to celebrity features and news pictures.

Illustrations: Shots of celebrities of all kinds considered on spec, especially exclusives or

unpublished archive material. Commissions available to experienced photographers.

Text: Exclusive stories/interviews with celebrities always of interest.

Overall freelance potential: Excellent for the right type of material.

Fees: Negotiable; depends on nature of the material or assignment.

PICK ME UP

Time Inc (UK) Ltd, Blue Fin Building, 110 Southwark Street, London SE1 0SU.

Tel: 020 3148 6160. E-mail: sophie.centeno@timeinc.com

Editor: Gilly Sinclair. Picture Editor: Sophie Centeno.

True life weekly presenting stories more graphically and in more detail than its rivals. Includes a limited amount of health material, but no celebrities.

Illustrations: Happy to hear from capable photographers around the country who are able to shoot stories as they arise. Initial contact should be made in writing, giving details of area covered and of any previous experience in the field.

Text: Suggestions for stories always welcomed, not only UK-based but also from overseas.

Overall freelance potential: Good for experienced contributors in this field.

Editor's tips: More is asked of contributors than is usually the case with real life material.

Photographers will be expected to cover more angles, such as going to where an event took place or covering other aspects of a story.

Fees: Variable depending on what the photographer is required to do and how much travel is involved.

PRIMA

Hearst Magazines UK, 72 Broadwick Street, London W1F 9EP.

Tel: 020 7439 5000. E-mail: jo.lockwood@hearst.co.uk

Editor: Gaby Huddart. **Art Director:** Jacqueline Hampsey. **Picture Editor:** Jo Lockwood. General interest women's monthly with a strong emphasis on practical subjects. Major topics covered include cookery, gardening, crafts, health, fashion and homecare.

Illustrations: Top quality work in the fields of food, fashion, still-life, interiors and portraiture, usually by commission. Some scope for good stock shots of family and domestic situations, food, pets, etc that could be used for general illustration purposes, but query needs before before submitting. **Text:** Short, illustrated practical features with a "how-to-do-it" approach.

Overall freelance potential: The magazine relies heavily on freelances.

Fees: Commissioned photography in the region of £400 per day. Other fees according to use.

PSYCHOLOGIES

Kelsey Publishing Group, Cudham Tithe Barn, Berry's Hill, Cudham, Kent TN16 3AG.

Tel: 01959 541444. E-mail: firstname.secondname@kelsey.co.uk

Editor: Suzy Greaves. Features Editor: Ali Roff. Picture Editor: Laura Doherty.

"The thinking woman's glossy", with the focus on "positive living", including topics such as work, health, family, social issues and travel.

Illustrations: Interested in both high-quality stock and in commissioning for specific features. Most images used are lifestyle-based, but relaxed and natural. Also opportunities for top-quality portraiture and beauty images. Initial approach should be by e-mail or telephone.

Text: Possible scope for high-quality lifestyle features.

Overall freelance potential: Good for experienced photographers.

Editor's tips: Examine the magazine closely to get a feel for its style.

Fees: By negotiation.

RED

Hearst Magazines UK, 72, Broadwick Street, london, W1F 9EP

Tel: 020 7439 5000. E-mail: beverley.croucher@hearst.co.uk

Editor: Sarah Bailey. Art Director: Jonathan Whitelocke. Picture Director: Beverley Croucher. Picture Editor: Rebecca Shannon.

Sophisticated monthly aimed at women in their 30s.

Illustrations: High quality commissioned photography covering portraiture, fashion, interior design, food and celebrities. Telephone to make an appointment to drop off portfolio in the first instance. Little scope for stock material.

Text: Ideas always welcome from experienced writers.

Overall freelance potential: Good for the experienced worker.

Fees: By negotiation.

REVEAL

Hearst Magazines UK, 33 Broadwick Street, London W1F 0DQ.

Tel: 020 7339 4524. E-mail: dara.levan-harris@hearst.co.uk

Editor: Jane Ennis. Picture Editor: Dara Levan-Harris.

A "five magazines in one" weekly package, with a mix of celebrities, real-life stories, fashion, lifestyle and TV listings.

Pictures: Good scope for celebrity shots, especially paparazzi-style pictures. Happy to hear from freelances if they think they have something, but ideally should be an exclusive. Send an e-mail first rather than sending images. Many opportunities for commissions to shoot celebrity, real-life or lifestyle features.

Text: Good, illustrated real-life stories always being sought; e-mail features.reveal@natmags.co.uk with suggestions.

Overall freelance potential: Excellent for the right type of material.

Fees: Photography by negotiation; £500 upwards for real-life stories.

THAT'S LIFE!

H.Bauer Publishing Ltd, 24-28 Oval Road, London NW1 7DT.

Tel: 020 7241 8000. E-mail: matthew.wevill@bauer.co.uk

Editor: Sophie Hearsey. Picture Editor: Matt Wevill.

Popular women's weekly concentrating on true-life stories and confessions.

Illustrations: Mostly commissioned shots of people to accompany stories; photographers who can produce good informal portrait work should write to the picture editor enclosing a couple of samples. Also limited opportunities in fashion, food and still life. Quirky and amusing "readers' pictures" always considered on spec- should be accompanied by a brief story or anecdote.

Text: Personal true-life stories always of interest- shocking, scandalous, embarrassing, tear-jerking, etc. Around 300 words. Contact the editor with suggestions first.

Fees: Story shoots around £150; readers' pictures £25; other photography by negotiation. £200 for true stories.

Are you working from the latest edition of The Freelance Photographer's Market Handbook? It's published on 1 October each year. Markets are constantly changing, so it pays to have the latest edition

WI LIFE

NFWI, 104 New Kings Road, Fulham, London SW6 4LY.

Tel: 020 7731 5777. E-mail: wilife@nfwi.org.uk

Editor: Kaye McIntosh.

Published eight times a year for Women's Institute members, includes WI news and features. Illustrations: Pictures of WI events, members, craft and cookery projects.

Text: Possible scope; submit suggestions in the first instance.

Overall freelance potential: Modest scope for both pictures and copy.

Editor's tips: Always consult the editor before submitting.

Fees: By agreement.

WOMAN

Time Inc (UK) Ltd, Blue Fin Building, 110 Southwark Street, London SE1 0SU.

Tel: 020 3148 5000. E-mail: claire.blake@timeinc.com

Editor: Karen Livermore. Picture Editor: Claire Blake. Deputy Picture Editor: Shaun Scott-Baker.

Weekly magazine devoted to all women's interests.

Illustrations: Most pictures commissioned to illustrate specific features. Some scope for human interest shots which are dramatic, off-beat or unusual.

Text: Interviews with leading personalities, human interest stories. Other features mostly staffproduced. Submit a synopsis in the first instance.

Overall freelance potential: Only for experienced contributors in the field.

Fees: Good; on a rising scale according to size of reproduction or length of articles.

WOMAN & HOME

Time Inc (UK) Ltd, Blue Fin Building, 110 Southwark Street, London SE1 0SU.

Tel: 020 3148 7836. E-mail: sharon.mears@timeinc.com

Editorial Director: Sue James. Picture Editor: Sharon Mears.

Monthly magazine for all women concerned with family and home.

Illustrations: All photography commissioned from experienced freelances, to illustrate subjects including cookery, fashion, beauty, interior design, DIY, gardening, travel, topical issues and personality articles.

Text: Articles on personalities, either well-known or who lead interesting lives. 1,500 words. **Overall freelance potential:** Very good for the experienced worker. Including regular contributors, about 50 per cent of the magazine is produced by freelances.

Fees: By negotiation.

WOMAN'S OWN

Time Inc (UK) Ltd, Blue Fin Building, 110 Southwark Street, London SE1 0SU.

Tel: 020 3148 5000. E-mail: womansown@timeinc.com

Editor: Catherine Westwood. Head of Picture Operations: Karen Whitehead.

Weekly publishing articles and practical features of interest to women.

Illustrations: Mostly commissioned to illustrate features on fashion, interior design, crafts, etc. **Text:** Mostly staff-produced. Send a brief outline of any proposed feature in the first instance to the features editor.

Overall freelance potential: Fair for commissioned work, but much is produced by regulars. **Fees:** Good; on a rising scale according to size of reproduction or length of article.

Are you working from the latest edition of The Freelance Photographer's Market Handbook? It's published on 1 October each year. Markets are constantly changing, so it pays to have the latest edition

WOMAN'S WEEKLY

Time Inc (UK) Ltd, Blue Fin Building, 110 Southwark Street, London SE1 0SU. Tel: 020 3148 6628. E-mail: diane.kenwood@timeinc.com

Editor: Diane Kenwood. Features Editor: Sue Pilkington. Head of Picture Operations: Karen

Whitehead.

General interest family-oriented magazine for women in the 35+ age group.

Illustrations: Mostly by commission to illustrate features on fashion, beauty, cookery, decoration, etc.

Text: Practical features on general women's topics, plus human interest stories and celebrity pieces. **Overall freelance potential:** Limited scope for photo commissions, most now handled by regulars. **Fees:** By negotiation.

NEWSPAPERS

In this section we list the national daily and Sunday newspapers, and their associated magazine supplements. While the supplements may publish a wide range of general interest subject matter, the parent papers are obviously only likely to be interested in hard news pictures and stories of genuine interest to a nationwide readership.

News pictures

Despite the heavy presence of professional press and agency photographers at major events, it is still perfectly possible for an independent freelance to get the shot that makes the front page.

"Citizen journalism" has become a regular source of up-to-the-minute news material. When it comes to unexpected events, the freelance or the ordinary citizen is usually the only one on the spot to capture the drama.

If you think you have obtained a "hot" news picture or story, the best plan is to telephone the papers most likely to be interested as soon as possible and let them know what you have to offer.

In the listings that follow, as well as the main switchboard number you will find direct line telephone numbers which take you directly through to the picture desk of the paper concerned.

Do always telephone rather than e-mail if you have anything you believe to be genuinely newsworthy.

There should be little need to use fax numbers these days, but if you must, always check the correct number for the department you want.

Other material

There is some scope for other material apart from hard news in most of the papers. Some use the occasional oddity or human interest item as a "filler", while in the tabloids there is always a good market for celebrity pictures and paparazzi-type material.

The weekend magazine supplements operate much like any other general interest magazine, but this is no market for the inexperienced. The bulk of their content is commissioned from well-established photographers and writers, though some may accept exceptional photojournalistic features or exclusives on spec.

Fees

Fees paid by newspapers can vary tremendously according to what is offered and how it is used. However, it can be taken for granted that rates paid by the national papers listed here are good.

Generally, picture fees are calculated on standard rates based on the size of the reproduction, with the minumum fee you might expect from a national newspaper being around $\pounds 45$.

However, for material that is exclusive or exceptional the sky is almost literally the limit. If you think you have something very special and are prepared to offer it as an exclusive, make sure you negotiate a fee, and perhaps get several offers, before committing the material to anyone.

National Daily Newspapers

DAILY EXPRESS

Express Newspapers, 10 Lower Thames Street, London EC3R 6EN. Tel: 020 8612 7000. Picture desk: 020 8612 7171. E-mail: expresspix@express.co.uk Editor: Hugh Whittow. Picture Editor: Mick Lidbury.

DAILY MAIL

The Daily Mail Ltd, Northcliffe House, 2 Derry Street, London W8 5TT. Tel: 020 7938 6000. Picture desk: 020 7938 6373. Fax: 020 7937 5560. E-mail: pictures@dailymail.co.uk **Editor:** Paul Dacre. **Picture Editor:** Paul Silva.

DAILY MIRROR

Mirror Group Newspapers Ltd, Canary Wharf Tower, 1 Canada Square, London E14 5AP. Tel: 020 7293 3000. Picture desk: 020 7293 3851. Fax: 020 7293 3983. E-mail: picturedesk@mirror.co.uk **Editor:** Lloyd Embley. **Picture Editor:** Ian Down.

DAILY RECORD

Media Scotland, One Central Quay, Glasgow G3 8DA. Tel: 0141 309 3000. Picture desk: 0141 309 3245. E-mail: pictures@dailyrecord.co.uk **Editor:** Murray Foote. **Picture Editor:** Alasdair Baird.

DAILY STAR

Express Newspapers, 10 Lower Thames Street, London EC3R 6EN. Tel: 020 8612 7373. Picture desk: 020 8612 7382. E-mail: rob.greener@dailystar.co.uk Editor: Dawn Neesom. Picture Editor: Rob Greener.

THE DAILY TELEGRAPH

Telegraph Media Group, Victoria Plaza, 111 Buckingham Palace Road, London SW1W 0SR. Tel: 020 7931 2000. Picture desk: 020 7931 2660. E-mail: photo@telegraph.co.uk Editor: Chris Evans. Picture Editor: Matthew Fearn. TELEGRAPH MAGAZINE Editor: Michele Lavery. Picture Editor: Andy Greenacre.

FINANCIAL TIMES

The Financial Times Ltd, Number One Southwark Bridge, London SE1 9HL. Tel: 020 7873 3000. Picture desk: 020 7873 3151. E-mail: jamie.han@ft.com Editor: Lionel Barber. Picture Editor: Jamie Han.

As a member of the Bureau of Freelance Photographers, you II be kept up-to-date with markets through the BFP Market Newsletter, published monthly. For details of membership, turn to page 9 The Freelance Photographer s Market Handbook 2015

THE GUARDIAN

Kings Place, 90 York Way, London N1 9GU. Tel: 020 3353 2000. Picture desk: 020 3353 4070. E-mail: pictures@guardian.co.uk Editor: Alan Rusbridger. Picture Editor: Roger Tooth. GUARDIAN WEEKEND Editor: Merope Mills. Picture Editor: Kate Edwards.

THE HERALD

Herald & Times Group, 200 Renfield Street, Glasgow G2 3QB. Tel: 0141 302 7000. Picture desk: 0141 302 6668. Fax: 0141 333 1147. E-mail: pictures@theherald.co.uk **Editor:** Magnus Llewellin. **Group Picture Editor:** Brodie Duncan.

THE INDEPENDENT

Independent News & Media Plc, Northcliffe House, 2 Derry Street, London W8 5TT. Tel: 020 7005 2000. Picture desk: 020 3615 2740. Fax: 020 7005 2086. E-mail: pix@independent.co.uk Editor: Amol Rajan. Picture Editor: Lynn Cullen. THE INDEPENDENT MAGAZINE Picture Editor: Annalee Mather.

THE SCOTSMAN

The Scotsman Publications Ltd, Conference House, 152 Morrison Street, Edinburgh EH3 8EB. Tel: 0131 620 8620. Picture desk: 0131 248 2494. E-mail: tspics@scotsman.com **Editor:** Ian Stewart. **Picture Editor:** Kayt Turner.

THE SUN

News UK, The News Building, 1 London Bridge Street, London SE1 9GF. Tel: 020 7782 4000. Picture desk: 020 7782 4199. Fax: 020 7782 4335. E-mail: pictures@thesun.co.uk; john.edwards@the-sun.co.uk Editor: David Dinsmore. Picture Editor: John Edwards.

THE TIMES

News UK, The News Building, 1 London Bridge Street, London SE1 9GF. Tel: 020 7782 5000. Picture desk: 020 7782 5877. Fax: 020 7782 5988. E-mail: pictures@thetimes.co.uk Editor John Witherow. **Picture Editor:** Sue Connolly. THE TIMES MAGAZINE **Editor-in-Chief:** Nicola Jeal. **Picture Editor:** Graham Wood.

National Sunday Newspapers

DAILY STAR SUNDAY

Express Newspapers, 10 Lower Thames Street, London EC3R 6EN. Tel: 020 8612 7424. Picture desk: 020 8612 7382. E-mail: dean.osborne@dailystar.co.uk Editor: Peter Carbery. Picture Editor: Dean Osborne. TV EXTRA Editor: Ella Buchan.

THE INDEPENDENT ON SUNDAY

Independent News & Media Plc, Northcliffe House, 2 Derry Street, London W8 5TT. Tel: 020 7005 2000. Picture desk: 020 7005 2740. Fax: 020 7005 2086. E-mail: pix@independent.co.uk Editor: Lisa Markwell. Picture Editor: Sophie Batterbury. THE NEW REVIEW Editor: Lawrence Earle. Picture Editor: TBA.

THE MAIL ON SUNDAY

Northcliffe House, 2 Derry Street, Kensington, London W8 5TS. Tel: 020 7938 6000. Picture desk: 020 7938 7017. Fax: 020 7938 6609. E-mail: pix@mailonsunday.co.uk **Editor:** Geordie Greig. **Picture Editor:** Liz Cocks. YOU MAGAZINE **Editor:** Sue Peart. **Picture Editor:** Eve George.

THE OBSERVER

Kings Place, 90 York Way, London N1 9GU. Tel: 020 3353 2000. Picture desk: 020 3353 4304. E-mail: picture.desk@observer.co.uk Editor: John Mulholland. Picture Editor: Greg Whitmore. THE OBSERVER MAGAZINE Editor: Ruaridh Nicoll. Picture Editors: Kit Burnet and Michael Whitaker. OBSERVER FOOD MONTHLY Editor: Allan Jenkins. Picture Editors: Kit Burnet and Josy Forsdike.

SCOTLAND ON SUNDAY

The Scotsman Publications Ltd, Barclay House, 108 Holyrood Road, Edinburgh EH8 8AS. Tel: 0131 620 8438. Fax: 0131 620 8491. E-mail: sospics@scotsman.com Editor: Ian Stewart. Picture Editor: Alan Macdonald.

THE SUN ON SUNDAY

News UK, The News Building, 1 London Bridge Street, London SE1 9GF. Tel: 020 7782 4000. Picture desk: 020 7782 4199. Fax: 020 7782 4335. E-mail: pictures@thesun.co.uk; john.edwards@thesun.co.uk Editor: Victoria Newton. Picture Editor: John Edwards. FABULOUS Editor: Rachel Richardson. Picture Editor: Alan Gittos.

SUNDAY EXPRESS

Express Newspapers, 10 Lower Thames Street, London EC3R 6EN. Tel: 020 8612 7000. Picture desk: 020 8612 7172/7176. E-mail: jane.sherwood@express.co.uk Editor: Martin Townsend. Picture Editor: Jane Sherwood. S MAGAZINE Editor: Louise Robinson. Picture Editor: Jane Woods.

THE SUNDAY MAIL

Media Scotland, One Central Quay, Glasgow G3 8DA. Tel: 0141 309 3000. Picture desk: 0141 309 3245. E-mail: pictures@dailyrecord.co.uk **Editor:** Jim Wilson. **Picture Editor:** Alasdair Baird.

SUNDAY MIRROR

Mirror Group plc, 1 Canada Square, Canary Wharf, London E14 5AP. Tel: 020 7293 3000. Picture desk: 020 7293 3335/6. Fax: 020 7510 6991. E-mail: pictures@sundaymirror.co.uk Editor: Lloyd Embley. Picture Editor: Ben Jones. NOTEBOOK Editor: Mel Brodie. Picture Editor: Sarah Mahon.

SUNDAY PEOPLE

Mirror Group plc, 1 Canada Square, Canary Wharf, London E14 5AP. Tel: 020 7293 3000. Picture desk: 020 7293 3901. Fax: 020 7293 3810. E-mail: pictures@people.co.uk Editor: Alison Phillips. Picture Editor: Mark Moylan. LOVE SUNDAY Editor: Samantha Cope. Picture Editor: Mark Moylan.

THE SUNDAY POST

D. C. Thomson & Co Ltd, Courier Place, Dundee DD1 9QJ. Tel: 01382 223131. Fax: 01382 201064. E-mail: mail@sundaypost.com News Editor: Craig Jackson. Picture Editor: Jeremy Bayston. IN 10 Editor: Jan Gooderham.

THE SUNDAY TELEGRAPH

Telegraph Media Group, Victoria Plaza, 111 Buckingham Palace Road, London SW1W OSR. Tel: 020 7931 2000. Picture desk: 020 7931 3542. E-mail: stpics@telegraph.co.uk Editor: Ian MacGregor. Picture Editor: Mike Spillard. STELLA Editor: Anna Murphy.

THE SUNDAY TIMES

News UK, The News Building, 1 London Bridge Street, London SE1 9GF. Tel: 020 7782 5000. Picture desk: 020 7782 5666. Fax: 020 7782 5563. E-mail: pictures@sunday-times.co.uk Editor: Martin Ivens. Picture Editor: Ray Wells. THE SUNDAY TIMES MAGAZINE Editor: Sarah Baxter. Picture Editor: Monica Allende

BOOKS

Books represent a substantial and ever-growing market for the photographer. In an increasingly visual age the market for heavily illustrated books continues to expand, with hundreds of new titles being published every year.

In this section we list major book publishers, and specifically those companies that make considerable use of photographic material.

As well as regular publishers, also included here are book packagers. These are companies that offer a complete editorial production service and specialise in producing books that can be sold as finished packages to publishers internationally. The majority of their products are of the heavily illustrated type, and thus these companies can often present a greater potential market for photographic material than do the mainstream publishers.

Making an approach

In this field the difficulty for the individual freelance is that there is no easy way of knowing who wants what and when.

Obviously book publishers only require pictures of specific subjects when they are currently working on a project requiring such material. Much of the time they will rely heavily on known sources such as picture libraries, but this does not mean that there is not good scope for the individual photographer who has a good collection of material on particular subjects, or who may be able to produce suitable work to order.

The solution for the photographer, therefore, is to place details of what he or she has to offer in front of all those companies that might conceivably require material of that type.

The initial approach is simply to send an introductory letter outlining

the sort of material that you can supply. A detailed list of subjects can be attached where appropriate.

There is little point however, in sending any photographs at this stage, unless it be one or two samples to indicate a particular style. And one should not expect an immediate response requesting that work be submitted; most likely the publisher will simply keep your details on file for future reference.

Preceding the listings of book publishers is a subject index that should assist in identifying the most promising markets for those areas in which you have good coverage.

In the listings that follow, the major areas of activity for each publisher are detailed under "Subjects". Of course, the larger companies publish on the widest range of subjects and therefore their coverage may be stated as "general", but in most entries you will find a list of specific subject areas. These are by no means a complete list of all the subjects handled by each publisher, but indicate those areas where the company is most active and therefore most likely to be in need of photographic material.

In some entries a "Contact" name is given. However, in a lot of cases it is not possible to give a specific name as larger book publishers usually have large numbers of editorial personnel with constantly shifting responsibilities for individual projects. In addition, many companies frequently use the services of freelance picture researchers. A general approach should therefore simply be addressed to the editorial director.

Rights and fees

Whereas the rights sold in the magazine world are invariably for UK use only, book publishers – and especially packagers – make a good deal of their profit from selling their products to other publishers in overseas markets.

It is therefore quite likely that when work is chosen for use in a particular book the publisher may at some stage request, in addition to British publishing rights, rights for other specific markets such as "North America", "Europe", "Spanish language", etc. These various territorial rights will, of course, affect the fees that the photographer receives – the more areas the book sells into, the higher the fees.

Other major factors affecting fees are the size of reproduction on the page and the quantity of the print-run.

Thus there is no easy way to generalise about the sort of fees paid in this field. On the whole, however, fees in book publishing are quite good and comparable with good magazine rates. For packages destined for the international co-edition market they can be substantially higher.

A word about names and imprints

The use by large publishers of a multiplicity of names for different divisions can be quite confusing.

Many famous publishing names, though still in existence, now belong to huge publishing conglomerates. A few are still run as separate companies, but most have effectively become "imprints".

These imprints are used by large publishers for specific sections of their list. In the past many imprints were run as completely separate operations, but in an age of consolidation most have now been incorporated into their parent company.

Only especially relevant imprints are given full listings here, that is those that are run as separate operations and use photography to any extent. Most imprints are simply listed under their parent company. The Freelance Photographer's Market Handbook 2015

Subject Index

Archaeology

Cambridge University Press Souvenir Press Ltd Thames & Hudson Ltd

Architecture/Design

Antique Collectors Club Ltd Cambridge University Press Robert Hale Ltd Laurence King Publishing Ltd Pavilion Books Phaidon Press Ltd RotoVision Thames & Hudson Ltd Yale University Press

Arts/Crafts

Anness Publishing Antique Collectors Club Ltd A & C Black (Publishers) Ltd **Breslich & Foss Cambridge University Press** The Crowood Press Laurence King Publishing Ltd Ebury Publishing F&W Media International Ltd W. Foulsham & Co Ltd Guild of Master Craftsman Publications Ltd Robert Hale Ltd **Ilex Press Limited** Frances Lincoln Ltd Lutterworth Press New Holland Publishers Octopus Publishing Group Ltd Orion Publishing Group Ltd **Pavilion Books** Phaidon Press Ltd Quarto Group **Reader's** Digest Jacqui Small LLP Souvenir Press Ltd Thames & Hudson Ltd **Usborne** Publishing Virgin Books Ltd

Aviation

Ian Allan Publishing Amber Books Ltd The Crowood Press Grub Street Osprey Publishing Ltd

DIY

The Crowood Press W. Foulsham & Co Ltd Haynes Publishing Orion Publishing Group Ltd Reader's Digest

Fashion

Laurence King Publishing Ltd Pavilion Books Piatkus Books Plexus Publishing Ltd Thames & Hudson Ltd

Food/Drink

Absolute Press Anness Publishing **Kyle** Cathie Ltd Ebury Publishing W. Foulsham & Co Ltd Grub Street Robert Hale Ltd Hodder Headline Ltd Frances Lincoln Ltd New Holland Publishers Octopus Publishing Group Ltd **Orion Publishing Group Ltd** Pan Macmillan **Pavilion Books** Quarto Group **Reader's** Digest Ryland, Peters & Small Sheldrake Press Simon & Schuster Jacqui Small Souvenir Press Ltd Weidenfeld & Nicolson

Gardening

Anness Publishing Antique Collectors' Club Ltd **Breslich & Foss** Kyle Cathie Ltd The Crowood Press W. Foulsham & Co Ltd Guild of Master Craftsman Publications Ltd Hodder Headline Ltd Frances Lincoln Ltd New Holland Publishers Octopus Publishing Group Ltd Orion Publishing Group Ltd Quarto Group **Reader's** Digest Ryland, Peters & Small Jacqui Small LLP Souvenir Press Ltd

Health/Medical

Breslich & Foss Cambridge University Press Carroll & Brown Publishers Kyle Cathie Ltd Constable & Robinson Ebury Publishing W. Foulsham & Co Ltd Grub Street Pavilion Books Piatkus Books Quarto Group Simon & Schuster Souvenir Press Ltd Transworld Publishers

Interior Design

Ebury Publishing Frances Lincoln Ltd New Holland Publishers Octopus Publishing Group Ltd Orion Publishing Group Ltd Ryland, Peters & Small Jacqui Small LLP Thames & Hudson

Military

Amber Books Ltd Cassell Military Constable & Robinson The Crowood Press Robert Hale Ltd Pavilion Books Osprey Publishing Transworld Publishers

Motoring

Ian Allan Publishing The Crowood Press Haynes Publishing

Music

Cambridge University Press Ebury Publishing Faber & Faber Ltd Guinness Publishing Ltd Robert Hale Ltd Hodder Headline Ltd Omnibus Press Pan Macmillan Plexus Publishing Ltd Thames & Hudson Virgin Books Ltd

Natural History

A & C Black (Publishers) Ltd Cambridge University Press The Crowood Press Robert Hale Ltd Christopher Helm Publishers Ltd Kingfisher Publications New Holland Publishers Orion Publishing Group Ltd T & A D Poyser Reader's Digest Souvenir Press Ltd Usborne Publishing

Photography

F&W Media International Ltd Ilex Press Limited Phaidon Press Ltd Photographer's Institute Press RotoVision Thames & Hudson Ltd

Politics/Current Affairs

Bloomsbury Publishing Ltd Chatto & Windus Constable & Robinson Faber & Faber Ltd Hutchinson Pan Macmillan Yale University Press

Railways

Ian Allan Publishing Railways – Milepost 92½

Science

Amber Books Ltd Cambridge University Press Lutterworth Press Orion Publishing Group Ltd Transworld Publishers

Sport

A & C Black (Publishers) Ltd Aurum Press The Crowood Press DB Publishing Ebury Publishing W. Foulsham & Co Ltd Guinness Publishing Ltd Robert Hale Ltd Hodder Headline Ltd Octopus Publishing Group Ltd Orion Publishing Group Ltd Transworld Publishers Virgin Books Ltd

Travel

AA Media Ltd Amber Books Ltd Bloomsbury Publishing Ltd **Cambridge University Press** Chatto & Windus Constable & Robinson The Crowood Press **Ebury Publishing** W. Foulsham & Co Ltd Robert Hale Ltd Hutchinson New Holland Publishers Octopus Publishing Group Ltd Orion Publishing Group Ltd Quarto Group Sheldrake Press Thames & Hudson Ltd

Book Publishers

AA MEDIA LTD

AA Media Ltd, Fanum House, Basingstoke, Hampshire RG21 4EA. Tel: 01256 495084. E-mail: travel.images@theaa.com **Contact:** James Tims, Digital Assets Manager. **Subjects:** Travel images for guide books, maps and atlases. Commissions only.

ABSOLUTE PRESS

Absolute Press, Scarborough House, 29 James Street West, Bath BA1 2BT. Tel: 01225 316013. E-mail info@absolutepress.co.uk Web: www.absolutepress.co.uk **Contact:** Meg Avent, Commissioning Editor; Matt Inwood, Art Director. **Subjects:** Food and drink.

IAN ALLAN PUBLISHING

Riverdene Business Park, Molesey Road, Hersham, Surrey KT12 4RG. Tel: 01932 266600. E-mail: info@ianallanpublishing.co.uk Web: www.ianallanpublishing.com **Subjects:** Aviation, motoring, railways, road transport.

AMBER BOOKS LTD

Bradleyis Close, 74-77 White Lion Street, London N1 9PF. Tel: 020 7520 7600. E-mail: terry@amberbooks.co.uk Web: www.amberbooks.co.uk **Contact:** Terry Forshaw, Picture Manager. **Subjects:** General; aviation, fitness and survival, military, naval, popular science, transport.

ANNESS PUBLISHING LTD

108 Great Russell Street, London WC1B 3NA.
Tel: 020 7401 2077. E-mail: info@anness.com
Web: www.annesspublishing.com
Contact: Picture Library Manager.
Imprints: Aquamarine, Armadillo, Lorenz Books, Southwater.
Subjects: Crafts, children's illustrated, cookery, gardening, health, reference.

ANTIQUE COLLECTORS CLUB LTD

Sandy Lane, Old Martlesham, Woodbridge, Suffolk IP12 4SD. Tel: 01394 389950. E-mail: editorial@antique-acc.com Web: www.antiquecollectorsclub.com **Contact:** Diana Steel, Managing Director (by letter only). **Subjects:** Antiques, architecture, art, gardening.

AURUM PRESS

74-77, White Lion Street, London, N1 9PF. Tel: 020 7284 9300. E-mail: robin.harvie@aurumpress.co.uk Web: www.aurumpress.co.uk **Contact:** Robin Harvie, Senior Commissioning Editor. **Subjects:** General non-fiction focused on entertainment, history, sport.

A & C BLACK (PUBLISHERS) LTD

50 Bedford Square, London WC1B 3DP Tel: 020 7631 5600. E-mail: enquiries@acblack.co.uk Web: www.acblack.com Imprints: Adlard Coles Nautical, Christopher Helm, Methuen Drama, T&AD Poyser. Subjects: Arts and crafts, childrenís educational, nautical, natural history, reference, sport, theatre.

BLOOMSBURY PUBLISHING PLC

50 Bedford Square, London WC1B 3DP. Tel: 020 7631 5600. E-mail: csm@bloomsbury.com Web: www.bloomsbury.com **Subjects:** General; biography, childrenís, current affairs, reference, travel.

BRESLICH & FOSS LTD

2a Union Court, 20-22 Union Road, London, SW4 6JP Tel: 020 7819 3990. E-mail: sales@breslichfoss.com Web: www.breslichfoss.co.uk **Contact:** Janet Ravenscroft. **Subjects:** Arts, childrenís, crafts, gardening, health, lifestyle.

CAMBRIDGE UNIVERSITY PRESS

The Edinburgh Building, Shaftesbury Road, Cambridge CB2 8RU. Tel: 01223 312393. E-mail: information@cambridge.org Web: www.cambridge.org **Subjects:** Archaeology, architecture, art, astronomy, biology, drama, geography, history, medicine, music, natural history, religion, science, sociology, travel.

CARROLL & BROWN PUBLISHERS LTD

Winchester House, 259-269 Old Marylebone Road, London NW1 5RA. Tel: 020 7025 5300. E-mail: amy.carroll@carrollandbrown.co.uk Web: www.carrollandbrown.co.uk **Contact:** Amy Carroll, Director. **Subjects:** General illustrated reference, health, parenting.

KYLE CATHIE LTD

122 Arlington Road, London NW1 7HP. Tel: 020 7692 7215. E-mail: vicki.murrell@kyle-cathie.com Web: www.kylecathie.com **Contact:** Vicki Murrell, Editorial Assistant. **Subjects:** Beauty, food and drink, gardening, health, reference.

CHATTO & WINDUS LTD

Random House, 20 Vauxhall Bridge Road, London SW1V 2SA. Tel: 020 7840 8894 E-mail: chattoeditorial@randomhouse.co.uk Web: www.randomhouse.co.uk **Subjects:** General; biography and memoirs, current affairs, history, travel.

THE CROWOOD PRESS LTD

The Stable Block, Crowood Lane, Ramsbury, Marlborough, Wiltshire SN8 2HR. Tel: 01672 520320. E-mail: enquiries@crowood.com Web: www.crowoodpress.co.uk **Subjects:** Angling, aviation, climbing, country interests, crafts, DIY, equestrian, gardening, motoring, military, natural history, sport, travel.

DB PUBLISHING

3 The Parker Centre, Mansfield Road, Derby DE21 4SZ. Tel: 01332 384235. E-mail: steve.caron@dbpublishing.co.uk Web: www.dbpublishing.co.uk **Contact:** Steve Caron, Managing Director. **Subjects:** British local and social history, sport (especially football).

EBURY PUBLISHING

Random House, 20 Vauxhall Bridge Road, London SW1V 2SA. Tel: 020 7840 8400. E-mail: eburyeditorial@randomhouse.co.uk Web: www.eburypublishing.co.uk **Imprints:** BBC Books, Ebury Press, Rider, Time Out Guides, Vermilion, Virgin Books. **Subjects:** Biography, cookery, crafts, current affairs, decorating and interiors, health and beauty, history, mind/body/spirit, music, parenting, sport, travel guides.

F&W MEDIA INTERNATIONAL LTD

Brunel House, Newton Abbot, Devon TQ12 4PU. Tel: 01626 323200. E-mail: ali.myer@fwmedia.com Web: www.fwmedia.co.uk Imprint: David & Charles. **Contact:** Ali Meyer. **Subjects:** Crafts, hobbies, nostalgia, railways.

FABER & FABER LTD

Bloomsbury House, 74-77 Great Russell Street, London WC1B 3DA. Tel: 020 7927 3800. E-mail: gadesign@faber.co.uk Web: www.faber.co.uk **Contact:** Design Department. **Subjects:** Biography, film, music, politics, theatre, wine.

W. FOULSHAM & CO

The Old Barrel Store, Brewery Courtyard, Draymans Lane, Marlow, Bucks SL7 2FF. Tel: 01628 400631 E-mail: sales@foulsham.com Web: www.foulsham.com **Contact:** Barry Belasco, Managing Director. **Subjects:** Crafts, collecting, cookery, DIY, gardening, health, hobbies, sport, travel.

GRUB STREET PUBLISHING

4 Rainham Close, London SW11 6SS. Tel: 020 7924 3966. E-mail: post@grubstreet.co.uk Web: www.grubstreet.co.uk **Subjects:** Aviation history, cookery.

GUILD OF MASTER CRAFTSMAN PUBLICATIONS LTD

166, High Street, Lewes, East Sussex BN7 1XN.
Tel: 01273 477374. E-mail: anthonyb@thegmcgroup.com
Web: www.thegmcgroup.com/www.pipress.co.uk
Imprints: Photographers' Institute Press
Contact: Anthony Bailey, Chief Photographer.
Subjects: Crafts; gardening, needlework, photography, woodworking.

The Freelance Photographer's Market Handbook 2015

GUINNESS WORLD RECORDS LTD

3rd Floor, 184 Drummond Street, London NW1 3HP.
Tel: 020 7891 4567.
Web: www.guinnessworldrecords.com
Contact: Design Department.
Subjects: Guinness World Records book, TV and merchandising, sport and popular music.

HALDANE MASON

PO Box 34196, London NW10 3YB. Tel: 020 8459 2131. E-mail: info@haldanemason.com Web: www.haldanemason.com **Contact:** Ron Samuel, Art Director. **Subjects:** Childrenís illustrated non-fiction, packaging services for other publishers.

ROBERT HALE LTD

Clerkenwell House, 45-47 Clerkenwell Green, London EC1R 0HT. Tel: 020 7251 2661. E-mail: submissions@halebooks.com Web: www.halebooks.com **Contact:** Non-Fiction Editor. **Subjects:** General; architecture, cookery, crafts, equestrian, gemmology, horology, mind, body and spirit, military, music, natural history, sport, topography, travel.

HARPERCOLLINS PUBLISHERS

77-85 Fulham Palace Road, London W6 8JB. Tel: 020 8741 7070. E-mail: enquiries@harpercollins.co.uk Web: www.harpercollins.co.uk Imprints: Collins, Fourth Estate, HarperElement, HarperPress, HarperSport, HarperThorsons. Subjects: General.

HARVILL SECKER

Random House, 20 Vauxhall Bridge Road, London SW1V 2SA. Tel: 020 7840 8400. E-mail: harvillseckereditorial@randomhouse.co.uk Web: www.randomhouse.co.uk **Contact:** Lily Richards. **Subjects:** General non-fiction.

HAYNES PUBLISHING

Sparkford, Yeovil, Somerset BA22 7JJ. Tel: 01963 440635. E-mail: bookseditorial@haynes.co.uk Web: www.haynes.co.uk **Contact:** Christine Smith, Adminstration Manager. **Subjects:** Transport, DIY, General Interest.

CHRISTOPHER HELM PUBLISHERS/T&AD POYSER

(Imprints of Bloomsbury Publishing) 50 Bedford Square, London WC1B 3DP. Tel: 020 7631 5600. E-mail: nigel.redman@bloomsbury.com Web: www.bloomsbury.com **Contact:** Nigel Redman, Head of Natural History. **Subjects:** Ornithology and natural history.

HODDER EDUCATION

338 Euston Road, London NW1 3BH.
Tel: 020 7873 6000. E-mail: helen.townson@hodder.co.uk
Web: www.hoddereducation.co.uk
Contact: Helen Townson, Design Manager.
Subjects: Education including geography, health, history, science, travel.

HODDER HEADLINE LTD

338 Euston Road, London NW1 3BH.
Tel: 020 7873 6000.
Web: www.hodderheadline.co.uk
Contact: Picture Manager, c/o division.
Imprints: Hachette Children's Books, Headline, Hodder Education, Hodder & Stoughton.
Subjects: General; academic, biography, children's, food and wine, history, music, sport.

HUTCHINSON

Random House, 20 Vauxhall Bridge Road, London SW1V 2SA. Tel: 020 7840 8400. E-mail: hutchinsoneditorial@randomhouse.co.uk Web: www.randomhouse.co.uk **Contact:** Sue Freestone. **Subjects:** Biography, current affairs, history, travel.

ILEX PRESS LIMITED

210 High Street, Lewes, East Sussex BN7 2NS. Tel: 01273 487440 E-mail: juniper@ilex-press.com Web: www.ilex-press.com; www.ilexinstant.com **Contact:** Adam Juniper, Associate Publisher. **Subjects:** Crafts, filmmaking, photography.

JACQUI SMALL LLP

74-77, White Lion Street, London, N1 9PF. Tel: 020 7284 9300. E-mail: info@jacquismallpub.com Web: www.jacquismallpub.com **Contact:** Jacqui Small, Publisher. **Subjects:** Crafts, interiors, food and drink, flowers and gardening.

LAURENCE KING PUBLISHING LTD

361ñ373 City Road, London EC1V 1LR. Tel: 020 7841 6900. Web: www.laurenceking.com **Contact:** Julia Ruxton, Picture Manager. **Subjects:** Arts and architecture, design, fashion.

KINGFISHER

The Macmillan Building, 20 New Wharf Road, London N1 9RR. Tel: 020 7014 4166. E-mail: m.davis@macmillan.co.uk Web: www.panmacmillan.com **Contact:** Michael Davis. **Subjects:** Childrenís non-fiction, natural history, reference.

FRANCES LINCOLN LTD

74-77, White Lion Street, London, N1 9PF. Tel: 020 7284 9300. E-mail: fl@frances-lincoln.com Web: www.franceslincoln.com **Contact:** Jessica Halliwell, Editorial Assistant. **Subjects:** General; architecture, art, gardening, travel.

LITTLE, BROWN BOOK GROUP

100 Victoria Embankment, London EC4Y 0DY. Tel: 020 7911 8000. E-mail: info@littlebrown.co.uk Web: www.littlebrown.co.uk Imprints: Little, Brown; Abacus; Piatkus; Sphere. Subjects: General.

THE LUTTERWORTH PRESS

P O Box 60, Cambridge CB1 2NT. Tel: 01223 350865. E-mail: publishing@lutterworth.com Web: www.lutterworth.com **Contact:** Adrian Brink. **Subjects:** Antiques, art and architecture, biography, crafts, natural history, reference, religion, science.

NEW HOLLAND PUBLISHERS (UK) LTD

Garfield House, 86-88 Edgware Road, London W2 2EA. Tel: 020 7724 7773. E-mail: enquires@nhpub.co.uk Web: www.newhollandpublishers.com **Subjects:** Biography, crafts, cookery, gardening, history, interior design, sports and outdoor pursuits, travel.

OCTOPUS PUBLISHING GROUP LTD

Endeavour House, 189, Shaftesbury Avenue, London, WC2H 8JY Tel:020 7632 5400. E-mail: info@octopus-publishing.co.uk Web: www.octopus-publishing.co.uk Imprints: Cassell Illustrated, Conran Octopus, Gaia Books, Godsfield Press, Hamlyn, Mitchell Beazley. Subjects: Illustrated general reference and non-fiction.

OMNIBUS PRESS

Music Sales Ltd, 14-15 Berners Street, London W1T 3LJ. Tel: 020 7612 7400. E-mail: info@omnibuspress.com Web: www.omnibuspress.com Contact: Chris Charlesworth, Editor. Subjects: Rock, pop and classical music.

ORION PUBLISHING GROUP LTD

Orion House, 5 Upper St Martinis Lane, London WC2H 9EA. Tel: 020 7240 3444. E-mail: artdepartment@orionbooks.co.uk Web: www.orionbooks.co.uk **Contact:** Art Department. **Imprints:** Orion; Gollancz; Indigo, Weidenfeld & Nicolson; Cassell Military; Halban Publishers; Allen & Unwin. **Subjects:** General; biography, cookery, design, gardening, history, interiors, natural history,

popular science, sport.

OSPREY PUBLISHING LTD

Kemp House, Chawley Park, Cumnor Hill, Oxford OX2 9PH. Tel: 01865 727022. E-mail: editorial@ospreypublishing.com Web: www.ospreypublishing.com **Contact:** Kate Moore, Publisher. **Subjects:** Illustrated military history and aviation.

OXFORD UNIVERSITY PRESS

Great Clarendon Street, Oxford OX2 6DP. Tel: 01865 556767. Web: www.oup.co.uk Imprints: Clarendon Press, Oxford Paperbacks. Subjects: General; academic, educational, reference.

PAN MACMILLAN

20 New Wharf Road, London N1 9RR. Tel: 020 7014 6000. E-mail: nonfiction@macmillan.co.uk Web: www.panmacmillan.com **Imprints:** Boxtree, Macmillan, Pan, Picador, Sidgwick & Jackson. **Subjects:** General; biography, cookery, current affairs, music, popular history, practical, self-help.

PAVILION BOOKS

1 Gower Street, London WC1E 6HD. Tel: 020 7462 1500. E-mail: info@pavilionbooks.com Web: www.pavilionbooks.com Imprints: Batsford, Collins & Brown, Conway, Pavilion, Portico, Robson, Salamander. Subjects: General illustrated; architecture, arts & crafts, biography, cookery, fashion, health, military, transport.

PENGUIN GROUP (UK)

80 Strand, London WC2R 0RL. Tel: 020 7010 3000. E-mail: alice.chandler@uk.penguingroup.com Web: www.penguin.co.uk Imprints: Allen Lane, Hamish Hamilton, Michael Joseph, Penguin, Viking. Contacts: Alice Chandler, Samantha Johnson (Picture Editors). Subjects: General.

PHAIDON PRESS LTD

18 Regent's Wharf, All Saints Street, London N1 9PA.
Tel: 020 7843 1000. E-mail: enquiries@phaidon.com
Web: www.phaidon.com
Subjects: Architecture, decorative and fine arts, design, photography.

PHOTOGRAPHERS' INSTITUTE PRESS

(Imprint of GMC Publications) 166 High Street, Lewes, East Sussex BN7 1XN. Tel: 01273 477374. E-mail: jonathonb@thegmcgroup.com Web: www.pipress.co.uk **Contact:** Jonathan Bailey, Associate Publisher. **Subjects:** Photography.

PIATKUS BOOKS LTD

Little, Brown Book Group, 100 Victoria Embankment, London EC4Y 0DY. Tel: 020 7911 8000. E-mail: info@littlebrown.co.uk Web: www.piatkus.co.uk **Contact:** Managing Editor. **Subjects:** Biography, health, leisure, lifestyle, mind body & spirit, popular culture, womenis interests.

PLEXUS PUBLISHING LTD

The Studio, Hillgate Place,18-20 Balham Hill, London SW12 9ER. Tel: 020 8673 9230. E-mail: info@plexusuk.demon.co.uk Web: www.plexusbooks.com **Contact:** Sandra Wake, Editorial Director. **Subjects:** Biography, fashion, film, music, popular culture.

THE QUARTO GROUP

The Old Brewery, 6 Blundell Street, London N7 9BH. Tel: 020 7700 6700. E-mail: info@quarto.com Web: www.quarto.com **Contact:** Caroline Guest, Art Director. **Subjects:** General; arts and crafts, cookery, gardening, home interest, lifestyle, popular culture, reference.

RAILWAYS - MILEPOST 92%

Newton Harcourt, Leicestershire LE8 9FH. Tel: 0116 259 2068. E-mail: studio@railphotolibrary.com Contacts: Colin Garratt, Director; James Garratt, Picture Library Manager. **Subjects:** Railways worldwide ñ past and present.

RANDOM HOUSE UK LTD

Random House, 20 Vauxhall Bridge Road, London SW1V 2SA. Tel: 020 7840 8400. Web: www.randomhouse.co.uk **Contact:** Suzanne Dean, Creative Director. **Imprints:** Bodley Head, Jonathan Cape, Century, Chatto & Windus, Harvill Secker, William Heinemann, Hutchinson, Pimlico, Yellow Jersey. **Subjects:** Various, see individual imprints.

READER'S DIGEST

Vivat Direct Ltd (T/A Readerís Digest), 157 Edgware Road, London W2 2HR. Tel: 020 7053 4636. Web: www.readersdigest.co.uk **Contact:** Art Director. **Subjects:** General illustrated; cookery, crafts, DIY, encyclopaedias, folklore, gardening, guide books, history, natural history.

ROTOVISION

Sheridan House, 112-116 Western Road, Hove BN3 1DD. Tel: 01273 716000. E-mail: alison.morris@quarto.com Web: www.rotovision.com **Contact:** Alison Morris, Commissioning Editor. **Subjects:** Art, beauty, craft, design, photography.

RYLAND PETERS & SMALL LTD

20-21 Jockey's Fields, London WC1R 4BW. Tel: 020 7025 2200. E-mail: leslie.harrington@rps.co.uk Web: www.rylandpeters.com **Contact:** Leslie Harrington, Art Director. **Subjects:** Body and soul, food and drink, gift, home and garden.

SHELDRAKE PRESS LTD

188 Cavendish Road, London SW12 0DA. Tel: 020 8675 1767. E-mail: enquiries@sheldrakepress.co.uk Web: www.sheldrakepress.co.uk **Contact:** Simon Rigge, Publisher. **Subjects:** Cookery, history, travel.

SHIRE PUBLICATIONS

Kemp House, Chawley Park, Botley, Cumnor Hill, Oxford OX2 9H . Tel: 01865 811332. E-mail: editorial@shirebooks.co.uk Web: www.shirebooks.co.uk **Contact:** Nick Wright, Publisher and Managing Director. **Subjects:** Art & antiques, nostalgia, history and motoring.

SIMON & SCHUSTER

1st Floor, 222 Gray's Inn Road, London, WC1X 8HB. Tel: 020 7316 1900. E-mail: Editorial.enquiries@simonandschuster.co.uk Web: www.simonandschuster.co.uk **Subjects:** Biography, cookery, health, history, self-help, childrens books and lifestyle.

SOUVENIR PRESS LTD

43 Great Russell Street, London WC1B 3PD. Tel: 020 7580 9307. E-mail: souvenirpress@souvenirpress.co.uk Web: www.souvenirpress.co.uk **Subjects:** General; archaelogy, art, animals, childcare, cookery, gardening, health, hobbies, plants, practical, sociology.

THAMES & HUDSON LTD

181a High Holborn, London WC1V 7QX. Tel: 020 7845 5000. E-mail: s.ruston@thameshudson.co.uk Web: www.thamesandhudson.com **Contact:** Sam Ruston, Head of Picture Research. **Subjects:** Art, architecture, archaeology, anthropology, cinema, fashion, interior design, music, photography, practical guides, religion and mythology, theatre, travel.

TOUCAN BOOKS LTD

The Old Fire Station,140 Tabernacle Street, London EC2A 4SD. Tel: 020 7250 3388. E-mail: info@toucanbooks.co.uk Web: www.toucanbooks.co.uk **Contact:** Christine Vincent, Picture Manager **Subjects:** General illustrated.

> As a member of the Bureau of Freelance Photographers, you'll be kept up-to-date with markets through the BFP Market Newsletter, published monthly. For details of membership, turn to page 9

TRANSWORLD PUBLISHERS

61-63 Uxbridge Road, London W5 5SA. Tel: 020 8579 2652. E-mail: info@transworld-publishers.co.uk Web: www.transworld-publishers.co.uk Imprints: Bantam, Doubleday, Expert. Subjects: General non-fiction; biography, food & drink, health, military, music, popular science, social history, sport, travel.

USBORNE PUBLISHING

83-85 Saffron Hill, London EC1N 8RT. Tel: 020 7430 2800. E-mail: mail@usborne.co.uk Web: www.usborne.com **Contacts:** Steve Wright; Mary Cartwright. **Subjects:** General childrenís; crafts, natural history, practical, reference.

VIRGIN BOOKS

Random House, 20 Vauxhall Bridge Road, London SW1V 2SA. Tel: 020 7840 8357. E-mail: yjacob@eburypublishing.co.uk Web: www.eburypublishing.co.uk **Contacts:** Yvonne Jacob, Editorial Assistant. **Subjects:** Popular reference, lifestyle, music, sport.

VISION SPORTS PUBLISHING

19-23 High Street, Kingston upon Thames, Surrey KT1 1LL. Tel: 020 8247 9900. E-mail: jim@visionsp.co.uk Web: www.visionsp.co.uk **Contact:** Jim Drewett, Editorial Director. **Subjects:** Sport.

WEIDENFELD & NICOLSON

Orion House, 5 Upper St Martinís Lane, London WC2H 9EA. Tel: 020 7240 3444. Fax: 020 7240 4822. Web: www.orionbooks.co.uk **Subjects:** Biography, cookery, history.

YALE UNIVERSITY PRESS

47 Bedford Square, London WC1B 3DP. Tel: 020 7079 4900. E-mail: x.x@yaleup.co.uk Web: www.yalebooks.co.uk Contact: Picture Research. Subjects: Architecture, art, history, politics, sociology.

CARDS, CALENDARS, POSTERS & PRINTS

This section lists publishers of postcards, greetings cards, calendars, posters and prints, along with their requirements. There is some overlap here, with many of the companies listed producing a range of products that fall into more than one of these categories,

With the exception of traditional viewcard producers, who have always offered rather meagre rates for freelance material, fees in this area are generally good. However, only those who can produce precisely what is required as far as subject matter, quality and format are concerned, are likely to succeed.

Market requirements

The need for material of the highest quality cannot be too strongly emphasised. The market is highly specialised with very specific requirements. If you aim to break into this field, you must be very sure of your photographic technique. You must be able to produce professional quality material that is pin sharp and perfectly exposed with excellent colour saturation.

You must also know and be able to supply *exactly* what the market requires. The listings will help you, but you should also carry out your own field study by examining the photographic products on general sale.

After a period in the doldrums the photographic greetings card has been making something of a comeback in recent years. Neverthless, the big mass-market card publishers still employ mostly art or graphics. Those that do use photography tend to be smaller, specialised companies, many of them publishing a full range of photographic products. These companies also use a lot of work from top photographers or picture libraries, which means that there is greater competition than ever to supply material for these products.

The calendar market is equally demanding, though fortunately there

are still large numbers of calendars using photographs being produced every year. Many calendar producers obtain the material they need from picture agencies, but this is not to say that individual photographers cannot successfully break into this field. Once again, though, you must be sure of your photographic technique and be able to produce really top quality work.

Make a point of studying the cards, calendars or posters that you see on general sale or hanging up in places you visit. Don't rely solely on what you think would make a good card or calendar picture; familiarise yourself with the type of pictures actually being used by these publishers.

Finally, it is worth noting that whilst many firms will consider submissions at any time, some in the calendar or greetings card market only select material at certain times of the year or when they are renewing their range. So when contemplating an approach to one of these firms, always check first to see if they are accepting submissions at the time.

Rights and fees

Where provided by the company concerned, fee guidelines are quoted. Some companies prefer to negotiate fees individually, depending upon the type of material you offer. If you are new to this field, the best plan is to make your submission (preferably after making an initial enquiry, outlining the material you have available) and let the company concerned make you an offer. Generally speaking, you should not accept less than about £75 for Greetings Card or Calendar Rights.

Remember, you are not selling your copyright for this fee; you are free to submit the same photograph to any *non-competitive* market (for example, a magazine) at a later date. But you should not attempt to sell the picture to another greetings card publisher once you have sold Greetings Card Rights to a competing firm.

CHRIS ANDREWS PUBLICATIONS LTD

15 Curtis Yard, North Hinksey Lane, Oxford OX2 0LX. Tel: 01865 723404. E-mail: enquiries@cap-ox.com Web: www.cap-ox.com/www.oxfordpicturelibrary.co.uk **Contact:** Chris Andrews (Proprietor). **Products:** Calendars, postcards, guidebooks, diaries, address books. **Products:** Atmospheric calcun impose of recominable places (terms

Requirements: Atmospheric colour images of recognisable places (towns, villages) throughout central England, specifically the Cotswolds, Oxfordshire, Cherwell Valley, Thames and Chilterns. Expanding range now covers London, the Thames, Windsor/Eton, Bristol, Winchester, Gloucester and York. Winterscapes especially welcome. Photographs not required for immediate use may be accepted into the Oxford Picture Library which is run in parallel.

Formats: Digital files on CD/DVD.

Fees: By negotiation.

THOMAS BENACCI

Unit 12, Bessemer Park, 250 Milkwood Road, London SE24 0HG. Tel: 020 7924 0635. E-mail: massimo@thomasbenacci.co.uk Web: www.thomasbenacci.co.uk **Contact:** Massimo Carminati (Manager). **Products:** Postcards. **Requirements:** Always interested in new views of London for sale to the tourist market – landmarks, scenes and buildings that are easily recognisable or interesting to tourists. Images should be bright and lively. **Formats:** All considered.

Fees: £50 for postcard rights.

CAROUSEL CALENDARS

Exe Box, Matford, Exeter EX2 8FD.

Tel: 01392 826482. E-mail: photoadmin@carouselcalendars.co.uk

Web: www.carouselcalendars.co.uk/photographers

Contact: Cathy Cornish (Photographic Administrator).

Products: Calendars.

Requirements: Wide range of subjects including British countryside; architecture and heritage; cottages and gardens; animals both domestic and wild, natural and humorous; transport. **Formats:** Digital submissions only, JPEG or TIFF. See website for full submission guidelines. **Fees:** Contact for standard rates or see website.

GB EYE LTD

1 Russell Street, Kelham Island, Sheffield S3 8RW. Tel: 0114 292 0086. E-mail: emily@gbeye.com

Web: www.gbeye.com

Contact: Emily Aldridge (Licensing Executive).

Products: Posters, prints, postcard packs, 3D lenticulars, badges, stickers, etc.

Requirements: Pin-up type images of youth-culture celebrities – contemporary pop stars, young film and TV actors/actresses, popular young sports stars. Colour or B&W, but must have immediate appeal to the youth market. Also open to new ideas for possible generic subjects – landscapes, animals, humour, etc.

Formats: Digital, 32x45cm at 300dpi. Fees: Negotiable.

HALLMARK CARDS PLC

Bingley Road, Heaton, Bradford BD9 6SD. Tel: 01274 252000. E-mail: creative-opportunities@hallmark-uk.com Web: www.hallmark.co.uk

The Freelance Photographer's Market Handbook 2015

Contact: Kelly Jones (Creative Manager). Products: Greetings cards, postcards, giftwrap. Requirements: Will consider any images suitable for these products. Formats: All considered. Fees: Dependent on work and use.

INDIGO ART LTD

Unit 1, Skiddaw Road, Croft Business Park, Bromborough, Wirral, CH62 3RB Tel: 0151 933 9779. E-mail: info@indigoart.co.uk Web: www.indigoart.co.uk **Contact:** Dave Bertram (Proprietor).

Products: Large-scale display prints for use in interior design projects.

Requirements: Striking colour or B&W images with a modern/contemporary look. Wide variety of styles considered: abstracts, close-ups, experimentation with light, angles or digital manipulation. Work in series preferred. See the Indigo Collection on website for current range of styles. Submission guidelines are available for download.

Formats: Digital (20–50MB), transparencies, prints or high-res scans (50MB). **Fees:** On a royalties basis, 10% of wholesale print price.

JUDGES POSTCARDS LTD

176 Bexhill Road, St Leonardís on Sea, East Sussex TN38 8BN.

Tel: 01424 420919. E-mail: michelle.renno@judges.co.uk

Web: www.judges.co.uk

Contact: Michelle Renno (Product Co-ordinator).

Products: Postcards, calendars, greetings cards.

Requirements: Images of England and Wales, local and regional, appealing to the tourist industry. Must be bright, sunny and vibrant. Landscapes, flowers, animals and any other imagery may be considered.

Formats: Film and digital. Small JPEG files may be sent for viewing purposes. Final digital submission must be to A3 at 300dpi, TIFFs in CMYK (convert RGB before submitting). Prefer unretouched original files.

Fees: Dependent on quality and quantity.

KARDORAMA LTD

PO Box 85, Potters Bar, Herts EN6 5AD. Tel: 01707 271710. E-mail: enquiries@kardorama.co.uk Web: www.kardorama.co.uk **Contact:** Alan Foxlee (Director).

Products: Postcards.

Requirements: Always seeking new views of London-major tourist sights or subjects that tourists would consider typical such as red buses, phone boxes, policemen, taxis, etc. Should be good record shots but with a hint of romance and plenty of detail in the main subject. Also, humorous images, any subject or location providing the image needs no explanation, but must be sharp and well exposed under good lighting conditions.

Formats: Digital files preferred (with print copy); 35mm and medium format transparencies also considered.

Fees: Variable, depending on quality of work, subject matter and quantities.

Are you working from the latest edition of The Freelance Photographer's Market Handbook? It's published on 1 October each year. Markets are constantly changing, so it pays to have the latest edition

PINEAPPLE PARK LTD

Unit 9, Henlow Trading Estate, Henlow, Bedfordshire SG16 6DS. Tel: 01462 814817. E-mail: sally@pineapplepark.co.uk Web: www.pineapplepark.co.uk **Contact:** Sally Kelly. **Products:** Greetings cards. **Requirements:** Seek high quality images of: 1) Animals-humourous or cute. 2) Male subjects – collections of wine bottles, sporting items, cars etc for male-orientated greetings cards. 3) Landscapes. Always happy to look at other ideas. **Formats:** Digital files.

Fees: By negotiation, for worldwide greetings card rights.

PORTFOLIO COLLECTION LTD

105 Golborne Road, London W10 5NL.
Tel: 020 8960 3051. E-mail: jayne@portfoliocards.com
Contact: Jayne Diggory (Director).
Products: Greetings cards and posters.
Requirements: Specialists in creative black and white photography. Strong, contemporary, expressive images – landscapes, cityscapes, people, etc. Also nostalgic images from the '60s and '70s-pop stars, swinging London, flower power, etc.
Formats: Prints from 10x8in up.

Fees: Usually on royalty basis at 12 per cent of distribution price. Flat fees may be negotiated.

QUAYSIDE CARDS

Exe Box, Matford, Exeter EX2 8FD. Tel: 01392 824300. E-mail: mjennings@otterhouse.co.uk Web: www.otterhouse.co.uk **Contact:** Michelle Jennings (Art Studio Manager). **Products:** Greetings cards. **Requirements:** Will consider British landscapes and wildlife, domestic pets (especially cats, dogs, horses), florals, transport, travel and Christmas images. **Formats:** Digital files preferred. **Fees:** By negotiation for purchase or on royalty basis.

NIGEL QUINEY PUBLICATIONS

Cloudesley House, Shire Hill, Saffron Walden, Essex CB11 3FB. Tel: 01799 520200. E-mail: alison.butterworth@nigelquiney.com Web: www.nigelquiney.com **Contact:** Carl Pledger. **Products:** Greetings cards. **Requirements:** Top quality colour images of animals (domestic and wild) in humorous or interesting situations, and florals – bright, modern, contemporary. Will also consider images suitable for anniversary, new baby, etc. **Formats:** Digital files.

Fees: Dependent on product/design, for world rights for five years.

RIVERSIDE CARDS

Unit 15, Jubilee Way, Grange Moor, Wakefield WF4 4TD. Tel: 01924 840500. E-mail: design@riversidecards.com Web: www.riversidecards.com **Contact:** Design Studio. **Products:** Greetings cards. **Requirements:** B&W and colour images of cute/funny domestic

Requirements: B&W and colour images of cute/funny domestic animals (kittens, puppies, etc), landscapes, seascapes, countryside scenes, snow scenes, artistic/natural florals,

dramatic/atmospheric sunsets/sunrise, sports, couples, trains, boats, vintage-style still life, wedding imagery.

Formats: Any considered including digital files (low-res JPEG for initial submission; high res TIFF required once order confirmed).

Fees: By negotiation.

ROSE OF COLCHESTER LTD

Clough Road, Severalls Industrial Estate, Colchester CO4 9QT.

Tel: 01206 844500. E-mail: simon@rosecalendars.co.uk

Web: www.rosecalendars.co.uk/www.reeve-calendars.com

Contact: Simon Williams (Publishing Manager).

Products: Calendars for business promotion.

Requirements: British and worldwide landscapes and wildlife. Also glamour, classic cars and supercars, adventure sport. Submit January for annual selection process, but material accepted throughout the year.

Formats: Full resolution files from high-end digital cameras or professional scans from medium and large format transparencies. All files must have accurate metadata embedded detailing subject matter, with exact location for scenic submissions.

Fees: Negotiable depending on subject matter.

SANTORO

Rotunda Point, 11 Hartfield Crescent, Wimbledon, London SW19 3RL.

Tel: 020 8781 1100. E-mail: submissions@santorographics.com

Web: santoro-london.com

Contact: J. Freeman

Products: Postcards and greetings cards.

Requirements: Striking and attractive images appealing to the typical young poster and card buyer: nostalgic, retro, contemporary, romantic, humorous and cute images of people, animals and situations. B&W a speciality, but colour images in contemporary styles are also sought. **Formats:** Any considered.

Fees: By negotiation for worldwide rights.

AGENCIES

Picture libraries and agencies are in the business of selling pictures. They are not in the business of teaching photography or advising photographers how to produce saleable work – although they can sometimes prove remarkably helpful in the latter respect to those who show promise. Their purpose is strictly a business one: to meet the demand for stock pictures from such markets as magazine and book publishers, advertising agencies, travel operators, greetings card and calendar publishers, and many more.

Many photographers look upon an agency as a last resort; they have been unable to sell their photographs themselves, so they think they might as well try unloading them on an agency. This is the wrong attitude. No agency will succeed in placing pictures which are quite simply unmarketable. In any event, the photographer who has had at least some success in selling pictures is in a far better position to approach an agency.

Agency requirements

If you hope to interest an agency in your work, you must be able to produce pictures which the agency feels are likely to sell to one of their markets. Although the acceptance of your work by an agency is no guarantee that it will sell, an efficient agency certainly will not clutter up its files with pictures which do not stand a reasonably good chance of finding a market.

Agents handle pictures of every subject under the sun. Some specialise in particular subjects – sport, natural history, etc – while others act as general agencies, covering the whole spectrum of subject matter. Any photograph that could be published in one form or another is a suitable picture for an agency.

Even if you eventually decide that you want to place all your potentially saleable material with an agency, you cannot expect to leave every aspect of the business to them. You must continue to study the market, watching for

The Freelance Photographer s Market Handbook 2015

trends; you must continue to study published pictures.

For example, if your speciality is travel material, you should use every opportunity to study the type of pictures published in current travel brochures and other markets using such material. Only by doing this – by being aware of the market – can you hope to continue to provide your agency with marketable pictures.

Nowadays agencies do most of their business online and maintain extensive websites displaying the images they hold. Though some still accept film images, most only want digitally-captured images or high-resolution scans.

Although agency websites are primarily aimed at potential picture buyers, they are equally valuable to the photographer considering an approach since they give a good indication of the type of subject and style of work the agency handles.

Commission and licensing

Agencies generally work on a commission basis, 50 per cent being the most usual rate – if they receive £100 for reproduction rights in a picture, the photographer gets £50 of this. Some agencies have more variable rates, depending on who handles keywording, scanning, etc should these be required.

The percentage taken may seem high, but it should be remembered that a picture agency, like any other business, has substantial overheads to account for.

There can also be high costs involved in making prospective buyers aware of the pictures that are available. Some larger agencies produce lavish colour catalogues featuring selections of their best pictures, while smaller agencies regularly send out flyers. All are involved in constantly maintaining and updating their websites.

Agencies do not normally sell pictures outright. As would the individual photographer, they merely sell reproduction rights, the image being licensed to the buyer for a specific purpose. Images may be licensed by size of reproduction, by territory in which they are published, by the medium in which they are reproduced, by time and/or quantity of reproductions, and can be exclusive or non-exclusive. Selling in this way is known as "rightsmanaged" licensing.

Other forms of selling undertaken by certain agencies are "royalty-free" and "microstock". Under these methods images are sold for a flat fee and pre-licensed for a specified range of uses. Fees are generally low, but this disadvantage may be offset by multiple sales of the same image.

A long-term investment

When dealing with a photographer for the first time, most agencies require a minimum initial submission – which can consist of anything from a few to 500 or more pictures. Most also stipulate that you must keep your material with them for a minimum period of anything from one to five years.

Dealing with an agency must therefore be considered a long-term investment. Having initially placed, say, a few hundred pictures with an agency, it could be at least several months before any are selected by a picture buyer, and even longer before any monies are seen by the photographer.

Normally, the photographer will also be expected to regularly submit new material to the library. Indeed, only when you have several hundred pictures lodged with the library can you hope for regular sales – and a reasonable return on your investment.

Making an approach

When considering placing work with an agency, the best plan is to make an initial short-list of those that seem most appropriate to your work.

Then contact the agency or agencies of your choice outlining the material you have available.

But remember that there is little point in approaching an agency until you have a sizeable collection of potentially saleable material. Most will not feel it worth their while dealing with a photographer who has only a dozen or so marketable pictures to offer – it just wouldn't be worth all the work and expense involved. And the chance of the photographer seeing a worthwhile return on just a dozen pictures placed with an agency are remote indeed; you'd be lucky to see more than one cheque in ten years!

In the listings that follow you'll find information on established agencies seeking work from new contributors: the subjects they handle, the markets they supply, the formats they stock, their terms of business (including any minimum submission quantity and minimum retention period), and their standard commission charged on sales.

Prefacing the listings you'll find an Agency Subject Index. This is a guide to agencies which have a special interest in those subjects, though many other agencies may also cover the same subjects within their general stock.

Remember: simply placing material with an agency doesn't guaran-

tee sales. And no agency can sell material for which there is no market. On the other hand, if you are able to produce good quality, marketable work, and can team up with the right agency, you could see a very worthwhile return from this association.

Subject Index

Agriculture

Ecoscene NHPA/Photoshot Panos Pictures Papilio Royal Geographical Society Picture Library

Architecture

Axiom Photographic Agency Living4media Loop Images View Pictures Ltd Elizabeth Whiting & Associates

Aviation

Alvey & Towers Skyscan Photolibrary

Botanical/Gardens

FLPA – Images of Nature Garden World Images Living4media NHPA/Photoshot Papilio Elizabeth Whiting & Associates TTL Plus

Business/Industry

Eye Ubiquitous Getty Images Robert Harding World Imagery Newscast Ltd Panos Pictures Picturebank Photo Library Ltd

Food/Drink

Bubbles Photo Library Foodanddrinkphotos.com Latitude Stock Stockfood Ltd Elizabeth Whiting & Associates

General (all subjects)

Adams Picture Library Alamy Corbis Eye Ubiquitous Getty Images Robert Harding World Imagery Image Source Photoshot Theimagefile.com Travel Pictures Ltd

Geography/Environment

Allan Cash Picture Library Axiom Photographic Agency Ecoscene Eye Ubiquitous FLPA – Images of Nature Latitude Stock NHPA/Photoshot Natural Science Photos Panos Pictures Papilio Picturebank Photo Library Ltd Royal Geographical Society Picture Library SCR Photo Library

Glamour

Camera Press Ltd Picturebank Photo Library Ltd

Historical

Bridgeman Images EE Heritage Images Royal Geographical Society Picture Library

Landscapes

Arcangel Images Collections Cornish Picture Library

The Freelance Photographer s Market Handbook 2015

Fotomaze Loop Images NHPA/Photoshot TTL Plus

Music

Arena PAL Camera Press Ltd Capital Pictures Famous Getty Images Jazz Index Photo Library Lebrecht Music & Arts Photo Library Retna Pictures

News/Current Affairs

Camera Press Ltd Demotix Express Syndication Getty Images News & Sport London Media Press London News Pictures Press Association Images Rex Features Ltd Zenith Image Library

People/Lifestyle

Allan Cash Picture Library Latitude Stock PYMCA Picturebank Photo Library Ltd Photofusion Picture Library Retna Pictures

Personalities/Celebrities

Arena PAL Camera Press Ltd Capital Pictures Eyevine Express Syndication FameFlynet Famous Getty Images News & Sport Lebrecht Music & Arts Photo Library London Media Press Newscast Ltd Nunn Syndication Press Association Images Retna Pictures Rex Features Ltd Writer Pictures

Science/Technology

Camera Press Ltd Image Source Picturebank Photo Library Ltd Science Photo Library

Social Documentary

Allan Cash Picture Library Bubbles Photo Library Collections EE Heritage Images Eye Ubiquitous PYMCA Panos Pictures Photofusion Picture Library Zenith Image Library

Sport

Action Images Ltd Action Plus/Compete Images Getty Images News & Sport Kos Picture Source Ltd Press Association Images

Transport

Alvey & Towers Railphotolibrary.com Skyscan Photolibrary

Travel/Tourist

A-Plus Image Bank Andes Press Agency Allan Cash Picture Library Axiom Photographic Agency Eye Ubiquitous Image Source Kos Picture Source Ltd Latitude Stock Picturebank Photo Library Ltd The Travel Library Travel Pictures Ltd World Pictures/Photoshot

Underwater

FLPA – Images of Nature Kos Picture Source Ltd Papilio

Wildlife

Ardea FLPA – Images of Nature NHPA/Photoshot Papilio Picturebank Photo Library Ltd TTL Plus

A-PLUS IMAGE BANK

29 Manor Court Drive, Handsacre, Rugeley WS15 4TF.
Tel: 01543 529747. E-mail: enquiries@aplusib.com
Web: www.aplusib.com
Contact: Ron Badkin or Caron Badkin.
Specialist subjects/requirements: Travel & tourism, plus general coverage of worldwide travel and associated topics including lifestyle, cultures, traditions, business and industry.
Markets supplied: Magazines, books, brochures, newspapers, travel companies, TV and advertising.
Formats accepted: Digital TIFF files of 28MB or higher.

Usual terms of business: Typically 3 years minimum retention.

Commision: 60 per cent to photographer.

Additional information: Formerly known as Andalucia Plus Image Bank. See Info for Photographers page on main website or for more details log on to contributor's site at www.apib-stockphotos.com

ACTION PLUS/COMPETE IMAGES

Pine Ridge, Dancers End Lane, Tring, Hertfordshire HP23 6TY.

Tel: 020 7403 1558. E-mail: photography@actionplus.co.uk

Contact: Stephen Hearn (Managing Director), Simon Gill (Picture Editor).

Web: www.actionplus.co.uk/www.compete-images.com

Specialist subjects/requirements: Seeks experienced sports photographers to cover events (Action Images). Also commercial sports images for use in generic applications (Compete Images). **Markets supplied:** News media, specialist magazines, advertising, etc.

Formats accepted: Digital only. For event photography an initial sample submission of 20-30 low resolution images that represent your work. For Compete Images TIFF files preferred, minimum 50MB.

Usual terms of business: For Compete Images pictures must be either model released or without recognisable people, minimum 50MB and not placed with any other agencies.

Commission: 50 per cent.

Additional information:: Regular photographers can be supplied with accreditation for events with the support of the agency.

ADAMS PICTURE LIBRARY (APL)

The Studio, Hillside Cottage, Hessenford, Cornwall PL11 3HH.

Tel: 01503 240211. E-mail: tam@adamspicturelibrary.com

Web: www.adamspicturelibrary.com

Contact: Dave Jarvis, Tamsyn Jarvis (Partners).

Specialist subjects/requirements: All subjects, with special interest in retro fashion.

Markets supplied: All markets including advertising, publishing, calendars and posters.

Formats accepted: Digital files preferred (30MB uncompressed).

Usual terms of business: Minimum initial submission: 100 images. Minimum retention period: 5 years; 1 yearís notice required for withdrawal.

Commission: 50 per cent (for exclusive images).

ALAMY

6ñ8 West Central, 127 Olympic Avenue, Milton Park, Abingdon, Oxon OX14 4SA. Tel: 01235 844608. Fax: 01235 844650. E-mail: memberservices@alamy.com

Web: www.alamy.com

Contact: Alan Capel (Head of Content); Alexandra Bortkiewicz (Director of Photography).

Specialist subjects/requirements: Quality images of all subjects ñ business, lifestyle, travel, food, abstracts, concepts, still life, science, wildlife, people, news, sport, celebrities and entertainment. Markets supplied: Advertising, design, corporate and publishing worldwide.

Formats accepted: Digital only, minimum 24MB, 48+MB preferred, uncompressed RGB JPEG. See website for full technical requirements.

Usual terms of business: Requires initial test submission of four images; if accepted no minimum submission applies.

Commission: 50 per cent.

Additional information: Photographers must supply their own digital files and keywording. Alamy do not edit photographersi submissions but files are checked for technical accuracy before being allowed online. For initial approach first register on the website.

ALVEY & TOWERS

Bythorn House, 8 Nether Street, Harby, Leicestershire LE14 4BW.

Tel/fax: 01949 861894. E-mail: office@alveyandtowers.com

Web: www.alveyandtowers.com

Contact: Emma Rowen (Library Manager).

Specialist subjects/requirements: All aspects of transport, air, sea and land, including associated industries and issues worldwide.

Markets supplied: Advertising, books, magazines, corporate brochures, calendars, audio visual.

Formats accepted: Digital only.

Usual terms of business: On application.

Commission: 40 per cent.

Additional information: It is essential that potential contributors make contact prior to making any submission in order to discuss precise requirements. Submission guidelines available via e-mail.

ANCIENT ART & ARCHITECTURE COLLECTION LTD

15, Heathfield Court, Heathfield Terrace, London W4 4LP.

Tel: 020 8995 0895. E-mail: library@aaacollection.co.uk

Web: www.aaacollection.com

Contact: Haruko Sheridan (Library Manager).

Specialist subjects/requirements: Historical art and artifacts mainly from pre-history up to the Middle Ages; everything which illustrates the civilisations of the ancient world, its cultures and technologies, religion, ideas, beliefs and development. Also warfare, weapons, fortifications and military historical movements. Statues, portraits and contemporary illustrations of historically important people ñ kings and other rulers.

Markets supplied: Mainly book publishers, but including magazines and TV.

Formats accepted: Digital files only, at 48MB minimum.

Usual terms of business: Minimum retention period: 3 years. 12 months notice of termination. **Commission:** 50 per cent to photographer.

Additional information: Detailed information for captions needed. All submissions must be accompanied by return sae. Only material of the highest quality with captions can be considered.

ANDES PRESS AGENCY

26 Padbury Court, Shoreditch, London E2 7EH.

Tel: 020 7613 5417. E-mail: photos@andespressagency.com

Web: www.andespressagency.com

Contact: Val Baker (Picture Editor).

Specialist subjects/requirements: Latin America, including the Caribbean; world religions. **Markets supplied:** Books, newspapers, magazines.

Formats accepted: All considered.

Usual terms of business: Minimum initial submission: 100 transparencies. Minimum retention period: 3 years.

Commission: By negotiation.

ANIMAL PHOTOGRAPHY

Unit K, Reliance Wharf, Hertford Road, London N1 5EW. Tel: 020 7193 4778. E-mail: info@animal-photography.com Web: www.animal-photography.com

The Freelance Photographer s Market Handbook 2015

Contact: Stephen Taylor (Director).

Specialist subjects/requirements: Domestic animals, especially cat, dog and horse breeds, farm animals, small pets. Only highest quality material from selected contributors.

Markets supplied: General publishing, cards and calendars, advertising.

Formats accepted: TIFF/JPEG files, minimum 12MB uncompressed, A4 at 300dpi.

Usual terms of business: Exclusivity required. Minimum submission: 1000 images. Minimum retention period: 3 or 5 years.

Commission: 50 per cent.

Additional information: New contributors are welcomed but must have a track record of producing work of the highest quality. New photographers are chosen to complement and build the variety of the collection.

ARCANGEL IMAGES LTD

Apartado 528, Calle Las Mimosas 85, Campo Mijas, Mijas Costa, 29649, Malaga, Spain. Tel: 0871 218 1023. E-mail: submissions@arcangel-images.com

Web: www.arcangel-images.com

Contact: Michael Mascaro (Director).

Specialist subjects/requirements: creative and fine art imagery, from nudes to landscapes and with the emphasis on digital capture. Will consider all types of images and styles, from general high-quality stock to personal fine art work.

Markets supplied: Book publishing, music industry, design companies, etc.

Formats accepted: Digital files only (minimum 17MB, preferred 30-40MB).

Usual terms of business: Minimum initial submission: 20 accepted images. Minimum retention period: 3 years.

Commission: 50 per cent.

Additional information: British/Spanish company with head office in Spain. Prefer initial approach by e-mail with a few sample images (totalling no more than 500KB) or a link to a personal website.

ARDEA

59 Tranquil Vale, London SE3 0BS.

Tel: 020 8318 1401. E-mail: paul@ardea.com

Web: www.ardea.com

Contact: Paul Brown (Managing Director).

Specialist subjects/requirements: International wildlife, pets and the environment.

Markets supplied: Magazines, books, newspapers, advertising etc.

Formats accepted: Digital only, minimum A4 size at 300dpi, ideally A3 at 300 dpi (55MB TIFF). **Usual terms of business:** Initial submission of 50 low-res JPEGs to reflect both quality and breadth of coverage of the work.

Additional information: All images must be clearly labelled in English in the IPTC of the image, with common name and scientific name to at least genus level, and a location if appropriate.

ARENA PAL

Thompson House, 42-44 Dolben Street, London SE1 0UQ.

Tel: 020 7403 8542. E-mail: enquiries@arenapal.com

Web: www.arenapal.com

Contact: Mike Markiewicz (Archive Manager).

Specialist subjects/requirements: Performing arts ñ theatre, music, dance, opera, jazz, TV, film, circus, festivals and venues, as well as relevant personalities.

Markets supplied: All media including publishing, arts bodies, advertising, design companies. Formats accepted: All formats, digital files preferred but transparencies still accepted.

Usual terms of business: No minimum initial submission, but expect around 100 images.

Minimum retention period: 3 years.

Commission: 50 per cent.

AXIOM PHOTOGRAPHIC AGENCY

10 The Shaftesbury Centre, 85 Barlby Road, London W10 6BN. Tel: 020 8964 9970. E-mail: submissions@axiomphotographic.com Web: www.axiomphotographic.com Contact: Tim Hook (General Manager). Specialist subjects/requirements: Top level travel photography, especially documentary, architectural and ethnographic material. Markets supplied: Publishing, design and advertising industries. Formats accepted: Digital 300dpi 50MB TIFF. Usual terms of business: Minimum initial submission: Maximum of 20 images submitted as low res JPEGs via e-mail. Commission: 50 per cent. Additional information: Material already with other agencies not accepted. For full submission guidelines see website. BRIDGEMAN IMAGES 17-19 Garway Road, London W2 4PH. Tel: 020 7727 4065. E-mail: info@bridgeman.co.uk

Web: www.bridgeman.co.uk

Contact: Adrian Gibbs (Collections Manager).

Specialist subjects/requirements: American, European and Oriental paintings and prints, antiques, antiquities, arms and armour, botanical subjects, ethnography, general historical subjects and personalities, maps and manuscripts, natural history, topography, transport, etc. Markets supplied: Publishing, advertising, television, greetings cards, calendars, etc. Formats accepted: Minimum 5x4in transparencies or 50MB digital files (RGB TIFF). Usual terms of business: No minimum initial submission. Retention period negotiable. Commission: 50 per cent.

BUBBLES PHOTO LIBRARY

3 Rose Lane, Ipswich IP1 1XE.

Tel: 01473 288247. E-mail: info@bubblesphotolibrary.co.uk

Web: www.bubblesphotolibrary.co.uk

Contact: Sarah Robinson, Loisjoy Thurstun (Partners).

Specialist subjects/requirements: Babies, children, pregnancy, mothercare, child development, education (especially aspects of multiculturalism), teenagers, old age, family life, women's health and medical, still lives of food, vegetables, herbs, etc.

Markets supplied: Books, magazines, newspapers and advertising.

Formats accepted: All formats but digital files preferred (A3 at 300dpi)

Usual terms of business: Minimum initial submission: 100 images. Regular contributions expected. Minimum retention period: 3 years.

Commission: 50 per cent.

Additional information: Attractive women and children sell best. Always looking for multicultural and multiracial children/adults. Photographers must pay close attention to selecting models that are healthy-looking and ensure that backgrounds are uncluttered. Best clothes to wear are light coloured and neutral fashion.

CAMERA PRESS LTD

21 Queen Elizabeth Street, London SE1 2PD. Tel: 020 7378 1300. E-mail: j.wald@camerapress.com Web: www.camerapress.com **Contact:** Jacqui Ann Wald (Editorial Director). **Specialist subjects/requirements:** Photographs and illustrated features covering celebrity and personality portraiture, news, reportage, humour, music, food, fashion, beauty and interiors. Formats accepted: Digital preferred (min 30MB) but scanning still undertaken. Usual terms of business: By mutual agreement. Commission: 50 per cent.

CAPITAL PICTURES

85 Randolph Avenue, London W9 1DL.

Tel: 020 7286 2212. E-mail: sales@capitalpictures.com

Web: www.capitalpictures.com

Contact: Phil Loftus (Manager).

Specialist subjects/requirements: Celebrities and personalities from the worlds of showbusiness, film and TV, rock and pop, politics and royalty.

Markets supplied: UK and international magazines, newspapers, etc.

Formats accepted: Digital only.

Usual terms of business: Minimum initial submission: 100 images. Minimum retention period: 1 year.

Commission: 50 per cent.

THE ALLAN CASH PICTURE LIBRARY

21 Ceylon Road, London W14 OPY.

Tel: 020 7371 2224. E-mail: david@allancashpicturelibrary.com

Web: www.allancashpicturelibrary.com

Contact: David Bromley (Manager).

Specialist subjects/requirements: Travel and documentary photography from around the world, including culture, industry, native peoples, nature, landmarks and historical images.

Markets supplied: Magazines, newspapers, advertising, travel trade.

Formats accepted: Digital files and film negatives.

Usual terms of business: Minimum initial submission: 100 images. Minimum retention period: 3 months.

Commission: 50 per cent.

Additional information: The library is based on the lifetime's work, covering over 75 countries, of the renowned 20th century travel photographer James Allan Cash FRPS, FIBP.

COLLECTIONS

13 Woodberry Crescent, London N10 1PJ.

Tel: 020 8883 0083. E-mail: sal@salshuel.co.uk

Web: www.collectionspicturelibrary.co.uk

Contact: Brian, Sal and Simon Shuel (Directors).

Specialist subjects: The British Isles and Ireland.

Markets supplied: All, particularly on the editorial side.

Formats accepted: All formats, digital preferred (min 26MB), will consider transparencies and B&W prints, but only in exceptional circumstances

Usual terms of business: By arrangement; ieasy going and on the side of the contributor.î **Commission:** 50 per cent.

Additional information: The library aims to stock quality pictures of as many places, things, happenings on these islands as possible.

CORBIS

111 Salusbury Road, London NW6 6RG. Tel: 020 7644 7644. E-mail: info@corbis.com Web: www.corbis.com **Contact:** Vanessa Kramer (Director of Artistic Relations).

Specialist subjects/requirements: General library handling most subjects, on both a licensed and royalty-free basis.

Markets supplied: Advertising, publishing, design, etc.

Formats accepted: Digital files only, minimum 10MB (current events) or 50MB (editorial/advertising).

Usual terms of business: Minimum initial submission variable. Minimum retention period: 3 years.

Commission: 20ñ50 per cent, depending on client and use.

Additional information: For detailed contributor submission information see http://studioplus.corbis.com

CORNISH PICTURE LIBRARY

40b Fore Street, St Columb Major, Cornwall TR9 6RH. Tel: 01637 880103. E-mail: paul@imageclick.co.uk Web: www.imageclick.co.uk

Contact: Paul Watts (Proprietor).

Specialist subjects/requirements: Cornwall and the West Country (Devon, Dorset, Somerset, Wiltshire, Isles of Scilly, Channel Isles) ñ landscapes, historic sites, gardens, people, activities, attractions, wildlife.

Markets supplied: Magazines, books, tourism, etc.

Formats accepted: Digital files from 10MP cameras upwards, minimum 30MB TIFF; must be colour correct preferably with Adobe 1998 profile and with full picture details and keywords in metadata.

Usual terms of business: No minimum submission. Minimum retention period: 5 years. Commission: 50 per cent.

Additional information: Contact by e-mail to request contributors' guidelines before sending submission. Browse website for more info and to view images already held; very similar images not required, only better shots or different views.

THE DEFENCE PICTURE LIBRARY LTD

Sherwell House, 54 Staddiscombe Road, Plymouth PL9 9NB.

Tel: 01752 403333. E-mail: dpl@defencepictures.com

Web: www.defencepictures.com

Contact: David Reynolds (Director).

Specialist subjects/requirements: Military images covering all aspects of the armed forces worldwide, in training and on operations. Pictures of UK and international forces across the globe are always of interest.

Markets supplied: Publishers, advertising agencies, national media.

Formats accepted: Digital.

Usual terms of business: Minimum initial submission: 50 quality images. Minimum retention period: 5 years.

Commission: 50 per cent.

Additional information: The library is the UKis leading specialist source of military and defence images.

DEMOTIX

111 Salusbury Road, London NW6 6RG.

Tel: 020 7644 7501. E-mail: info@demotix.com

Web: www.demotix.com

Contact: Ossie Ikeogu (Newsdesk & Assignments Manager).

Specialist subjects/requirements: News and current affairs images and footage, from any part of the world. Will also consider eyewitness accounts, analysis of current events and opinion pieces. **Markets supplied:** Worldwide news media.

Formats accepted: Digital only, 6MB+.

Usual terms of business: No minimum submission terms. Maximum of 25 images per story/upload. Contributors may opt to sell on an exclusive or non-exclusive basis.

Commission: 50 per cent.

Additional information: Ensure correct keywording and as much background information as possible.

EE HERITAGE IMAGES

Beggars Roost, Woolpack Hill, Smeeth, Nr Ashford, Kent TN25 6RR.

Tel: 01303 812608. E-mail: isobel@eeimages.co.uk

Contact: Isobel Sinden (Manager).

Specialist subjects/requirements: British and world heritage, religions, death (ceremonies etc), architecture, festivals, manuscripts/illustrations, Biblelands, religious and secular stained glass, places of interest, eccentricities, transport, vintage.

Markets supplied: General publishing, advertising, TV, merchandising.

Formats accepted: Digital files with short explanatory caption and keywords.

Usual terms of business: Minimum initial submission: 50 images unless specialist subject.

Minimum retention period: 5 years. Commission: 50 per cent.

ECOSCENE

Empire Farm, Throop Road, Templecombe, Somerset BA8 0HR.

Tel: 01963 371700. E-mail: sally@ecoscene.com

Web: www.ecoscene.com

Contact: Sally Morgan (Proprietor).

Specialist subjects/requirements: Environmental issues worldwide including agriculture, conservation, energy, pollution, transport, sustainable development.

Markets supplied: Books, magazines, organisations, etc.

Formats accepted: Digital files at 50MB.

Usual terms of business: Minimum initial submission: 100 quality images. Minimum retention period: 4 years.

Commission: 55 per cent to photographer.

Additional information: Contributorsí guidelines available on request ñ can also be found on the libraryís website along with details of specific current requirements.

EXPRESS SYNDICATION

10 Lower Thames Street, London EC3R 6EN.

Tel: 0208 612 7884. E-mail: mark.swift@express.co.uk

Web: www.expresspictures.com

Contact: Mark Swift (Syndication Manager).

Specialist subjects/requirements: Current news, features and personalities.

Markets supplied: Magazines and newspapers, UK and overseas.

Formats accepted: All formats.

Usual terms of business: Minimum retention period: 90 days.

Commission: 50 per cent.

Additional information: Represents the Daily and Sunday Express, Daily Star and OK! magazine as well as freelance photographers and other agencies.

EYE UBIQUITOUS & HUTCHISON

PO Box 2190, Shoreham, West Sussex BN43 7EZ.

Tel: 01243 864005. E-mail: library@eyeubiquitous.com

Web: www.eyeubiquitous.com

Contacts: Paul Scheult (Proprietor), Stephen Rafferty (Library Manager).

Specialist subjects/requirements: Material suitable for the travel/tourist industry (scenics,

resorts, beaches, major sights), plus general stock and social documentary material (people,

lifestyles, work, environment, etc). Also incorporates the Hutchison Picture Library offering in-depth documentary coverage of indigenous cultures worldwide.

Markets supplied: Publishing markets, travel industry, UK and European advertising agencies. **Formats accepted:** Digital (50MB TIFF) or colour transparency.

Usual terms of business: Suggested minimum submission 200 images, but terms open to discussion.

Commission: 40 per cent.

Additional information: The collections are run as separate entities, though contributing photographers may have work with more than one.

EYEVINE

3 Mills Studios, Three Mill Lane, London E3 3DU.

Tel: 020 8709 8709. E-mail: info@eyevine.com

Web: www.eyevine.com

Contact: Graham Cross (Director).

Specialist subjects/requirements: Portraiture, news and reportage.

Markets supplied: Worldwide editorial publishing (newspapers, magazines, books etc). **Formats accepted:** Digital files preferred, minimum 30MB RGB JPEG. Colour/B&W print or transparency also accepted.

Usual terms of business: Minimum initial submission: 1 image. Minimum retention period: 3 years.

Commission rate: 50 per cent.

Additional information: Although a news, feature, personalities and assignments agency we are only looking to take on portraiture at this stage. See website for further information.

FLPA - IMAGES OF NATURE

Pages Green House, Wetheringsett, Stowmarket, Suffolk IP14 5QA.

Tel: 01728 860789. Fax: 01728 860222. E-mail: pictures@flpa-images.co.uk

Web: www.flpa-images.co.uk

Contact: Jean Hosking, David Hosking (Directors).

Specialist subjects/requirements: Natural history and weather phenomena: birds, clouds, fish, fungi, insects, mammals, pollution, rainbows, reptiles, sea, snow, seasons, trees, underwater, hurricanes, earthquakes, lightning, volcanoes, dew, rain, fog, etc. Ecology and the environment. Horse, dog and cat breeds.

Markets supplied: Book publishers, advertising agencies, magazines.

Formats accepted: Digital files at 50MB (contact agency for guidelines).

Usual terms of business: Minimum initial submission: 20 images for evaluation. Minimum retention period: 4 years.

Commission: 50 per cent.

Additional information: Only a few new photographers taken on each year. Competition in the natural history field is fierce, so only really sharp, well-composed pictures are needed. Sales are slow to start with, and a really keen photographer must be prepared to invest money in building up stock to the 1,000 mark.

FAMEFLYNET

Suite 14, 20 Churchill Square Business Centre, Kings Hill, West Malling, Kent ME19 4YU. Tel: 020 3551 5049. E-mail: info@fameflynet.uk.com

Web: www.fameflynet.biz

Contact: John Churchill (UK Director).

Specialist subjects/requirements: Celebrity images ñ news pictures, paparazzi and candid shots, pictures from film sets, red carpet events, awards, premieres and fashion shows. etc. Also celebrity news stories and video coverage.

Markets supplied: Worldwide media.

Formats accepted: Digital.

Usual terms of business: Minimum initial submission: N/A. Minimum retention period: N/A. **Commission:** Variable, dependent on material offered.

Additional information: The agency was formed out of the merger of leading US celebrity agencies Fame Pictures and Flynet Pictures. Now international with affiliate offices in UK, Germany, France, Spain, Portugal, Sweden and Norway.

FAMOUS

13 Harwood Road, London SW6 4QP.
13 Harwood Road, London SW6 4QP.
14 rel: 020 7731 9333. Fax: 020 7731 9330. E-mail: info@famous.uk.com
Web: www.famous.uk.com
Contact: Rob Howard (Managing Director).
Specialist subjects/requirements: Celebrity photographs, especially personalities in the TV, movie, music, fashion and Royal fields. Taken in any situation: red carpet, paparazzi, party, performance, studio and at home.
Markets supplied: Editorial, advertising, merchandise.
Formats accepted: Digital only.
Usual terms of business: No minimum submission or retention period.
Commission: 50 per cent.

Additional information: Always looking for photographers who can supply relevant pictures fast.

FOODANDDRINKPHOTOS.COM

Food and Drink Photos Ltd, Unit 321 Wey House, 15 Church Street, Weybridge, Surrey KT13 8NA. Tel: 01932 702287. E-mail: support@foodanddrinkphotos.com

Web: www.foodanddrinkphotos.com

Contact: Mark Butler (Proprietor).

Specialist subjects/requirements: All food and drink related photography, all styles, both traditional and more conceptual.

Markets supplied: Editorial, advertising and design.

Formats accepted: Digital files (50ñ80MB).

Usual terms of business: Minimum initial submission: 20 images. Minimum retention period: 3 years.

FOTOMAZE

12 Penlee Street, Penzance, Cornwall TR18 2DE.

Tel: 01736 350192. E-mail: admin@fotomaze.com

Web: www.fotomaze.com

Contact: Lee Searle (Managing Director).

Specialist subjects/requirements: All Cornwall-related subjects ñ landscapes, seascapes,

lifestyle, music, etc. Also creative images suitable for wall display or decoration.

Markets supplied: Tourist/travel trade, publishing, advertising and design. Also sells display prints to business or public.

Formats accepted: Digital files, 300 dpi and over 5MB in size. All images to be uploaded online. Usual terms of business: Minimum initial submission: 5 sample images. Minimum retention period: None stated.

Commission: 60 per cent to photographer.

Additional information: The agency is particularly interested in new talent. Contributors can choose to sell rights-managed or royalty-free. See website for further details.

GARDEN WORLD IMAGES LTD

70, Chapel Road, West Berghott, Colchester, Essex, CO6 3JA.

Tel: 01206 343620. E-mail: info@gardenworldimages.com

Web: www.gardenworldimages.com

Contact: Tyrone McGlinchey (Director).

Specialist subjects/requirements: All aspects of horticulture, plants, vegetables, fruit, herbs, trees, gardens, pools, patios, etc. Also gardening action shots, people doing things, step-by-step, making patios, etc. Creative abstract images.

Markets supplied: Publishing, calendars, seed catalogues, etc.

Formats accepted: Digital images preferred, minimum 50MB.

Usual terms of business: Minimum initial submission: 50 images. Minimum retention period: 2 years.

Commission: 50 per cent.

Additional information: Plant portraits must be identified with Latin name.

GETTY IMAGES

101 Bayham Street, London NW1 0AG.

Tel: 020 7267 8988. E-mail: editor@gettyartists.com

Web: http://creative.gettyimages.com

Contact: Editorial Submissions Team.

Specialist subjects/requirements: Conceptual and general stock photography on all subjects. **Markets supplied:** Advertising, publishing, design agencies, etc.

Formats accepted: Digital.

Usual terms of business: On application, for rights-managed and royalty-free sales. **Commission:** Variable, usually 35% to photographer.

Additional information: The Getty Images Creative division incorporates several major collections including Digital Vision, The Image Bank, Photolibrary, Redferns, Stockbyte, Stone and Photodisc. For contributor information see www.gettyimages.com/contributors

GETTY IMAGES NEWS & SPORT

101Bayham Street, London NW1 0AG.
Tel: 0800 376 7981. E-mail: editorialsubmissions@gettyimages.com
Web: http://editorial.gettyimages.com
Contact: Hugh Pinney (Director of Photography).
Specialist subjects/requirements: Contemporary news, sport and entertainment images.
Markets supplied: Newspapers, magazines, television, etc.
Formats accepted: 35mm and digital (for news).
Usual terms of business: Minimum retention period: 3 years.
Commission: 35-50 per cent to photographer.

ROBERT HARDING WORLD IMAGERY

Nicholsons House, Nicholsons Walk, Maidenhead, Berkshire SL6 1LD. Tel: 020 7478 4000. E-mail: fraser@robertharding.com Web: www.robertharding.com **Contact:** Fraser Hall (Picture Editor). **Specialist subjects/requirements:** Travel. **Markets supplied:** Publishers, advertising agencies, design groups, calendar publishers, etc. **Formats accepted:** Digital only, 50MB+. **Usual terms of business:** Minimum initial submission: 150ñ300 images. Minimum retention period: 7 years; 12 months notice of withdrawal.

Commission: As per contract; usually 30% to photographer.

Additional information: For initial submission RAW files must also be included. Will only consider images from professional digital SLR cameras with a minimum data capability of 16 megapixels, shot as RAW and converted to JPEG.

As a member of the Bureau of Freelance Photographers, you'll be kept up-to-date with markets through the BFP Market Newsletter, published monthly. For details of membership, turn to page 9

IMAGE SOURCE

41 Great Pulteney Street, London W1F 9NZ.

Tel: 020 7851 5600. E-mail: submissions@imagesource.com

Web: www.imagesource.com

Contact: Siri Vorbeck (Director of Photography Europe).

Specialist subjects/requirements: Nine main collections covering all styles and subjects: Image Source RF, Cultura RF, Cultura RM, Cultura RM (Getty Images), Cultura RM (Travel), Cultura RM (Science), Cultura RM Science (Oxford Scientific), Image Source Asia RF and Image Source Asia RM.

Markets supplied: Publishing, advertising and design worldwide.

Formats accepted: Digital.

Usual terms of business: Send link to portfolio or a selection of sample images. A formal contract will be offered after work has been reviewed for suitability.

Commission: 50 per cent.

Additional information: Each contributing photographer has an assigned art director who can supply creative direction, market information and feedback. The agency has offices in both London and New York plus a global distribution network in more than 80 countries.

JAZZ INDEX PHOTO LIBRARY

26 Fosse Way, London W13 0BZ.

Tel: 020 8998 1232. E-mail: christianhim@jazzindex.co.uk

Web: www.jazzindex.co.uk

Contact: Christian Him (Principal).

Specialist subjects/requirements: Jazz, blues, world music and related contemporary music. Good atmospheric shots of musicians (do not have to be well-known). Both contemporary and archive material of interest.

Markets supplied: Newspapers, book publishers, videos, television.

Formats accepted: All transparency formats; B&W prints or negs; digital at 300dpi.

Commission: 50 per cent.

Usual terms of business: No minimum submission.

Additional information: Always interested in jazz photos from the '50s, '60s or '70s and may buy old negs or slides outright if suitable. Contributors should always telephone first.

KOS PICTURE SOURCE LTD

PO Box 104, Midhurst, West Sussex GU29 1AS.

Tel: 020 7801 0044. Fax: 020 7801 0055. E-mail: images@kospictures.com

Web: kospictures.com

Contact: Chris Savage (Library Manager).

Specialist subjects/requirements: Water-related images from around the world. International yacht racing, all watersports, seascapes, underwater photography, and general travel.

Markets supplied: Advertising, design, publishing.

Formats accepted: Digital files (min 30MB).

Usual terms of business: No minimum initial submission. Minimum retention period: 2 years. Commission: Variable.

LATITUDESTOCK

The Old Coach House, 14 High Street, Goring-on-Thames, Berkshire RG8 9AR.

Tel: 01491 873011. E-mail: info@latitudestock.com

Web: www.latitudestock.com

Contact: Felicity Bazell (Collections Manager), Stuart Cox.

Specialist subjects/requirements: All aspects of travel and tourism, from destinations to forms of transport, food, things to buy, famous sights, hotel shots to native lifestyles. All countries including the UK. Particularly interested in travel lifestyle images.

Markets supplied: Travel industry, magazines, books, newspapers, advertising etc.

Formats accepted: Digital only.

Usual terms of business: Minimum initial submission: 200 images. Minimum retention period: 3 years.

Commission: 40 per cent to photographer.

Additional information: Full submissions guidelines on website. If interested in submitting, please e-mail in the first instance.

LEBRECHT MUSIC & ARTS PHOTO LIBRARY

3 Bolton Road, London NW8 0RJ.

Tel: 020 7625 5341. E-mail: pictures@lebrecht.co.uk

Web: www.lebrecht.co.uk; www.authorpictures.co.uk

Contact: Elbie Lebrecht (Proprietor).

Specialist subjects/requirements: Music & Arts pictures. All aspects of music (classical, opera, jazz, rock) and the performing arts, instruments, composers, musicians, singers, interiors and exteriors of concert halls and opera houses, statues and tombs of famous composers in the UK and abroad. Author Pictures ñ living and dead writers, novelists, politicians, scientists, philosophers, theologians. Playwrights and their plays; historic and modern performances. Visual artists and their work.

Markets supplied: Specialist magazines, national press, book publishers.

Formats accepted: Digital submissions preferred, minimum 20MB (300dpi 50MB TIFF). **Usual terms of business:** No minimum initial submission or retention period.

Commission: 50 per cent.

Additional information: The library has three connected divisions with their own websites ñ Music & Arts Pictures, Author Pictures and Art-Images.

LIVING4MEDIA

Signet House, 49-51 Farringdon Road, London EC1M 3JP.

Tel: 020 7438 1227 (UK sales).

Web: www.living4media.com

Contact: Petra Thierry (Photographers & Art Department, Munich).

Tel: +49 89 747 202 22. E-mail: photographer@living4media.com

Specialist subjects/requirements: All types of interior design, home and garden imagery and illustrated features, including home decoration, DIY and design-related lifestyle pictures.

Markets supplied: Advertising, design, magazine and book publishing.

Formats accepted: Digital (34MB+ from camera, scans at least 50MB+).

Usual terms of business: Minimum initial submission: 100 images. Minimum retention period: 5 years (exclusive representation required).

Commission: Commission to photographer 40 per cent for rights-managed, 30 per cent royalty-free. **Additional information:** As a subsidiary of StockFood, the world's leading food image agency, the living4media collection is distributed worldwide in more than 75 countries. Head office is based in Munich (Germany), with other offices in Kennebunk, Maine (USA) and London. All initial photographer contact should be made via website.

LONDON MEDIA PRESS

11a Printing House Yard, London E2 7PR.

Tel: 020 7613 2548. Fax: 020 7729 9209. E-mail: pictures@london-media.co.uk

Web: www.london-media.co.uk

Contact: Rick Hewett, Andrew Buckwell (Directors).

Specialist subjects/requirements: News pictures, picture stories and features for worldwide syndication, especially celebrity/paparazzi material.

Markets supplied: National and international newspapers and magazines.

Formats accepted: Digital only.

Usual terms of business: No minimum initial submission. Minimum retention period: None stated.

Commission: 60 per cent to contributor.

Additional information: Freelance shift work frequently available.

LONDON NEWS PICTURES (LNP)

7 Portman Road, Kingston, KT1 3DY

Tel: 020 8408 0190 E-mail: press@londonnewspictures.co.uk (professional assignment photography); mypix@londonnewspictures.co.uk (on-spec images)

Web: www.londonnewspictures.co.uk

Contact: Stephen Simpson (Director).

Specialist subjects/requirements: News and press feature photography. Will consider approaches from professional editorial photographers based outside London who can to contribute news and feature images on a story by story basis. Newsworthy, interesting or amusing single images also considered on spec.

Markets supplied: News media and magazines worldwide.

Formats accepted: Digital only.

Usual terms of business: Initial submission of 10-15 representative images, sized at 1000px on the longest side at around 500k. Include cuttings and/or website link.

Commission: 60 per cent.

Additional information: Regular contributors are expected to have professional equipment, laptop and access to an FTP client for filing images. LNP is a collaborative agency run by professional editorial photographers working in London and throughout the UK.

LOOP IMAGES

86-90 Paul Street, London EC2A 4NE.

Tel: 020 3397 0804. E-mail: picturedesk@loopimages.com

Web: www.loopimages.com

Contact: Paul Mortlock (Proprietor).

Specialist subjects/requirements: Contemporary Britain, worldwide travel and creative imagery. **Markets supplied:** Magazine/book/newspaper publishers, design and ad agencies, travel and tourism industry in UK/US and Europe.

Formats accepted: Digital only ñ 50MB TIFF as library master.

Usual terms of business: Minimum initial submission: 50 images. Minimum retention period: 3 years.

Commission rate: 50 per cent.

Additional information: Looking for quality material taken on professional cameras.

MILLENNIUM IMAGES LTD

17D Ellingfort Road, London, E8 3PA.

Tel: 020 8985 1144. E-mail: mail@milim.com

Web: www.milim.com

Contact: Niall O'Leary (Art Director).

Specialist subjects/requirements: Creative contemporary photography with a strong individual style.

Markets supplied: Book publishers, advertising and design, general publishing.

Formats accepted: Digital files, 50-60MB TIFF.

Usual terms of business: Minimum initial submission: 20 - 40 images. Minimum retention period: 3 years.

Commission: 50 per cent.

Additional information: Particularly keen to see work from young innovative photographers. The agency not only sells reproductions rights but also arranges commissions and passes on image requests from picture buyers.

NHPA/PHOTOSHOT

29-31 Saffron Hill, London EC1N 8SW. Tel: 020 7421 6003. E-mail: ldalton@photoshot.com Web: www.nhpa.co.uk

Contact: Lee Dalton (Picture Editor).

Specialist subjects/requirements: Worldwide wildlife, domestic animals and pets, plants and gardens, landscapes, agriculture and environmental subjects. Endangered and appealing wildlife of particular interest.

Markets supplied: Books, magazines, advertising and design, cards and calendars, electronic publishing, exhibitions, etc (UK and overseas).

Formats accepted: Digital files preferred, transparencies accepted.

Usual terms of business: Minimum initial submission: 200 images. Minimum retention period: 3 years, with a one year rolling extension.

Commission: 50 per cent.

Additional information: Pictures should be strong, active and well-composed. Full submissions guidelines available on website. NHPA forms the central wildlife and nature collection in the Photoshot group of companies.

NEWSCAST LTD

First Floor, The Communications Building, 48 Leicester Square, London WC2H 7FG. Tel: 020 3137 9137. Fax: 020 3137 1553. E-mail: photo@newscast.co.uk

Web: www.newscast.co.uk

Contact: Scott Draper (Head of Client Services).

Specialist subjects/requirements: Corporate, consumer and professional portrait photography. Markets supplied: Magazines, newspapers, online publications and broadcasting media worldwide. Formats accepted: Digital files preferred, minimum 18MB JPEG/TIFF.

Usual terms of business: No minimum requirements.

Commission: 50 per cent.

Additional information: This is an entirely Web-based syndication service. For image security the website is password-protected allowing the image owner to track daily downloads. All images are watermarked for protection.

NUNN SYNDICATION

PO Box 11014, Bishops Stortford, CM23 9HH.

Tel: 020 7357 9000. Fax: 020 7231 3912. E-mail: production@nunn-syndication.com

Web: www.nunn-syndication.com

Contact: Robin Nunn (Managing Director).

Specialist subjects/requirements: All aspects of the British royal family, including state occasions, foreign tours, informal shots, etc. Also foreign royalty and general celebrities. **Markets supplied:** General publishing.

Formats accepted: Digital files and 35mm transparencies.

Usual terms of business: No minimum terms specified.

Commission: 40 per cent.

ONIMAGE

27 Graham Road, London, N15 3EH.

Tel/fax: 020 8881 5101. E-mail: info@onimage.co.uk

Web: www.onimage.co.uk

Contact: Andre Pinkowski (Managing Director).

Specialist subjects/requirements: Contemporary and evocative imagery with a distinctive visual style and character.

Markets supplied: Advertising, design agencies, magazine publishing and book publishing. **Formats accepted:** Digital files preferred, shot on at least a 12.5MP camera or scans of near drum scan quality at 50MB (for 35mm). Colour negative and transparency also accepted for in-house scanning.

Usual terms of business: Minimum initial submission: 40 images. Minimum retention period: 3 years.

Commission: 50 per cent.

Additional information: Potential contributors are advised to look at the website to gain an idea of the type and style of material required.

PYMCA

39, Aldensley Road, London, W6 0DH.

Tel: 020 7437 0391. E-mail: james@pymca.com

Web: www.pymca.com

Contact: James Lange (Library Manager).

Specialist subjects/requirements: All images related to youth and subcultures, from the past (1940s/50s) to the present day, UK and abroad. Areas of particular interest: street fashions; lifestyle; social documentary; music/clubbing; recreational sport; related incidental imagery.

Markets supplied: General publishing, editorial, advertising, design, music industry etc.

Formats accepted: All formats, digital files preferred (min 28MB TIFF). Video footage.

Usual terms of business: Minimum initial submission: 20 pictures. Minimum retention period: 3 years.

Commission: 50 per cent.

Additional information: Particularly interested in model-released work for the Model Release collection, which is aimed primarily at commercial advertising and design markets. Also seeking video footage of youth subcultures, plus essays/text about different scenes and stories/experiences about being involved in these.

PANOS PICTURES

Unit K, Reliance Wharf, Hertford Road, London N1 5EW. Tel: 020 3322 8382. E-mail: pics@panos.co.uk

Web: www.panos.co.uk

Contact: Adrian Evans (Director).

Specialist subjects/requirements: Documentary coverage of the Third World and Eastern Europe, focusing on global social, economic and political issues and with special emphasis on enviroment and development.

Markets supplied: Newspapers and magazines, book publishers, development agencies. Formats accepted: Digital only.

Usual terms of business: No minimum initial submission or retention period. Commission: 50 per cent.

Additional information: 50 per cent of all profits from the library are covenanted to the Panos Institute, an international development studies group.

PAPILIO

155 Station Road, Herne Bay, Kent CT6 5QA.

Tel: 01227 360996. E-mail: library@papiliophotos.com

Web: www.papiliophotos.com

Contact: Justine Pickett or Robert Pickett (Directors).

Specialist subjects/requirements: All aspects of natural history worldwide, including plants, insects, birds, mammals and marine life.

Markets supplied: Books, magazines, advertising, etc.

Formats accepted: Digital preferred (shot as RAW in camera, minimum 17MB TIFF after conversion).

Usual terms of business: Minimum initial submission: 100 images. Minimum retention period: 5 years.

Commission: 50 per cent.

Additional information: Digital files preferred, but contact first before sending digital submissions to obtain full detailed requirements.

PHOTOFUSION PICTURE LIBRARY

17a Electric Lane, Brixton, London SW9 8LA.

Tel: 020 7733 3500. E-mail: library@photofusion.org

Web: www.photofusionpictures.org

Contact: Gavin Bambrick (Library Manager).

Specialist subjects/requirements: All aspects of contemporary life with an emphasis on environmental and social issues. Specialist areas include children, disability, education, environment, the elderly, families, health, housing & homelessness, plus people generally. Markets supplied: UK book and magazine publishing, newspapers, charities, annual reports, etc.

Formats accepted: Digital files (minimum 30MB).

Usual terms of business: No minimum initial submission. Minimum retention period: 3 years. **Commission:** 50 per cent.

Additional information: Particularly looking for photographers who have good access to cover education and health. Also coverage from Scotland and/or Northern Ireland.

PHOTOSHOT

29-31 Saffron Hill, London EC1N 8SW.

Tel: 020 7421 6000. Fax: 020 7421 6006. E-mail: info@photoshot.com

Web: www.photoshot.com

Contact: Charles Taylor (Managing Director).

Specialist subjects/requirements: Wide variety of subject matter within various distinct collections including UPPA (news); London Features International, Starstock and Stay Still (celebrity, entertainment); World Illustrated (culture, environment, heritage); Red Cover (homes/interiors), Talking Sport (sport). Also several nature and travel collections including NHPA, PictureNature and World Pictures (see separate listings).

Markets supplied: Newspapers, magazines, book publishers, broadcasting, advertising, etc. Formats accepted: All formats, digital preferred.

Usual terms of business: Minimum retention period: 3 years, with a one year rolling extension. **Commission:** Usually 40 per cent to photographer.

Additional information: See website for futher details on individual collections.

PICTUREBANK PHOTO LIBRARY LTD

Unit 7, Princess Court, Horace Road, Kingston-upon-Thames, Surrey KT1 2SY. Tel: 020 8547 2344. E-mail: info@picturebank.co.uk Web: www.picturebank.co.uk

Contact: Martin Bagge (Managing Director).

Specialist subjects/requirements: Worldwide travel and tourism, UK cities and countryside, people (lifestyle, glamour, families, ethnic peoples), environment, animals (domestic and wild), business, industry and technology.

Markets supplied: Magazines, calendars, travel industry, advertising, etc.

Formats accepted: Digital files at 50MB+.

Usual terms of business: Minimum initial submission: 100 images. Minimum retention period: 5 years.

Commission: Variable - maximum 50 per cent.

Addotional information: Releases must be supplied for all people pictures and private property.

PRESS ASSOCIATION IMAGES

Pearl House, Friar Lane, Nottingham NG1 6BT.

Tel: 0115 844 7447. Fax: 0115 844 7448. E-mail: images@pressassociation.com

Web: www.pressassociation.com/images

Contact: Scott Wilson (Picture Editor).

Specialist subjects/requirements: Worldwide news, sport and showbusiness, past and present. **Markets supplied:** Newspapers, magazines, websites, advertising agencies, etc.

Formats accepted: Digital, film negative and transparency.

Usual terms of business: No minimum terms.

Commission: 50 per cent.

Additional information: Includes pictures from The Press Association, Empics Sport, Empics Entertainment and Associated Press.

RAILPHOTOLIBRARY.COM

Newton Harcourt, Leicestershire LE8 9FH.

Tel: 0116 259 2068. E-mail: studio@railphotolibrary.com

Web: www.railphotolibrary.com

Contact: James Garratt (Library Manager).

Specialist subjects/requirements: Railways – all aspects, national and international, contemporary and archive.

Markets supplied: Advertising, publishing, design, corporate railways.

Formats accepted: Digital preferred (min 25MB JPEG/TIFF); colour transparencies accepted. Archive B&W.

Usual terms of business: Minimum initial submission: 25 pictures. No minimum retention period.

Commission: 50 per cent.

Additional information: All material must be of the highest quality. Transparencies must be mounted and captioned with brief, accurate details.

RETNA PICTURES

29-31 Saffron Hill, London EC1N 8SW.

Tel: 020 7421 6001. E-mail: ed@lfi.co.uk

Web: www.retna.co.uk

Contact: Ed de Sancha (LFI & Entertainment Editor).

Specialist subjects/requirements: Celebrity/music images: portraiture, studio and events photography. Lifestyle images: men, women, couples, family life, health and beauty, leisure, babies, children, teenagers, business and food.

Markets supplied: Newspapers, magazines, books, record companies, advertising.

Formats accepted: All formats but digital files preferred.

Usual terms of business: Minimum initial submission: 40 - 50 images. Minimum retention period: 3 years.

Commission: Negotiable, depending on material.

Additional information: Lifestyle images must be fully model-released.

REX FEATURES

18 Vine Hill, London EC1R 5DZ.

Tel: 020 7278 7294. E-mail: photogs@rexfeatures.com

Web: www.rexfeatures.com

Contact: Steve Brown (Content Manager).

Specialist subjects/requirements: Human interest and general features, current affairs,

personalities, entertainment news, animals, humour, travel.

Markets supplied: UK national newspapers and magazines, book publishers, websites, television and international press. Daily worldwide syndication.

Formats accepted: Digital.

Usual terms of business: No minimum submission. Preferred minimum retention period: 2 years. **Commission:** 50 per cent.

ROYAL GEOGRAPHICAL SOCIETY PICTURE LIBRARY

1 Kensington Gore, London SW7 2AR. Tel: 020 7591 3064. E-mail: images@rgs.org Web: www.rgs.org/images

Contact: Library Manager.

Specialist subjects/requirements: Exploration and geographical coverage, both historic and current. Travel photography from remote destinations: indigenous peoples and daily life, landscapes, environmental and geographical phenomena, agriculture, crafts, human impact on the environment. **Markets supplied:** Commercial publishing and academic research.

Formats accepted: Digital files preferred; minimum 17MB digital capture, 50MB scans.

Usual terms of business: Minimum initial submission: 250 pictures. Minimum retention period: At least 2 years.

Commission: 50 per cent.

SCR PHOTO LIBRARY

Society for Co-operation in Russian and Soviet Studies, 320 Brixton Road, London SW9 6AB. Tel: 020 7274 2282. E-mail: ruslibrary@scrss.org.uk

Web: www.scrss.org.uk

Contact: John Cunningham (Librarian).

Specialist subjects/requirements: Pictures from Russia and all Republics of the former Soviet Union. General/everyday scenes, landscapes, architecture, towns and cities, politics, arts, industry, agriculture, science, etc.

Markets supplied: General.

Formats accepted: All formats.

Usual terms of business: No minimum submission. Minimum retention period: 2 years. Commission: 50 per cent.

SCIENCE PHOTO LIBRARY (SPL)

327-329 Harrow Road, London W9 3RB.

Tel: 020 7432 1100. E-mail: info@sciencephoto.com

Web: www.sciencephoto.com

Contact: Rosemary Taylor (Director).

Specialist subjects/requirements: All types of science-related imagery including health and medicine people and lifestyle, flowers and nature, wildlife and environment, technology and industry, astronomy and space, history of science and medicine.

Markets supplied: Books, magazines, advertising, design, corporate, audio visual.

Formats accepted: Digital only, 50MB with no interpolation.

Usual terms of business: No minimum submission. Minimum retention period: 5 years. **Commission:** 50 per cent.

Additional information: All photographs must be accompanied by full and accurate caption information.

SKYSCAN PHOTOLIBRARY

Oak House, Toddington, Cheltenham GL54 5BY. Tel: 01242 621357. Fax: 01242 621343. E-mail: info@skyscan.co.uk Web: www.skyscan.co.uk **Contact:** Brenda Marks (Library Manager).

> As a member of the Bureau of Freelance Photographers, you'll be kept up-to-date with markets through the BFP Market Newsletter, published monthly. For details of membership, turn to page 9

Specialist subjects/requirements: Air to ground images, particularly historic air photos of the UK.

Markets supplied: Editorial, advertising, design, calendars.

Formats accepted: Prefer digital files of 28+MB (preferably 50+MB) uninterpolated; transparencies, negatives and prints.

Usual terms of business: Minimum initial submission: 20+ images. Minimum retention period: 2 years.

Commission: 50 per cent.

Additional information: Also operates a brokerage service which is sometimes more appropriate than agency terms. Photographs are retained by the photographer; picture requests are initiated and negotiated by Skyscan and fees split 50/50.

STOCKFOOD LTD

UK Office: Signet House, 49-51 Farringdon Road, London EC1M 3JP.

Tel: 020 7438 1220 (UK sales).

Web: www.stockfood.com

Contact: Petra Thierry (Photographers & Art Department, Munich).

Tel: +49 89 747 202 22. E-mail: photographer@stockfood.com

Specialist subjects/requirements: All types of food and drink imagery, including people eating and drinking and other food-related lifestyle pictures.

Markets supplied: Advertising, design, magazine and book publishing.

Formats accepted: Digital (34MB+ from camera, scans at least 50MB+).

Usual terms of business: Minimum initial submission: 100 images. Minimum retention period: 5 years (exclusive representation required).

Commission: Commission to photographer 40 per cent for rights-managed, 30 per cent royalty-free. **Additional information:** With its head office in Munich (Germany), further offices in Kennebunk, Maine (USA) and London, as well as a global network of partner agencies, the agency is represented in more than 75 countries. StockFood is the largest source of food-related media content in the world. All initial photographer contact should be made via website.

TTL PLUS

29-31 Saffron Hill, London EC1N 8SW.

Tel: 020 7421 6005. E-mail: gdunn@photoshot.com

Web: www.ttl-plus.com

Contact: Garry Dunn.

Specialist subjects/requirements: Professional quality images suitable for use on calendars, greetings cards and posters – cats, kittens, dogs, puppies, florals, nature, landscapes, panoramics, abstracts, railways, the seasons, colours, etc.

Markets supplied: Specialist paper product publishers, as above.

Formats accepted: Digital, minimum 24MB, 50 – 60MB preferred. Will view transparencies but any selected will require scanning after editing at the cost of the photographer.

Usual terms of business: No minimum initial submission. Minimum retention period: 5 years. **Additional information:** Images must be of the highest standard and genuinely suitable for upmarket products in relevant fields.

THEIMAGEFILE.COM

3000 Hillswood Drive, Chertsey, Surrey KT16 0RZ.
Tel: 0845 118 0030. E-mail: membership@theimagefile.com
Web: www.theimagefile.com
Contact: Howard Butterfield (Director).
Specialist subjects/requirements: All major commercial subjects.
Markets supplied: Advertising, design agencies, general publishing.
Formats accepted: Digital only.
Usual terms of business: No minimum initial submission or retention period.

188

Commission: 75 per cent to photographer, but because of the personalised facilities offered (see below) there is a monthly subscription charge (discount to BFP members: 20%).

Additional information: Contributing photographers have their own account through which they set their own prices for images sold. They are able to deal direct with purchasers if they wish and also obtain commissions. Other facilities include direct uploading of images and real time payment tracking.

THE TRAVEL LIBRARY

29-31 Saffron Hill, London EC1N 8SW. Tel: 020 7421 6005. E-mail: gdunn@photoshot.com

Web: www.travel-library.co.uk

Contact: Garry Dunn.

Specialist subjects/requirements: Top quality tourist travel material covering destinations worldwide.

Markets supplied: UK tour operators and travel industry, advertising, design and corporate. **Formats accepted:** Digital RAW files saved and submitted as TIFF (minimum 24MB).

Transparencies only accepted in exceptional circumstances.

Usual terms of business: Minimum initial submission: 100 images. Minimum retention period: 5 years.

TRAVEL PICTURES LTD

Blackness Barn, East Cornworthy, Totnes, Devon TQ9 7HQ.

Tel: 0845 1163184. E-mail: enquiries@travel-pictures.co

Web: www.travel-pictures.co

Contact: Karen McCunnall (Submissions Manager).

Specialist subjects/requirements: Travel and travel-related images; food and drink.

Markets supplied: Magazines, newspapers, travel companies, advertising and design, calendars and greetings cards.

Formats accepted: Digital only (minimum file size 50MB).

Usual terms of business: Minimum initial submission: 500 images. Minimum retention period: 3 years.

Commission: 50 per cent.

TRIGGER IMAGE

Lavender Cottage, Brome Avenue, Eye, Suffolk IP23 7HW.

Tel: 01379 871358. E-mail: studio@triggerimage.co.uk

Web: www.triggerimage.co.uk

Contact: Tim Kahane (Director).

Specialist subjects/requirements: Personal, creative photography on any subject, especially images that are atmospheric, emotive or inspiring.

Markets supplied: Art buyers in publishing, design and advertising.

Formats accepted: Digital only, minimum 5100x3000 pixels.

Usual terms of business: Minimum initial submission: 10 sample images. Minimum retention period: 36 months.

Commission: Standard rate 50 per cent.

Additional information: Standard stock images are not accepted; study website first to see the type of work held. Creativity and expression is more important than experience.

VIEW PICTURES LTD

Suite 120, Rosden House, 372 Old Street, London EC1V 9LT. Tel: 0845 862 0115. E-mail: info@viewpictures.co.uk Web:.www.viewpictures.co.uk **Contact:** Dennis Gilbert (Director). **Specialist subjects/requirements:** Top quality images of modern architecture and interior design, with the emphasis on recently-completed projects by leading architects. Classic modern buildings and historic structures also represented.

Markets supplied: Book and magazine publishers, advertising agencies, graphic designers. Formats accepted: Digital, 48MB TIFF files.

Usual terms of business: Minimum initial submission: None stated. Minimum retention period: Negotiable.

Commission: 40 per cent to photographer.

Additional information: Seeks only top quality work from experienced architectural photographers. Commissions may also be available.

ELIZABETH WHITING & ASSOCIATES

21 Albert Street, London NW1 7LU.

Tel: 020 7388 2828. E-mail: ewa@elizabethwhiting.com

Web: www.ewastock.com

Contact: Liz Whiting (Director).

Specialist subjects/requirements: Home interest topics – architecture, interiors, design, DIY, crafts, gardens, food. Some travel and scenic material.

Markets supplied: Book and magazine publishers, advertising, design companies.

Formats accepted: Digital files preferred (minimum 50MB). Colour transparencies accepted with special terms available for in-house scanning.

Usual terms of business: No minimum initial submission, but a contract is only entered into if both parties envisage a long-term commitment. Minimum retention period: 1 year. **Commission:** 50 per cent.

e o minimosi o e per centi

WORLD PICTURES/PHOTOSHOT

29-31 Saffron Hill, London EC1N 8SW.

Tel: 020 7421 6004. Fax: 020 7421 6006. E-mail: info@photoshot.com

Web: www.worldpictures.co.uk

Contact: David Brenes (Library Manager).

Specialist subjects/requirements: Travel material: cities, resorts, hotels worldwide plus girls, couples and families on holiday suitable for travel brochure, magazine and newspaper use.

Markets supplied: Tour operators, airlines, design houses, advertising agencies.

Formats accepted: Digital files, 50MB.

Usual terms of business: No minimum submission but usually like the chance of placing material for minimum period of 2 years. Minimum retention period: 3 years, with a one year rolling extension.

Commission: 50 per cent.

Additional information: World Pictures forms the central travel collection in the Photoshot group of companies.

WRITER PICTURES LTD

90 Temple Park Crescent, Edinburgh EH11 1HZ.

Tel: 020 8224 1564. E-mail: info@writerpictures.com

Web: www.writerpictures.com

Contact: Alex Hewitt (Partner).

Specialist subjects/requirements: Photographs of authors and writers, mainly editorial-style portraiture.

Markets supplied: Publishing industry, news media.

Formats accepted: Digital preferred, minimum 30MB, but transparencies/negs always considered. **Usual terms of business:** No minimum initial submission. Minimum retention period: 1 year. **Commission:** 50 per cent.

Additional information: Commissions to photograph individual writers may also be available.

ZENITH IMAGE LIBRARY

Apollo 11, 18 All Saints Road, London W11 1HH. Tel: 020 7221 1691. E-mail: info@zenithfoundation.com Web: www.zenithimagelibrary.com

Contact: Mona Deeley (Director).

Specialist subjects/requirements: The Arab world and the Middle East – current events, historic/recent history events, everyday lives, culture, sport, religion, and other aspects of the unreported Middle East. Both stills and clips. Also interested in private archive collections of images relating to the region.

Markets supplied: Newspapers, magazines, general publishing, etc.

Formats accepted: Digital.

Usual terms of business: No minimum terms stated.

Commission: 50 per cent.

Additional information: All stock is rights-managed, licensed to buyers for specified project uses only and priced according to size.

SERVICES

This section lists companies providing products and services of use to the photographer. A number of those listed offer discounts to BFP members. To obtain the discounts indicated, members should simply produce their current membership card. In the case of mail order transactions, enclose your membership card with your order, requesting that this be returned with the completed order or as soon as membership has been verified. But in all cases, ensure that your membership card is valid: the discount will not be available to those who present an expired card.

Courses & Training

NATIONAL COUNCIL FOR THE TRAINING OF JOURNALISTS (NCTJ)

The New Granary, Station Road, Newport, Saffron Walden, Essex CB11 3PL. Tel: 01799 544014. Fax: 01799 544015. E-mail: info@nctj.com Web: www.nctj.com

Official training body for the journalism industry. Offers press photography and journalism training through its accredited colleges/universities and by distance learning. Short mid-term courses are available in various disciplines for journalists wishing to progress their career. **Discount to BFP Members:** 10%

TRAVELLERS' TALES

92 Hillfield Road, London NW6 1QA.

E-mail: info@travellerstales.org

Web: www.travellerstales.org

Training agency dedicated to travel photography and writing, offering masterclasses in London and training holidays around the world. Tutors are top travel photographers, editors and writers. Courses suitable for beginners and professionals, online tuition available. Hosts annual Traveller's Tales Festival featuring the world's leading travel writers and photographers. Details and booking via website.

As a member of the Bureau of Freelance Photographers, you'll be kept up-to-date with markets through the BFP Market Newsletter, published monthly. For details of membership, turn to page 9

Equipment Hire

DIRECT PHOTOGRAPHIC

200-202 Hercules Road, Waterloo, London SE1 7LD. Tel: 020 7620 8500. E-mail: hello@directphotographic.com Web: www.directphotographic.com Comprehensive photographic and lighting equipment hire services. Also sale of studio accessories and 2000 sq ft drive-in studio for hire.

FILM PLUS

77-81 Scrubs Lane, London, NW10 6QW Tel/fax: 020 8969 0234. E-mail: neil@filmplus.com Web: www.filmplus.com Professional rental and sales. Digital, lighting and camera equipment hire. Film and hardware sales. Also studio hire. Discount to BFP Members: 10%

THE FLASH CENTRE

Carlot Value Contre, Marchmont Street, London WC1N 1AE.
Tel: 020 7837 5649. E-mail: hire@theflashcentre.co.uk
2 Mount Street Business Centre, Birmingham B7 5RD.
Tel: 0121 327 9220.
Unit 7 Scala Court, Leathley Road, Leeds LS10 1JD.
Tel: 0113 247 0937.
Web: www.theflashcentre.com
Hire of electronic flash, digital photographic equipment. HD DSLR and production video equipment.

HIREACAMERA

Unit 5, Wellbrook Farm, Berkeley Road, Mayfield, East Sussex TN20 6EH. Tel: 01435 873028. E-mail: enquiries@hireacamera.com Web: www.hireacamera.com Hire of wide range of digital cameras, camcorders, lenses and accessories catering for both private and corporate needs. Discount to BFP Members: 5%

SFL

Unit 23 Headley Park 10, Headley Road East, Woodley, Reading RG5 4SW. Tel: 0118 969 0900. Fax: 0118 969 1397. E-mail: info@sflgroup.co.uk Web: www.sflgroup.co.uk Hire and sale of AV equipment, film production and video production equipment.

Equipment Repair

BOURNEMOUTH PHOTOGRAPHIC REPAIR SERVICES LTD

251 Holdenhurst Road, Bournemouth, Dorset BH8 8DA. Tel: 01202 301273. Professional repairs to all makes of equipment. Full test f

Professional repairs to all makes of equipment. Full test facilities including modern electronic diagnostic test equipment.

Discount to BFP Members: 5% off labour charges (cash sales).

THE CAMERA REPAIR CENTRE

47 London Road, Southborough, Tunbridge Wells, Kent TN4 0PB. Tel: 01892 619136. E-mail: info@thecameracentre.com Web: www.thecameracentre.com Repairs to all makes of photographic equipment, including camcorders and digital. Canon authorised.

THE FLASH CENTRE

68 Brunswick Centre, Marchmont Street, London WC1N 1AE.
Tel: 020 7833 4737. E-mail: service@theflashcentre.co.uk
Web: www.theflashcentre.com
2 Mount Street Business Centre, Birmingham B7 5RD.
Tel: 0121 327 9220.
Unit 7 Scala Court, Leathley Road, Leeds LS10 1JD.
Tel: 0113 247 0937.
Specialists in electronic flash service and repair.

A J JOHNSTONE & CO LTD

395 Central Chambers, 93 Hope Street, Glasgow G2 6LD. Tel: 0141 221 2106. Fax: 0141 221 9166. E-mail: ajjohnstone@btconnect.com Web: www.ajjohnstone.co.uk All equipment repairs, including AV equipment. Authorised service centre for Canon, Olympus and Nikon. Canon and Nikon warranty repairs. **Discount to BFP Members:** 10%.

SENDEAN

9ñ12 St Anneis Court, London W1F 0BB. 22/23 St Cross Street, Clerkenwell, London EC1N 8UH. Tel: 020 7439 8418; 020 7242 7733. E-mail: mail@sendeancameras.com Web: www.sendeancameras.com General repair service. Estimates free. **Discount to BFP Members:** 10%.

Insurance

AUA INSURANCE

Kingfisher House, 1, Gilders Way, Norwich NR3 1ub. Tel: 01603 628034. E-mail: sales@aua-insurance.com Web: www.aua-insurance.com Insurance for professional and semi-professional photographers. Comprehensive package policies covering equipment, liabilities, loss of income, professional negligence, etc. Discount to BFP Members: 10%.

AADUKI MULTIMEDIA INSURANCE

Bridge House, Okehampton EX20 1DL.

Tel: 01837 658880. E-mail: info@aaduki.com

Web: www.aaduki.com

Specialist service to photographers for the insurance of cameras and other equipment. Range of products suitable for full-time professional, semi-pro or amateur, including liability and indemnity insurance, and high-risk travel. Bespoke policies also available.

Discount to BFP Members: 15% (subject to minimum premiums).

E & L INSURANCE

Thorpe Underwood Hall, Ouseburn, York YO26 9SS. Tel: 08449 809 520. Fax: 08449 809 410. E-mail: info@eandl.co.uk Web: www.eandl.co.uk/camera-insurance Specialist photographic insurance scheme covering private, domestic or commercial photo equipment. 25% online discount.

GLOVER & HOWE LTD

4 St Peters Court, St Peters Street, Colchester, CO1 1WD. Tel: 01206 814500. Fax: 01206 814501. E-mail: insurance@gloverhowe.co.uk Web: www.gloverhowe.co.uk Insurance for photographic equipment and associated risks, for the amateur, semi-pro or professional.

Discount to BFP Members: 10%.

INDEMNITYGUARD

JLT | Online, Pavilion House, Mercia Business Village, Coventry CV4 8HX. Tel: 02476 851000. Fax: 02476 851080. E-mail: sales@indemnityguard.co.uk Web: www.indemnityguard.co.uk Professional indemnity insurance for photographers and videographers, offering a range of cover levels. Instant quotes, cover, renewals and changes available online. Discount to BFP Members: 10%.

INFOCUS PHOTOGRAPHY INSURANCE

34 Victoria Street, Altrincham, Cheshire WA14 1ET. Tel: 0844 811 8056. E-mail: info@infocusinsurance.co.uk Web: www.infocusinsurance.co.uk Photographic insurance specialists. Photography Insurance Policies specially designed for professional photographers but also available to semi-professionals and amateur photographers hoping to begin a career in photography. Discount to BFP Members: 10%.

MORGAN RICHARDSON LTD

Westgate Court, Western Road, Billericay, Essex CM12 9ZZ. Tel: Freecall 0800 731 2940. E-mail: quotes@morganrichardson.co.uk Web: www.morganrichardson.co.uk Specialist iPolicy Portfolioî and iPhotographersí Economyî insurance for photographers. Tailored packages. Professional indemnity automatically insured up to £50,000. **Discount to BFP Members:** 10%

PHOTOGUARD

Thistle Insurance Services Ltd, Pavilion House, Mercia Business Village, Coventry CV4 8HX. Tel: 02476 851000. Fax: 02476 851080. E-mail: sales@photoguard.co.uk Web: www.photoguard.co.uk Specialist insurance cover for photographers and their equipment, offering a range of flexible

options. Instant quotes, cover, renewals and changes available online. **Discount to BFP Members:** 10%.

As a member of the Bureau of Freelance Photographers, you II be kept up-to-date with markets through the BFP Market Newsletter, published monthly. For details of membership, turn to page 9

TOWERGATE CAMERASURE

Funtley Court, Funtley Hill, Fareham, Hampshire PO16 7UY. Tel: 0870 4115511. Fax: 0870 4115515. E-mail: camerasure@towergate.co.uk Web: www.towergatecamerasure.co.uk

Range of specialist insurances for amateur, semi-professional and professional photographers, including comprehensive cover for equipment, studios, work in progress and legal liabilities (public, products and employer's).

Discount to BFP Members: Up to 40%, subject to minimum premium requirements.

WEALD INSURANCE BROKERS LTD

Falcon House, Black Eagle Square, Westerham, Kent TN16 1SE. Tel: 01959 565678. E-mail: info@wealdinsurance.com Web: www.wealdinsurance.com Comprehensive specialist insurance policies for professional and semi-pro photographers. **Discount to BFP Members:** 15% (subject to no claims).

Postcard Printers

COLOURCARDS

Unit 1&2, Wadsworth Close, Perivale, Ealing UB6 7JF. Tel: 020 8799 6355. E-mail: sales@colourcards.co.uk Web: www.colourcards.co.uk 7-day postcard and greetings card printing service. Any digital artwork accepted. Card design service also available. Discount to BFP Members: 10%.

JUDGES POSTCARDS LTD

176 Bexhill Road, St Leonards on Sea, East Sussex TN38 8BN. Tel: 01424 420919. E-mail: sales@judges.co.uk Web: www.judges.co.uk Printers of postcards, greetings cards and calendars. Minimum quantity: 100. Discount to BFP Members: 10%.

THE POSTCARD COMPANY

51 Gortin Road, Omagh BT79 7HZ. Tel: 028 8224 9222. E-mail: sales@thepostcardcompany.com Web: www.thepostcardcompany.com Printers of postcards, greetings cards and product cards. No minimum quantity.

THOUGHT FACTORY

KPE Group, 40 Waterside Road, Hailton, Leicester LE5 1TL. Tel: 0116 276 5302. Fax: 0116 246 0506. E-mail: sales@thoughtfactory.co.uk Web: www.thoughtfactory.co.uk Minimum quantity: 100. Price: £50 + VAT. **Discount to BFP Members:** 10%.

Are you working from the latest edition of The Freelance Photographer s Market Handbook? It s published on 1 October each year. Markets are constantly changing, so it pays to have the latest edition

Processing & Finishing

ACTPIX LTD

Trefechan, 2 Dolybont, St Harmon, Rhayader, Powys LD6 5LZ. Tel: 01597 870017. E-mail: enquire@actpix.com Web: www.actpix.com Picture framing, Giclee printing, image retouching and scanning of commercial images at very high resolution. Discount to BFP Members: 5% on orders over £200.

ANDREWS IMAGING

10 Stafford Close, Ashford, Kent TN23 4TT. Tel: 01233 620764. E-mail: info@andrewsimaging.co.uk Web: www.andrewsimaging.co.uk Comprehensive range of digital printing and scanning from negatives, transparencies and digital files.

BLUE MOON DIGITAL LTD

Davina House, 5th Floor, 137-149 Goswell Road, London EC1V 7ET. Tel: 020 7253 9993. Fax: 020 7253 9995. E-mail: info@bluemoondigital.com Web: www.bluemoondigital.com Full film and digital imaging service including printing, processing and duplicating. Other services include mounting, CD/DVD burning and website design.

CC IMAGING

7 Scala Court, Leathley Road, Leeds LS10 1JD. Tel: 0113 244 8329. E-mail: ccimaging@btconnect.com Web: www.ccimaging.co.uk Comprehensive colour and B&W processing and printing services. E6 specialists. Specialist digital photographic print service. Full mounting and finishing services. Digital scanning, retouching and printing.

Discount to BFP Members: 15%.

CPL GRAPHICS & DISPLAY

Head Office: 14 Vale Rise, Tonbridge, Kent TN9 1TB.
Tel: 01732 367222. Fax: 01732 366863. E-mail: info@cpl-graphics.com
Web: www.cpl-graphics.com
Specialist digital printing services. Professional and personal service where the photographer can talk directly to the person printing their work.
Discount to BFP Members: 10% on orders over £100.

DUNNS IMAGING GROUP LTD

Chester Road, Cradley Heath, West Midlands B64 6AA. Tel: 01384 564770. Fax: 01384 637165. E-mail: enquiries@dunns.co.uk Web: www.dunns.co.uk Comprehensive printing services, with online ordering. Event photography and schools service.

GENESIS IMAGING

Unit 1, Hurlingham Business Park, Sulivan Road, Fulham, London SW6 3DU. Tel: 020 7384 6299. E-mail: info@genesisimaging.co.uk Web: www.genesisimaging.co.uk Services: Large Format (Lambda) photographic prints, extra wide Giclee fine art prints, stretched canvas prints, Acrylic face mounts (perspex face mounts), aluminium mounts, Dibond mounts, Foamex mounts, foam board mounts and bespoke framing services. Film and flatbed scanning, digital image retouching and image composition, printing direct to media. **Discount to BFP Members:** 10%.

HMD GROUP PLC

Olympia House, 4 Garnett Close, Watford WD24 7JY. Tel: 01923 237012. Fax: 01923 817421. E-mail: sales@hmdgroup.com Web: www.hmdgroup.com Digital printing services, mounting and finishing. **Discount to BFP Members:** 15%.

HOME COUNTIES COLOUR SERVICES LTD

Treelands, Oldhill Wood, Studham, Bedfordshire LU6 2NE. Tel: 01582 873338. E-mail: sales@hccs.co.uk Web: www.hccs.co.uk Photographic processing services for photographers, including digital. **Discount to BFP Members:** On volume work only; open to negotiation.

KAY MOUNTING SERVICE

4c, Athelstane Mews, London N4 3EH. Tel: 020 7272 7799. E-mail: info@kaymounting.co.uk Web: www.kaymounting.co.uk Specialists in Diasec bonding behind perspex/aluminium with sub-frames; ready to hang frameless artwork. Discount to BFP Members: 10%

ONE VISION IMAGING LTD

Herald Way, Binley, Coventry CV3 2NY. Tel: 0845 862 0217. Fax: 024 7644 4219. E-mail: info@onevisionimaging.com Web: www.onevisionimaging.com Comprehensive colour processing and digital imaging services.

PEAK IMAGING

Unit 6, Flockton Park, Holbrook Avenue, Halfway, Sheffield S20 3PP. Tel: 01142 243207. E-mail: info@peak-imaging.com Web: www.peak-imaging.com. Mail order pro-am photographic and digital imaging centre. **Discount to BFP Members:** 10% on pro lab services.

REDWOOD PRO LAB & WHOLESALER

7 Brunel Court, Severalls Park, Colchester, Essex CO4 9XW. Tel: 01206 751241. Fax: 01206 855134. E-mail: info@redwoodphoto.com Web: www.redwoodphoto.com Colour and B&W processing, electronic imaging, in-house wedding album manufacture. **Discount to BFP Members:** 5%.

RUSSELL PHOTO IMAGING

17 Elm Grove, Wimbledon, London SW19 4HE. Tel: 020 8947 6172. E-mail: info@russellsgroup.co.uk Web: www.russellsgroup.co.uk Comprehensive colour processing services; 2-hour E6 processing, C41, machine and hand line printing, exhibition printing and mounting service. Digital services; scanning, digital printing and Giclee printing.

Discount to BFP Members: 5%.

SCL

16 Bull Lane, Edmonton, London N18 1SX.
Tel: 020 8807 0725. E-mail: davids@sclimage.net
Web: www.sclimage.net
Printing of digital photos up 20"x30" on lustre, gloss or metallic paper. Plus mounting and finishing, exhibition graphics, roller banners and display stands.

THEPRINTSPACE

74 Kingsland Road, London E2 8DL. Tel: 020 7739 1060. E-mail: info@theprintspace.co.uk Web: www.theprintspace.co.uk Professional photographic printing, museum quality print mounting, bespoke professional framing. Also provides high-end digital darkroom facilities for hire to photographers.

THE VAULT IMAGING LTD

1 Dorset Place, Brighton BN2 1ST. Tel: 01273 688733. E-mail: info@thevaultimaging.co.uk Web: www.thevaultimaging.co.uk Comprehensive professional processing, scanning and printing services. Specialists in large format printing on a selection of premium papers and canvas, giclee and photo art archival prints.

Specialised Equipment & Materials

THE FLASH CENTRE

68 Brunswick Centre, Marchmont Street, London WC1N 1AE.
Tel: 020 7837 5649. E-mail: sales@theflashcentre.co.uk
Web: www.theflashcentre.com
2 Mount Street Business Centre, Birmingham B7 5RD.
Tel: 0121 327 9220.
Unit 7 Scala Court, Leathley Road, Leeds LS10 1JD.
Tel: 0113 247 0937.
Specialist suppliers of electronic flash systems, medium format digital cameras, HD DSLR and production video equipment.

KENRO LTD

Greenbridge Road, Swindon SN3 3LH. Tel: 01793 615836. E-mail: sales@kenro.co.uk Web: www.kenro.co.uk Wide variety of accessories including camera bags, batteries and chargers, Benbo tripods and camera bags, Nissin flashguns, Marumi filters, Reflecta digitisation products, Braun photo and optical products, background supports, reflector kits, lightboxes and viewers, memory cards.

S.W. KENYON

The Old Parsonage, Church Road, Sandhurst, Cranbrook, Kent TN18 5NS. Tel: 01580 850770. E-mail: swkenyon@btinternet.com Web: www.swkenyon.com K-Line dulling and colour sprays, air duster spray for cleaning photographic equipment.

SILVERPRINT LTD

120, London Road, Elephant & Castle, London, SE1 6LF Tel: 020 7620 0169. E-mail: sales@silverprint.co.uk Web: www.silverprint.co.uk

Specialist suppliers of B&W materials. Importers of Maco and Foma fibre-based and RC papers and a wide range of other papers, toners, liquid emulsions, tinting and retouching materials. Products for archival mounting, and archival storage boxes and folio cases. Mail order service.

Storage & Presentation

ABLE DIRECT CENTRE LTD

5 Mallard Close, Earls Barton, Northampton NN6 0LS. Tel: 0844 8482733. E-mail: sales@able-labels.co.uk Web: www.able-labels.co.uk Able-Labels ñ printed self-adhesive labels; business cards.

ARROWFILE

PO Box 637, Wetherby Road, York YO26 0DQ. Tel: 0844 855 1100. E-mail: customerservices@arrowfile.com Web: www.arrowfile.com Archival photographic storage and presentation specialists. The Arrowfile System organises, stores and protects varying photo sizes, negs, slides, and CDs all in one single binder album.

CHALLONER MARKETING LTD

Quill Hall Lane, Off Raans Road, Amersham, Buckinghamshire HP6 6LU. Tel: 01494 721270. Fax: 01494 725732. E-mail: info@challoner-marketing.com Web: www.challoner-marketing.com Suppliers of Fly-Weight polypropylene envelope stiffener. Minimum quantity: 100. **Discount to BFP Members:** 10% on orders over 5,000.

DW GROUP LTD

Unit 7, Peverel Drive, Granby, Milton Keynes MK1 1NL. Tel: 01908 642323. Fax: 01908 640164. E-mail: sales@dw-view.com Web: www.photopages.com Filing and presentation systems, masks for all formats, mounts, wallets, storage cabinets, lightboxes, display boxes, viewing booths, viewtowers, ultra-slim light panels. Also CD-ROM production and replication, CD printers and replication systems, floppy disk duping, poster prints.

NICHOLAS HUNTER LTD

Discount to BFP Members: 10%.

Unit 17, Chiltern Business Centre, Garsington Road, Cowley, Oxford OX4 6NG. Tel: 01865 777365. Fax: 01865 773856. E-mail: office@nicholashunter.com Web: www.photofiling.com Plastic wallets for presentation of prints, slides and negatives.

Discount to BFP Members: 5% on orders over £100; 10% over £500.

KENRO LTD

Greenbridge Road, Swindon, Wilts SN3 3LH. Tel: 01793 615836. E-mail: sales@kenro.co.uk Web: www.kenro.co.uk Professional and retail photo albums and frames, CD storage products, strut mounts and folders, lightboxes and viewers, storage and presentation accessories for digital and film.

LONDON LABELS LTD

20 Oval Road, London NW1 7DJ. Tel: 020 7267 7105. E-mail: del@londonlabels.co.uk Self-adhesive labels for 35mm slides, printed with name, address or logo. Also plain labels.

SECOL LTD

Howlett Way, Thetford, Norfolk IP24 1HZ. Tel: 01842 752341. Fax: 01842 762159. E-mail: sales@secol.co.uk Web: www.secol.co.uk Wide range of photographic storage and display products including sleeves, filing sheets, storage boxes, black card masks, mounting systems, portfolio cases and portfolio boxes. **Discount to BFP Members:** 10% on prepaid orders of £100 or more.

SLIDEPACKS

1 The Moorings, Aldenham Road, Bushey, Herts WD23 2NR.

Tel: 01923 254790. E-mail: sales@slidepacks.com

Web: www.slidepacks.com

Binders, folders, mounts and wallets for transparency presentation, storage and filing. Custommade service also available. Also supply labels, lightboxes, lupes and other accessories.

Studio Hire & Services

BASE MODELS

5th Floor, 104 Oxford Street, London W1D 1LP. Tel: 020 7323 0499/01202 461073. E-mail: info@basemodels.co.uk Web: www.basemodels.co.uk Commercial, fashion and glamour model agency supplying models throughout the UK. Branches in Bournemouth, Manchester, Liverpool, Leeds, Birmingham, Newcastle, Bristol, Brighton, Southampton, Edinburgh, Plymouth and Portugal. Discount to BFP Members: 10%.

FARNHAM STUDIO

Frampton Cottage, Pankridge Street, Crondall, Near Farnham GU10 5QU. Tel. 01252 850792. E-mail: enquiries@model-media.co.uk Web: www.model-media.co.uk Photographic studio based in an attractive cottage with gardens and two large studio rooms. Studio tuition and models also available. **Discount to BFP Members:** 20%.

HOLBORN STUDIOS

49/50 Eagle Wharf Road, London N1 7ED. Tel: 020 7490 4099. Fax: 020 7253 8120. E-mail: bookings@holbornstudios.com Web: www.holbornstudios.com 15 studios to hire, plus very comprehensive equipment hire. **Discount to BFP Members:** 10% on full week bookings.

SIMULACRA STUDIO

302-304 Barrington Road, London SW9 7JJ. Tel: 020 7733 1979, E-mail: info@simulacrastudio.com Web: www.simulacrastudio.com Fully equipped studio offering characteful space under a converted railway arch. Wide range of hire equipment available. Discount to BFP Members: 25% on full-day hire.

Web Services

AMAZING INTERNET LTD

69 Strathmore Road, Teddington, TW11 8UH. Tel: 020 8977 8943. E-mail: contact@amazinginternet.com Web: www.amazinginternet.com Website solutions for photographers. Range from fully updateable portfolio websites to large photo library systems, plus full e-commerce facilities and online sales modules for wedding and social photographers.

Discount to BFP Members: 10%.

CONTACT CREATIVE UK

Room 19, Redhill Aerodrome, Kings Mill Lane, Surrey RH1 5YP. Tel: 01737 241399. E-mail: sales@contact-creative.com Web: www.contact-creative.com Self-promotion solutions for photographers: Online portfolio portal, annual source books, e-mail marketing and high-quality printing services. Discount to BFP Members: 5%.

CRUNCH

Unit 11, Hove Business Centre, Fonthill Road, Hove, BN3 6HA. Tel: 0844 500 8000. E-mail: info@crunch.co.uk Web: www.crunch.co.uk Online accounting system and accountancy practice dedicated to freelances and other small

businesses. Full end-to-end accountancy process backed by gualified Chartered Accountants. Discount to BFP Members: 10% for first two years of service.

IMENSE

21 Sanderling Lodge, Star Place, London E1W 1AJ. Tel: 020 3283 4225. E-mail: sales@imense.com Web: www.imense.com Imense Annotator keywording application aimed at professional and semi-professional photographers. Provides automated kyewording designed to speed up workflow and attract buyers with commercially relevant keywords.

LIGHT BLUE SOFTWARE

101 Teversham Drift, Cambridge CB1 3LL. Tel: 07881 952510. E-mail: admin@lightbluesoftware.com Web: www.lightbluesoftware.com

Provider of iLight Blueî business management software specifically designed for photographers. Includes contacts, shoot records, order and payment tracking, purchases and more. Free 30-day trial version available from website.

MISTERCLIPPING.COM

MisterClipping.com UK Ltd, 229 Shoreditch High Street, London E1 6PJ. UK Support Tel: 020 3695 1886. E-mail: vincent@misterclipping.com www.misterclipping.com Graphic processing service providing handmade clipping paths to isolate images from their backgrounds. Uploaded images can be downloaded with a path or isolated from their background within 24 hours.

PIXELRIGHTS

16 Camden Road, Camden Town, London NW1 9DP. E-mail: hello@pixelrights.com Web: www.pixelrights.com Website solution for professional and semi-pro photographers based on easily-customisable templates. Additionally provides digital security tools allowing work to be displayed online without fear of theft.

SIGNUM TECHNOLOGIES LTD

Dunraven House, 5 Meadow Court, High Street, Witney, Oxfordshire OX28 6ER. Tel: 01933 776929. E-mail: signum@signumtech.com Web: www.signumtech.com SureSign digital watermarking plug-ins for Photoshop, for copyright protection and notification.

WEBBOUTIQUES LTD

1 Abbey Street, Eynsham, Oxfordshire OX29 4TB.

Tel: 01865 883852. E-mail: ask@webboutiques.co.uk

Web: www.webboutiques.co.uk

Bespoke web design services to photographers and artists, from standard sites to complex code driven solutions. On-line ordering and printing services and a full on-line portfolio search are available.

Discount to BFP Members: On application.

USEFUL ADDRESSES

ASSOCIATION OF MODEL AGENTS

11ñ29 Fashion Street, London E1 6PX. Tel: 020 7422 0699. E-mail: amainfo@btinternet.com Web: www.associationofmodelagents.org

ASSOCIATION OF PHOTOGRAPHERS (AOP)

Studio 9, Holborn Studios, 49/50 Eagle Wharf Road, London N1 7ED. Tel: 020 7739 6669. E-mail: info@aophoto.co.uk Web: www.the-aop.org

BRITISH ASSOCIATION OF PICTURE LIBRARIES AND AGENCIES (BAPLA)

59 Tranquil Vale, Blackheath, London, SE3 0BS. Tel: 020 8297 1198. E-mail: enquiries@bapla.org.uk Web: www.bapla.org.uk

BRITISH INSTITUTE OF PROFESSIONAL PHOTOGRAPHY (BIPP)

The Coach House, The Firs, High Street, Whitchurch, Aylesbury HP22 4SJ. Tel: 01296 642020. E-mail: info@bipp.com Web: www.bipp.com

BRITISH PRESS PHOTOGRAPHERS' ASSOCIATION (BPPA)

Suite 219, 2 Lansdowne Crescent, Bournemouth BH1 1SA. E-mail: info@thebppa.com Web: www.thebppa.com

BUREAU OF FREELANCE PHOTOGRAPHERS (BFP)

Vision House, PO Box 474, Hatfield AL10 1FY. Tel: 01707 651450. E-mail: mail@thebfp.com Web: www.thebfp.com

CHARTERED INSTITUTE OF JOURNALISTS (CIOJ)

2, Dock Offices, Surrey Quays Road, London SE16 2XU. Tel: 020 7252 1187. E-mail: memberservices@cioj.co.uk Web: www.cioj.co.uk

DESIGN & ARTISTS COPYRIGHT SOCIETY (DACS)

33 Great Sutton Street, London EC1V 0DX. Tel: 020 7336 8811. E-mail: info@dacs.org.uk Web: www.dacs.org.uk

GUILD OF PHOTOGRAPHERS

Hillcrest House, 2 Woodland Avenue, Newcastle-Under-Lyme ST5 8AZ. Tel: 01782 639500. E-mail: info@photoguild.co.uk Web: www.photoguild.co.uk

MASTER PHOTOGRAPHERS ASSOCIATION (MPA)

Jubilee House, 1 Chancery Lane, Darlington, Co Durham DL1 5QP. Tel: 01325 356555. E-mail: general@mpauk.com Web: www.thempa.com

NATIONAL ASSOCIATION OF PRESS AGENCIES (NAPA)

Suite 302, Queens Dock Business Centre, 67-83 Norfolk Street, Liverpool L1 0BG. Tel: 0870 240 0311. E-mail: enquiries@napa.org.uk Web: www.napa.org.uk

NATIONAL UNION OF JOURNALISTS (NUJ)

Headland House, 308-312 Grayis Inn Road, London WC1X 8DP. Tel: 020 7278 7916. E-mail: info@nuj.org.uk Web: www.nuj.org.uk

REUTERS

Thomson Reuters Building, South Colonnade, Canary Wharf, London E14 5EP. Tel: 020 7542 7949 (UK news picture desk); 020 7542 8088 (international news picture desk). E-mail: lon.pictures@reuters.com Web: uk.reuters.com/news/pictures

ROYAL PHOTOGRAPHIC SOCIETY (RPS)

Fenton House, 122 Wells Road, Bath BA2 3AH. Tel: 01225 325733. E-mail: reception@rps.org Web: www.rps.org

SOCIETY OF WEDDING & PORTRAIT PHOTOGRAPHERS (SWPP)

6 Bath Street, Rhyl LL16 3EB. Tel: 01745 356935. E-mail: info@swpp.co.uk Web: www.swpp.co.uk

INDEX

A

AA Media Ltd 147 ACTPIX Ltd 199 AM (Automotive Management) 115 A-Plus Image Bank 170 AUA Insurance 196 AV 92 Aaduki Multimedia Insurance 196 Able-Direct Centre Ltd 202 Absolute Press 147 Action Images 170 Action Plus 170 Ad Lib 99 Adams Picture Library 170 Advanced Photographer 92 Aeroplane 35 Air International 35 Airforces Monthly 36 Airliner World 36 Airport World 36 Airports International 36 Alamy 171 All Out Cricket 106 Allan, Ian, Publishing 147 Alphafit 64 Alvey & Towers 171 Amateur Photographer 92 Amazing Internet 204 Amber Books 147 American Car Magazine 82

Ancient Art & Architecture 171 Andes Press Agency 172 Andrews, Chris, Publications 159 Andrews Imaging 199 Angler's Mail 27 Angling Times 27 Animal Photography 172 Anness Publishing 147 Antique Collector's Club Ltd 147 Arcangel Images 172 Architecture Today 31 Ardea 172 Arena PAL 172 Arrowfile 202 Association of Model Agents 206 Association of Photographers 206 Athletics Weekly 106 Attitude 79 Aurum Press 147 Auto Express 82 Autocar 83 Automobile, The 83 Aviation News 37 Australia & New Zealand 122 **Axiom Photographic Agency** 173

В

BBC Wildlife 28 Back Street Heroes 51 **Badminton** 106 Base Models 203 Bella 126 Bennaci, Thomas 159 Best 126 Best of British 62 Big Issue, The 99 Bike 52 Bird Watching 29 Birdwatch 29 Bizarre 63 Black, A & C, Publishers Ltd 148Black+White Photography 92 Bloomsbury Publishing Ltd 148 Blue Moon Digital Ltd 199 Boards 38 Boat International 38 **Boating Business** 38 Bookseller, The 115 **Bournemouth Photographic Repair** Services 195 Boxing Monthly 107 Breslich & Foss 148 Bridgeman Images 173 British Association of Picture Libraries & Agencies 206 British Press Photographers' Association 206 British Baker 116 British Institute of Professional Photography 206 British Journal of Photography 92 **Bubbles Photo Library** 173 Build It 31 **Builders Merchants Journal** (BMJ) 32 **Bureau of Freelance Photographers** 9-10,206Business Traveller 122

С

CC Imaging 199 CPL Graphics & Display 199 CSMA Club Magazine Cambridge University Press 148 Camera Press Ltd 174 Camera Repair Centre, The 196 Camping 44 Camping & Caravanning 44 Canal Boat 39 Capital Pictures 174 Car & Accessory Trader 83 Caravan 45 Caravan Industry 45 Carousel Calendars 159 Carroll & Brown 148 Caterer & Hotelkeeper 116 Cathie, Kyle, Ltd 148 Catholic Herald 104 Catholic Times 104 Cash, Allan, Picture Library 174 Challoner Marketing Ltd 202 Chartered Institute of Journalists 206 Chatto & Windus 148 C+D (Chemist & Druggist) 116 Cheshire Life 46 Children & Young People Now 77 Church of England Newspaper 104 Church Times 104 Classic American 83 Classic Bike 52 Classic Boat 39 Classic Cars 84 Classic Land Rover 84 Classic Motorcycle, The 52 Classic & Sports Car 84 Classical Music 88 Classics Monthly 84 Classic Plant & Machinery 74 Clocks 66 Closer 127 Club International 79 Coach & Bus Week 120 Coast 63 Collections 174 Colorama 207 Colourcards 198 Commercial Motor 120 Company 127 Compete Images 174 Condé Nast Customer Publishing 63 Condé Nast Traveller 122 Contact Creative UK 204 Convenience Store 116 Corbis 176 Cornish Picture Library 175 Cosmopolitan 127 Cotswold Life 46

The Freelance Photographer's Market Handbook 2015

Country Homes & Interiors 70 Country Life 46 Country Smallholding 29 Country Walking 47 Countryfile 47 Countryman, The 47 Craft Butcher Cricket Paper, The 107 Cricketer, The 107 Crops 57 Crowood Press, The 49 Crunch 204 Cumbria 47 Cycle Sport 52 Cycling Plus 53 Cycling Weekly 53 Cyclist 53

D

DB Publishing 149 DW Group Ltd 202 Daily Express 137 Daily Mail 137 Daily Mirror 137 Daily Record 137 Daily Star 137 Daily Star Sunday 138 Daily Telegraph, The 137 Dairy Farmer 57 Dalesman 48 Darts World 108 Decanter 58 Defence Helicopter 37 **Defence Picture Library Ltd** 175 Demotix 175 Design & Artists Copyright Society 206 Digital Camera 93 Digital Photo 94 Digital Photographer 94 Digital SLR 94 Digital SLR Photography 94 Direct Photographic 195 Director 43 Dirt Bike Rider 53 Dive 108 Dogs Today 29 Dorset 48 Dorset Life 48 Drapers 117 Dunns Imaging Group Ltd 199

E

EE Heritage Images 176 E & L Insurance 197 Ebury Publishing 149 Ecoscene 176 Education In Chemistry 105 Elle 127 Elle Decoration 70 Energy In Buildings & Industry 74 Engineering 74 Engineering In Miniature 66 English Home, The 73 English Garden, The 70 EOS Magazine 95 Equestrian Trade News 56 Equi-Ads 56 Escort 79 Esquire 79 Essentials 128 Eurofruit Magazine 117 Evergreen 53 Evo 85 Express Syndication 176 Eye Ubiquitous & Hutchison 176 Eyevine 177

F

FHM 80 FLPA - Images of Nature 178 F&W Media International Ltd 149 FX 32 F1 Racing 108 Faber & Faber Ltd 149 Fabulous 140 Falconers & Raptor Conservation Magazine 30 FameFlynet 177 Famous 177 Farmers Guardian 57 Farmers Weekly 58 Farnham Studio 203 Fibre 63 Field, The 48 Fieldsports 108 Film Plus 195 Financial Management 43 Financial Times 137 Fire & Rescue 74 Fire Risk Management 77

Fishing News 117 Flash Centre, The 195, 196, 201 Fleet News 85 Flight International 37 Florist, The 118 Fly Fishing & Fly Tying 27 Flypast 37 Focus 105 Foodanddrinkphotos.com 178 Food and Travel 123 Forecourt Trader 118 Forestry Journal 118 Forever Sports 108 Forty-20 109 Fotomaze 180 Foulsham, W, & Co Ltd 149 4x4 85 FourFourTwo 109 .fr France Travel Magazine 122 France 123 France Today 123 FrenchEntrée Magazine 124 FRoots 88 Furniture & Cabinetmaking 66

G

GB Eye 159 GP 65 GP International 109 GQ 82 Garden, The 60 Garden Answers 61 Garden News 61 Garden Trade News 61 Garden World Images Ltd 178 Gardeners' World 61 Gardens Illustrated 62 Geographical 124 Genesis Imaging 199 Getty Images 179 Getty Images News & Sport 179 Gibbons Stamp Monthly 67 Glamour 128 Glover & Howe Ltd 197 Golf Monthly 109 Golf World 110 Good Homes 70 Good Housekeeping 128 Good Woodworking 67 Grazia 128 Grub Street Publishing 149 Guardian, The 138

Guardian Weekend 138 Guild of Master Craftsman Publications 150 Guild of Photographers 207 Guinness World Records Ltd 150 Gurgle 91

Н

H&E Naturist Monthly 65 HMD Group 200 Haldane Mason Ltd 150 Hale, Robert, Ltd 150 Hallmark Cards UK 160 Harding, Robert, World Imagery 179 Harpercollins Publishers 150 Harper's Bazaar 129 Harvill Secker 150 Haynes Publishing 150 Health & Fitness 65 Heat 34 Hello! 129 Hello! Fashion Monthly 128 Helm, Christopher, Publishers Ltd 151 Herald, The 138 Heritage Railway 101 Hireacamera 195 Hodder Education Group 151 Hodder Headline Ltd 151 Holborn Studios Ltd 203 Home Counties Colour Services Ltd 200 Home Farmer 58 Homes & Gardens 71 Horse 56 Horse & Hound 56 Horse & Rider 57 Horticulture Week 62 Hotshoe International 95 House Beautiful 71 Housebuilder 32 How It Works 105 Hunter, Nicholas, Ltd 202 Hutchinson 151

I

Icon 32 Ideal Home 71 Image Source 180

The Freelance Photographer's Market Handbook 2015

Imense 204 Improve Your Coarse Fishing 27 Indemnityguard 197 Independent, The 138 Independent Magazine 138 Independent on Sunday, The 139 Independent Retail News 118 Indigo Art 160 Industrial Fire Journal 74 InFocus 197 International Boat Industry 39 International Railway Journal 101 Italia! 124

J

Jane's Defence Weekly 100 Jazz Index Photo Library 180 Jewish Chronicle 100 Johnstone, A J, & Co Ltd 196 Judges Postcards Ltd 160, 198

K

Kardorama Ltd 161 Kay Mounting Service 200 Kennel and Cattery Management 30 Kenro Ltd 201, 203 Kenyon, S W, 202 Kerrang! 88 Keyboard Player 89 King, Laurence, Publishing 151 Kingfisher Publications 152 Kos Picture Source Ltd 180

L

Lady, The 129 Lancashire Life 49 Land Rover Monthly 85 Land Rover Owner International 86 LandLove 71 Landscape 72 LandScape 74 Latitude Stock 182 Lebrecht Music & Arts Photo Library 181 Legal Action 77 Light Blue Software 204 Lincoln, Frances, Ltd 152 Lincolnshire Life 49 Little, Brown Book Group 152 Living France 124 Living4media 181 Loaded 80 London Labels 203 London Media Press 181 London News Pictures 182 Look 129 Loop Images 184 Love It! 130 Lutterworth Press, The 152

Μ

MEED 43 MJ, The (Municipal Journal) 78 Mail on Sunday, The 139 Manufacturing Chemist 75 Marie Claire 130 Marine Engineers' Review 75 Market Newsletter 95 Martial Arts Illustrated 110 Master Photographers Association 207 Master Photography 95 Match 110 Mayfair 81 Meat Trades Journal 119 Men Only 81 Men's Health 81 Metal Hammer 89 Middle East. The 100 Millennium Images Ltd 184 Misterclipping.com 205 MixMag 89 Model Engineer 67 Mojo 89 Morgan Richardson 197 Mother & Baby 91 Moto Magazine 53 Motor Boat & Yachting 40 Motor Cycle News 54 Motor Sport 86 Motorhome & Campervan 45 Mountain Biking UK 54

Ν

NHPA/Photoshot 184 NME 90 N-Photo 96 National Association of Press Agencies 207 National Council for the Training of Journalists 194 National Geographic Traveller 125National Union of Journalists 207 New Civil Engineer 75 New Design 75 New Holland Publishers 152 New Internationalist 100 New Scientist 105 Newscast Ltd 185 911 & Porsche World 86 Non-League Paper, The 110 North East Times 43 Notebook 139 Now 130 Nunn Syndication Ltd 185 Nursery World 91

0

Observer, The 139 **Observer Food Monthly** 139 Observer Magazine, The 139 Octane 87 **Octopus Publishing Group** 152 OK! 131 OK! Extra 143 Old Glory 120 Olive 59 **Omnibus Press** 152 One Vision Imaging Ltd 200 OnImage 185 Orion Publishing Group 153 Osprey Publishing Ltd 153 Outdoor Fitness 111 Outdoor Photography 96 Oxford University Press 153

Ρ

PCS People 101 PYMCA 185 Pan Macmillan 153 Panos Pictures 186 Panstadia & Arena Management 33 Papilio 186 Park Home & Holiday Caravan 45 Parrots 67 Pavilion Books 147 Peak Imaging 200 Penguin Group (UK) 153 Pentax User 96 People Management 43 Performance Ford 87 Period Living 72 Pet Product Marketing 119 Phaidon Press Ltd 153 Photo Professional Magazine 97 PhotoDimension 165 Photography for Beginners 97 Photography Monthly 97 Photography Week 97 Photofusion Picture Library 186 Photographer's Institute Press 153 Photoguard 197 PhotoPlus 98 Photoshot 185 Piatkus Books 154 Pick Me Up 131 PictureBank Photo Library 185 Pilot 38 Pineapple Park 161 Pixelrights 203 Place in the Sun, A 125 Plexus Publishing Ltd 154 Portfolio Collection Ltd 161 Postcard Company, The 198 Post Magazine 44 Poultry World 58 Practical Boat Owner 40 Practical Caravan 45 Practical Fishkeeping 98 Practical Motorhome 46 Practical Photography 98 Practical Photoshop 98 Practical Sportsbikes 54 Practical Wireless 68 Press Association Images 185 Prima 131 Prima Baby & Pregnancy 91 Printspace, The 200 Pro Sound News Europe 75 Professional Engineering 76 Professional Photographer 99 Psychologies 131 Publicans' Morning Advertiser, The 59 Pulse 65

The Freelance Photographer's Market Handbook 2015

Q

Q 90 Quarto Group 154 Quiney, Nigel 161 Quayside Cards 161

R

RIBA Journal 33 RYA Magazine 40 Racing Pigeon, The 111 **Racing Pigeon Pictorial** International 111 Radio Times 34 Radio User 68 Rail 102 Rail Express 102 Railnews 102 Railway Magazine, The 102 Railphotolibrary.com 186 Railways-Milepost 92½ 154 Random House UK Ltd 154 Reader's Digest 64 Reader's Digest (books) 154 Real Homes 72 Red 132 Redwood Pro Lab and Wholesaler 201 Restaurant 59 Resurgence & the Ecologist 101 Retna Pictures 186 Reuters 207 Reveal 132 Rex Features 186 Rhythm 90 Ride 54 Right Start 92 **Riverside Cards** 162 Rose of Colchester Ltd 162 Rotorhub 37 RotoVision 154 Rowing & Regatta 41 **Royal Geographical Society** Picture Library 187 Royal Photographic Society, The 207 Rugby Paper, The 111 Rugby World 111 Runner's World 111 Running Fitness 112

Russell Photo Imaging 201 Ryland, Peters and Small 155

S

S Magazine 139 SCL 201 SCR Photo Library 187 SFL 195 SGB UK 112 Saga Magazine 64 Sailing Today 41 Santoro 162 Scholastic Magazines 78 Science Photo Library 187 Scootering 55 Scotland on Sunday 139 Scots Magazine, The 49 Scotsman, The 138 Scottish Field 49 Scottish Licensed Trade News 60 Scottish Sporting Gazette 112 Sea Angler 28 Secol Ltd 203 SelfBuild & Design 34 Sendean Ltd 196 Sheldrake Press 155 Shire Publications 155 Shooting Gazette, The 113 Shooting Times and County Magazine 116 Signum Technologies Ltd 205 Silverprint Ltd 202 Simon & Schuster 155 Simple Things, The 72 Simulacra Studio 204 Ski & Board 113 Skier & Snowboarder Magazine, The 114 Skyscan Photolibrary 189 Slidepacks 203 Small, Jacqui, LLP 151 Smallish 91 Snooker Scene 114 Society of Wedding & Portrait Photographers 207 Somerset Life 50 Souvenir Press Ltd 155 Sporting Shooter 114 Stage, The 34

Steam Railway 103 Stella 140 Stockfood Ltd 188 Sun, The 138 Sun on Sunday 140 Sunday Express 139 Sunday Mail, The 140 Sunday Mirror 139 Sunday People, The 140 Sunday Post 140 Sunday Review, The 142 Sunday Telegraph, The 140 Sunday Times, The 140 Sunday Times Magazine, The 140 Sunday Times Travel Magazine 125 Superbike 55 Sussex Life 50 Swimming Times 115

Т

T3 106 TLM 64 TTL Plus 188 TV Times 35 Take it Easy 140 Teacher, The 78 Telegraph Magazine 137 Thames & Hudson Ltd 155 That's Life! 133 The Great Outdoors 50 Theimagefile.com 188 This England/Evergreen 50 Thought Factory, The 198 Times, The 138 Times Magazine, The 138 Today's Golfer 115 Today's Railways UK 103 Top Gear Magazine 87 Total Guitar 90 Total 911 87 Toucan Books Ltd 155 **Towergate Camerasure** 198 Towpath Talk 120 Traction 103 Tractor 121 Tractor & Machinerv 121 Trail 51 **Transworld Publishers** 156

Travel Library, The 191 Travel Pictures Ltd 191 Traveller 125 Travellers' Tales 194 Treasure Hunting 68 Trigger Image 192 Trout Fisherman 28 Trout and Salmon 28 Truck & Driver 121 25 Beautiful Homes 73

U

Urethanes Technology International 76 Usborne Publishing 156 Utility Week 76

V

Vault Imaging Ltd, The 201 View Pictures Ltd 192 Virgin Books Ltd 156 Vision Sports Publishing 156 Visordown 55

W

WI Life 133 Waitrose Kitchen 60 Walk 51 Wanderlust 126 Water Craft 41 Waterways World 41 Weald Insurance Brokers Ltd 198 Webboutiques Ltd 205 Weidenfeld & Nicolson 156 Whiting, Elizabeth, & Associates 190 What Digital Camera 99 Windsurf 42 Woman 133 Woman&Home 134 Woman's Own 134 Woman's Weekly 134 Women's Cycling 55 Woodcarving 69 Woodturning 69 Woodworker, The 69 Works Management 76

World of Animals 30 World Fishing 119 World of Interiors, The 73 World Pictures/Photoshot 190 Writer Pictures 190

Y

Yachting Monthly 42 Yachting World 42 Yachts & Yachting 43 Yale University Press 156 Yorkshire Life 51 You Magazine 139 Your Cat 30 Your Chickens 30 Your Dog 31 Your Home 73

Ζ

Zenith Image Library 191 Zoo 82

Join the BFP today and get 14 months for the price of 12!

As a member of the Bureau of Freelance Photographers, you'll be kept right up to date with market requirements. Every month, you'll receive the BFP *Market Newsletter*, a unique publication telling you what picture buyers are looking for now. It will keep you informed of new markets – including new magazines – as they appear and the type of pictures they're looking for. It also serves to keep *The Freelance Photographer's Market Handbook* up to date between editions, since it reports important changes as they occur.

And as part of membership, you receive the Handbook automatically each year as it is published. For details of some of the other services available to members please see page 9.

Membership currently costs just $\pounds 54$ a year. Join now and you'll get 14 months for the price of 12. Complete the form below – or phone 01707 651450 – to join now.

Please enrol me as a member of the Bureau of Freelance Photographers the price of 12. I understand that if, once I receive my initial membershi membership is not for me, I may return it within 21 days for a full refur	ip pack, I decide that	
I enclose cheque/po value £54 (or £75 Overseas rate)		
Debit my mastercard/visa/switch no	Start	
Expiry Issue No (Switch only) Security code	_ in the sum of £54.	
NAMEADDRESS	BLOCK CAPS PLEASE	
Postcoo	Postcode	
Post to:		
Bureau of Freelance Photographers,		
Vision House, PO Box 474, Hatfield AL10 1FY. Overseas applicants must send cheque/draft drawn on a UK bank; or pay by credit	H15	

The new BFP self-teaching Course

This brand new edition of **THE BFP FREELANCE PHOTOGRAPHY COURSE** will teach you the secrets of successful freelancing. A practical, lavishly illustrated hardback, it covers all you need to know to sell your pictures to magazines, greetings cards, calendars, newspapers and more.

Like the original BFP correspondence course, it is presented in lesson format so that you will feel like you have a tutor at your side, showing you how to produce the kind of pictures that sell in today's market. And, when ordered through the BFP, it comes with a set of tutorials, designed to be read in conjunction with each lesson.

Or, why not buy the book as part of a complete self-instruction Course including

membership of the BFP. By doing so, you will also receive the monthly *Market Newsletter* giving information on markets currently looking for pictures, *The Freelance Photographer's Market Handbook* every year as it is published, and access to the BFP Advisory Service. All for just £75.00 per annum.

Order today. Full refund if not completely satisfied.

 Please send me the complete BFP Self-Instruction Freelance Photography Course including BFP membership at the special reduced price of £75. Alternatively, please send me The BFP Freelance Photography Course book alone at just £27 inc P&P. I enclose cheque/po value £ Alternatively, charge my MASTERCARD/ VISA/MAESTRO card 				
no	START DATE	EXP DATE		
ISSUE NO (MAESTRO ONLY)	THREE DIGIT SEC CODE	WITH AMOUNT OF £		
NAME	5		BLOCK	
ADDRESS			DECOR	
			PLEASE	
		Postcode		
Post to: BUREAU OF FREELANCE PHOTOGRAPHERS Vision House, PO Box 474, Hatfield AL10 1FY.				

Get a special previous user's discount when you order next year's Handbook direct

Each year's *Handbook* contains hundreds of amended listings as well as new entries. To take the magazine section alone, during the course of the year, new publications launch while existing titles fold. In addition, editors change which often leads to a change in picture requirements. Similar important changes occur in every other section of the book.

It's vital to keep up-to-date, therefore, by working from the latest edition. The *Handbook* is published in October each year, and you can order next year's edition from September onwards. By using this form, you'll benefit from a special previous user's discount, saving you £3 on the usual direct-from-the-publishers price. While the normal price is £16.95 (£14.95 plus £2 p&p), you pay only £13.95.

Phone 01707 651450 to order or complete and post the coupon below

Please send me a copy of The Freelance Photographer's Market Handook 2015 at the special Previous User's Discount price of £11.95 plus £2.00 p&p.				
I enclose cheque/po value £	ue/po value £ Alternatively, charge my MASTERCARD/ VISA/MAESTRO card			
no	START DATE	EXP DATE		
ISSUE NO (MAESTRO ONLY)	THREE DIGIT SEC CODE	_ WITH AMOUNT OF \pounds _		
NAME			BLOCK CAPS	
ADDRESS			PLEASE	
	Postcode			
Post to:				
Bureau of Freelance Pho	otographers,			
Vision House, PO Box 47 *Overseas readers must send cheque/dra	4, Hatfield AL10 1FY aft drawn on a UK bank; or pay by credit car	d	H15	